SCISSORS,PAPER,STONE

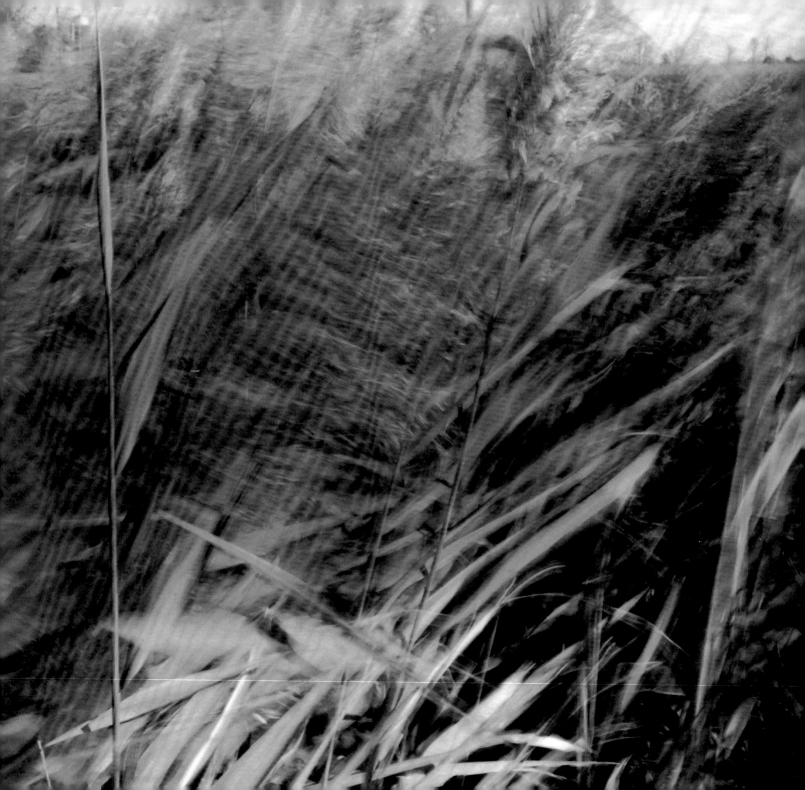

MARTHA LANGFORD

SCISSORS, PAPER, STONE

Expressions of Memory in Contemporary Photographic Art

McGILL-QUEEN'S UNIVERSITY PRESS | Montreal & Kingston • London • Ithaca

ISBN 978-0-7735-3211-3

Legal deposit second quarter 2007
Bibliothèque nationale du Québec

Printed in Canada

This book has been published with the help of a grant from the Canadian Federation for the Humanities and Social Sciences, through the Aid to Scholarly Publications Programme, using funds provided by the Social Sciences and Humanities Research Council of Canada. Funding has also been received from the Faculty of Fine Arts, Concordia University, and from the Canada Council for the Arts through their Visual Arts and Writing and Publishing Program.

McGill-Queen's University Press acknowledges the support of the Canada Council for the Arts for our publishing program. We also acknowledge the financial support of the Government of Canada through the Book Publishing Industry Development Program (BPIDP) for our publishing activities.

Library and Archives Canada Cataloguing in Publication
Langford, Martha

Scissors, paper, stone : expressions of memory in contemporary photographic art / Martha Langford.

Includes bibliographical references and index.
ISBN 978-0-7735-3211-3

1. Photography—Canada. 2. Photography, Artistic. 3. Memory in art. I. Title.

TR26.CL35 2007 770.971 C2007-901645-6

Frontispiece: detail from Sylvie Readman, *Reflux ou les herbes fraiches* (1995) from the series *Reviviscences*.

This book was designed and typeset by studio oneonone in 10.3/13 Filosofia

CONTENTS

SCISSORS, PAPER, STONE

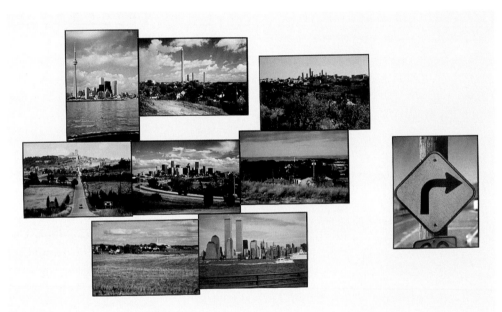

16.5 Stan Denniston
How to Read (1984–86).
Fourth segment (skylines), variable dimensions.

1 | INTRODUCTION: SCISSORS, PAPER, STONE

The viewer's visual game of make-believe is crucial.
— Kendall L. Walton[1]

Photographs bring visions of the past into the present. In that respect, they are felt to be like memories, though no sane person would think they were the same. Memories are neither recorded nor preserved by photographic technology. They are, however, expressed and activated by photographic works of art.

Scissors, Paper, Stone is an interdisciplinary study of the expression of memory in contemporary photographic art. The inquiry complements, and greatly extends, the correlation of photography and orality which was the task of my previous book, *Suspended Conversations: The Afterlife of Memory in Photographic Albums.* The wellspring of both studies is a desire to understand and describe how different modes of remembering translate into photographic images.

Critical deconstructions of photography notwithstanding, we still live with unexamined associations between photography and memory. A fair response is that the link

between photography and memory is just an analogy – fair, and pretty safe, since no analogy is ever wrong. An analogy is the expression of an opinion hung on a likeness. That's a pretty good definition of photography as well, though the question remains: Whose opinion are we talking about? To stand before a photograph in the early twenty-first century is no longer simply to ask, What is this? What message is intended by this picture? First we ask, or ought to ask, Why am I here, standing before this picture? What do I expect from photographic experience and what part should I expect to play? The spectator who wants to engage with a photographic work of art, on his or her own ground, is the reader I have imagined for this book.

Suspended Conversations began to take shape in my mind when I realized that the mass production of photographs that started in the 1860s with the carte-de-visite was neither supporting, nor replacing, memory; it was instead overwhelming it with visual data for which there appeared to be no modern mnemotechnics. Under cover of literacy, compilers of albums worked the problem out, using tools with which they were familiar: the art of memory still lingering in the churches and schools, and the art of conversation still practised in the parlour. *Suspended Conversations* elucidated an oral-photographic framework for storytelling that accommodated personal photographic histories, structured them, and invested them with potential for re-telling, re-remembering, and re-imagining. While researching and writing *Suspended Conversations*, I was constantly reminded that these characteristics are writ large in the work of contemporary photographic artists, though with major differences that seemed to warrant more attention.

This book, *Scissors, Paper, Stone*, explores the great variety of photographic images that makers, critics, and audiences accept as public expressions of memory. The unifying principle of the book is that picturing memory is, first and

foremost, the exhibition of a mental process. Images of memory spring from our beliefs about memory, that is to say, we recognize a mental image as a memory, rather than a perception, because of our beliefs about the way that memory comes. William James called this "the human ontological imagination," stressing its "convincingness," and I should say that, in the early days of this project, James's *The Varieties of Religious Experience* served as a model, or more precisely, as a whip to consider the photographic representation of all kinds of mnemonic experience, whether persuasive to me, or not.[2]

The first glimmers of my research for *Scissors, Paper, Stone* can be seen in *Suspended Conversations* where I looked at artists' adaptations of the photographic album to multi-image installations and artists' books. I considered these contemporary photographic album-works in order to understand better the type of personal photographic album that had inspired them. I found, as critic John Berger had before me, that these photographic arrangements were prompts for polyphonic tellings, reawakening and reshaping social memory on each new telling, or looking.[3] The album model accommodated this kind of fluid compilation and reception, but as I continued to think about photography and memory, it became clear that there were many other models besides. And so my contemporary sampling grew, including photographic works of art that manifested traits of elusiveness, circularity, incompleteness, repetitiousness, or translation, as well as those that laid claim to memory through title, artists' statements, curatorial contextualization, critical interpretation, or combinations thereof. As I studied this unruly collection, I was developing an understanding of the varieties of mnemonic experience and their substantiation by phenomenology, psychoanalysis, cognitive psychology, sociology, ethnography, philosophy, criminology, and historiography. In the spirit of James's inquiry, it

seemed important to include as many viewpoints on memory as there were types of photographic manifestation, though it soon became clear that none of these disciplines was dealing with memory from a rigid perspective, but rather benefiting from interdisciplinarity to expand the territory of memory in the individual mind and in the culture.

Indeed, I was struck by the parallel between the rise of interdisciplinary studies and our growing appetite for memory in all fields of endeavour. This parallel seemed to support Maurice Halbwachs's theory of collective memory and its foundation in a structure of intersection – the basic argument being that memory is inscribed when two normally distinct fields of experience collide.[4] This is of course a social scientist's way of saying that ordinary days form a forgettable continuum, while extraordinary events that transform our roles as social actors are remembered: I was flirting with a co-worker at the water cooler when they called from the hospital and told me that my wife had just given birth prematurely. Phenomenologists, ethicists, and psychologists are interested in the same kinds of events and mental forces and, though they frame these things in different ways, intersections crop up with regularity across the literature.

Memory itself is at a crossroads, which is why we will remember it as a feature of our age. At a post-millenial conference, *Memory and Archives*, David Galloway, an American scholar resident in Germany, examined the collision of positive and negative memories that he associated with the city of Weimar. Marvelling at its historical thickness, Galloway seemed fixed on the uniqueness of Weimar. "Every cobblestone," he said, "every second house seems to be an archive."[5] My silent response was very much of my times. Surely, I thought, Galloway's statement is true of every city, town, and country village; it is even true of what we call the wilderness. The French historian Pierre Nora has impressed us with the idea that any place, object, action, or condition is a potential realm of memory.[6] At the same time, remembering is clashing with forgetting; we seem to have forgotten that we need both, or as the American phenomenologist Edward S. Casey puts it, that forgetting is "the primary other of memory."[7] An aging population demands to know how memory works and how to retain it. Memory is big, speculative business; medical science and information management are merging into global conglomerates whose chief executive officers may well turn out to be cyborgs.

We are constantly urged to remember, though we can't always read the signs. We drive along the highway and see little crosses adorned with plastic flowers and other bits of memorabilia, including snapshots. *Memento mori*, I always thought, until someone explained to me that the spot marked and remembered was where "the spirit had left the body." This is spreading the Word, not just grieving, and that's what memorials do. Our memorializing culture has energetic partners who want to invest cultural memory with Hegelian authority and Wagnerian spectacle. Those who swim against the tide caution us against memory without analysis, the visual seduction of "nostalgic longing."[8] Edward W. Said suggests that collective memory has become "something to be used, misused, and exploited, rather than something that sits inertly there for each person to possess and contain."[9] The discourse of memory thus becomes a source of inspiration and counter-inspiration to a great and varied constituency of chroniclers, entrepreneurs, theoreticians, scientists, and artists. As an art historian, I might appear to be fixed on the last, on those artists who want to translate their experiences of memory into photographic images that cultivate mnemonic experience. In whom? In us: our psychological participation is crucial.

For photography to loosen its grip on the external world (perception) and attend to internalized images (memory) –

for a photographic work to engage a spectator in that process – a rehearsal of memory must be conducted through the work. The spectator must be prompted visually to seek signs of mental activity and recognize the shift from the here-and-now into the realms of memory. The title of the book frames this sense of anticipation as a game of *scissors, paper, stone* – a game that focuses attention on the power of the *invisible*. How is this ancient game played? Two people stand face-to-face, one hand held out in front of them. Chopping the air, to a count of three, they make a sign: two fingers out-stretched means scissors, a flat hand means paper, a fist means stone. The winner is determined thus: scissors cut paper, paper covers stone, stone blunts scissors. In the heat of the game, in the split-second realization that your scissors have defeated my paper, we are both struck by the power of the absent stone. Likewise, in the photographic expression of memory, paper's fragile evidence of the past cannot hold against the mental scissors that fragment the subject. Scissors cut paper. But, and there is always a *but*, photography's capacity to preserve a fugitive reality and carve identity in stone claims to defeat fragmentation. Stone blunts scissors. But as we also know, the imagination can prevail over history, and generate another memory, or at least a *might-have been*. Paper covers stone. And so the game continues as a contest between two visible forces, always taunted and destabilized by the invisible third.

Translating the game to contemporary photography, *scissors* becomes the joust between remembering and forgetting; *paper*, the meeting ground for memory and imagination; and *stone*, the relationship between memory and history. These constitute the three sections of the book, each of which is developed in a brief introduction and four or five chapters. Each section contains thematic studies and individual case studies. The sections can be read in order, or the three sec-

tion introductions can be read as a group for more detailed guidance to the framework and contents of the chapters. Here I will briefly introduce the three sections.

"Scissors" examines works that express the fragmentary natures of photography and memory: composite images held together by association, juxtaposition, non-photographic additions, and traces of elision. In "Remembering and Forgetting," a work by Max Dean introduces the spectator's choice of remembering *or* forgetting on behalf of the collective. Walter Benjamin presides over a circle of philosophers, cultural theorists, and psychologists whose comments underscore similarities between the morbidity/ fluidity of the collection and the dialectics of a Postmodern subject-in-process. The late emergence of autobiographical memory as an arena of experimental psychology, and the rapprochement with psychoanalysis are noted in light of Ulric Neisser's "ecology of memory." The introduction to "Scissors" wants to shake ideas of the fixed photographic image, insisting on continuous adjustment and reconsideration of assumptions. Misremembering is also given its due.

Oral tradition and folklore frame the investigation of artists' photographic album-works in "Lives of the Artists." The photographic autobiographers are Raymonde April, Hamish Buchanan, June Clark, Henri Robideau, and Sandra Semchuk. A second thematic study, "Reflections on Reflection," gazes on the photographic *mise en abyme* (the reflection of the artist in the image). This ancient trope and literary device nests in the photographic image as a sign for subjecthood nested in the subject. Between mirror-metaphor and mirror-mimesis we find doubles and scape-goats reflected in the work of Richard Baillargeon, Karin Bubaš, Bertrand Carrière, Michel Lambeth, and George Steeves. "A Forgotten Man" cobbles together memory and knowledge through feverish oscillation between Proustian

involuntary memory and Locke's mental storehouse, as Donigan Cumming grasps at empirical straws in a stack of family photographs. In the last chapter of the section, "Memory/False Memory," the investigation turns to Diana Thorneycroft's photographic tableaux, sometimes described as Surrealist or grotesque, sometimes interpreted as the expression of trauma. Across this section, the relationship between remembering and forgetting shifts from co-operation to combative co-presence.

"Paper" opens on a monumental work of body memory by Geneviève Cadieux. "Memory and Imagination" develops a systematic comparison of these modes and their photographic expressions, based on Casey's five phenomenological distinctions. I move from this discussion into a direct challenge to Walton's omission of photographic spectatorship from his otherwise capacious notion of psychological participation in works of art. Entering a photograph imaginatively takes time, and this is precisely what is lacking in Walton's influential theory which is stuck on photographic instantaneity – its immediate delivery of the real. "Paper" proceeds to the next mental stage through a door opened by Casey's notion of "bound imagining," correlating the mediated image with the waking dream.

In "Exchange Places," the silent ruminations of psychoanalyst Christopher Bollas and a patient exploration of work by Michel Lamothe, Brenda Pelkey, and Greg Staats slow photographic reception into a state that is open to both the visible and the invisible, and also willing to supplement, to fill the descriptive and narrative gaps. The benefits of heightened receptivity are reaped in the next two chapters. "Object-Image-Memory" explores Michael Snow's definition of the photographs as "events-that-become-objects." Snow's works give form to his observations of natural phenomena and cultural production, and both Henri

Bergson's false recognition and Jean-Paul Sartre's imagination are summoned to reconstruct the process. A thematic chapter, "Persistent Paths," follows four landscape photographers – Michel Campeau, Thaddeus Holownia, Robin Mackenzie, and Sylvie Readman – to understand the reactivations of their landscape memories through conscious and unconscious repetition. These impulses know no boundaries: quite the contrary, the manifest desire to cross stylistic, temporal, and spatial lines makes their photographic landscapes more memorable (according to the rule of intersection). And this rule is certainly invoked when the wilderness is viewed through layers of European pictorial convention and New World photographic immediacy. Finally, a chapter entitled "Mimics" deals with the mnemonic in-between of photographic conflation. Various notions of mimicry intersect as Jeff Wall and Jin-me Yoon, informed and assisted by mechanical and electronic reproduction, make free with art and social histories to re-imagine community.

"Stone" enters the negotiation between what Jacques Le Goff calls "the raw material of history" and "historical knowledge."[10] The key work, a photographic reinvigoration of a statue, is by Jeff Thomas. "Memory and History" summarizes the debate through recourse to European, Australian, and Canadian historiography, including insights gleaned from cultural, ethical, and psychological studies of twentieth-century violence and its visual legacy. Photography is implicated in all these discussions. Since its invention, the medium has served history as an instrument of record: capturing historical events, sites of history, and historical figures; documenting people, architecture, landscapes, and material culture threatened with disappearance. The indexical nature of photography (its attachment to the real) fuels the expectation that today's decisive

moment is tomorrow's irrefutable document; we rely on and do not trust these documents. Now photography is doubly invoked as the carrier of official and unofficial histories, and historiographers scramble to adjust. Memory and history are not the same, though it is becoming more difficult to tell them apart as tribunals admit oral histories into evidence in land disputes, and the pliability of the documentary photograph becomes a commonplace. So as memories expressed photographically move up, gaining authority – as we develop the analytical tools to make this happen – documentary photographs lose ground. This is our loss, as a culture, as I argue throughout the section, though we have much mental work to do to keep these documentary photographs working.

Part of that work is imaginative: in the arenas of social and political activism, this is taking a risk. This is precisely what we see in the work of Carole Condé and Karl Beveridge in which labour history and workers' memory are the raw material of fictionalized reality. In "Agit-prompters," I pay particular attention to the artists' representations of time, finding that sociologist Tamara Hareven's correlation of industrial, family, and individual times comes to life in their photographic tableaux. In the following chapter, "Repossessions," I discuss photographic works by First Nations artists Carl Beam and Robert Houle, showing how the formal tension between "incompatible knowledge systems" is extended temporally and sent into the future as a harbinger of change. Two case studies follow. "The Pictures That We Have" addresses Postmodern criticisms of the archive with the modest proposal that we examine more closely the philosophies and methods of Modernist documentary photographers. Robert Minden's collective portraits of racial, ethnic, and social communities are revisited in light of his training by renegade sociologist Erving Goffman, bringing out the dia-

logic features of these photographic encounters. In "Flashbulb Memories?" I look at the paired and layered imagery of Stan Denniston, paying close attention to the intersections of public and personal memory and their possible explications by cognitive psychology and psychoanalysis. Giving each system of knowledge its due, and looking hard at the pictures, patterns emerge that make sense of Denniston's predilection for games of true-or-false? and his obsessive pursuit of visual reminders. The last chapter, "Markers," anchors memory to place through various forms of photographic monuments and counter-monuments. Through cultural theorist Marita Sturken's inflection of Foucault's "technologies of the self," photography emerges as both process and product of "technologies of memory," embodied social engagements with the histories of place. Photographic installations or works-in-series by Marian Penner Bancroft, Marlene Creates, Evergon, and Arnaud Maggs represent different, though curiously complementary, gifts of cultural memory.

The expression of memory, even in a still photograph, is the very picture of mobility; likewise, the traits differentiating these three families of resemblance are by no means fixed. Imagination creeps into history; archiving is a responsible way of forgetting; remembering disguises itself as a waking dream. Take for example the notion of pictorial convention, here taken up under "Paper." One could legitimately argue that every work of art is somehow shaped by precedent. But some artists, more than others, emphasize sources of inspiration, or counter-inspiration, in their work. Those whose emulations, or parodies, also engage the spectator's memory are of interest here.

In selecting the artworks to be discussed, I have looked for evidence that the activation of memory was anticipated by the artist and felt by others besides myself. The book

wants to remember the theorists, historians, and curators who played the game before me, calling it by another name. The three sections bring together similar modes of mnemonic expression and systems of analysis with which these modes have demonstrable rapport. It need hardly be said that a work of art unpacked by philosophy might also be seen under the light of social history. I hope that the correlations are useful and that they stick in the reader's mind as long as they remain suggestive.

For this game of *Scissors, Paper, Stone* has only one rule: spectatorial complicity. Memory cannot be inscribed in a still photograph, it can only be felt as a mode of consciousness vying with the merely visible for mental ascendance, *for attention*. Moved by this force that the photograph has activated, the spectator moves into memory.

Finally, some words about the field of inquiry which is contemporary Canadian photography. First, I have laboured in this field as a practitioner, a curator, a critic, a theorist, and a historian for some thirty years. In this book, regular appeals to phenomenology confirm my interest in spectatorial experience, and specifically the visual experience offered by direct exposure to the work of art. The examples treated in this study are almost all works that I know firsthand, and the few exceptions are noted. I can only hope, as all art historians do, that exposure to works in reproduction will whet the reader's appetite for more direct exposure. In the interim, close description of the works is a guide to what I have seen and sensed as their mnemonic lode. Second, setting this book in a Canadian context, drawing on my own Canadian consciousness, has forced me and, by extension, forces the reader to bring the issues of memory home – to patriate the discomfort as well as the gains of the investigation. Discomfort flows from the moral and legal questions raised by works that deal with recovered memory or cultural genocide. The gains emerge through the enlargement of alternative histories, or I should say, alternatives to history, which include the history of photography.

In the conclusion, I ask, "Is photography an art of memory?" The question is not posed lightly. I do mean "the art of memory" as defined by Frances Yates, which derives from a classical system of mental association for memorizing texts or tables. Some of us learned it at school. To commit a speech to memory, you imagine a room, or a series of rooms, with vivid, therefore memorable, features. Each point in your speech is anchored to one of these architectural features. To recite your speech, you imagine yourself walking through the space, retrieving each point in turn. As Yates explains, this creative skill, the art of memory, flowered into a rich, sedimented symbolic system, a code, sometimes used that way, to keep secrets.

Is photography an art of memory? For now, I'll say yes, if the spectator is willing to play the game. This book wants to experiment with that idea, without imposing too rigid a set of rules. The art of memory is instructive. To think memorable thoughts, we have to place our thoughts where we can find them. As a Canadian photographic historian I have chosen to think about Canadian art within a framework of memory. Memory is close to history, but they remain distinct, as Paul Ricoeur, Susannah Radstone, and others help us to understand. At the same time, this book is intended as a contribution to Canadian photographic history, which as yet has no canonical text; that task lies before us. How shall it be written? The historiography of Western photography – its first century and a half – has been surveyed by French historian Michel Frizot who finds narratives of technological progress, interwoven with accounts of "social evolution" and artistic maturation, disciplined by genres; he frames his account as "a history of photographs considered as working

objects in their own time."[11] By this light, photographic work can be defined as participation to the best of its technological capabilities in whatever is going on. Add to this Mary Warner Marien's approach to photography, "as both a visual language and a cluster of expectations and ideas."[12] Artists participate in this work and refine its language, and their contributions are received to the degree that the culture can accommodate them in its expectations and ideas.

Canada has enjoyed a photogenic existence. It has participated in Western technological progress; fought the major wars; colonized and been colonized; rebelled, repelled, and repressed; opened its borders when it seemed propitious, and closed them when it did not. Its economy has ridden the waves of other Western economies, offering the same photo-opportunities to the haves and the have-nots. In short, while Canada has accumulated all manner of images that Western photographic history enjoys, it has been slow to forge the canon. Is there some benefit, some latent wisdom, in having delayed the inscription of our photographic history until other voices, other versions, more of our secrets could be pictured and heard? Perhaps, instead of chronology or hagiography, a Canadian photographic history needs the framework of a *memoriography*. Imagining a photographic history through the optic of remembering and forgetting is a tantalizing notion ... a game of paper, stone, scissors may be the Canadian way.

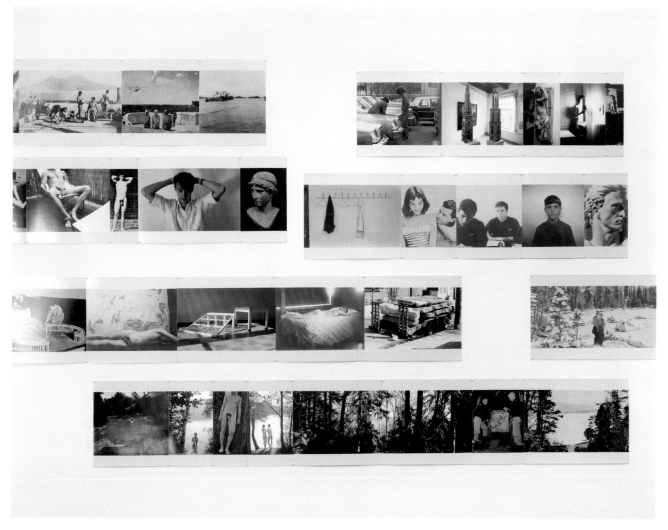

3.1 Hamish Buchanan
Some Partial Continua (1991–96)
Detail of installation. Black and white and colour photographs, variable dimensions

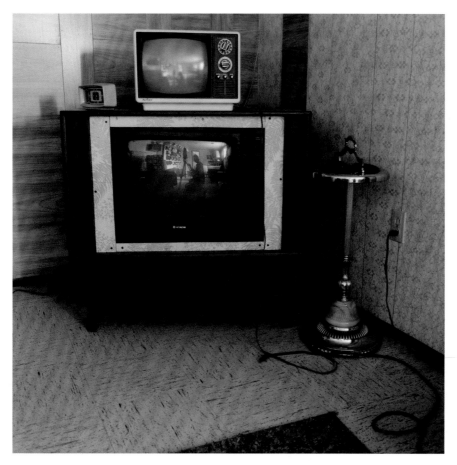

4.3 Karin Bubaš
Two TVs and an Ashtray (1998).
Colour print, 40.5 x 40.5 cm. Courtesy of the artist and Monte Clark Gallery

5.5 Donigan Cumming
Voice: off (2003, colour, stereo, 39 min.) and *Locke's Way* (2003, colour, stereo, 21 min.).
Production stills from both videotapes

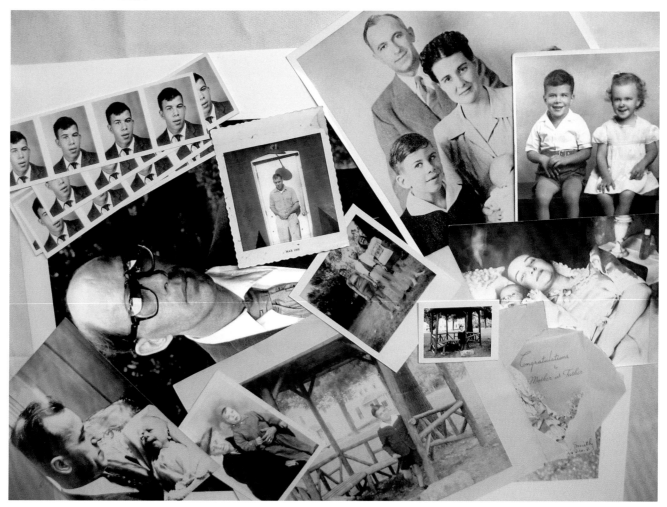

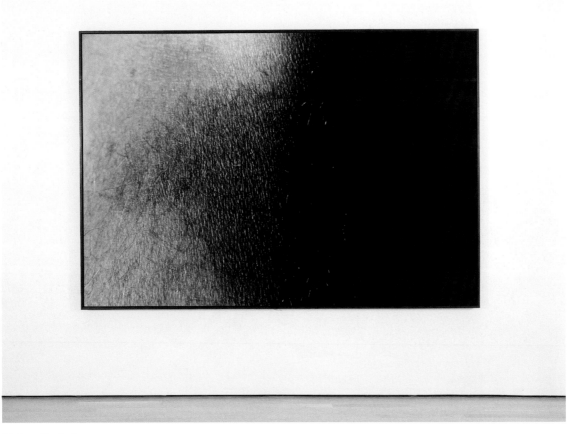

7.1 Geneviève Cadieux
Blues (1992).
Chromogenic print, 168 x 249cm. Collection: Canada Council Art Bank, Ottawa.
Photo: Louis Lussier. Courtesy: Galerie René Blouin, Montreal

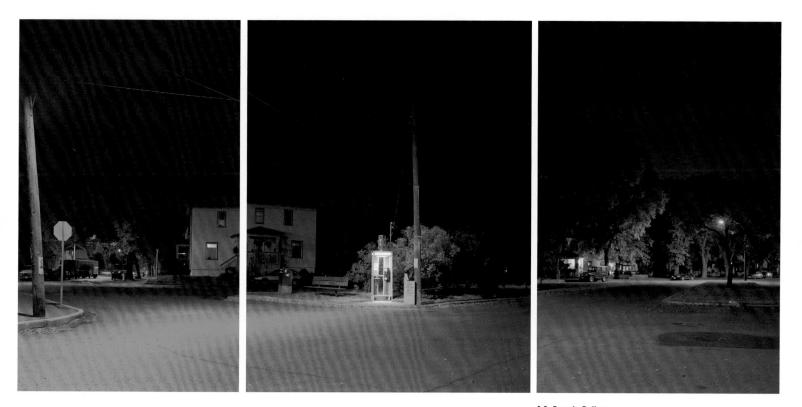

8.6 Brenda Pelkey
telephone booth (1994).
3 panels: Ilfochrome, mounted on sintra,
total dimension of 101.6 x 205.7 cm

9.2 Michael Snow
Midnight Blue (1973–74).
Wood, acrylic, colour photograph, wax. 73 x 66 x 12.5 cm.
Musée National d'Art Moderne, Centre Georges
Pompidou, Paris

9.3 Michael Snow
In Medias Res (1998).
Colour photograph presented on the floor, 260 x 360 x .5 cm

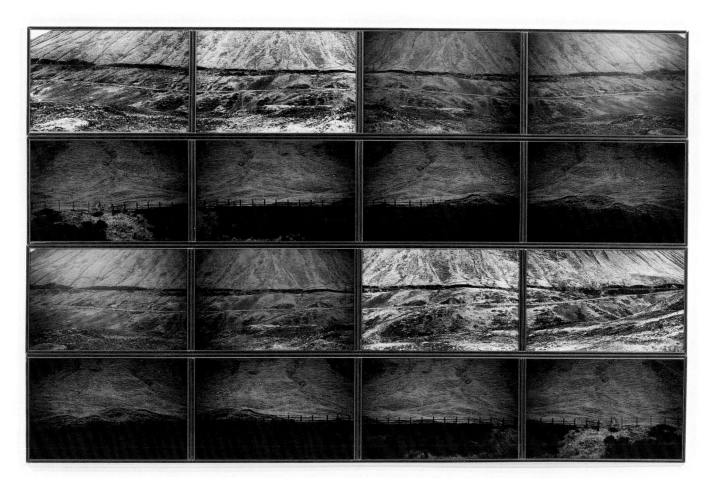

10.2 Robin Mackenzie
Untitled Memory Piece No. 2 (1975–76).
12 colour photographs, 4 black and white photographs, 40.64 x 60.96 cm each,
overall 132.08 x 243.84 cm. Photograph by Henk Visser

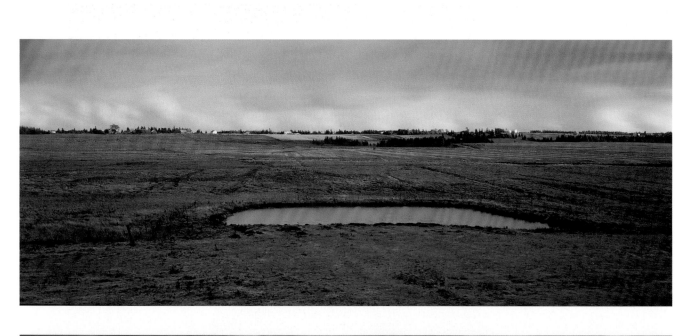

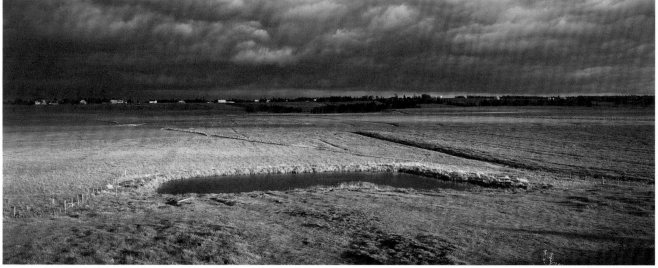

10.4 Thaddeus Holownia
Details from *Jolicure Pond* (1996–2004).
2 untitled chromogenic contact prints, 16.9 x 42.4 cm each.
Courtesy Corkin Shopland Gallery, Toronto

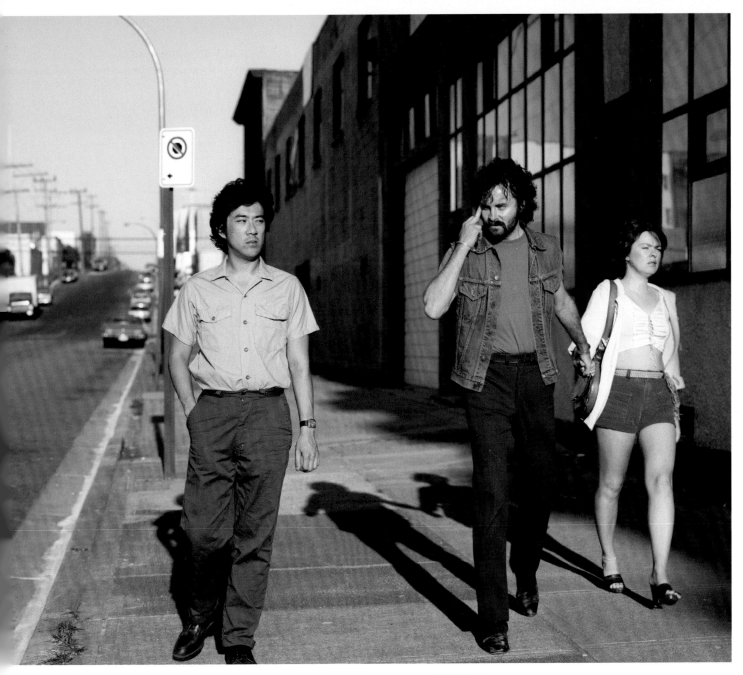

11.1 Jeff Wall
Mimic (1982).
Transparency in lightbox, 198 x 228.5 cm. Collection: Fredrik Roos, Zug, Switzerland

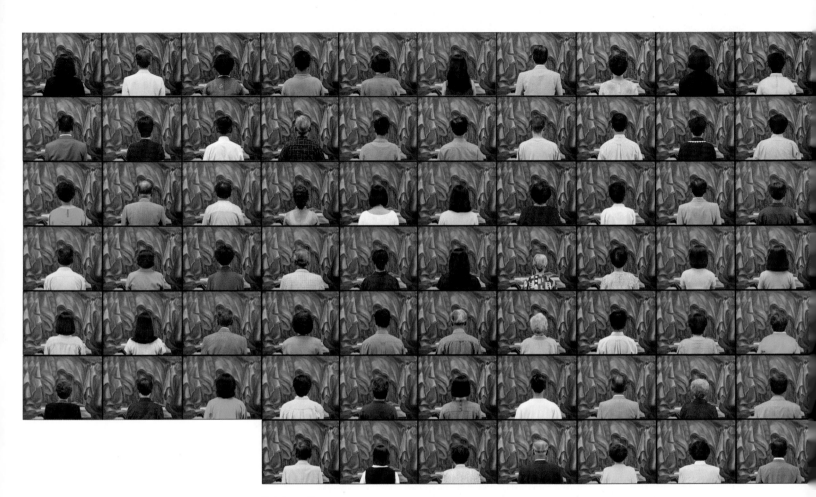

11.4 Jin-me Yoon
Detail from *A Group of Sixty-Seven* (1996).
137 C-type photographs, 40 x 50 cm each. Photo: Trevor Mills.
Collection: Vancouver Art Gallery, Acquisition Fund

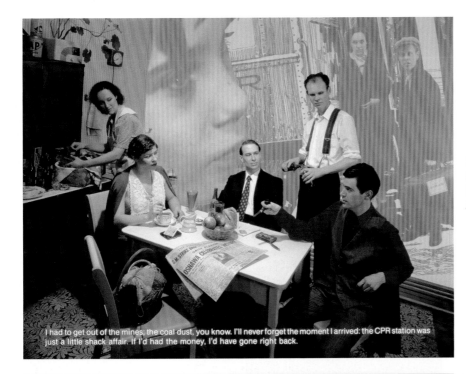

I had to get out of the mines; the coal dust, you know. I'll never forget the moment I arrived: the CPR station was just a little shack affair. If I'd had the money, I'd have gone right back.

13.3 Carole Condé and Karl Beveridge
Detail from *Oshawa, A History of Local 222,*
United Steel Workers of Canada, CLC (Part 1) 1937 (1982–84).
Azo dye print, 40.1 x 50.5 cm

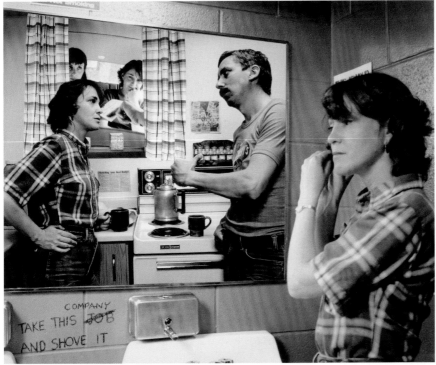

COMPANY
TAKE THIS JOB
AND SHOVE IT

13.4 Carole Condé and Karl Beveridge
Detail from *Standing Up* (1981–82).
Colour print, 40.64 x 50.8 cm

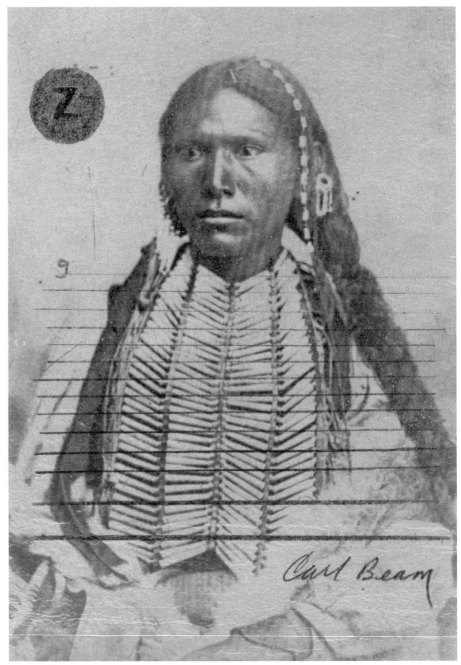

14.3 Carl Beam
Z, from the series *The Columbus Project* (1991).
Photo emulsion on paper with coloured crayon and
coloured ink, 26.1 cm x 18.4 cm. Collection: Canadian
Museum of Contemporary Photography/National Gallery
of Canada. Courtesy of Ann Beam

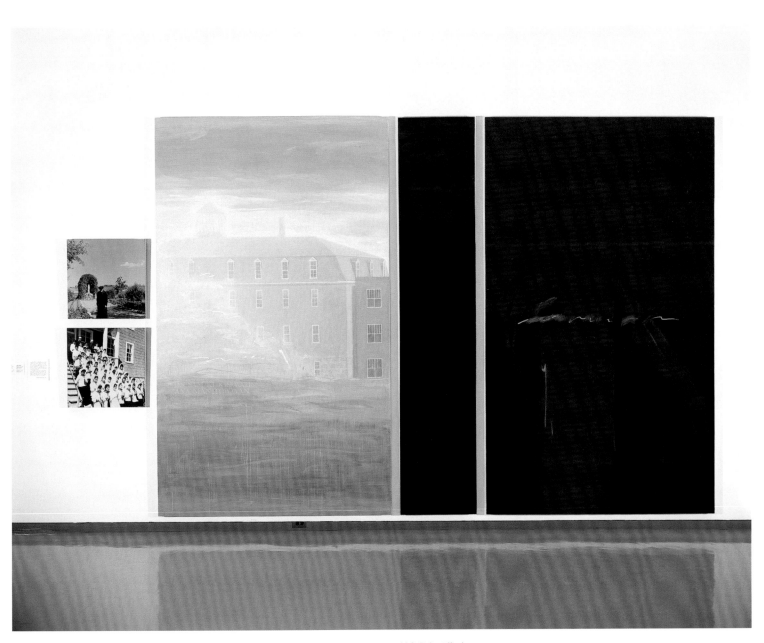

14.6 Robert Houle
Sandy Bay (1998–99).
Oil on canvas, black and white photographs on masonite, 300 x 548.4 cm. Collection: Winnipeg Art Gallery; Acquired with funds from the President's Appeal 2000 and with the support of the Canada Council for the Arts Acquisition Assistance

17.2 Arnaud Maggs
Répertoire (1997).
Installation view and detail. 48 chromogenic prints, 51 x 61 cm each; installation 250 x 720cm

17.3 Evergon
Shipshaw: aubergine. Passage entre les deux plages, from the series, *Manscapes* (2003). Inkjet print from Polaroid negative on watercolour paper, 117 x 91.5 cm

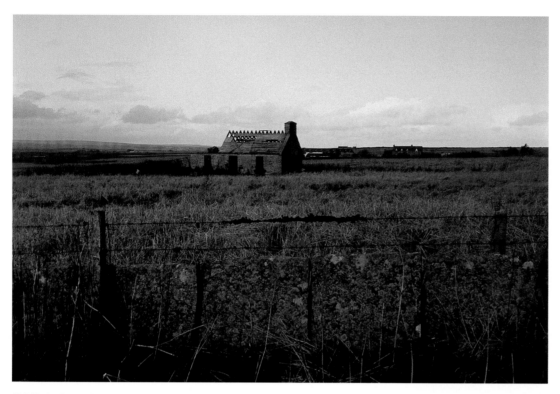

17.8 Marian Penner Bancroft
By Land and Sea (prospect and refuge) (1999).
Detail: *Auchingills farm near Sordale, Caithness – Iverach home in the 1700s.*
Colour photograph, 58.42 x 76.2 cm framed

17.9 Marian Penner Bancroft
Visit (2000).
Detail: site of former residential school, Birtle, Manitoba. Courtesy Catriona
Jeffries Gallery, Vancouver. Giclée archival print, 69 x 104 cm

SCISSORS, PAPER, STONE

2 | REMEMBERING AND FORGETTING

How visual memories emerge transformed after long years.
The pocketknife that came to me as I chanced upon one in
a shop indow in Saint-Moritz (with the name of the place
inscribed between sprigs of mother-of-pearl edelweiss) had
a taste and odor.

— Walter Benjamin[1]

In the brute logic of *Scissors, Paper, Stone*, scissors beat paper because they cut. The cut – the extraction of an image from the spatio-temporal flow – is also one of photography's decisive moves, and possibly the first conscious sensation of picturing.[2] *"Ma mémoire arrêtée,"* memory's *arrest*, with all the startling clarity and arbitrary violence that such a phrase entails, is Philippe Dubois's point of departure for an essay on the nature of the photographic act.[3]

Taking, or otherwise making, a photograph, is cutting an image out of the mental pack, and so is collecting. Collecting breaks down the differences between hunting and gathering, between the photographs that we cut from nature by *taking* and those that we cut from culture by *saving*. It's a matter of life and death, so choosing the right course will not be simple. A photographic work by Max Dean, *As Yet Untitled* (1992–95), efficiently exposes the ambiguities (fig. 2.1). The work is described as an industrial robot: it

consists of a pivoting arm, a paper shredder, a conveyor belt, a pair of metal hand silhouettes, and two boxes of "found photographs," machine-processed colour snapshots. Set to work, Dean's anti-processor picks up a photograph from one of the boxes and holds it up to the audience for a decision. There is a pause. Without interference, the robotic arm will feed the snapshot to the shredder; its colourful remains will then be carried along the conveyor belt and dumped on a pile. A spectator may choose to save a picture by placing his or her hands against the metal hands – a simple touch. The robotic arm then rotates in the direction of the other box; the picture is saved, and another round of display and decision begins. One photograph has been taken; another has been saved; which of these images shall be preserved in memory? Dean specializes in staging such personal dilemmas in public.[4]

Images, whether taken or saved, become *personal* if consigned to a private collection (an album, a bulletin board, or a digital file) and *public* if assigned to a photographic work of art (a collage, installation, or Website). The meaning of the abducted object – an arrested image – is transformed as part of its adaptation to a new setting. And as Benjamin suggests, the operation can be fatal:

What is decisive in collecting is that the object is detached from all its original functions in order to enter into the closest conceivable relation to things of the same kind. This relation is the diametric opposite of any utility, and falls into the peculiar category of completeness. What is this "completeness"? It is a grand attempt to overcome the wholly irrational character of the object's mere presence at hand through its integration into a new, expressly devised historical system: the collection. And for the true collector, every single thing in this system becomes an encyclopedia of all knowledge of the epoch, the landscape, the industry, and the owner from which it comes. It is the deepest enchantment of the collector to enclose the particular item within a magic circle, where, as a last shudder runs through it (the shudder of being acquired), it turns to stone.[5]

Of course, there are collectors and collectors: the great ones, Benjamin also says, live in a dream world where there is no closure (Bergson's state of constant flux).[6] Within the photographic realm, a realm composed of still images, we can understand Benjamin's propositions as two sides of the same coin: we look at images differently in different contexts by putting a construction on what we see; the construction holds until an alteration (to the collection, to the object, or to ourselves) prompts us to look again.

At each stage of the cycle, we are trying to make sense of the collector's impulses by positing rules of inclusion and exclusion, by joining the epistemological end-game, by judging it against our own. Part of that process is separating the novel and the memorable from the ordinary and the forgettable. Here again, we are competent and we discriminate. We know, for example, that each new baby is a novelty to its family; we know too that all babies look alike. So while the posting of a baby picture on an office worker's bulletin board is an event that refreshes that worker's collection, and may even represent "completeness" in that person's mind, neither the social history of the Western family, nor the stylistic development of Western portraiture will have been much advanced. The history being written is local. What the posting of the picture indicates is that the man in the next office, a lifeless fish whose bulletin board has previously been dominated by procedural directives from the company, has an inner life and loves his new baby:

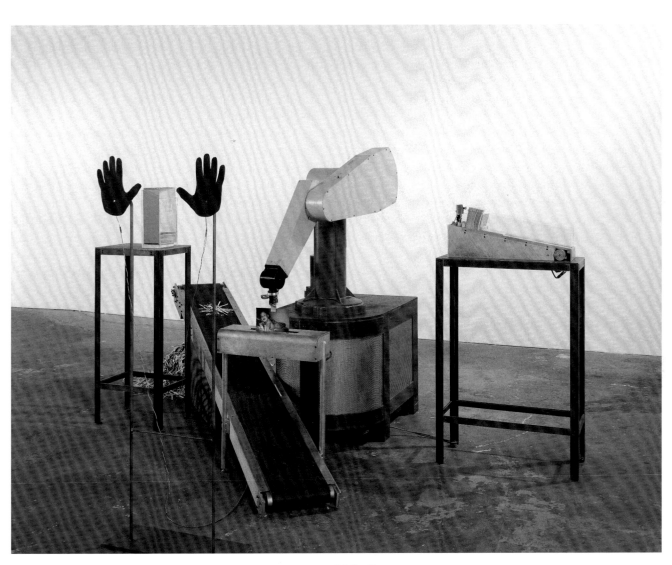

2.1 Max Dean
As Yet Untitled (1992–05)
Industrial robot, metal, found photographs, variable dimensions.
Photograph by Isaac Applebaum. Original in colour

he is now lifeless-fish-and-doting-father. If the picture remains on the bulletin board, the incongruity of its appearance will be forgotten, and the baby will be absorbed into the history of the company. There are other possible outcomes that we might imagine, as many as there are bulletin boards and theories of memory.

Catherine Keenan's analysis of personal photographs and individual memory revisits canonical texts by Kracauer, Benjamin, and Barthes in which they have challenged the conventional belief that a photograph is a repository of memory. Following Benjamin back to Proust, Keenan separates the bare representation of the past from its thick vivication; she compares the rigidity of the photographic image to a *mémoire volontaire*, proposing that the province of living memory – the Proustian madeleine, the *mémoire involontaire* – is the aura, a realm of mental association accessible to familiars and strangers alike. Keenan argues persuasively that the photograph, as a potential site of memory, stands for remembering *and* forgetting. Remembrance dominates as long as memory's flow is continuous and associations are strong, while the rediscovery of an image whose content has been forgotten transforms photographic experience into a crisis of memory – a mixture of self-doubt and mourning.

Keenan's insights are extremely valuable, but do they constitute Everybody's Autobiography? On the basis of her chosen example, this might seem to be her aim. She draws a mental picture of the bulletin board in her room, which is "mainly covered with photographs of absent family and friends. It is their absence that largely prompts me to place their photographs on the board, and it is also this absence, and the inevitable fading of memory that attends it, that prompts me to counter this by treating these images as memory-images, by trying to invest them, that is, with aura."[7] Absence is Keenan's motive, but absence is not nec-

essarily linked to memory. As Mary Warnock explains, "memory and imagination overlap and cannot be wholly distinguished. Both consist in thinking of things in their absence."[8] Or thinking of things *in absentia*: the political exile's memory inextricably linked to imagining what-might-have-been.[9]

The link between photography and memory is not natural, nor is it simply a choice. Keenan's bulletin board makes sense to her, and by extension to us, because it frames a kind of redemptive memory-work that we have been trained to do by Benjamin, Barthes, and others whose keenness on photography has been sharpened by keening. Thus, she concludes her essay with a parable on the "morality of remembrance" in which the spectre of a lost photograph accuses the grieving protagonist of the crime of forgetting; she finds this example in Milan Kundera's novel, *The Book of Laughter and Forgetting*.[10] Keenan explains the protagonist's dilemma: a widow, Tamina, "is gradually losing the ability to conjure the face of her dead husband." She lacks a good, clear photograph and Kundera's plot, according to Keenan, turns on "a frantic search for photographs," specifically, the ones that the couple had to abandon when they left Czechoslovakia.[11] The interesting thing is that Keenan has misremembered the story. Tamina has no hope, in fact, no expressed desire for photographs; she knows that they were left behind and confiscated with the apartment. What Tamina wants are the journals that she kept about their marriage – rather spottily, she admits – at the urging of her husband. These, along with some letters, were the personal belongings that the couple left with his mother when they escaped. As incomplete as Tamina remembers them to be, the journals have become precious to her in widowhood as the details of her husband's face and their life together begin to fade.

Keenan's "false memory" of a photograph reflects the aura of allegiances – philosophical, psychological, ideological, bio-

logical, and so forth – that subtends both her pin-board of pictures (assuming that it exists) and her research. Her reimagined story illustrates her belief that the idea of photographs stimulates the mental process of remembrance, as much or more than photographic objects; that their absence is as powerful as their presence in memory's state of "constant flux." As Keenan's creative reconstruction shows, what is sauce for the storyteller, is sauce for the critic.

A visual memory embodied by a knife, stumbled upon by chance, and inexplicably infused with taste and odour, has all the makings of a story. We transmit memories in stories, and not just for our entertainment, but for adaptive needs – for our physical and emotional survival. The force of this drive can be felt in Donigan Cumming's videotaped performance, *Locke's Way*, in which the fevered artist races back and forth between two types of *aides-mémoire*: a collection of family photographs and a medical report on a damaged child. Cumming's oscillations between diagnosis/prognosis and the perennial optimism of the snapshot world are accompanied by his confessional monologue as he rehearses the protagonists' illusions and alibis, his own unsparingly included.

In *The Ethics of Memory*, philosopher Avishai Margalit takes up Benedict Anderson's question about the absence of monuments "for the unknown social democrat or for the unknown liberal." The answer is simple, according to Margalit. These are not "'natural' communities of memory, because such ideologies are not engaged in the business of immortality, in whatever form."[12] I disagree with Margalit because I think that Anderson's question is naive. These monuments do exist, though they are not chiselled, but collected in drawers or compiled in albums – we are in fact inveterate immortalizers with the photographic tools and materials to do the job. And a photographic record *creates* community, as Cumming's entire oeuvre has come to show.

Perhaps the difficulty lies with the word "immortality." Monuments are meant to last, but their significance changes over time: they function as flashpoints for demonstrations of dissent and revisionist debate.[13] Family members build such monuments: our first exposure to collective myth-making is the accumulation of personal photographic legacies and the weaving of stories around them, stories that are constantly revised. The seen and the unseen, the heard and the suppressed, compete for our attention – any 'natural' community of memory has "A Forgotten Man." Whether in the archives or the shoebox, our Kodak memories can be bitter competitors for the present.

Temporal tempests and historical deconstruction have been claimed as the preserves of Postmodernism but these activities have been going on a great deal longer, both in the private and public memory. Literary critic James Olney explains that for the life-historian, the present is really a triad of co-presence, or so it was for Augustine as he struggled to frame his *Confessions*: "'There are three times – a present of things past, a present of things present, and a present of things future.' For these three do exist in the mind, and I do not see them anywhere else: the present time of things past is memory; the present of things present is sight; the present time of things future is expectation."[14] Storytellers juggle the three presents with ease because the oral arena is nowhere else but in the auditor's mind. Modern writers have more of a struggle, as Olney brings out in relation to Samuel Beckett's late work. Beckett's narratives take place "in the mind" but they have to come out on the page, either to be read or recited, and in a frame that, as Beckett himself said, "admits the chaos, and does not try to say that the chaos is really something else." For Beckett, the solution has to be found in "a form that accommodates the mess" of experience, but is not its equivalent: "The form and the chaos remain separate."

This recognition places Beckett's work on the cusp of Modernism and Postmodernism.[15]

In "Reflections on Reflection," we discover the same delicate balance in the photographic work of Bertrand Carrière, Karin Bubaš, Richard Baillargeon, and George Steeves. Each artist uses the device of *mise en abyme* (a reflected or mirror image within the image) to express the cogitation at the heart of their acts of memory. As Craig Owens once argued, the photograph within the photograph instantiates a *"genuine* rhetoric of the image." Noting that the infant's mirror stage coincides with the transition from babbling (wild repetition) to the symbolic order (the law of language), Owens recounts the history of photography as a transition from reflection to codification — he thereby counters Barthes's notion of photography as a "message without a code." Pictures within pictures are signs for photography's construction of meaning, a process of *reduplication*.[16] The artists considered under "Reflections on Reflection" further complicate Owens's semiotics by claiming photographic authorship: they *sign* their pictures by reflecting themselves in them. This sign is then redoubled in the enfolding of the spectator, who must situate himself or herself, both mentally and physically, in this play of reflections.

I am struck by the realization that this reflexive pictorial structure is the mirror-image of Keenan's division between the representational picture and its aura of association: in a *mise en abyme*, the fugitive act of self-remembrance is surrounded by, and comments upon, the actual circumstances of creation. The sealed surface of the photographic image fuses the creator's mind/body to the spatio-temporal context. As viewers, we enter the picture through a fanciful cut within a factual cut into the real; we pass through subjectivity and enter the realm of the subject. Postmodernism maintains the tensile structure of creator, creation, and contemplation, but shifts the fulcrum from the material object to the spectatorial body.

Cultural theorist Mark A. Cheetham takes the position that Postmodern practice, especially in Canada, can fundamentally be construed as a kind of memory-work. Indeed, he goes further, breaking through disciplinary and national boundaries to claim that "Memory, with its evanescent yet specific inflections of meaning, *is* history in a Postmodern culture."[17] He thus suggests that the historical mode of calcification — its turning of memory to stone — has systematically been displaced by the mnemonic mode of continuous revision by, and of, the subject. We might want to stop and consider the validity of this point, but Cheetham himself is not stopping. His real point is that the relationship between history and memory has always been Postmodern, in large part because selective forgetting has always been part of the construction of our historical narratives and myths.[18] In effect, Cheetham is arguing that the Postmodern condition of revision is *natural*, or at least more compatible with the way we actually think than its highfalutin reputation suggests.

Forgetting is certainly embedded in our make-up. Some anthropologists believe that in an oral society, individuals and societies slough off memories that have outlived their usefulness; in literate societies, we often say that history is written by the victors, implying that all other versions have been erased. Hanno Hardt describes his encounter with a family album, bayoneted during World War I by an invading soldier: "The bayonet may have cut through the lives of people, defaced the imagery of past experiences, and destroyed the physical autonomy of private memories, but it could not eradicate history or displace the resilience of memory. On the contrary, the slashed photograph survives

in its incompleteness and gives rise to new interpretations and confidence to those in search of understanding their own lives."[19] Whether through gradual erosion or violent elision, forgetting is an imperfect process that leaves its marks. In our literate culture, and here we must include photographic literacy, the processes of erasure and substitution by which memory comes to inflect or displace history do not pass into the culture unnoticed – for Postmodern artists *and* theorists, this ought to come as good news. The challenge, and here is where Cheetham's study becomes extremely useful, is to insert ourselves as subjects of the revisionist process.

In *Artifact: Memory and Desire*, curator Ted Fraser introduces his exhibition of contemporary art as a "theatre for the art of memory." His principal actors are the spectators: "Images and traces of memory in the mind and body of the viewer merge past, present and future from diverse psychic levels and distances to reconstitute the temporal flow and disjunction of the history of the site as a legitimate subject."[20] Fraser is describing the temporal trinity of the Postmodern viewer, an individual that I also know as formed within, and expectant of, the photomechanical translation of experience. Within this photographic order, Augustine's three presents are only the barest beginning. Fragmentation creates the raw material of a free association that is liberated from the mind of its creator and truly unpredictable. Memory, in league with desire, rises as an artifact in a blurry present that knows no temporal, spatial, social, or psychological bounds.

The Postmodern art of memory has been informed by twentieth-century developments in psychology – both psychoanalytic theory and cognitive research need to be taken into account. Psychoanalytic theory – its literature, therapy, and popularization – has redefined Western concepts of identity and continues to flood the culture with images from, and interpretive pathways to, the unconscious mind and the collective unconscious. Cognitive psychology is, by comparison, a steady drip: its influence on the way that we conceptualize memory and its operations has been absorbed into the culture and tends to be taken for granted. But we are still formed by its precepts. The "art of memory" – a phrase that evokes associations, symbologies, numerologies – is, properly speaking, a mnemotechnics that still operates mechanically within our schools.[21] Our fluency with the processes of memory – encoding, retrieving, and shedding – derives from research that was initially aimed at smoothing mental functions, rather than interpreting their uneven results. Thus the rather late emergence of autobiographical memory as an area of cognitive research, one that has gained ground in dealing with memory function in the disabled and the aged, as well as more storied disorders, such as the controversies surrounding recovered memory and false memory. These scientific trends are central to this discussion, but it would be misleading to imply that their application to visual art has always been rigorous; more accurately, one might speak of a barter economy in which the terms of exchange range between helpful analogues and catch-phrases – cognitive psychology's "flashbulb memories" and psychoanalysis' "screen memories" most commonly bandied about.

In the realm of visual representation, references to the art or archaeology of memory, to memory as a wax tablet or to memories as the rooms of a house, are useful to the degree that they prompt consideration of the *processes* of crafting, excavating, engraving, or inspecting. These processes correspond to counter-processes, just as remembering and forgetting are embodied in Penelope's weaving and unravelling of Laertes's shroud. Remember that she

wove by day and unravelled by night – both the visible and the invisible make up our individual and collective life-histories. Remember too the reverse: how Benjamin held "the Penelope work of recollection" up to the mirror, seeing in the weaving of Proust's memory (the *textum*) "a Penelope work of forgetting."[22]

Pictures, not a single picture, might capture the mental shift between "field memories" and "observer memories," a phenomenon first adumbrated by Freud and tabled as evidence of the "reconstructed nature of early memories." Cognitive psychologists interpret this change in the rememberer's "perspective" as an expression of diminished feeling for the experience described.[23] In "Lives of the Artists," Sandra Semchuk's diaristic process and Raymonde April's continuous circling of her social circle can be seen as symbolizing these affective displacements. June Clark's recycling of her social documentary photographs of Toronto to represent her Harlem girlhood becomes possible only when the particulars of her Toronto days begin to recede.

Most analogies are upheld by a system of values; in an era attuned to the fragility of the planet, cognitive psychology gives us the *ecology* of memory. Within this interlocking structure, there are different modes of experience and remembrance that function discretely, synchronically, and embryonically. Ulric Neisser explains that, "Recalling an experienced event is a matter not of reviving a single record but of moving appropriately among nested levels of structure."[24] Neisser the writer recognizes that "molecular" units of activity, such as key strokes, nest within "molar" units, such as sentences or arguments, and that the memories of these units are fated to disappear into the larger, though equally fragmented, event-structure of writing a particular chapter of a book. The ecology of memory is complex, made up of conscious and unconscious acts, things vaguely remembered, things instantly forgotten.

For the photographic artist, the reconstruction of an experienced event is correspondingly complex: how to express photographically the felt differences between long-lasting or repeated events – Neisser adopts the term "extendure" – and unique events, each of which nests in one or more extendures? These temporal factors are nuances, often built on emotion, sometimes confused by hindsight, and essentially inseparable. As Neisser adds, "Because nothing is ever entirely new and nothing is ever exactly repeated, the distinctions between repetitions and other types of extendures is not a sharp one."[25] Semchuk and April have explored the very nature of extendure by working as visual diarists. They struggle productively with the problem of repetition: their cuts into the continua of their lives must be sensed as both remarkable and ordinary – as poems to the quotidian – and they must also appeal, somehow, to a viewer who knows nothing of the artists' private lives. They must appeal to the nesting instincts in each of us, twig by twig, picture by picture.

We see this clearly in artists' emulations of photographic albums. In *Suspended Conversations*, I showed that amateur photographic albums were erected on an invisible scaffolding of oral tradition. In "Lives of the Artists," we find five storytellers working self-consciously and intertextually at one degree of separation from the oral-photographic framework: Hamish Buchanan and Henri Robideau, in addition to Semchuk, April, and Clark, each building a visual framework for continuously evolving life-telling. Buchanan's clusters and sequences of snapshots and appropriated images are his memoir of sexual awakening. Robideau's pseudo-album is pure visual theatre, stretching his audience's willing suspension of

disbelief to the breaking point. Playing the meta-artist, Robideau presents as an unreliable cultural witness whose photographic version of events, figuratively and literally, opens the floodgates of ficto-memory.

Truth and memory are closely associated and often opposed in paradoxical philosophical debate. Psychoanalytic theory defines memory-work as the unlocking of the unconscious. Formative experiences can be recalled and reassembled, piece by piece, or they may erupt suddenly and mysteriously from the depths of the unconscious. Translated to photographic language, these memories become images or part-images whose startling clarity cuts through the dark. Such are Diana Thorneycroft's paintings with light. The last chapter in this section has been given over to Thorneycroft's work because its processes, iconography, performances, and textual apparatus — all autobiographical in nature — recapitulate many of the problems and strategies examined under the heading of "Scissors." But for students of memory, Thorneycroft offers a great deal more besides.

Dark and ritualistically violent, with the artist herself displayed as both perpetrator and victim, Thorneycroft's work raises troubling questions about the sources of her extreme visions. There are at least two responses to traumatic experiences: persistent memories and blocked memories. In the latter category we find "retrieval inhibition," a term that cognitive psychologists apply to non-emotional events as well as the more familiar "Freudian notion of repression."[26] In the 1980s and early 90s, these terms came through the media into public consciousness as part of the scientific, litigious, and political battles between exponents of Recovered Memory, on one side, and False Memory Syndrome, on the other.

The emergence of Thorneycroft's memory-work during the memory wars ties its discussion to a public debate that is unlikely ever to be resolved. Conversely, "Memory/False Memory" appeals for reconciliation. The chapter is intended to shorten the distance between remembering and forgetting, easing us into the space between memory and imagination whose photographic traces we will find materialized on "Paper."

Ironically, just as women and other disenfranchised groups begin to claim the status of author, the author is stripped of function and authority.

— Barbara Kosta[1]

He collected the photographs in an album: you could see ashtrays brimming with cigarette butts, an unmade bed, a damp stain on the wall. He got the idea of composing a catalogue of everything in the world that resists photography, that is systematically omitted from the visual field not only by cameras but also by human beings. On every subject he spent days, using up whole rolls at intervals of hours, so as to follow the changes of light and shadow. One day he became obsessed with a completely empty corner of the room, containing a radiator pipe and nothing else: he was tempted to go on photographing that spot and only that till the end of his days.

— Italo Calvino[2]

The report of my death was an exaggeration.

— Mark Twain[3]

The death of the author notwithstanding, a significant number of artists continue to generate work in which personal photographs are used to construct a public image. These autobiographical or pseudo-autobiographical works present as photographic expressions of memory – visual reconstructions of interior states of being and becoming. The photographic album has become a notional vessel for such explorations – I say "notional" because it is really an "idea of album" that survives the voyage from private to public work of art; certain qualities will be modified or sacrificed along the way.[4] Intimacy, for one, becomes a generic term, generative of this condition in the viewing Other. Autobiography becomes a vehicle for public social experience, for swapping tales, transmitting desires, and howling at the moon.

Many artists keep private albums and sometimes these are the seedbeds for public works of art. Their memories and stories are thus engaged. But placing an album before the public for its consumption changes the object completely. A private album becomes an album-work.

The formal differences between albums and album-works will be evident from the descriptions to follow. I will look at album-works by five artists: Raymonde April, Hamish Buchanan, June Clark (formerly known as June Clark-Greenberg), Henri Robideau, and Sandra Semchuk. But before entering these works, it seems important to look briefly at the context of their creation, both in terms of cultural production and the psychology of memory.

The compilation of personal photographic albums began in the 1860s with the introduction of the carte-de-visite. As the compilers and their descendants passed away, their albums passed into the mist of incomprehension. Expressions of memory still lingered on the surface – one could feel communicative desires – but no album could be unlocked completely without recourse to orality because a photographic album is built on the oral scaffolding of story-telling. Its content and structure match those of oral recitation, patterns developed in non-literary societies whose survival depends on memory. Rehearsals of memory – visits to the past by the light of the present – script the album's presentation. Vestigial oral consciousness makes the photographic album into an instrument of memory that is reactivated in performance.

In Western photographic practice, the album-work that refers to private albums can be traced to the 1960s when artists and theorists became interested in the photographic vernacular. This movement, sometimes called the "snapshot aesthetic," ran parallel to the re-evaluation of folklore and funky architecture that was beginning to shake Modernism to the core. The snapshot aesthetic was really no threat; on the contrary, it could be seen as an important late addition to photographic Modernism, validating both purity and individual style. Still, as we know, the Modernist centre could not hold. Postmodernism expanded photographic studies vertically and horizontally, including all kinds of images that had been deemed below notice. Artists and theorists were learning to look at documentary photographs as "flexible illustrations,"[5] and many of these learners were home-schooled by their family albums, discovering that ancestral images of praise could be turned to blame, and vice-versa. The photographic vernacular showed the need, and offered a form, for photographic art works of social and political reconstruction, and so the album was adapted to album-work, and with great efficiency, as all the necessary impulses and contradictions were already built in. The private album, taken as an instrument of bourgeois self-affirmation, could be turned against itself by the simplest re-presentation. The same private album, seen by a survivor, or exile, as the last bulwark against erasure, might be venerated as a relic in a museum installation. Album-

works dilate these paradoxical conditions. As public works of art, they build dialectically on the subject matter, form, and function of the amateur album, sometimes to the point of hyperbole or even parody. Photography's capacity to fix the moment and register its specificity is put to the service of memory's mutations and obsessive recurrences. While the works are copious, serpentine, layered, and symbolically coded, their reception follows a predictable line. Album-works, like albums, prompt us to tell life-stories. The reflexiveness of album-works also prompts stories about albums which are essentially stories about memory rising.

Contemporary album-works seem at first blush to fit nicely with Mark Cheetham's view of Postmodernism in the visual arts as "defined by a fixation on the past, a 'past' that is frequently demarcated through the assertion of memory with its concomitant sense of subjecthood defined and redefined by the particularities of context."[6] This is in part because album-works are typically so tightly bound to the personal – they make no claims to revising history, though they show politically minded historiographers where to look. In album-works, a particular kind of memory is at stake, perhaps more supportive than assertive, remembrance that aspires to narrative, and is therefore diachronic, not episodic.[7] Certain kinds of memories must be evacuated from album-works: sudden reminders of past slights or missed appointments are not wanted on the voyage. In an album-work, memory is transporting; it can never be interrupted. An album-work forms an entire visual field; approached in a gallery, or inspected in a book, the album-work presents first in its aggregative structure, and then, on closer inspection, in the visual details of its personal content. As a spectator, one is hardly conscious of the shift from global impression to local interest, and this is as well, for neither should dominate. To create the viewing conditions proper to an album, the form and content of the album-work must *assert*, before anything else, an ecology of *pastness* and *presentness*, *specificity* and *typicality*. It might seem odd to think of a life-story being presented in this way, oscillating between past and present, copiousness and detail. But the experience is in fact quite ordinary, grounded in the normal processes of remembering and forgetting the facts and facets of one's life.

Cognitive psychologist William F. Brewer defines autobiographical memory broadly as "memory for information related to the self." Personal memories are part of this storehouse, as are autobiographical facts. These terms are often treated loosely, as interchangeable, but I want to follow Brewer's reasoning here, as a way of drawing out the nuances of life-memory. Personal memory derives from the ego's phenomenal experience: "A personal memory is a recollection of a particular episode from an individual's past." Personal memories are visual in character and staunch in their claims, "typically accompanied by a belief that they are a veridical record of the originally experienced episode." In this aspect alone, Brewer's personal memory differs sharply from autobiographical memory. We may, for example, have very vivid and visually detailed personal memories of finding our first student apartment without being able to recall the address, but this failure of autobiographical memory is of relatively small importance: we remain confident in our recollection of the event. That being said, our faith in personal memory is no guarantee of its accuracy. Brewer opts for what he calls "a partial reconstructive view" of memory, that is, a combination of copy theories and reconstructive theories, the former explaining the preponderance of irrelevant details in personal memories, and the latter exploring the transformation of personal memory under the pressure of changing circumstances, or simply over time. Psychological studies have shown that personal experiences are well recalled if they are unique,

consequential, unexpected, or emotional. By no coincidence, these are the personal experiences that are repeatedly revisited in memory and conversation. Conversely, repeated or trivial life experiences are either forgotten over time or form generic personal memories "at the expense of the individual personal memories that were repeated."[8] What Brewer means is that we can remember that we walked to school without remembering each morning walk – that is a generic personal memory.

This brings us to an interesting point, and a curious challenge to the artists and viewers of album-works. Repetition is the servant of two masters. To repeat: the causes and effects of repeated tellings and repeated actions are complete opposites. Repeated tellings are sparked by, and perpetuate, a singular experience; repeated actions, by dint of repetition, accrue to generalization.

Repetition of images and motifs is a common feature of album-works, translating memory to imagery in three ways. Repetition expresses duration, while blurring the dates. It features certain types of activities or psychological states, while siphoning off their specificity. Repetition is crucial to the album-work's performativity; it builds familiarity through its network of generic gateways; it lets the spectator in. Thus generic personal memories share certain key aspects of public, or collective, memories. These two types of memory are also mutually reflective. Much revisited and broadly accessible, collective memories are also embedded in highly personal contexts, so-called "flashbulb memories" being the most dramatic instances of the historical moments that measure off and colour our personal lives.

Measure and colour are very much the point. We are dealing here with visual representations of memory in autobiographical works of art. Autobiography – whether textual or visual – is not the transcription of autobiographical memory. It is a story of one's life, inflected by one's purpose in the telling, whether to convey a message, weave a tale, or explore the meaning of one's existence.[9] The autobiographical form depends on autobiographical memory and collective memory to frame and thicken the individual personal memories that are the essence of the tale. An autobiography is supposed to be truthful – it is otherwise fiction – but deviations from the truth are also standard parts, whether reconstructions of memory or evidence of its failure. We know from personal experience that the ecology of memory is easily disturbed. A belaboured anecdote is a candidate for oblivion. Collective memories are rogue elements whose instant recognition makes them both useful and potentially overbearing in a personal memory-work, for their meaning is uncontrollable. Indeed, signaling that fact may be the very task that generic memories and collective memories are called into an album-work to do – to loosen the reins of authorship.

This chapter opens with a comment on the status of the author. In his much cited essay "What is an author?" Michel Foucault proposes that the author's proper name be considered a form of classification – a kind of fence – defining a family of texts and "a particular manner of existence of discourse" whose status and reception is "regulated by the culture in which it circulates." The rules under which discourse is sustained, suffered, or suppressed define the author-function, as much as the "relationships of homogeneity, filiation, reciprocal explanation, authentification, or of common utilization" established under the same conditions of author-function, or as one *might* say, managed by the same person. Foucault underscores the "plurality of egos" involved in the production of a first-person text: the split between writer and fictional narrator, as well as the distance that grows between the two over the course of the writing.[10] These observations can be applied to any "autobiographical"

work of art, and are particularly fitted to album-works in which a subject is constructed and displayed within a set of conventions that diminish or eliminate the author from the start. Personal photographic albums have compilers, whether we know their names or not, but "the idea of album" belongs to an amorphous collective, a set of biological, psychological, legal, and cultural conditions. Foucaultian reasoning subtends the production of many album-works, obviating the necessity to search out the author's particular circumstances and intentions. By erecting the screen of the album form, these authors, or artists, give sign that their autobiographical project is larger than a single life.

At the same time, some album-works can be inscribed in the resurgence of autobiographical activity that began in the 1970s and has continued as a cultural force. Barbara Kosta's deft analysis of this phenomenon in German women's literature and film has much broader application. She identifies a socio-political need for investigations of female identity that can move past essentialism and exemplary self-representation into multiplicity, exploring "the repertoire of selves." As Kosta explains, "The self discussed here is not a unitary Cartesian self rooted in bourgeois origins, absolute, rational self-consciousness fully present to itself, timeless and above language, but a self decentered and fragmented in time. It is a self intersubjectively constituted, constantly in a state of change, constantly in dialogue with the outer world. It is a subject-in-process whose identity must be continually assumed and then called into question, evading any ideological unity."[11] There is a starting point for this process which is a real person, a feeling mind-body, prepared to offer his or her personal memory as a site of social encounter. These are the artist-compilers with whom this chapter is concerned.

Personal photographic albums can be divided into four categories: collections, genealogies, memoirs, and trave-logues. In *Suspended Conversations*, I showed that many albums juggle more than one task, by cutting and pasting (excising and digressing); the artists' works that we will be examining are no less complex. And to complicate things even further, multiplicity of form follows this multiplicity of function: photographic installations, montage, performance, film, video, photo-etchings, bookworks, and multimedia combinations extend the album form. Still, for continuity's sake, and to signal some interesting differences, I use the four album categories as springboards for the examination of four album-works, concluding the chapter with a body of album-work that combines the characteristics and functions of the other four.

ALBUM-WORK AS COLLECTION

Hamish Buchanan's photo-installation, *Some Partial Continua* (1991–96), could be described as an unfinished memoir of sexual awakening and experience (fig. 3.1). Including family snapshots, advertisements, publicity pictures, and erotica, the work is an ephemeral assemblage, a design for continual self-exploration open to the viewer through visual, symbolic, and mnemonic associations. The male body, posing and gesturing, is the work's central motif; one can find archetypes of male beauty and stereotypes of male behaviour. In terms of albums, the work falls under the general category of album-as-collection. There is also a bulletin-board effect in Buchanan's method of pinning the work up or laying it out for publication in different combinations. The work mixes black and white images with colour, figure studies and landscapes, fantasies and natural histories. At a glance, Buchanan's appropriations might situate the work in the general area of media deconstruction or gay politics. Art historians might

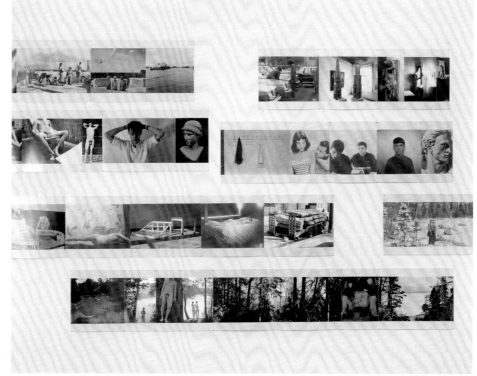

3.1 Hamish Buchanan
Some Partial Continua (1991–96)
Detail of installation. Black and white and
colour photographs, variable dimensions

draw a line to Aby Warburg's cross-cultural, cross-tempo-ral arrangements of visual motifs, the *Mnemosyne Atlas*, or sociologists to Erving Goffman's comparative groupings by gesture and pose, *Gender Advertisements*.[12] More careful examination suggests that matters are rather more per-sonal than empirical, or that feminism's fusion of the per-sonal and the political has been taken on board. Such an intimate project is risky, or in the words of critic Lisa Gabrielle Mark, "Buchanan has taken risks. He has al-lowed a subjective voice to emerge, one which is shy, vul-nerable, curious and longing." Mark's reading of this album-work is steeped in orality. She writes of pictures

that "speak of a boy, awkwardly posing for his father's camera … speak of a man, reveling in his body's capacity for pleasure … speak of the gap between object and sub-ject, perceived and perceiving, of the moment you recog-nize your face in a photograph. (That's me?)."[13] Silence is a large part of this album-work's lucidity. Mark draws our attention to the essential gap between subject and photo-graphic representation. Another gap opens up between the portraits of Buchanan and his collection of images of men. Basic similarities (gender, body type, age, and pose) culti-vate comparisons between the real and the ideal. And curator Bas Vroege reminds us that there are systemic gaps

in any autobiographical album: "feelings that are not susceptible to photographic record, or private moments when the camera is normally excluded." Vroege further suggests that these unrecordable feelings and moments may figure more prominently in the collective memory of sexual minorities whose very safety has depended on keeping the camera away.[14]

In "Ordinary Boys," Simon Watney analyses a clutch of snapshots from his childhood, trying to correlate his knowledge of himself as a gay man with the little boy who looks "just like millions of other little English boys in the mid 1950s. Yet I am shocked to discover that the picture reveals nothing of the terrible secret that drove me so deeply into myself for so many long irrecoverable years – years that, without photographs, do not exist." This discordance is not taken lightly. Lacking childhood images (his mother, for unexplained reasons, purged the collection) leaves Watney in a chronic state of in-between, yearning to be *seen* while knowing that appearances can be deceiving. Still, the snapshot world retains its aura: Watney still believes in the stabilizing narrative function of domestic photography. He keeps an "Extended Family" album, considering it "an archive, one fragment of the much greater enterprise that is modern gay history."[15] Buchanan, for his part, uses found images to supplement the photographic record of his youth; he papers over the gaps. His system defines a space for personal memory; it keeps the memory of keeping secrets alive.

Some Partial Continua offers us a clear example of personal photographs, their relationship to personal memory and their function in autobiographical works. Buchanan has compiled a private collection of photographs chosen to represent, or expand upon, personal memories – call them "personal photographs" – photographic images that somehow relate to the idea of self that delimits autobiographical memory. As Marita Sturken explains, personal photographs can be taken at birth, torn from magazines, purchased at auction, or fired off in an automat; the source is of no matter, the key feature is personal significance, however one defines it.[16] By stressing choice, I am not ignoring the power of the unconscious, but I am suggesting that the most mysterious image has to fit some criterion, it has to fit somewhere in the autobiographical puzzle to be included in a work like *Some Partial Continua* – perhaps the image simply bedevils the artist and won't go away. Here I've said "image" when I should perhaps say "artifact." In effect, Buchanan's medium is material culture; his motive force is imagistic – an urge to give his personal memories material form. Semiologist Susan Stewart uncovers the same impulses in her analysis of souvenir collections, such as scrapbooks, "used most often to evoke a voluntary memory of childhood." As she continues:

This childhood is not a childhood as lived; it is a childhood voluntarily remembered, a childhood manufactured from its material survivals. Thus it is a collage made of presents rather than a reawakening of a past. As in an album of photographs or a collection of antiquarian relics, the past is constructed from a set of presently existing pieces. There is no continuous identity between these objects and their referents. Only the act of memory constitutes their resemblance. And it is in this gap between resemblance and identity that nostalgic desire arises.[17]

I have argued elsewhere that Stewart's notion of the souvenir as a form of longing that can *never* be filled slights the spectatorial imagination.[18] On some levels, however, we can agree with Stewart: it is provocative to consider the indexicality of the photograph jeopardized in the manner she describes, that is, cut off from its causative referent. In her

analysis, as in Buchanan's work, the referent is nudged out by intention, re-formed, as she would have it, and sustained in the symbolic by memory. This feeling may be very much based in the present. For an artist-collector, working with an artifact is memorable in itself, an intense experience of recognition that is both self-affirming and outwardly connecting. This artifact that is a surrogate for a mental image – this representation of personal memory – is processed into a work of art, returning to the image bank of cultural memory from whence it came. We might think in terms of a compound, the "image-artifact," signalling its function as a communicating vessel between the artist-collector and others.

It goes without saying that most personal photographs need some kind of contextualization to make their significance clear, or even suggestive, to others. *Some Partial Continua* creates meaning through plenty and duration – many images have been brought together over time and assembled in a gallery to form a photographic presence. The work's significance grows as we identify images that we deem to be private. We understand more of the work's meaning as we find instances of internal repetition and typological allusion. We may also appreciate the beauty of the individual images, whether for their subject matter or execution. A stranger's reception of this work unlocks the flood of desires that made it, but not its personal memories. The album-work shields its particular sources behind protective and commodious generalities.

ALBUM-WORK AS GENEALOGY

Sandra Semchuk's album-type work began in the mid-1970s with a series of images based on her extended family. She was working within a Modernist tradition, finding her subjects by following lines of kinship, ethnic affiliation, and community. Folding the personal into her humane social documentary style, Semchuk made carefully posed environmental portraits, and she also took more candid shots which curator Pierre Dessureault likens to "snapshots … reminiscent of a family album in their marking of the rituals of life together – parties, gatherings, birthdays, weddings – that make up the family annals where each finds confirmation of their own memories."[19] For Semchuk's contemporaries, this phase established the context and philosophical underpinnings of her practice, so that her parallel adoption of more self-conscious, programmatic approaches to portraiture were also seen as extensions of the album. Using her own mind-body as subject, Semchuk committed herself to a systematic study of female identity. Her primary vehicle became the self-portrait; she pursued herself relentlessly.

There are exterior and interior views. Semchuk's self-portraits in the landscape record her intense gaze and clothed body in different settings and seasons that are legible, though slightly out of focus. The titles give us place, month, and year, for instance, "Emma Lake, August, 1977." Her hieratic figure – again and again, a woman artist's photographic self-portrait – is washed with light, sometimes softened by a breeze, and surrounded by natural elements. This was one formula; the other was even more rigorous in its examination/construction of the subject. For four years, Semchuk made self-portraits against a neutral backdrop, staring into a camera that framed her head and shoulders. Their titles are their dates. These formal self-portraits are mechanistic physiognomic descriptions – mug-shots and psychological revelators to the degree that we take Semchuk's art project and life project as a whole. Thus essayist Penny Cousineau introduces Semchuk's 1982 exhibition, *Excerpts from a Diary*: "Sandra Semchuk has taken as the

structural underpinning of the sequence of photographs in this exhibition the prototype of the family album and uses this armature to build a largely autobiographical narrative having to do with the quest for selfhood."[20]

Excerpts from a Diary included group portraits and self-portraits, as well as Semchuk's co-operative self-portraits, images in pairs or clusters that featured Semchuk and her subject in a kind of photographic exchange. These images widened the gap between Semchuk and Modernism's split-second perceptions by insisting on the flow of events and the provisionality of any single representation. For Cousineau, Semchuk's photo-autobiography functioned on descriptive and metaphoric levels, the latter partaking in a "restless interiority that is profoundly Canadian," as well as in feminism's investigations of the self "as weathervanes of the psychic events passing through and around them."[21] I am struck by Cousineau's choice of words, her reference to folk art which so efficiently describes the obsessive nature of Semchuk's production, her attention to craft, and her deep desire for communion with nature. The sensuality and rituals of womanhood are embedded in Semchuk's pattern of production. This is an essentialist version of woman's work, challenging female stereotypes by internalizing them, standing up for them, staring out at the world barefaced, and inviting strangers to stare back. The culmination of this woman-artist's labours is *Mute/Voice* (1991) (fig. 3.2).

Installed as a grid, *Mute/Voice* consists of seventy-seven black and white interior self-portraits and a videotape in which Semchuk chronicles the women in her family, a four-generational history from her grandmother to her daughter, Rowenna. None of these women are pictured, save the artist, whose facial construction and vocal intonations are the body memories that correspond to her genealogical recitation. Repetition and variation, socialization and deviation, progress and regression, recordings and revisions,

love and loss: the ebb and flow of a woman's life history is contained in the kernel story that spirals out from the moving image and makes sense of all the rest.

"Makes sense": what in the capacious context of album-work could that possibly mean? For one might argue that, to this point, before the introduction of a first-person narrative, there was nothing in the pictures to prove that they were self-portraits. Photographic history is replete with examples of extended portraits, often taken by men of women; how should we separate Semchuk's extended portrait of the self from Nicholas Nixon's annual group portrait of his wife and her siblings, *The Brown Sisters*? Is it the intensity of Semchuk's gaze, and if so, is it appreciably different from the gazes of Arnaud Maggs's captive subjects in *48 Views Series*? I can't answer these questions. In fact, I have elsewhere suggested that an untutored stranger's visual recognition of a portrait as a self-portrait is largely a matter of personal choice.[22] I choose to view this work through the glass of Western feminism, to understand it as a "repertoire of selves" who might be Semchuk, or might be her sisters. In her formulaic, repetitive approach, there is just enough ambiguity for this to occur, for the work to slip the traces of one-subject-in-formation and obtain to the level of abstraction that loosens the flow of spectatorial memory, that effectively loosens my tongue. Semchuk's recorded performance of her autobiographical memories infuses her self-portraits with personal memory and narrative potential – the work is also pregnant with untold stories, some of them mine. True to its oral roots, the recitation seeks completion in spectatorial empathy.

There are thus three intertwining mnemonic prompts in Semchuk's album-work. The first is transparent and accessible: photography's ruthless mapping of the aging face. Orality and photography revel in real-life situations; we do not need dates to follow the lines of shock, worry, smiles,

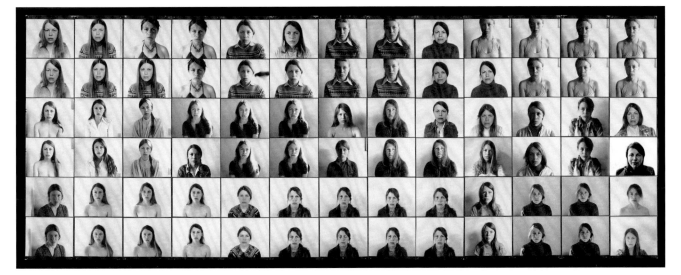

3.2 Sandra Semchuk
Mute/Voice (1991)
View of installation. Black and white photographs and colour monitor.
77 gelatin silver prints, laminated on acrylic, each 27.9 x 35.3 cm, and videotape;
171.6 x 459 cm installed. Collection: Glenbow Museum, Calgary

frowns, and bruises as they burrow through Semchuk's skin into her psyche; we need only memory and mirror. The second is the work's imitation of autobiographical memory through its insistence on dailiness. Semchuk's photographic effort to seize hold of, and preserve, a fragment of each day is both poignant and quixotic. We feel the tension between autobiographical memory and personal memory. We share her fear of change, her struggle against erasure. The third arrives with the self-consciousness of secondary orality, in the interjection of the video.[23] Semchuk's speaking body reproaches the mute bodies that her photographic imagery has stilled. They lose their presentness; they are driven back into the past. Translations of photography to other media have that damning effect: Raymonde April flirts with its dangers in *Tout embrasser*.

ALBUM-WORK AS MEMOIR

Like Semchuk's *Mute/Voice*, April's *Tout embrasser* (2000–01) is drawn from the artist's photographic archives. The photographs were taken over twenty-five years (1975–98) (fig. 3.3). In April's case, however, the individual images had never been exhibited, or published, before their incorpo-

ration into *Tout embrasser*. As images, they had seen the light of day on contact sheets, and possibly work prints, which had gone no further. Year after year, these pictures came and were put away – they were the loam nourishing April's public production until she began to think about *Tout embrasser*.

Strictly speaking, there are four major works with this title. The first, completed in 2000, is a 16mm film, just under 58 minutes long, with a soundtrack. The second is an installation of 517 black and white prints; this work was premiered in Montreal on 11 September 2001. The third and fourth variations followed the transfer of the film to DVD. This allowed for its continuous projection as a single-screen gallery work (Canadian Museum of Contemporary Photography, 2002) or as four simultaneous, unsynchronized presentations in a line of video monitors placed beside the works on paper (Musée du Québec, 2003). For the spectator, these are very different experiences – as concerns us here, they appeal to memory in different ways.

Unlike Semchuk's *Mute/Voice*, there is no matrix, or pictorial formula, to enable us to measure real time. April is a presence in *Tout embrasser*, as are her friends and family, but the rigorous portrayal that forces comparisons in Semchuk's work has never been a feature of April's work. The artist's informal photographic style – the style that she favoured, possibly exaggerated, in her selection and sequence – creates memorable, individual pictures whose organization is like a string of pearls. These, of course, belong to April. She made the photographs in a particular way that we can locate midway between autobiographical memory and personal memory: *autobiographical* because her systematic endeavour to picture her life on a reliable basis, possibly every day, created an archive that exceeded memory's capacity; *personal* because she photographed what were to her memorable moments, and could no doubt

have described her day's catch in glowing terms of intimacy, spontaneity, audacity, and light. But as Anne-Marie Ninacs confirms, 517 images "give but an inkling of the thousands of photographs that the artist has taken in thirty years … are but an infinitesimal part of all the moments caught by the eye but not by the camera … take the measure of an attentively lived life."[24] Personal memory is overburdened by personal photographs taken and not taken; this phenomenal production is immeasurable. And still certain things have been missed: when perception and memory compete for consciousness, we attend to one by neglecting the other. So an "attentively lived life" – its eager translation into imagery – means dailiness eclipsing dailiness, the continuous streaming of the present into the past. April's twenty-five-year effort to preserve fleeting moments has resulted in a photographic cache whose placement before the public does not so much represent her life history as recast it in photographic legend.

When we encounter April's universe on the walls, the prints are in clusters that are sometimes thematic, sometimes episodic, and most times governed by the artist's closely guarded logic. This is album-work, to be sure: never a straight story line when a curved line will do; never a plot, without a sub-plot, or better yet, a digression. In the gallery, we are left to our own devices, encouraged by the simplicity and familiarity of the pictures to supplement them with our own mental images of place, or fashion, or ways of being together. Sociability is a theme: there are many photographs of people at table or going for walks; there are also actors in strange, futuristic costumes. Introspection is also a current; there are images of empty rooms, studio spaces and a darkroom; there are solitary figures with eyes closed.

The viewing of the film is not lonely; I may sit alone in the dark, but I am being shown the pictures, one at a time. The film was shot by a stationary camera under whose

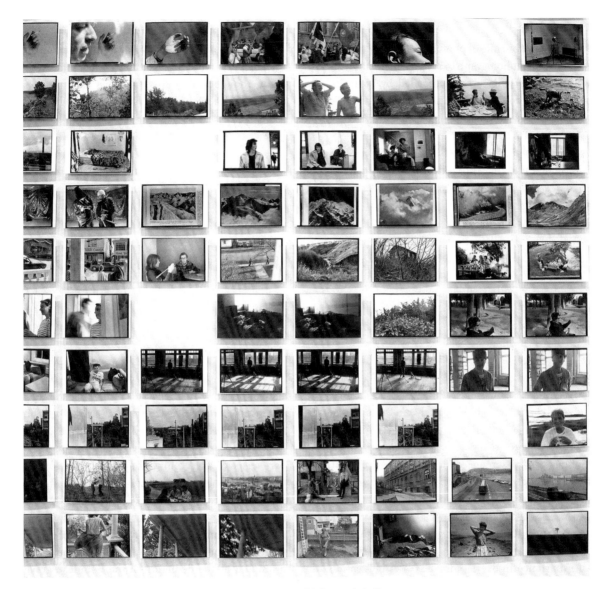

3.3 Raymonde April
Tout embrasser (2000–01)
Detail from photographic installation. 517 gelatin silver prints, 171 x 1120cm installed. Photo: Patrick Altman. Collection: Musée national des beaux-arts du Québec. Acquired with the support of the Canada Council for the Arts Acquisition Assistance

design is retained in the layout of the combined image-text; each is contained in a white field, a stubbier version of the panel, but the shape still reminiscent of a window. In book form, the rounded shape reminds me of the arched aperture of a nineteenth-century carte-de-visite album, leading me to deem it an album-work, though the first-person narration that accompanies each image is far longer than anything I have ever seen in a personal album. Still, in both function and style, the text perpetuates a certain telling of the album, thus placing Robideau's project firmly in the realm of secondary photographic orality.

Acts of God is the Story of the *Pancanadienne* Artist as a Young Man. Based on a real story (Robideau's life), *Acts of God* establishes the narrator's French-Canadian ancestry and American childhood, then covers the philosophies and trials of his grandparents and parents in four dramatic episodes that include ruminations on life, death, and the Apocalypse, a traffic accident, a snake bite, and a tornado. Certain formative experiences are underscored. A young American boy's dream of growing up to be President is shattered. Under an image of helmeted troops with bayoneted rifles advancing on unarmed civilians, the narrator writes, "I must find some other, more enlightened route to fame and fortune." The images comment obliquely on his search using cultural symbols, religious icons, and flagrant clichés: Saint John the Baptist's head on a plate is used to symbolize Quebec; a flock of plastic flamingos stands in for Florida. This approach fits with Robideau's longstanding interest in folk monuments – an earlier series, *The Pancanadienne Gianthropological Survey*, documented and commented on Canada's quirky, giant monuments, such as the Sudbury Nickel and the North Battleford Mountie. There is no mention of this series in *Acts of God*, however, and this rather startling omission prompts us to consider the nature and purpose of this autobiographical act.

Taking his cue and tone from Robideau's text, essayist Edward Morose calls *Acts of God* "a hymn to the spirit of the individual." Citing Robideau's interest in the "twists and turns of fate," Morose categorizes the work as an odyssey in which "The plight of the artist is a metaphor for everyman's struggle."[27] This is a fair summary of Robideau's album-work, with the caveat that every turn of fate that he recounts is a twist on the Romantic myth of genius; the inference is clear that his growing state of angst and restlessness ought to be recognized and rewarded by the State. Two self-portraits crystallize the artist's dreams of power and fame: Robideau re-enacts the ecstasy of his "exile years in Tangier" where he supposedly decided to become a Canadian Artist while lolling in the arms of dancing girls; a tale of success, scandal, and intercultural flight is accompanied by photographic evidence of Robideau performing Michelangelo's *David* "à la Judy Chicago," that is, standing naked on the picnic table in his Vancouver backyard. *Acts of God* parodies the tortured life of the artist, plotting his quest through two nations, four Promised Lands, fire, flood, pestilence, revelation, and repeated misunderstanding. "The Land of the Ancestors" (Quebec) holds out the false promise of roots. Religious martyrdom also beckons, but there is no higher calling than the "Canadian Art struggle." Staged photographs do some of the narrative work, but straight photography dominates. A snapshot of the famous Canadian photographer, Yousuf Karsh, captures him walking past the grand entrance of the Château Laurier where some nobody sits shivering on the stairs. This visual juxtaposition represents the narrator's blighted hopes for stardom. Hope of a kind is held out by the penultimate image-text which contains the artist's announcement that he has bequeathed his body to the National Gallery "with the stipulation that my pickled remains become a permanent back-lit installation piece." The accompanying photograph depicts a piglet in

formaldehyde with a hand-written note that reads "Please turn the pig slowly." Hopes are dashed by the last picture which shows a man passed out on the edge of a sidewalk. In the text, the narrator thanks Canadian Art for teaching him the facts about "messing with fame."

Anthropologist A. David Napier draws an arresting parallel between romantic ideas of mad genius and a cancerous tumour to its host body: "As the epitome of uncontrollable individualism, both the image of the artist and that of the mentally insane are mirrored in the volition – the egotism and the independence – we attribute to our own cells in diseases of proportion." "Enlightened" cultures, meaning "cultures that actively promote a cult of self-consciousness," have sacrificed proportion to singularity. Conjuring the infinite reflections of opposing barbershop mirrors, Napier describes a quest for self-knowledge that does not need others, or worse, measures otherness only in terms of the self: "because one's own self is thought to be least known, that 'otherness' most like the self – one's mirror image – represents, indeed, the essence of exoticism." Napier argues that Western culture is in a double bind: "as a culture, we refuse to institutionalize those avenues of personality development that suggest any ambivalence about self-knowledge while simultaneously maintaining that there can be no such thing as a *positive* loss of self." His argument fits with the Robideau myth of American boyhood, for in American life, any threat of such loss is battled with the myth of individual freedom and a rallying of the pioneering spirit. The impetus is to seek the horizon; the wagon trains move out: "American culture is, indeed, cognitively entrapped in a rite of passage, and it has, moreover, yet to emerge from its romance with liminality."[28] Cousineau-Levine has made a similar argument about Canadian photographic art practice, suggesting that it may just now be emerging from a fraught adolescence that is obsessed with death. Of *Acts of God*, she writes, "Despite the humour of Robideau's piece, the familiar Canadian template of descent into the Land of the Dead and identification with trapped and dead animals is evident."[29]

Considering these complementary points, we might find in the double-edged hysteria of Robideau's *Acts of God* both Western culture's solipsism and Canadian photography's puerile *cri de coeur*. But the template that we have been applying here, that of the personal photographic album, suggests a more positive, and potentially more radical, interpretation. As Robideau attended in his previous work to the eccentric monuments of collective memory, he has here turned to the personal memory-work of the compiler. His entire body of work, in fact, draws on, and contributes to, alternative sources of knowledge and experience. *Gianthropology* credited the expressions of popular culture that most people simply laugh at, driving by. As Napier says, "The *bricoleurs* and *idiots savants* are there before us whether or not we give them serious attention; and their ways of embodying, of understanding, are … at least partially accessible to us and may even come to be 'known' through a concerted attempt to move within a social space to which we have been sensitized."[30]

The personal album, as I have argued at length, is just such a social space, and the album-work of artists traverses it, while simultaneously reframing it. Robideau's version implicates its audience in an absurd poetics of selfhood. April's image-by-image oscillation between self and community activates memory through empathetic participation. Semchuk's extended self-portrait takes a woman's potential for life experience – joy, suffering, and growth – and moulds it; *she* moulds it from her own image with her own hands. Buchanan's album bravely risks a "positive loss of self" by releasing secrets of self-consciousness, fantasy, and fear.

The four albums considered thus far expose the edges of community – the social, political, sexual, and/or cultural context of their creation – and employ various strategies to bring the sympathetic stranger into the circle. June Clark's album-work cultivates a very different spectatorial experience: the memory-haunted, memory-enriched condition of the exile. In this album-work, the ground is constantly shifting under the maker's feet.

Clark was born in New York City in 1941 and grew up in Harlem; she emigrated to Canada in 1968. She left the United States during a period of political unrest, military adventurism, and urban violence – the war in Vietnam, the civil rights movement, and feminism define her generation's collective memory and contextualize the memory-work that she began to exhibit in the early nineties. These are sculptural assemblages and large photo-etchings, very different objects that are conceptually complementary. The unifying theme of exile situates autobiographical memory in the collective memory of diasporic African women. This is, to say the least, *difficult* remembering, a reconstituting act of resistance to denial and erasure, nested in personal experience: Clark's acute sense of borders, beginning with a young New Yorker's self-consciousness about being from the troubled and feared community of Harlem; a sensitivity redoubled by leaving her home and trying to settle in Toronto. As Alice Jim has noted, "for many diasporic subjects, the notion of 'home' often involves a metaphor of migration, or journey, rather than a fixed geographical point."[31] In Clark's case, the metaphor has moment, or indeed, many moments, as she revisits episodes of her personal journey.

The untitled photo-etchings and a series of nineteen boxes, *Family Secrets*, evoke an African-American childhood behind the virtual walls of the ghetto. The photographic works are reconstructions of that history from family photographs, memorabilia, and negatives from Clark's black and white documentary photographs of Toronto (fig. 3.5). Montage fuses these images with phrases recollected from childhood or borrowed from literature; their marriage articulates the survivals, mutations, cross-pollination, and disjuncture of Pan-African culture.[32] A photographic historian recognizes elements of street photography: pedestrians, parades, and spontaneous encounters, captured by the roving eye. The modern art critic is reminded of the urban content and juxtaposition found in American Assemblage, and specifically Robert Rauschenberg's Pop-protestations of the 1960s; Clark's work is superficially similar, especially in reproduction, but its appeal to autobiographical memory sets it on very different grounds. Her settings are intimate, though they do not fit the ideal of "homeplace" identified by bell hooks as the affirming, healing refuge for Black people.[33] Nor are they quite in the public sphere: *Family Secrets* is set on the sidewalks of a generic urban neighbourhood, where children play and merchants traffic, where the histories of communities pass quickly between members, in a whisper. A loss of frame and a suppression of detail in her printing technique recreate Clark's photographic archive as a boundless, floating world of memories. The imagery does not fill the sheet, edge to edge, but wafts across a white (empty) field; its porous edges suggest the intimacy of life experience inhaled and exhaled. In its recourse to the personal, through autobiographical fragments, there are sisterly reminders of May Stevens's layered images and text. Faith Ringgold's variations on symbolic objects and Black women's voices also come to mind.

The boxes draw a direct line to African culture, its perpetuation in the domestic sphere and reinvigoration in 1960s African-American feminist art. The work of Evange-

line J. Montgomery is exemplary, as described by Nkiru Nzegwu:

The anamnestic role of the *mojo* boxes transforms each sculpture into a mnemonic device and counter-acculturationist thesis. Each box preserves both ancestral and personal memories that underscore the validity of another artistic legacy. Each box is full of 'historical texts' to be voiced to others in narrative rites of remembrance. This idea of boxes as sites of ancestral preservation is very much a feature of African cultural life that survived in diaspora.[34]

At the same time, the box is a container of terrifying memories. These are awakened and set free by Buseje Bailey, her *Black Box* (1989) evoking "the deplorable conditions in slave ships which Africans were forced to endure during their transportation across the Atlantic as well as an allusion to the story of Pandora's Box."[35] For Clark, the activity of collecting objects in cigar boxes goes back to her childhood in Harlem; it represents both continuity and rupture with her African-American past; it also contains the secrets of her present. Making a link with the prints, the treatment of borders by this restless exile deserves our attention. In *Family Secrets*, the solid edges of the boxes are sometimes respected, sometimes breached by their symbolically charged contents. As Carolyn Bell Farrell explains,

Concrete expressions of containment, these structures reveal aspects of the psyche and of collective experience which, through socialization and repression, have been compartmentalized and hidden. One contains an American flag, denoting the artist's heritage. The image of the flag crammed tightly into this tiny box belies the traditional view of Canada as a utopian place of liberty, freedom, and equality.[36]

EVEN THEN

I KNEW THAT PEOPLE MISTOOK KINDNESS FOR WEAKNESS

3.5 June Clark
Untitled (1994). Text: *Even then I knew that people mistook kindness for weakness*, Photo-etching, 53.9 x 42.1 cm

Set in Toronto, an untitled photo-etching (1994) is a curved horizon line, a row of houses punctuated by a passing woman whose oblique expression denies us any real contact (fig. 3.6). Between the woman's head and a telephone pole, jumpy letters spell out the following: "When she said, 'You dirty little wench,' I ran home to look it up in the dictionary." The genesis of this piece in a verbal encounter is explicit; the shakiness of the lettering suggests

3.6 June Clark
Untitled (1994). Text: *When she said, You dirty little wench, I ran home to look it up in the dictionary*, Photo-etching, 42.1 x 53.9 cm

the emotional tone of the work's voicing; the combination releases the words from the particulars of time and place. Orality is a mainspring of Pan-African creativity; its anamnestic function is the source of its fluidity.[37] Clark's use of her photographic archive is another feature of the oral-photographic framework with its tendency to homeostasis, to the sloughing of memories, or revision of myths, that no longer contribute to survival. The phenomenon is here perfectly pictured. Words spoken elsewhere, in another time, nest in a partially erased documentary photograph of a Toronto street. Scarring lines and a fleeting image are translated across time, space, and media. They merge in this visual telling of an exile's memories, still running to home.

I can report a similar adventure. I was sitting alone in my *wagon-lit* compartment when a more than usually violent jolt of the train swung back the door of the adjoining washing-cabinet, and an elderly gentleman in a dressing-gown and a travelling cap came in. I assumed that in leaving the washing-cabinet, which lay between the two compartments, he had taken the wrong direction and come into my compartment by mistake. Jumping up with the intention of putting him right, I at once realized to my dismay that the intruder was nothing but my own reflection in the looking-glass on the open door. I can still recollect that I thoroughly disliked his appearance. Instead, therefore, of being *frightened* by our 'doubles,' both Mach and I simply failed to recognize them as such. Is it not possible, though, that our dislike of them was a vestigial trace of the archaic reaction which feels the 'double' to be something uncanny?

— Sigmund Freud[1]

What a loss to civilization. Had Freud just shot the intruder with his trusty Brownie, his aesthetic project on the uncanny would have been illustrated perfectly: a portrait of the psychoanalyst-as-other, a photographic reflection on the nature of the photographic act. His decisive moment missed, Freud's memoir of his confrontation wants for evidence — it hardly qualifies as an ekphrasis — though scores of artists have filled the gap by making photographic images that include their own image in reflection.

These are mirrored self-portraits, and a great deal more. Here is one visually complex example: Bertrand Carrière's *Sur le train entre Paris et Rouen, France* (1982) (fig. 4.1). The sharpest image of the photographer is an embryonic figure at the centre of the frame, mirrored in the window of the train compartment that he is recording from the corridor. In between, a partition of glass throws back his enlarged reflection: his smaller self nests in this figure like a Russian doll. Add to that the sleepers of the compartment and the spectral line of poplars that forms a separate register of motion across the upper half of the print and we have an image of temporal and spatial flow, only partially arrested by a photographer who signals his devotion to his real father, a railroader, and his photographic forebears, the travellers.

Carrière's memory-work reminds me of Roland Barthes's assignment of photography to "that class of laminated objects whose two leaves cannot be separated without destroying them both: the windowpane and the landscape, and why not: Good and Evil, desire and its object: dualities we can conceive but not perceive," the photograph and its referent reality.[2] Barthes finds the essence of photography, and his love for it, when this stickiness breaks through the surface of the image and also sticks to him. The rupture is memorable because memory presents as an interruption in the flow of mediated experience, a tear in the fabric of rational Western cultural conditioning. The moment is creative. It is, as Barthes puts it at the end of his book, "mad."[3]

Camera Lucida gives only the slightest nod to the photographer. Barthes in effect usurps that role. *Camera Lucida* is itself a photographic work of art, descriptive and symbolic of mnemonic intersection. Like collodion, Barthes's text pours over and seals the wounds left by his scalpel eye: however fluid at the source, his book, because it is a book, is another lamination. Except that here, as in Carrière's photograph, we are confounded by many leaves of transparency and reflection, including the figure of the photographer where we do not expect to find it: *in camera*, and, in the words of Rosalind Krauss, convulsing reality from within.[4] Setting the photographic act into the image, the reflection becomes a figure for the photographic act: it is its simulacrum or double. In Surrealist production, says Krauss, this is "not only a thematic concern. It is a structural one … the mark of the sign." Among the many actions effected by doubling, Krauss draws our attention to its banishment of simultaneity from the photograph: "being seen in conjunction with the original, the double destroys the pure singularity of the first. Through duplication, it opens the original to the effect of difference, of deferral, of one-thing-after-another."[5]

Doubling is short form for repetition; we have seen repetition at memory-work in artists' adaptations of the album. But Carrière's photograph, and all the photographs to be examined in this chapter, function quite differently. They are all single exposures that combine what is in front of the camera with what seems to be behind it. That is their scissoring effect, sometimes amplified by different degrees of sharpness, depending on how the photographer decided to focus. Another cutting edge is the frame of the reflective surface that separates the image-within-the-image from its photographic surround. In this instance, the photographer's cameo appearance is both explicable and contained, though graphic isolation takes nothing from the figure's power. However it occurs, the visual presence of the maker sparks a particular kind of fragmentation. The integrity of the host composition is compromised, its spatio-temporal borders are breached, by admitting this figure from the other side – the normally invisible photographer – whose vantage point is destined to become the spectator's. The image is both the memory of its making and the rehearsal of its viewing.

4.1 Bertrand Carrière
Sur le train entre Paris et Rouen, France (1982).
Gelatin silver print, 40.4 x 50.3 cm

This type of thing can occur by chance; I am interested here in self-reflection as a premeditated visual strategy that expands our definition of "the mirror with a memory."[6] Having situated the device within the larger culture, we will look at its emergence as a comment on the photographic act before delving deeper into its activation of memory.

MIMESIS AS METAPHOR

The mirror is an ancient image. How far back shall we go? "From the earliest times, the mirror has been thought of as ambivalent."[7] Of human consciousness and unconsciousness, the mirror-image is portal and preserve; vanity and *vanitas*; speculation and knowledge. Scholar-poets of the Middle Ages cultivated the duality of reflection's true and fanciful nature. For Dante, Chaucer, and Aquinas, mirror-metaphor and mirror-mimesis were opposites only by degree.[8] In the Renaissance, the mirror intensified the Albertian window; the painter's mind was the reflective surface of nature; the mirror was also the teacher. "Take the mirror as your master," Leonardo da Vinci counselled. "The work will appear to you in reverse and will seem to be by the hand of another master and thereby you will better judge its faults."[9] This mixture of philosophy and practicality helps to explain the hardiness of what M.H. Abrams calls "archetypal analogies," complementary metaphors that weathered the tempests of aesthetics and metaphysics, thriving in the Romanticism of the early nineteenth century, a period sometimes called "before photography."[10]

A philosophical engagement with reflection begins by noting the metaphoric convergence of self-consciousness and reflected light. The "eye-mirror" perceives the external world and reflects the soul. A precedent from the Middle Ages is the "double mirror" of the eye which, as Herbert Grabes explains, "reflected the world inwards and the inner world outwards."[11] Rodolphe Gasché minimally defines "reflection" as both structure and process, "designating the action of a mirror reproducing an object … that mirror's mirroring itself, by which process the mirror is made to see itself." This "double movement" contains "two distinct moments" which are unified in the mirroring subject's recognition of the reflected object as self. The ensuing dialectic forms a "conceptual totality" in which the optical metaphor still predominates.[12] As the mechanical offspring of mimesis and metaphor, the "mirror with a memory" offers a way of visualizing those conceptual operations. The difficulty to be surmounted is the literalist association of "mirroring" with truth. Again, the problem is not new: the mirror of historiography – a didactic instrument used to gain distance on the past and fix the flow of events – returns to Elizabethan times when the historiographical mirror was regarded as "superior to the mirror of individual experience," that is, memory. Grabes explains the attractiveness of this mirror-function in terms that resonate with photographic theory: "That the real mirror can offer only a fleeting image, and that the past cannot be permanently captured, did not deter those who favoured this didactically motivated mirror-metaphor."[13] Some contemporary photographers still cling to the authority of the didactic function, despite the partiality of their reports. Others more attuned to the mutability of history and memory, and sensible to workings of their own double mirrors, offer images of the mirror-function that capture both their visions and their thoughts.

In a photographic image, the reflected presence of the maker intrudes on the mirror of nature and intensifies our awareness of the photographic act, and most acutely, the photographic actor, who is clearly someone other than ourselves. Film theorists argue for, and against, such devices: as Kaja Silverman explains, "even so simple a device as the

implied frame around a given shot" tips the viewer that he or she is "only seeing a pregiven spectacle, and the *jouissance* of the original relation to the image is lost."[14] However disillusioning, the mirroring of process within creation takes many forms: the play within the play that encapsulates the greater plot; the novel within the novel that articulates the writing; the painting within the painting that reflects the translation of vision onto the picture plane. French semiologists call this device a *structure en abyme* or a *mise en abyme*, a phrase borrowed from heraldry by the writer André Gide, who confided it to his journal in 1893.[15] Gide was looking for a way to describe instances of transposition "on the scale of the characters" of "the very subject of that work." He trolled European culture in a heuristic mode, reeling off examples from Memling, Metzys, Velázquez, Shakespeare, Goethe, and Poe that came close to the notion he had in mind. Then, finally, something more exact, an expression of *process* (in heraldic language, *placement*): "the device of heraldry that consists in setting in the escutcheon a smaller one 'en abyme,' at the heart-point."[16]

Gide was certainly not the first to see doubled plots and mirrored easels: his interest may have been sparked by Victor Hugo's analysis of Shakespearean structure and Renaissance typology; Hugo also commented on heraldry as a key or codified language.[17] Gide's attention to the abyss can thus be seen as a qualified act of fealty and an inescutcheon of pretense: archaic and predictive, shot through with intriguing, paradoxical flaws.[18] An emblem of generation, his structure "en abyme" must be embraced in all its contradictions as an abyss superimposed on a cultural field crowned with quarterings: history, instruction, prognosis, and invention.[19] Semiologists and their translators do not tamper with the phrase — how could they? In 1893, it was already a message in a bottle, sealed in quotation marks and addressed to an unknown future, somewhere out in the linguistic field. Gide employed the mirror in imagery and actuality: his journal records his adult re-enactment of a childhood memory, writing at a dressing table in dialogue with his doubled reflection.[20] As Lucien Dällenbach has shown, the *mise en abyme* is the same dialectical structure, unclosed yet complete as a "miniature model" compressing time and space. The reflection moves toward abstraction: "By stylizing what it copies, the model distinguishes what is essential from what is only contingent: it in-forms."[21] This distillation is essential if placement *en abyme* is to fulfill its analogical potential, as multiple reality (house of mirrors) and mimetic rupture (vertiginous abyss).

In 1967, literary critic Jean Ricardou imagined the *mise en abyme* (the story within the story) as an instrument of contestation whose possibilities might literally explode if taken beyond storytelling and applied to the physical object, the book: "Whether they reproduce pages already read, unveil subsequent pages, or successively repeat the same pages, these autografts, in each case, are a form of sabotage. Just as fictional *mises en abyme* attack the temporality of fiction, textual *mises en abyme* contest the very principle of the chronology of the book, the sequence of the pages." Ricardou's extreme *mise en abyme* wanted page numbers suppressed and a full reorientation — the back cover stamped with a title that answered, or counterattacked, the title stamped on the front.[22] At least one visual artist, Michael Snow, has given Ricardou his wish, and many photographers have inscribed their work with photographic "autografts."[23]

SIGNING THE DOCUMENT

The image within the image confirms the presence of the maker (the intelligence of the eye) and autographs the

work. As a recursive gesture, the "autograft" finds a natural habitat in a philosophical artistic practice, such as Snow's. It is quite another matter to find the device in a body of work that is supposed to reflect with objectivity on the human condition. In a documentary photograph, an admission of subjectivity is akin to journalistic bias, that is, inadmissable in the court of public opinion. An "autograft" becomes a small act of sabotage; it insists on the affective presence of the photographer; it explodes the myth of objectivity.

Journalistic or photographic objectivity is a myth, of course, and one long recognized by its more thoughtful practitioners. In his well-known self-portrait of 1959, Michel Lambeth, a humanist documentarian whose pictures of the poor, the foolish, and the bereft depended on our faith in his superior ability to *see*, to give *witness*, proclaimed his subjectivity, and emancipated both his subjects and his spectators in one, brilliantly efficient "autograft." He turned the camera on his reflection in a photomat mirror, inserting his self-portrait into the crowd of anonymous subjects (fig. 4.2).

The liberating potential of the photomat had been recognized on sight when, in 1928, the first *photomaton* was

4.2 Michel Lambeth
Union Station, Toronto (1959).
Gelatin silver print, 27.9 x 35.4 cm. Collection: Canadian Museum of Contemporary Photography/National Gallery of Canada

installed in Paris. André Breton, who had defined Surrealism as "psychic automatism in its pure state,"[24] rushed to have his picture taken by a machine, and urged his fellow Surrealists to do the same. The following year, René Magritte, who had participated in the Parisian experiment, extended it to the Brussels circle. The Surrealists, already intrigued by the immediate and unmediated aspects of the snapshot, saw two marvellous features of the photomat: first, its complete mechanization freed the photographic image of human intervention, even the hack's or the snapshooter's; the photomat could thus be the instrument of Automatism. Second, the photomat's stream of pictures – the initial, blinding shock of self-exposure, quickly followed by another shock, and the whole thing over before the subject got control – was thought to release the unconscious of the subject. Was this level of surrender good or bad? Magritte and his collaborators simply closed their eyes.[25] Lambeth's self-portrait records his eyes wide open: his bold gesture simultaneously abdicates and displays the authorial role. Picking up the language of advertising, Lambeth's self-portrait seems to say, "Here ... Take your own photo." Let your photographic memories be your own.

Thirty-nine years later, the medium has changed, the message has not, in Karin Bubaš *Two TVs and an Ashtray* (1998) (fig. 4.3). The photograph is part of a series, *Florence and George*, that documents "a small museum of everyday life," the apparently empty house of the photographer's grandparents.[26] This particular image rekindles the hearth of modern family life as Bubaš crouches down to the height of a child to enter her documentary photograph. The image is a still life situated in a decor that is itself a collage of *heimlich* comforts: wood panelling, wallpaper, linoleum tile, chrome, carpet, and veneer. As these layers have built up on the walls, the two TVs have been stacked, the portable on top of the older cabinet, forming a twentieth-century

4.3 Karin Bubaš
Two TVs and an Ashtray (1998).
Colour print, 40.5 x 40.5 cm. Courtesy of the artist and Monte Clark Gallery

totem, a folkloric Nam June Paik. The TVs are not on, so they actually tell us something about their immediate surroundings. In the lower screen, the reflection is relatively bright, its elements, including Bubaš's silhouette, are quite distinct and immediate, whereas in the upper, smaller screen, the image is diffuse and recessive. Bubaš is thus doubly, though unevenly, reflected, and her third presence is felt by the spectator who mentally occupies the spot on which Bubaš is kneeling, what we might call the anti-fore-ground of the picture. Most photographs cede that position to the spectator, but here it must be shared with the creator – we regain the perspective of childhood through the look-ing-glass of reenactment.

Documentary photography is supposed to insist on the mirror-metaphors of information, knowledge, and author-ity – screens that belong to the stubborn analogy of mind (and memory) as a mirror.[27] But in this photograph, at least, Bubaš is questioning the epistemology of the image. If her project makes her grandparents' house into a public muse-um, her multiple presence defeats any claims for disinter-ested recording – this radical gesture simultaneously erects and brings down documentary photography's mirrored house of cards.

REFLECTED STATES OF BEING

My reading of Bubaš depends on an understanding of pho-tographic reception as performative: to look at a photograph is to rehearse its making, to stand where the photographer stood and see what he or she saw. In principle, this is true, though in practice the photographer's previsualization may have been different, possibly imperfect, the negative yield-ing information that he or she may barely have been aware of at the time of exposure. Shooting through a pane of glass

(a lens and an optical symbol), the opacity of the reflection is hard to predict, melting as it does into the tonal values of the receding planes. And confusing things even further, these fields are also invaded by the reflection of what is behind the photographer. We are being shown, but we can-not determine just where in relation to the subject the pho-tographer was standing (often, they cannot remember themselves). As spectators, we are bound to lose our bear-ings, and possibly to question the mimetic competence of the image. This condition of uncertainty mimics the insta-bility of memory. The spatial ambiguity of an image filled with reflections is a perfect metaphor for the reflexiveness of the photographic act.

An untitled work by Richard Baillargeon, from the series *Commes des îles* (1987–91), is a conundrum of spatial and elemental reconstruction (fig. 4.4). A large black and white photograph, the image is marked as a full, single exposure by its rough and narrow black edge.[28] At first glance, the image is dominated by a single element, a dark shape from the lower edge, recognizable as a head by the halo of curls. Gradually, more elements begin to make sense, beginning in the lower half of the picture with the silhouettes of tall, leafless trees and a wire mesh fence, and with a soft, grey field that might be an overcast winter sky filling in the upper field. Finally, the exotic cleaves from the familiar and comes clear: we see the fronds of a palm tree and a pale monkey. The juxtapositions suddenly cohere: the monkey is being photographed in a large glass cage on whose surface the photographer's head and the deciduous planting be-hind him are reflected. Masked by the vaporous sky, the dematerializing monkey rises like smoke out of the photog-rapher's brain.

Everything in this picture has its double: the wire fence and the glass partition; the tropical and northern trees; the dark figure of a man and the luminous apparition of a mon-

4.4 Richard Baillargeon
Commes des îles (1987–91).
Detail from series. Gelatin silver print, 70 x 101 cm

key. The print itself, which is large, dark, and covered with protective glass, also reflects the spectator and his or her surroundings, adding them to the layers of lamination.[29] The ghostly monkey reminds us of photography's association with death, and also mocks the sentimentality of the allusion.

In some cultures, the monkey as the savage human twin represents our baser instincts, yet somehow also offers luck.[30] In *The Monkey as Mirror*, Emiko Ohnuki Tierney traces the history of this reflexive symbol in Japanese culture:

As a mediator, it harnessed the positive power of deities to rejuvenate and purify the self of humans. However, seeing a disconcerting likeness between themselves and the monkey, the Japanese also attempt to create distance by projecting their negative side onto the monkey and turning it into a scapegoat, a laughable animal who in vain imitates humans … By shouldering their negative side, the monkey cleanses the self of the Japanese. As scapegoat, it marks the boundary between humans and animals.[31]

Baillargeon and his simian double meet on that narrow boundary. As Lisanne Nadeau describes this and other zoo pictures in the series, "These images speak of captivity, the animals' and our own gaze that knows not how to go further. One and the same gaze that lingers and searches."[32] The photograph fits within a series of words and images, this suite introduced by two lines, "Passages incertains / Escales improbables," that underscore Baillargeon's productive ambivalence. This condition, it must be said, is not memory's alone; the dream state is also recognizable in the associations and palpable sense of yearning that Baillargeon expresses in his work. But memory has perhaps a stronger claim in a work so deftly balanced between description and suggestion, and one so expressive of the conflation of times present and past. As Roger Shattuck observes in explaining Proust's ability to make us "*see time,*" "Merely to remember something is meaningless unless the remembered image is combined with a moment in the present affording a view of the same object or objects. Like our eyes, our memories must see double; these two images then converge in our minds into a single heightened reality."[33] The veiling of detail in Baillargeon's image fuses his shadowy reflection with the spectral image of the monkey; the animal is figured as being in the man's thoughts. They are thus together in real time, for us now as they were then, as well as sometime long before now, a time inscribed in the mytho-poetics of racial memory, when human and animal met and spoke together.

FRAMING THE DOUBLE

The double visions found in the work of George Steeves are of three sorts. The first group belongs to the realm of homages and quotations; the second is autobiographical and ritualistic; the third is psychological and ontological. All three are cathartic expressions of memory; all three stem from Steeves's passion for photography, his belief that the medium sustains his inner life.

In terms of motivation and chronology, the groups that I am creating are not perfectly discrete. Steeves's reverence for the American and European Modernists, such as Alfred Stieglitz and Lisette Model, relates directly to his photographic education: the works that drew him to photography as a means of self-expression are indelibly impressed on his mind. Thus, in his extended portraits of Ellen Pierce and Astrid Brunner, we find references to canonical images: Stieglitz's intimate studies of Georgia O'Keeffe jostle with Model's caustic snapshots of stran-

gers. As Steeves has matured and experienced some of the vicissitudes of his avocation he has sought inspiration elsewhere, as often from the visionaries and outcasts of Western culture, as from its more celebrated artists. Regardless of the source, these images rise up before Steeves with the force of autobiographical memories because that is precisely what they are.[34]

This referential group, which thrives on a combination of memory and imagination, anticipates the discussion of imagistic persistence that will be pursued through the work of other artists under the rubric of *Paper* in the second section of this book. I have mentioned Steeves's history of conscious and unconscious homages to contextualize the emergence of other kinds of doubles in his work, those of the second and third groups. In these photographic works, the inextricable link between memory and photography is expressed both symbolically and processually in various forms of mirroring self-portraits.

Steeves made very few self-portraits, and made none public, until 1985 when, in an intense and unexpected moment of psychological crisis, he attempted suicide by drinking a cocktail of photographic chemistry. His oesophagus, as well as his mouth and arms, suffered severe burns, but he survived. While still in hospital, he resumed his work by asking a visitor to photograph him in bed. This image was used three times in the series *Edges* (1979–89).

Technically the hospital pictures are not self-portraits in a mirror, but their use in *Edges* has a mirror-effect. Each is paired with a landscape or a still life that is replete with personal associations; these pairs are intended to function as unified portraits. It is perhaps important to mention the treatment of the emblematic half of *Edges*: they are all contact-printed on different watercolour papers in a non-silver process (platinotype, palladiotype, cyanotype, or Vandyke brown) and overpainted with watercolour or ink, sometimes in garish, carnivalesque colours; they are thus unique and unrepeatable. By contrast, the portraits are conventional black and white enlargements. *The Suicide Attempt of 1985* exists in three versions. Version 2 pairs the hospital self-portrait with a brilliantly hand-coloured print of a small merry-go-round that Steeves first photographed in 1979, used as a site with various models, and eventually acquired for his studio.

As one might assume, Steeves's brush with death haunts him, especially on its anniversary. The person who would try such a thing is strange to him, in part because "he" did it so sloppily. Steeves's response has been to make something of this synchronic memory by re-enacting his suicide attempt before the camera. The hospital self-portrait thus marks the beginning of Steeves's project in unsparing self-portraiture, some of whose images have appeared in the series *Equations* (1986–93) and *Elsa's Kind* (1991–98), but most still forthcoming in a monumental, extended self-portrait entitled *This Excavations Project*.

The 1990 re-enactment of the suicide attempt is featured in *Equations* which is, like *Edges*, a series of pairs. Steeves's self-portrait constitutes the left image in *Spalanzani & Olympia* (1990, 1996) (fig. 4.5). The diptych's title refers to Jacques Offenbach's opera, *Tales of Hoffmann*, which was based on E.T.A. Hoffmann's short story "The Sand-Man." Hoffmann's fantastic story of Spalanzani, the mechanician, Coppola, the optician, and their automaton, Olympia, is retold by Freud in his essay "The Uncanny," who (as hardly need be repeated) stresses patterns of multiple repetition and doubling that Steeves and other photographic artists have adopted in their work. For Freud, a crucial motif of Hoffmann's story is the repeated threat of blindness: the hero Nathaniel is told that when the Sand-Man comes to

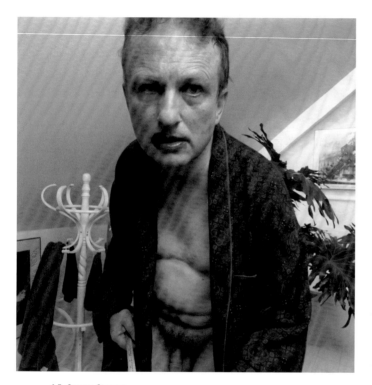

4.5 George Steeves
Spalanzani & Olympia (1990/1986).
Detail (left panel). Gelatin silver print, 37 x 37 cm

bad children, he throws sand in their eyes, and then steals them to be pecked by his children. This nightmarish vision sets off a string of associations and recognitions that ultimately lead to Nathaniel's suicide. The story is replete with optical images and doubles. In Offenbach's opera, Hoffmann's reflection in a mirror is requested by Giulietta as a token of love; he consents, only later discovering to his horror that he has no reflection to give. This reflexive exchange is also a motif of *Equations* whose binary structure was partially inspired by the marriage of George Steeves and Susan Rome. In fact, the Olympia of the title is modelled by Rome as a beautiful, broken doll.

For psychoanalyst Christopher Bollas, Freud's elaboration of the uncanny is an illumination of the unconscious ego at work. Bollas frames its intelligence in terms that also describe the photographer's recursive presence in his or her work: "We do not customarily see this part of us: it would appear to be impossible. The audience at a play does not see the production team behind the scenes; they witness only the actors on the stage, who enact the play." Or so we might say of the Modernist photographer, that the image must be allowed to speak for itself, that the photograph must obtain to a level of psychological equivalence as a reflection of its maker's psychic travails. As Bollas continues, "The dreaming subject inside the dream does not see the figure who dreams the dream — even though its wise processional presence is everywhere."[35] Steeves's symbolic works have struggled against his invisibility. His mounting desire to see, and be seen, as the "dreaming subject" becomes more explicit in the third group of mirror-images.

The seedbed of self-revelation has been there from the beginning, slowly germinating in the recurrence of certain painful motifs, such as the white frilly blouse that his first wife left behind in the closet. Catharsis, fetishism, strong photographic theatre, or all three at once: the blouse, or its

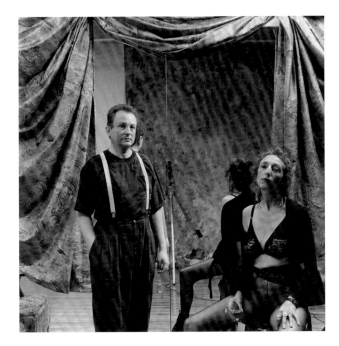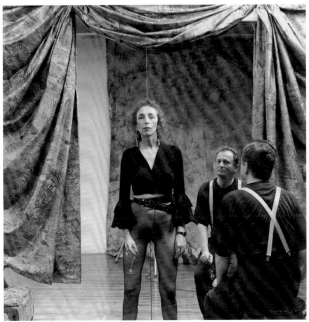

4.6 George Steeves
Intermediaries I & II (1993).
Detail from diptych. Gelatin silver paper prints laser-printed from digitized negatives, 101.5 x 101.5 cm

like, was modelled for Steeves who wove the memories of first love and rejection into a number of series, including *Evidence* (1981–88), in which his shadow falls across the body of Angela as she poses in the frilly blouse. He is otherwise present only as a name, summoned as a witness to Angela's crumbling marriage.

Steeves's next move into the work as subject is through a mirror, the backdrop to a portrait of Astrid Brunner, entitled *Astrid Speaks* (1988). Brunner is seated, leaning toward the camera, her body twisted to place her right arm, with its bandaged wrist, at the centre of the composition. Steeves's reflection is small and partially blocked by a gooseneck lamp,

seen in the mirror and intruding, out of focus, into the top right corner of the overall composition. Astrid's proud pose dominates the picture; Steeves's head is bowed over his camera; he remains, to this point, anonymous. The text, inspired by Brunner and written by Steeves, nevertheless recognizes the volatility of his presence. The tone is melodramatic. Steeves is called teutonic, remote, and incisive: "Then our union in the mirror. The mirror and the camera between us like the sword between Wagner's lovers." At this stage in his work, the theatrical metaphor figures powerfully in Steeves's work: the idea of performance – the sense of being a character – gives him permission to appear.

Brunner's extended portrait, *Exile*, was completed in 1990, though the artists' collaboration has continued intermittently, not surprisingly returning to the mirror metaphor. In *Elsa's Kind*, the doubling mirror redoubles in a pair of portraits entitled *Intermediaries I & II* (1993) (fig. 4.6). Shot against the mirror of a dance studio, these two works amplify the psychological intensity of the artist-model relationship, and from those dramatic heights plunges into the impossibility of representing the other, and our compulsive need to try. Each photograph is a bit of a visual puzzle: the almost inexplicable detail in the line that splits the frame and is itself divided horizontally into black and white. The proscenium is implied in a luxurious curtain that frames the protagonists' provisional union. For everything seems contrived (it is), and temporary. One wonders, Is the drapery real (is it reflected only once in the camera?), or is it also a reflection? Where are we, the spectators, between mirror and camera? The strict pairing of the images (the fixed position of the camera) creates a canonic structure of imitation – within that frame, the photographer and the subject switch roles, a device reminiscent of mirror canon in which two voices chase each other by means of compositional inversion. The miracle, or the mirage, is the perfect balance between the figures – the extraordinary power as Brunner, alone, stands her ground between Steeves and his double.

One last example, a preview of *The Excavations Project*, needs to be examined. This mirrored self-portrait of 2001 exudes a kind of uncanny sufficiency that makes it both disturbing and familiar (fig. 4.7). The host composition is a figure study of a clothed model, the skirt, stockings, shoes, and fingers suggesting a woman, the rest of the body concealed behind a large, broken mirror in which we see the photographer nude. What we can discern of the host setting is the corner of a room whose walls have been covered with dark curtains; a string of Christmas lights loops into the frame from above. The model's calves have been dusted with powder or sand, the back leg more thickly, so that it pushes forward in the composition and also extends the reflected figure, a torso cut off by the mirror's edge below the knees. The mirror image, an exemplary *mise en abyme*, is not filled by the figure of the artist, but rather introduces a bourgeois domestic scene, a rustic sideboard with flowers, a framed picture, and so on. This is the dual backdrop, surreal and banal, against which a naked, middle-aged man contemplates his reflection, his right hand pulling his penis and scrotum up into his belly, his left hand behind his back, pressing the shutter release. His self-castrating gesture is naturally arresting, though no more so than his gaze which is – can one say? – powerfully impassive.

Freud's well-known interpretation of the Sand-Man story is that the hero's fatal fear of blindness is symbolic of the castration complex of childhood. While one could debate endlessly whether blindness or castration would be the greater evil for an aging visual artist, Steeves's self-portrait expresses the twinning of these fears. The model's hand gripping the sharp broken edge of the mirror is especially threatening. Steeves's image might be read simply as another picture that Freud should have made. The artist and the psychoanalyst are remembering the same tale. But we need to be careful. A too close correlation of Freud's and Steeves's literary sources leaves out certain elements of the uncanny, notably its eruption in everyday life – our daily confrontation with the double. Steeves brings this aspect in.

Two settings are juxtaposed in this photograph; one is studio-like, therefore generically creative; the other is domestic, idiosyncratically homely; the reflected home is a bright island in the dark creative sea. They are, of course, one and the same room. I once questioned Steeves about the messiness of some of the environments that he shoots

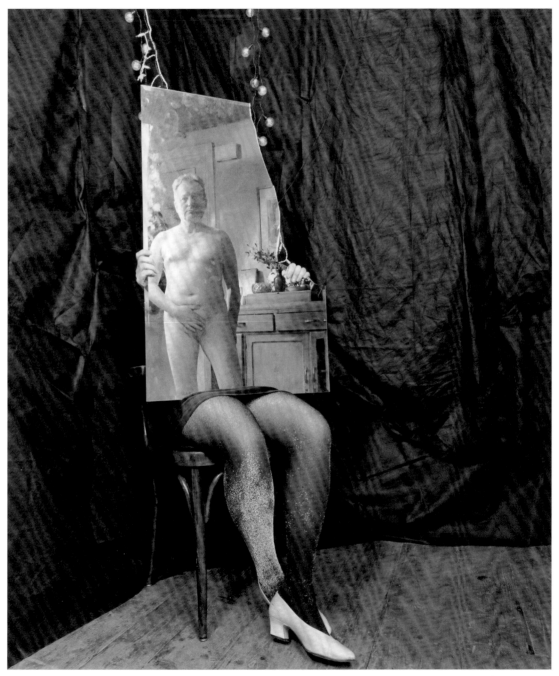

4.7 George Steeves
H-01-03-18-3372-07, from the series
The Excavations Project (2001). Detail from
series. Gelatin silver print, 46 x 37 cm

in. Specifically, I wondered whether a kitchen counter loaded with appliances and cereal boxes was the ideal setting for one of his more theatrical nudes. His response was very telling: that kind of detail, the detritus of everyday life, was to him what made photography so interesting. One could not – should not – try to predict what element in the background might become important to someone over the long life of the picture. To Steeves, detritus was the opposite of incidental, it was ontological, meaning too that it was psychological, in the sense that one part of him has been formed by his passion for photography and the way he defines it. A passage from Bollas suggests how Steeves has turned this sensibility to account: "I believe that our ordinary experiences of psychically intense moments during the day suggest to us the presence of unconscious meaning and unconscious work. We are preconsciously aware that such moments – the birthplaces of inspiration and reflection – will eventually prove meaningful: thus, during the day our separate sense makes us aware of this meaning, even if we have to wait for a fragmentary reflection on the day, or for the dream that will follow that night, or weeks, months, and even years hence before it will yield up something of its truth."[36] For Steeves, that yield must be a picture into which he pours cultural and autobiographical references. These are one and the same as fragments from a life of the mind.

Steeves has an undeniable predilection for images that others might deem shocking. The inscription of androgyny in this and other mirror pictures is the ideal-grown-monstrous expression of reciprocal love, Breton's "system of mirrors" which fragments the object into "the thousand angles that the unknown can take for me."[37] The cutting and reconstituting of bodies in the mirror prompts collective memories of Blake's blind maker of possible forms, the Androgyne of Fire:

Blind in Fire with shield & spear,
Two Horn'd Reasoning, Cloven Fiction,
In Doubt, which is Self contradiction,
A dark Hermaphrodite We stood[38]

Such visions rise up from the splitting of the subject in everyday life, the co-habiting of the conscious and unconscious, the private and public personae wearing the same outer body.

Steeves himself has led what he conceives to be a double life, as an engineer for the Bedford Institute and as an artist. These two characters rarely, if ever, intersect, though they share certain characteristics: creative thinking, game theory, and a fascination with optical instruments. Uncannily, their memories are the same: they have identical family histories; they have loved the same women; they have shared the same suburban house for over thirty years.

The uncanny in everyday life is part of a mnemonic chain of associations. Carrière, Lambeth, Bubaš, and Baillargeon link us to that chain by pulling us bodily into their pictures through the temporal and spatial cracks of auto-reflection. If Steeves's mirror photographs provoke a combination of shock and recognition – if they inscribe themselves in our memories – it is perhaps because he has found a photographic idiom for our darker, more fearful reflections on the scissored self. And if they also comfort us, is it perhaps the irrational hope of mythic union that they hold out, of *possible* forms, and the inscription of this dream, not on paper, but on stone?

5 | A FORGOTTEN MAN

For, methinks, the understanding is not much unlike a closet
wholly shut from light, with only some little openings left, to let
in external visible resemblances, or ideas of things without:
would the pictures coming into such a dark room but stay there,
and lie so orderly as to be found upon occasion, it would very
much resemble the understanding of a man, in reference to all
objects of sight, and the ideas of them.

— John Locke[1]

And even before my brain, lingering in consideration of when
things had happened and of what they had looked like, had col-
lected sufficient impressions to enable it to identify the room, it,
my body, would recall from each room in succession what the bed
was like, where the doors were, how daylight came in at the win-
dows, whether there was a passage outside, what I had had in my
mind when I went to sleep, and had found there when I awoke.

— Marcel Proust[2]

Remembering is both revelatory and affirming, or so
Proust's story of the tea-soaked madeleine would suggest.
The *mémoire involontaire* is awakened by one or more of the
five senses, and it comes like a gentle tap on the shoulder
from a friend whose touch you could never forget. But
Proust's memories are not all of this happy kind. In the
"Overture" to *Swann's Way*, the character Marcel describes

the body and space memories that overtake a man who lies awake in a strange dark room, too refreshed after a short sleep. He tosses and turns; he cannot *place* his body: "Its memory, the composite memory of its ribs, knees, and shoulder-blades offered it a whole series of rooms in which it had at one time or another slept; while the unseen walls kept changing, adapting themselves to the shape of each successive room that it remembered, whirling madly through the darkness." This composite museum without walls offers no shelter, only "shifting and confused gusts of memory." Yet these are the memories that count. Facts that can be summoned at will – *mémoire volontaire* – are just mental pictures that "preserve nothing of the past itself." That past is permanently dead, unless some chance combination of sensations rolls back the stone.

In the afterglow of the madeleine, as the fictional Marcel starts to excavate his mnemonic lode, he is overwhelmed and confused, unable "to discern between the three strata, between my oldest, my instinctive memories, those others, inspired more recently by a taste or 'perfume,' and those which were actually the memories of another, from whom I had acquired them at second hand."[3] His postmemories of Combray, things that had occurred before he was born but yet affected him, are as substantial as the rest. The writer Marcel spends the rest of his life translating the multiple and varying sensations symbolized by Swann's and the Guermantes' ways into solidity. As readers, we are anticipated and embedded in the thickness of this literary matter; we shoulder its weight and its protocols, including its distrust of the photographic.

The mind is not a camera. Locke himself warns us against similitudes and affinities, and his famous analogy would lead us into error if taken too literally, if say, the unpicturable instruments of inscription – pleasure and especially pain – were not also taken into account. Among the external stimuli that lead to the ideas lodged in memory, Locke privileges sight, of this there can be no doubt, but the sorting of this mental storehouse is the opposite of contemplative. "The mind very often sets itself on work in search of some hidden idea, and turns as it were the eye of the soul upon it; though sometimes too they start up in our minds of their own accord, and offer themselves to the understanding; and very often are roused and tumbled out of their dark cells into open daylight, by turbulent and tempestuous passions; our affections bringing ideas to our memory, which had otherwise lain quiet and unregarded."[4] The ocular metaphor is quite overbearing: ideas lying "quiet" must additionally be qualified as "unregarded," that is, not looked back upon and in the word's Germanic root, not protected, not defended by watchful attention. But Locke's dark room, if it is anything like a camera obscura, is neither still nor necessarily quiet. Solitary it may be, but again, not necessarily, and if pleasurable experience is heightened by sociable exchange, passive reception by an immobilized spectator is only the initial perceptual passage to active understanding.[5] In Locke's study of memory, there is much ink spilt in mental struggle.

For if we accept, as I suppose we must, a certain level of spectatorial passivity in the reception of visual data, the life of images in the mind is quite another matter. Locke's way through memory is a process of revival that annexes fresh perceptions, paints memories anew, or brightens their faded colours with recognitions. Forgetting seems part of this activity, though Locke wishes it could be otherwise, as for the angels, "some of them … endowed with capacities able to retain together, and constantly set before them, as in one picture, all their past knowledge at once."[6] This statement leaps to the eye as a flaw in the ocular model (one of many): it builds on a superior system – faith – that disputes mortal cognition and privileges hearing over sight. In this

hierarchy, the visible is an expression of the invisible – faith locks them together – and as Krzysztof Pomian explains, the metaphysical character of intellectual vision, maintained by Descartes, persists in Locke's framing of the mind in dualities.[7] In the system of belief that concerns us here, Locke's notion of memory, we find that his model mind tends all too humanly to forgetfulness. Memory lost and regained is so common and vivid an experience that Locke devises an avatar that remembers by day and forgets by night to demonstrate the impossibility of dual identity in the same body, in the same intelligent moral self.[8] We are some time before Freud, and still in the thrall of the angels, but we do have "floating Visions" passing like specks before our mind's eye, some of which will not be established in memory's storehouse of ideas for want of depth or frequency, yet acknowledged by Locke to have been there, especially in childhood.[9] These are not registered as forgotten, for they were never remembered, but if that is so, how does Locke know that they were ever there?

Humans compare and compound; brutes do too, though less successfully, according to Locke, and with less reliance on vision. In Donigan Cumming's title, *Locke's Way*, we are advised that two complex systems of belief will be brought into play. To summarize brutally: memory is the essence of art; to look is to know. The compounding is redoubled in the structure of the work and its layering of media: a videotape recording a performance involving two types of photographic portraiture, public (social documentary) and personal (professional and amateur). The implication of compounding is that neither system on its own is adequate, and Cumming's tape drives that message home. Neither mental accumulation, nor atomizing observation, quite answers the questions raised by the artist's frantic in-camera performance. Pictures fail and storytelling fails, or rather they fail to mesh in any way that might pretend to

forensic inquiry unless the unreliability of the witness is also entered into evidence. This has been the artist's position from the beginning, since Part 1 of his three-part documentary project, *Reality and Motive in Documentary Photography* (1986), began to be seen and critically challenged in the early 1980s. *Reality and Motive* was initially aimed at unpacking the humanist myths encoded in Modernist documentary photography. *Locke's Way* (2003) extends that critique to the vernacular, or more accurately, it addresses the appropriation of the vernacular by Postmodern art. Placing your faith in either is patently absurd; that is the pessimistic message of the work whose optimism is found in the sheer relentlessness of memory work prompted by the photographic hoard. We cannot stop, we cannot stop consulting, comparing, and recasting our memories.

In theatrical presentation, *Locke's Way* begins, as this chapter has begun, at the very end of creation that is the act of imposing a title. "This is the end," says the narrator, holding up a colour snapshot of a dead woman. "But there was a beginning, with him and her." In installation, *Locke's Way* is a continuous loop, something like the roll of paper that ran through Jack Kerouac's typewriter and became the manuscript of *On the Road*, and very like its manic expression of disappointment in the human condition:

Dean took out other pictures. I realized these were all the snapshots which our children would look at someday with wonder, thinking their parents had lived smooth, well-ordered, stabilized-within-the-photo lives and got up in the morning to walk proudly on the sidewalks of life, never dreaming the raggedy madness and riot of our actual lives, our actual night, the hell of it, the senseless nightmare road. All of it inside endless and beginningless emptiness. Pitiful forms of ignorance ... He made one last signal. I waved back. Suddenly he bent to his life and walked

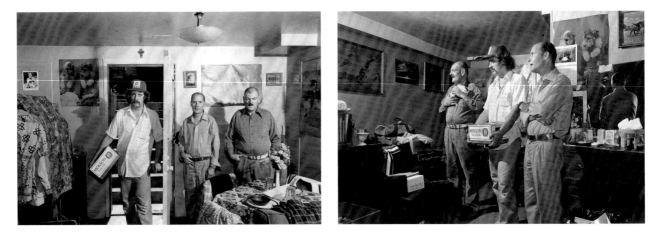

5.2 Donigan Cumming
Reality and Motive in Documentary Photography, Part 1
[details: July 18, 1982; July 18, 1982] (1986).
Gelatin silver prints, 32.5 x 48 cm each

and Modernist documentarians try to mimic. But Beckett's authorship coheres when his work is examined as a whole. By cataloguing Beckett's obsessional memories and recurrent figures ("my troop of lunatics … my people"[17]), literary critic James Olney begins to break the silence of Modernist dissociation. The same approach works on Cumming and his created community with the added precision that neither he, nor his community, has ever been truly silent.

The demographics of *Reality and Motive* speak volumes about the kind of society that forms before a photographer who wants to make an urban document and makes that his daytime job. Solving the riddle is child's play. Knock, knock. Who's there? Not the office workers, not the single moms, not the schoolchildren, not anyone who has somewhere else to be. The people who were available to pose for Cumming – to work for him, for he paid his models by the session – were

the night-shift and seasonal workers, the unemployed, and the pensioners. The overwhelming majority of those who said Yes – who first of all were prepared to let him in, then allowed him to plug in his lights, to stick things up on their walls, to rearrange their furniture, and to give them instructions on how to pose – were men living alone in rooming houses or some kind of assisted living who enjoyed Cumming's attention as a break in the daily routine. These are the day-crawlers, as opposed to Brassaï's night-crawlers, people that you can meet by sharing a pitcher of beer in a local tavern, people who may have friends and relatives in the suburbs who would also enjoy a photographer's visit as a lark. There are 118 photographs in the original three-part cycle of *Reality and Motive in Documentary Photography*, of which 50 depict men alone in rooms, and another 21 images feature two or more men. That leaves a balance of 47 images

to cover single or paired women, couples, families, and mixed social groups. Canadian society this is not, which is one reason why Cumming refuses to be drawn out by questions about the social welfare system or the working poor. His sampling, he knows, is imbalanced, though it satisfied his photographic purposes and, I would argue, his psychological needs.[18] The proof can be found in the series that he conceived to respond to his critics, *The Mirror, the Hammer, and the Stage*, which extends his relationship with about twenty models, most of them men. In these works, the poses are hieratic, spasmotic expressions of isolation. The still lifes are empty rooms, with odd combinations of sentimental prints, disastrous school reports, and medical prescriptions "still" pinned to the walls. Romance, success, and health are thus established as the abandoned hopes of the disappeared. These bittersweet themes run true through the work and grab for our attention in *Locke's Way*.

By leaping forward to Cumming's work in video, I am telescoping roughly fifteen years of photographic activity, and by emphasizing his relations with his male models, could be accused of minimizing the importance of his long and productive relationship with Nettie Harris, the central figure of *Pretty Ribbons*, the exhibition and book, as well as the multimedia installation and videotape *A Prayer for Nettie*. The tape cannot be neglected here. It offers very moving expressions of memory and forgetting, in the rote repetition of childish prayers and the growing sense that Nettie's mourners (mostly men) never knew her, but are the mouthpieces for the grieving photographer who is heard, prompting their prayers.

But the spectator need not identify with Cumming to feel the presence of a bereft and isolated male, for there is one at the very heart of *Pretty Ribbons*, the late "Harry Strong," whose complaints become both textual backdrop and soundscape to Nettie's exaltation. Cumming saved Harry's

diary from the dustbin when he was tidying up his dead friend's personal effects. He also kept Harry's tooth. Cumming has often remarked that his plunge into the extended portrait of an elderly female was almost an accident – inspired by the diary, he had been looking for an actor to play Harry. This information is anecdotal unless one uses it to understand the framing of Nettie as everything that the loveless, underachieving, and cancer-riddled Harry was not – this strictly within Cumming's portrayals, of course, as his attitude makes the difference. Nettie is present, she is demonstrative, she is the picture of vitality, even unto death; Harry is absent, he is secretive, he represents the death of memory, which is a text.

Through *Harry's Diary*, through his epistolary response to Harry's confessions, Cumming enters his own work for the first time *as a writer*: he responds to the diary entries in a voice tinged with bitterness and regret over what he saw (and failed to see) while Harry was still alive. On the soundtrack, Cumming's interjections punctuate Robert Graham's reading of Harry. Thus at the core of what many critics have celebrated as a visual memorial to a remarkable woman are two male voices scratching in the dirt of loneliness, failure, and fear of aging. Cumming conspires with Harris to break taboos on the representation of old age; he puts her body and spirit at centre stage, but he identifies with the exit of a forgotten man.

PORTRAITS OF MEN

Cumming's shift from photography into video puts faces and names to the models/voices-become-actors who feature in his work – the members of his "created community" – and introduces storytelling, as well as carnivalesque subversions of what Dominick LaCapra calls "the objectivity-

effect."[19] A durational medium naturally brings other differences, underscoring Cumming's affinity for broken narrative and drawing a parallel between thick description and thick human relations. Simply put, Cumming puts in the time, going over the same ground again and again, and he preserves the density of that experience, whether in long, unedited takes, or by recording his off-camera directions and his actors' responses to the tedium of "doing it again." We are reminded of the repetitiousness of our life stories, how we remember and how we try to shape the memories of others. This is a soft, if sometimes testing, feature of the work, which also has jagged edges. In the recurrent figure of Colin Kane, the skeptical viewer finds a champion who repeatedly attacks the naivety and hypocrisy of the bleeding-heart, bourgeois documentarian who has come to join Kane and the others on camera. These are real, if provoked, outbursts – reality checks – that keep the work honest in the same way that James Agee deconstructed and heckled Walker Evans's motives from the inside, making them both into subjects. Kane on screen is Cumming's doppelgänger, though it may sometimes appear the reverse, as Cumming plays the recorder of Kane's relentless drive to attack the social welfare and medical systems on which he and the people he cares about depend. But Kane speaks true: he is living these systems as Cumming is not; their shared social background and nights at the Bistro are just touchstones – old stories. One guy slipped into a cycle of drug and alcohol abuse; the other did not. At the same time, Kane totally rejects Cumming's safer course. The alterity is mutual, though they need each other.

Cumming's registry of Kane's mutinies is the only real record of his angry passage across this earth; no one feels more keenly than Kane himself the ordinariness of his social rebellion and the price that he has paid for staying too long at the fair. Kane does not beg and he lives indoors, but he represents the legion of beggars that Canadians like myself pass every day on the street and feel no compunction to pay because we have already paid for their erasure. Our social safety net includes shelter, food, and medicine, including the psychotropic prescription drugs that the ranters ought to be taking; we can thus hurry on; we can forget it.[20] Cumming's work disturbs in the moment because it is intrusive, carrying too much detail of sad and sordid lives, but its real disturbance lies in the yawning oblivion that haunts the end of each tape. Who but the prurient Cumming would continue to pay attention to Marty Corbin, a retired teacher and aging alcoholic, reminiscing about his days in New York where he fought the good fight for pacifism, socialism, and civil rights beside other destined-to-be-forgotten American Catholic Workers? The obituary filed, the plot too grim and pointless for Disney, who but Cumming, a middle-aged former war resister, following his subjects to the grave.

Cumming's work is haunted by death and other modes of disappearance: his first two videotapes were elegies. Nettie's was followed by *Cut the Parrot*, a ribald wake for Albert whose play-acting at the end of *A Prayer for Nettie* had guaranteed him a central role in the next tape, until he turned up dead in his apartment. His body consigned to the morgue, the Albert memorial becomes a burn mark in the tiled floor, the resting place of his last cigarette. Albert's part in the tape is as the absent corpse, around whom stories are told about life, love, and other unclaimed bodies, including a mother.

Cumming, for the first time on camera, tells a story about a family visit to his brother Julien at "school" in New Jersey. While the Cumming family eats bowls of ice cream in the institutional cafeteria – Julien, speechless – the father is approached by a young man whose air of competence and stories of the outside world type him as an employee, one of

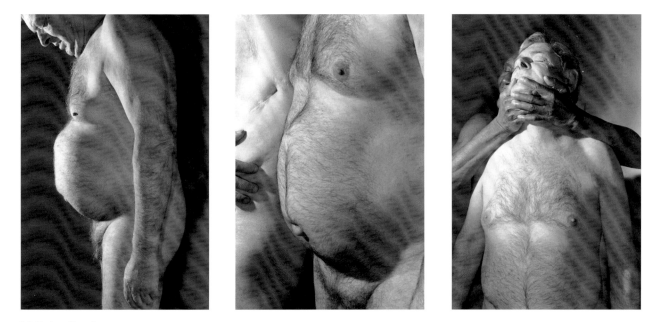

5.3 Donigan Cumming
Barber's Music (1999).
Detail of photographic installation, 274 x 183 cm each

Julien's caretakers. Later the parents are told that they have been fooled, that the young man, like Julien, is "retarded." They leave the institution amazed. Julien thus slips into Cumming's community in a part foreshadowed by Albert, as an invisible motive force, introduced by a story about, and narrated by, a very unreliable witness. From this point forward, Cumming assumes a dual physical presence in his work as a social artist and a thespian. In *After Brenda*, he plays the absurdly plodding "social worker," whose desperate search for a missing client, Gerry, parallels Pierre's obsessional panting after his love object, Brenda. Gerry never turns up in *After Brenda*, though he returns in *Erratic Angel*, where he too plays a dual role, one of three men swapping

lies in a bedsitter, as well as the phantasmic angel, dancing naked in Colin's room and failing to rescue him from the flood. The history of Cumming's community is also Gerry Harvey's. His presence in the work is fully referenced, beginning with *Reality and Motive*, when he and Albert "receive the beer." As Peggy Gale has noted, "We see [Gerry] with a moustache and big belly, then later thin, toothless, and a little bewildered, or joking as, voiceless, he writes his comment about lunch: 'Horse meat.'"[21] On tape, he is the walk-on character who is just as likely to walk off; in photographs, he is the three-metre, pot-bellied, and scarred figure of male ending-up (fig. 5.3). Still, Gerry somehow remains anonymous; even when he speaks, he is more body

than voice, and he is utterly without affect even as he obliges with a story or a joke. What is outstanding about Gerry is also what causes him to slip behind the other characters in the shuffle, his steady indifference to the artistic process. This passivity writes him into the background, as though he were a visitor from the past.

The complexity and self-implication of Cumming's medium-length videographic portraits is fully supported by self-conscious, cinematic presence. Colleen, Marty, Colin, and Donigan come alive on the screen because they want, and know how, to enlarge themselves as characters. They present vividly in the present. Increasingly, however, Cumming has cut into this flow with still photographs. In *My Dinner with Weegee*, portraits of unnamed young men are omnisciently scanned as an off-screen discussion between Corbin and Cumming shifts to the Vietnam war.[22] As realistic portraits of some who *might* have served, or *might* have died, these images create an uncomfortably banal interregnum in the character development of two war-resisting heroes, Corbin's version punctured by Kane's sarcastic voice as he deconstructs the *pacifism* of a man who is drinking himself to death. In *Culture*, Cumming's citations of his own imagery are more clearly articulated as encounters between the videographer in the present and the photographer in the past. In the tape, Cumming is discovered rifling an apartment, having been dispatched from the hospital bed of one of his models, Nelson Coombs, with vague instructions to pick up a chequebook, and having confronted the stench of food left in the fridge and under the bed. The nausea and self-recrimination provoked by this decay is nothing compared to the shock and distress of finding his own photographic history amidst the detritus of Nelson's life. The first sighting is shameful, a yellowing black and white print, with all the indications of tired fix. But the next pictures that Cumming finds in a cracking brown envelope are enough to break his heart. Extracts from *Reality and Motive in Documentary Photography, Part 1*, show Nelson with Joyce, George, and Petula, all in their prime, some twenty years ago (fig. 5.4). These startling images were the instruments of Cumming's project to transform documentary photography. Responsibly reflexive, he gave copies to his subjects who put them away in drawers, as our preservationist culture dictates. This domestic museum is now headed for the dumpster. Sifting through the images – he goes through the packet twice – Cumming invokes the dead and dying, as well as his own dreams. "I was so young," he mutters, before shoving the lot back in the drawer and resuming his fruitless search.

SCAVENGER HUNT

The search for Gerry, launched in *After Brenda*, continues in *Voice: off* under a set of rules explained in an off-camera exchange between a man and a woman:

MALE VOICE
Do you mind telling me just what a scavenger hunt is?

FEMALE VOICE
Well a scavenger hunt is exactly like a treasure hunt, except in a treasure hunt you try to find something you want, and in a scavenger hunt, you try to find something that nobody wants.

MALE VOICE
Like a forgotten man.

FEMALE VOICE
That's right, and the one that wins gets a prize, except

there really is no prize. It's just the honour of winning because all the money goes to charity, that is, if there's any money left over, but then there never is.

This nugget, appropriated from the 1936 screwball comedy *My Man Godfrey*, trips lightly over the bodies of two men posing nude in a studio as Cumming's videocam scans and rotates around their bodies. Gerry is held captive from behind; his broad face is pressed between the other man's hands; his mask-like features are frozen. A strange compound image sets the tone for a composite portrait of a man who, as Cumming blandly reports, "has never been able to say anything," and has finally lost the power of speech. The mirror with a memory will be his prosthesis.

But the mirror's doubling and redoubling quickly fractures any hope of an orderly life history or sound diagnosis of Gerry's condition. The work consists of a series of episodes, Gerry generally, though not always, on camera. There are improvised monologues in B-movie and horse opera modes, and snippets of song, as well as Cumming's trademark conversations with subjects very closely framed, his off-camera voice pressing for intimate details. An intertextual detour is taken when Cumming asks Beatrice to help him look for the burn left in the tile floor by Albert's last cigarette – they return to the main stage of *Cut the Parrot*. Cumming has come prepared with three photographic details that he and Beatrice will use to find the historic marker. The spectator enters these meetings in the middle and stays there, piecing together the past and supplying possible denouements of the dramatic complications being rehearsed. Mental space for such speculation is provided by mysterious segments of men moving silently around a room or Gerry hustling another man up a flight of stairs.

The spine of this biography is a heap of photographs that the artist finds in a basement, sifts, and sloppily presents to

5.4 Donigan Cumming
Culture (2002, colour, stereo, 17:04 min.).
Production still from videotape. Original in colour

the camera while speculating over the causes of Gerry's disadvantages. A disembodied voice, Cumming is looking for photographic evidence to corroborate family legend and medical diagnosis – to get to the root cause of "Gerry's" lifelong problems. Except that they are not Gerry Harvey's, but Julien Cumming's. As Gale explains, nicely fusing the principals' names: "For the duration of *Voice: off* Gerald Harvey is identified with Julien, 'Jerry's' family *becoming* Gerry's. All the stories come together, recounted, reviewed, remembered, as if the complex Cumming family has been overtaken, infused, by this new family of collaborators and friends. Replaced, even."[23] Or *displaced*, as Silverman might say, possibly also enjoying Cumming's frequent slips of the tongue that are quickly and coolly covered up by a shift in narrative direction – Beckett's Krapp comes to mind, as another adept forecloser, switching his younger self on and off by twisting a dial.

Gale's recognition of one community being substituted for another conforms within its social boundaries to Hirsch's form of heteropathic memory. Postmemory is therefore a factor, and indeed, Cumming tells stories about events that occurred before he was born. We learn, for example, that when Gerry/Julien's mother was pregnant with a third child, the boy's grandmothers intervened to have him sent away to school. That story is told over a picture of a seven-year-old boy in his Sunday-best, appealingly posing in a gazebo. Cumming thereby uses the photographic archive as a theatre of possibility, milking each image for its dashed hopes. Memories of the family's burden and shame are ruthlessly contrasted with their hopes for "the best" – here we have Silverman's memory mode, the look "with an appetite for alterity … the productively remembering look … in which the movement forward is no longer at the service of a return, but has developed an independent momentum."[24] This is the portion of selfhood that neurologist Antonio R. Damasio calls a "memory of the possible future."[25]

Cumming's compounded portrait of Gerry, however contrived and carnivalesque, represents something closer to the actual outcome. He cuts from a pregnant statement about Julien's sister's lifelong embarrassment to a ridiculous scene staged in the semi-public bubble of a parked car. Gerry is singing "What a Friend We Have in Jesus" through his mechanical voice box, while Cumming lugubriously chants what they have done and learned on that day's round of visiting in the community. The pattern repeats itself later in the tape, with heightened contrast and tension. Holding up the sister's picture, Cumming speculates about her embarrassment; this time, the remark is followed by Gerry's excruciating story of being "stabbed in the ass," a story illustrated by the video camera's close visual inspection of his body, including his inflamed stoma, his but-

tocks, and his scrotum. It is hard to remember the sensitivity of a young girl in the wake of these images, or to give it much weight, and that is the very struggle that Cumming is continually setting up. He places the spectator between the psychic abrasion, or specular "panic," suffered by the privileged and the arbitrary selection that is happening everywhere, all the time. Photographs of a woman – either Gerry's or Cumming's mother – who appears to have died in her bed are framed by tales of horror: a woman's suicide leap in front of a train, her earlier attempt with a plastic bag over her head. An account of the lapse of attention that precipitated the death of "Gerry's" father is paired with a scene of the person that we now recognize as Julien Cumming mechanically combing his almost bald head and beard in a bathroom mirror. Painful and trivial memories are the coin of the realm and they are virtually interchangeable, so the structure of this work would suggest.

Voice: off revives many of Cumming's structural devices and motifs; serpentine narration; reflexive commentary; repetition and mimicry; visual and aural juxtaposition that startles in the moment, then begins to form a pattern. *Locke's Way* is, by comparison, quite orderly as a twenty-one-minute stream of consciousness; Cumming is the only actor, and he is only a part-figure, his hand seen shuffling photographs (fig. 5.5).

Locke's Way is based entirely on the Cumming family archive of photographs and medical documents. The images given centre stage are compelling in the way that family albums tend to be; we are drawn into their created community through anecdote and cultural milestones. Clothes, cars, and even ways of being together are the currency of such tellings, enabling us to fix certain moments in the temporal flow, and even to correct the narrator when he seems to be getting things wrong. But while the same story

5.5 Donigan Cumming
Voice: off (2003, colour, stereo, 39 min.) and *Locke's Way* (2003, colour, stereo, 21 min.).
Production stills from both videotapes. Original in colour

is rehearsed and the juggling of Gerry/Julien carried forward, questions of cause and culpability for pain and suffering are projected at a larger scale.

The story of Gerry/Julien being sent away to school, told calmly and without recrimination in *Voice: off*, is retold in *Locke's Way*, the sad facts reinterpreted as a brutal banishment driven by the grandmothers' will: "They wanted him out of the house. There were two in, then a third. They said, Get him out of there, get him out of there." This accusation is made over a picture of the boy sitting on his grandmother's knee. At this point, the tape speeds up, the narrator's voice transformed into that of a righteous chipmunk, a cartoonish superego taxing the dead. Then, in real time, the race for knowledge begins, up the stairs to the office, where the medical papers are kept, then back down the stairs to the photographic storeroom, for visual proof of what the doctor said happened to Gerry/Julien as a baby. This trip is made eight times, with Cumming sounding more and more exhausted, panting, steaming up the camcorder lens. In this aberrant exercise, the line between normality and abnormality is sought; signs of brain damage include bad taste, bad posture, and even the squint of a figure photographed *à la* Walker Evans in full sunlight. Tactless observations are mixed up with loving effusions over the beauty of the mother and the health of her brood, Gerry/Julien's deficiencies momentarily forgotten.

The pictures rather facilitate these memory lapses. The mother's guilt, the father's "shattered life," the sister's bad memories hardly make sense against the glowing studio portraits of a middle-class nuclear family that is supposed to have driven up the coast and "slammed him into Saranac Lake," pausing only to take a picture. In this family's life, there were many photo opportunities and few seem to have been missed. But the professional portraits of mother and newborn, the summer holiday snapshots, and pictures around the Christmas tree block, rather than advance, the investigation. The narrator is thrown onto the "big pictures," Cumming's own strobe-struck, highly detailed, black and white portraits, taken in his stilted – some would say, deviant – *Reality and Motive* style. They are all of Julien and his family, of course. There is nothing in this lot of Gerry except a name pasted over another body whose condition seems fated never to be fully explained, his exile from the world of normality never to be fully justified. "You can't go back far enough," gasps the narrator. We are stuck in the middle of things, peering through murky waters, never getting to the bottom of this myth of origins, never able to reconstruct that first improvisational telling. Petrified archetypes are all that remain: there was widespread suffering; the scapegoat was driven out into the desert; there is no one to interrogate; the perpetrators and the witnesses are all dead; the forensic evidence is engraved; the photographic record is sealed. The last word, which is not a word but a monstrous electronic distortion, reposes on a portrait of the artist's brother.

REALITY AND MOTIVE

When Cumming is asked about the motives behind his work, he often refers to his brother Julien's mental disability, to the constant awareness of one's mental fragility that Julien's example promotes, and to the community that Julien has introduced him to. Gale calls Julien "one of the triggers for this video work."[26] Cumming's social role as an artist has been to communicate the arbitrary nature of cruel misfortune – to force people to pay attention and to force them to consider the kind of attention that they pay.

As Jonathan Crary explains, attention to *attention* complements modernity's fascination with distraction. Attention and distraction are neither successive nor oppositional states, but intermingled as part of a unified social sphere. Crary traces its development through nineteenth-century theories of the unconscious, as well as automatic behaviour, that exposed the forces involved in focusing the mind: these, he says, were plainly incompatible with the Empiricist model; observation had to be redefined in terms of exclusions or demarcations of the visual field. Thus, even the motionless observer, jacked by the light, could be understood as a hapless agent of selection, "the site of a ferment of physiological (and motor) occurrences." A Marxist perspective sees these forces unconsciously harnessed to mechanized labour, while Cumming locates the same processes of selection in the front of the spectator's mind. As his cruel observations prompt us to question his rights and responsibilities as a social actor, we are also forced to question our own. We must decide whether to look or turn away, whether to embrace or banish these wounded bodies to oblivion. Thus more pertinent to Cumming's work – to his aggressive cultivation of attention in the distracted leisure class – is Crary's ancillary point, that "attention, as a shutting out, a powerful filter, also could be seen as a model of Nietzschean forgetting ... for affirmation of the self through *action*."[27]

Friedrich Nietzsche's "On the Uses and Disadvantages of History for Life" identifies three "species" of history: monumental, antiquarian, and critical. Monumental history seeks greatness in the past and finds only that. Antiquarian history reveres the past and revels in its relics. Critical history is a process that returns in excruciating detail to myths of origins and preservationist alibis for one reason alone: to diagnose the diseased body politic and prepare for the rad-

ical surgery that will restore it to health. The process is violent and unsparing, especially of the self, for it cuts to the heart of what nations (and families) hold dear to expose their darkest secrets. As Nietzsche writes,

It requires a great deal of strength to be able to live and to forget the extent to which to live and to be unjust is one and the same thing ... Sometimes, however, this same life that requires forgetting demands a temporary suspension of this forgetfulness; it wants to be clear as to how unjust the existence of anything – a privilege, a caste, a dynasty, for example – is, and how greatly this thing deserves to perish. Then its past is regarded critically, then one takes the knife to its roots, then one cruelly tramples over every kind of piety."[28]

Linda Bishai applies Nietzsche's theory to the challenges faced by war-torn societies, survivors of sectarian violence and ethnic cleansing, supplementing the basic framework with William Connolly's call for "critical responsiveness."[29] A key feature of Connolly's analysis is the recognition that all the participants exist – that is, their identities are formed – in thick relations and with respect to others, so that perpetuation of roles based on a history of violence eliminates any real possibility of systemic change. Even the victim has to change, for "If a history of violent conflict continues to be regarded in terms of innocence and guilt then that society's memories will continue to reinforce opposing identities and relations of stress and wounding. These memories will stifle any attempts to develop different relations among the parties involved and thus must be forgotten in the process of critical remembering."[30] Nietzschean forgetting, it must be stressed, is only reached through a process of active remembering; forgetting is action in the form of psychological,

social, and political adjustment that will not be seeking a return to the mythic past, nor uncritically preserving its relics. We *must* see the pictures plain.

Forgetting is anathema to many communities that cultivate collective memory as a counterpoint to exclusionary or murderous histories. I will return to these issues in the third part of this book. Here I am concerned with another form of murder, "the murderous repudiation of alterity" that Silverman sees resulting from "the attempt to sustain one's ever-failing identification with ideality." She calls for "the continual deconstruction and displacement" of a desire that we can never entirely abandon, the desire to be ideal.[31] Deconstruction and displacement have been Cumming's strategies since *Reality and Motive in Documentary Photography.* He began by adapting Modernist social documentary strategies to his critical history of the genre, fighting fire with fire, generating powerful parodies of the mythic universality and temporary bonds of intimacy represented by *The Family of Man* and Concerned Photography. *Locke's Way*'s frenetic rehearsal of the realities and motives embedded in a family's photographic history – the photographer's own family – turns the culture of memory on its head, displacing the myths and sentimentality that Nietzsche sees as the impediments to a critical history. The work confronts the raw facts and photographic glosses of the past in a process that tests Nietzsche's critical model, and projects on a very small scale, within a single family, the thick relations that are involved: "For since we are the outcome of earlier generations, we are also the outcome of the aberrations, passions, and errors, and indeed of their crimes; it is not possible wholly to free oneself from this chain. If we condemn these aberrations and regard ourselves as free of them, this does not alter the fact that we originate in them."[32]

Cumming once concluded a public presentation on his work with a simple question to the audience: "I am not my brother. Why not?"[33] *Locke's Way* makes public the source of that unanswerable question in the story of Julien's removal from the family home when the third child was about to be born in the late 1940s. This is the only specific temporal reference in the tape; it is in fact erroneously applied to the dating of a later model car. But the late forties signify and those facts will out. Cumming's birth in 1947 is revealed to be the instrument that pried Julien from his mother's arms and placed him in an institution. As Cumming's oscillations between myth and memory reveal, it was a case of doing the right thing; we are told that the mother never got over it, and minutes later, we are told that she did. The photographic trove is the record of attention paid and attention withdrawn as the family came and went as aliens in this Julien/Gerry universe, or drew him ritualistically into temporary communion. Each crossing would be the occasion to make a picture.

Locke's Way's immersion in a family's photographic memories suggests that there is some form of critical remembering active in every human constellation; we select our own jury, we weigh the evidence of our actions, and we die while the jury is out. Drawing out that death is in part what Cumming's project has been about, and here the parallel with Beckett holds true: "The memory came faint and cold of the story I might have told, a story in the likeness of my life, I mean without the courage to end or the strength to go on."[34] My brother is not here because I am; I am here because he is not. *Locke's Way* unlocks one motif in Cumming's enigmatic oeuvre, and quite possibly explains the stubborn circularity of its structure. Obsessional memories of forgotten men clinging to one another in fragile symbiosis mark the ends that are always beginnings.

At first I had no idea what I was going to get. There's this image called *Self-portrait (Dog Face Father Mask)*. When I saw what emerged in the darkroom my temperature went up about five degrees. I remember thinking, who the hell did this photograph? It was terrifying and exciting at the same time.

— Diana Thorneycroft[1]

Memory-work is a lifelong project, but its translation into art must begin somewhere and end somewhere else, whether linear narrative or thick description comes in between. When Diana Thorneycroft asks herself, the artist, Who the hell did this photograph? she is simultaneously disavowing knowledge of her work's psychic origins and hinting that they might be revealed if this line of questioning is pursued. She asks: Who did this? She asks this of a floating image. There is no reply.

As a nascent photographer in her early thirties, Thorneycroft came to national attention with a series of photographs based on mental images that were striking her with the force of recovered memory. The personal nature of her work was explicit, signalled by her practice of photographing her own naked body surrounded, and sometimes violated, by a repertoire of found or fabricated objects that she related *somehow* to her life. In the beginning were studies of

an androgynous female figure masked as father, mother, brother, and sister. These composite figures were identified by name and by props. Thorneycroft (it was always she) performatively and photographically fused her body with her brother's; she wore a false penis and held a gun across her breasts. The attributes of father, mother, and sister were similarly displayed; the symbolic repertoire was singular, though sufficiently typical to capture these socio-biological roles. The poses were just as important. Thorneycroft would later appropriate the Roman Catholic ritual of monstrance – the display of the host for adoration – but she was effectively mimicking such ceremonial gestures from the beginning, bringing our collective memory of brutal sacrifice and transubstantiation into play. Later she kept company with a troupe of mutilated dolls as she displayed her maturing female body. That same body then suffered the binding and invasion of medical instruments. All these photographs expressed pain, symbolically locating its sources *somewhere* close to home, in the mind/body, *somewhere* just under the unmarked skin.

The artist stripped bare by her memories: repetitively, some might say, obsessively, Thorneycroft spent ten years making heuristic images about suffering, placing them before the public in the name of psychic excavation. What was happening to this woman? Who did this? The image never did reply, though suspicions were fomented as the pictures grew more monstrous, more loaded.

Now, after a decade, the situation report is as follows. Thorneycroft has expressed – squeezed out, manifested, symbolized, and set forth – confusing and sometimes terrifying memories. The results of this process are works of art. The artistic work that presented itself and justified its excesses as a sincere process of *working through* memory to understanding has come to a conclusion. This end point is not to be confused with resolution. Thorneycroft has not

determined the precise sources of the psychic and, for a time, somatic, episodes that drove the process. Rather, she has stopped using these episodes as the basis of her work. Perhaps she has stopped having them. I first noticed the shift in 2002, when Thorneycroft was making a public presentation of her work. In an otherwise extemporaneous slide lecture, she resorted to a statement written in the past tense about a time (1992–95) when the surfacing of these inchoate memories was frequent, frightening, and negatively inspiring.

Several years ago, for a stretch of time that lasted over two years, I relived on a daily basis discomforting memories that were beyond my cognitive understanding. My body claimed it had suffered. My conscious memory would not verify this claim. As I was hospitalized five times before the age of one, I have speculated that what my body recalled happened when I was a baby under the care of medical practitioners. I wonder if the repeated use of the doll in my work pertains to the sickness and possible harm I experienced as an infant.[2]

In its storybook style and detached voice, this text serves Thorneycroft in two ways: it shields her from recurrence – she reads rather than tells a story – and it evokes for the audience feelings that she no longer has with such dramatic intensity. That chapter in her life is for the moment closed. Her current work situates the expression of violence in a larger arena. She is making photographs and installations about the pictorial exaltation and spectatorial consumption of martyrdom.

Thorneycroft is an artist about whom much has been written, and much of that in a speculative vein, in an attempt to decipher the clues and solve the mysteries of her motivations. She co-operates in these investigations;

indeed, the longest and most candid is a collaboration, a two-part interview (1996/1999) conducted by critic Robert Enright. Over the years, my own interpretations have been informed by the literature of recovered memory, as well as the countering movements under the rubric of "false memory syndrome," a cauldron that philosopher Ian Hacking has justly labelled "memoro-politics."[3] I entered this field with due caution, basing my readings on Thorneycroft's inability to identify the sources of her anxieties, and especially, on her claims of disassociation from the photographic products of her unconscious mind: "Who the hell did this photograph?" My aim, possibly a naive one, was to get at the truth through the evidence of the pictures.

There is an obvious, and even facile, parallel between philosophical debates over truth and falsehood in photography (objectivity and subjectivity, and so on), and the claims and counter-claims of memoro-politics, but there is no comparison on one level, that being the devastating effect on the lives of people whose suffering has dragged them into the therapeutic and legal debates conducted in the name of reclamation and healing. As Hacking makes plain,

It is a power struggle built around knowledge, or claims to knowledge. It takes for granted that a certain sort of knowledge is possible. Individual factual claims are batted back and forth, claims about this patient, that therapist, combined with larger views about vice and virtue. Underlying these competing claims to surface knowledge there is a depth knowledge; that is, a knowledge that there are facts out there about memory, truth-or-falsehoods to get a fix on. There would not be politics of this sort if there were not that assumption of knowledge about memory, known to science. Power struggles are fought out on the basis of surface knowledge, where opponents take the depth

knowledge as common ground. Each side opposes the other, claiming it has better, more exact, surface knowledge, drawing on superior evidence and methodology. That is exactly the form of the confrontations between those who recover memory of trauma and those who question it.[4]

Trauma. I have not used this word up to now, though its introduction was inevitable. Thorneycroft's work has been understood from the start as an expression of trauma, the sole remaining difficulty being to name it. This problem is itself of no small significance. Sufferers of Post-Traumatic Stress Disorder (PTSD) are said to be carriers of impossible histories, or even "symptoms of a history they cannot entirely possess." Theorists and clinicians speak of "a gap that carries the force of the event"; a history of trauma is a history that can be "grasped only in the very inaccessibility of its occurrence."[5] This is a particular kind of forgetting, one that has sometimes been misunderstood. As Cathy Caruth explains, trauma is "not experienced as mere repression or defense, but as a temporal delay that carries the individual beyond the shock of the first moment. The trauma is a repeated suffering of the event, but it is also a continual leaving of its site." The challenge for the therapeutic listener "is *how to listen to departure*."[6] In 2002, I was hearing *departure* in Thorneycroft's detached delivery.

Setting aside, for the moment, the specifics of Thorneycroft's imagery (the symbolic evidence), and holding off her own speculative explanations of this image or that performance, it is important to recollect the wave that broke over our society in the 1980s when the phenomena of recovered memory and its extreme opposite, multiple personality, began to be discussed in the media in relation to child abuse and other acts of extreme violence. The outpouring of books by survivors, specialists, investigators,

and commentators was staggering.[7] An influential figure in Canadian photography, the founding editor of *Photo Communiqué*, Gail Fisher-Taylor, announced publicly that she had recovered memories of atrocious crimes committed in her presence by a family member; she eventually left the photographic field and became a psychotherapist, working with adult survivors of sexual abuse and mind control.[8]

To reconstruct this period is our memory-work as a collective, for the dam that broke unleashed a flow that carried Thorneycroft's work along with praise and blame. The work was labelled as memory-work and the expectation developed that Thorneycroft would get to the bottom of her psychic depths and come up with the missing key. That she did not caused some distress, and even some accusations that she was somehow faking it, appropriating what was for others real pain. Other spectators did not question the truthfulness of the work, but simply rejected it as too graphic. And still others responded to the work positively as a woman artist's contribution to Surrealism, finding the work enthralling because of its transgressive beauty.

The passions aroused by Thorneycroft's work have never ceased to amaze her and, like any artist, she is intrigued by her power and inclined to push the same button again, just a little harder, to see what happens next. Thus, unconsciously and consciously, Thorneycroft has entered the fray of "memoro-politics," and a discussion of her work in relation to memory must reflect that historical condition. Her work emerged in the eye of a storm, a public battle over remembering and forgetting; the art and the artist have been buffeted and bolstered by the debate, though the effects have been generally positive. This is cultural production, after all. No one is on trial here.[9] In characterizing the work's reception, we might properly speak of "memoro-politico-optics," different viewpoints converging on a photographic surface. My own perspective has shifted over the years. I have seen the work through the optic of the photographic grotesque as the symbolic expression of trauma; I have interpreted one installation as a coming of age through the shoals of shame.[10]

These readings are actually complementary. Many aspects of the work suggest that Thorneycroft's fascination with the grotesque is rooted in some childhood occurrence that she cannot picture, even to herself. Her mnemonic images will not materialize realistically, or evidentially, because the event, or chain of events, that she is consciously capable of remembering is nothing like the mnemonic residue that bubbles up through her unconscious and frightens her. So is this memory real? The fear is real, however confused, or so I believe.

My personal beliefs are embedded in this research – it is the nature of Thorneycroft's work to elicit visceral response, and mine has been shaped by my understanding and some limited experience of recovered memory. But in this I am hardly alone. No writer who has addressed Thorneycroft's work can claim innocence of the debates over recovered memory being conducted in the courts, on the talk shows, and around the water coolers of North America. The issue had to enter the art gallery, and it did. To ignore the struggle with memory that Thorneycroft was exhibiting in her work was to miss its very point, as well as its broadest reception. One might argue – and a number of writers have clearly felt – that the source of Thorneycroft's anxieties was in equal parts obscure and irrelevant, that the work needed to be judged on other criteria than verifiability. Indeed it did, for the indeterminacy of memory was what the work was about. This was its fearfulness and its power.

The artist having shifted her attention elsewhere, we are presented with an intriguing case of closure brought to bear on what appeared, and appears still, to be an open wound. Unlike Diane Arbus or Francesca Woodman, whose sui-

cides brought their traumatic practices to an end, this artist continues, unhealed and sanguine about her unresolved condition. Her current practice suggests that the personal matters that were *made to matter* to her audience have been displayed with sufficiency. They have yielded enough to art, and we are now able to take their measure and the measure of their reception. As a critic who has attempted to grapple with the meaning of Thorneycroft's images as they were emerging, I have my own memories and interpretations to process and adjust, in order to accept what feels almost like an arbitrary end point.

Thorneycroft's theatre proclaims: See what is being done to me (I cannot). In this chapter, I take over the excavation. The images to be considered are from four series: *TOUCHING: THE SELF* (1990–91); *a slow remembering* (1994); *On the Skin of a Doll* (1996); and the installation *slytod* (1997).[11] Drawing on the Thorneycroft literature, I will rehearse and oppose two inadequate explanations: the life of the artist and the art histories that have influenced her work. Both pretexts offer a set of references that compete for attention, sometimes vigorously, sometimes subliminally. Responding with patience, I want to treat Thorneycroft's references functionally as pieces of a puzzle without locking the work prematurely into any system of knowledge or causation. Whether such a system can be found, or will hold, will be discussed in the chapter's conclusion.

DISCLOSURES AND DECOYS

The self-styled "reluctant critic," Michael Maranda, is rightfully skeptical about artistic hagiography or what he calls "insider-trading" of biographical notes. Nevertheless, his rule for "hermeneutically responsible interpretation" admits the identity of the artist, though within limits: "The set of references that are included in the work or its immediate context."[12] Thorneycroft's "set of references," drawn from titles, statements, and public discussions about her work, includes family (her family), gender, religion, physical suffering, female sexuality, the history of art, the possibility of remembering, and the frustration of forgetting. In other words, her life has been tabled. The following is an authorized biography.

Diana Thorneycroft was born in Claresholm, Alberta, in 1956, the daughter of a Canadian Air Force pilot and a former nurse who worked at home as a wife and mother. As an infant, Thorneycroft was hospitalized five times before her first birthday with a series of illnesses, including respiratory problems that had her placed in an oxygen tent. The artist was the middle child of three, her sister Sandy, two years older, and her brother Rob, two years younger. With their father in the military, the family moved around quite a bit. From 1963 to 1967, they lived on a Canadian military base in Germany; back in Canada, they subsequently lived on the base at Cold Lake, then at Yorkton, Saskatchewan, where the artist finished grade school. She attended high school in Chatham, New Brunswick, and Champlain Regional College in the Montreal suburb of St-Lambert.

Her interest in art was anomalous in her family; her two siblings very closely followed the pattern set by her parents. By the time Thorneycroft was seventeen, she was making drawings that fantastically expressed her fascination with the open mouth (*Self-portrait*, 1973). She trained as a printmaker at the University of Manitoba in Winnipeg (1975–79) and at the University of Wisconsin at Madison (1979–80). In 1976, she met her future husband, printmaker and composer William Pura. They were married in 1979 and divorced in 1995. There were no children. Their 1993 separation was initiated by Thorneycroft who felt restrained by her husband's traditional, that is, patriarchal, definition of marriage.

Prior to leaving her husband, Thorneycroft suffered depression and the somatic episodes described above, a choking feeling that came over her at night. With the aid of a therapist, she explored the possibility of abuse and amnesia, but found nothing conclusive. As an adolescent, she had been fondled inappropriately and verbally tutored on matters of masturbation and procreation by her paternal grandfather. He was a repressive character, a fervent Christian and lay minister who found "Archie and Veronica" comic books sexually explicit. Thorneycroft was puzzled by the instruction and disliked being touched, so she tried with limited success to avoid her grandfather. His incongruous behaviour – the link between Christianity and sexuality – was always part of her conscious memory; she swapped tales with a cousin who was treated in a similar way. She also told her mother, though not immediately. As for the choking, Thorneycroft came to believe that her body was reliving the experience of a tube being forced down her throat by doctors. Her mother denies that this ever occurred.

While Thorneycroft's decision to become an artist and subsequent life course was a deviation from her upbringing, while her relationships as daughter and sister have been through some challenging times, Thorneycroft generally feels very positive toward her family; she is close to her mother and has tended to identify with her father, whose male independence matched her desire for a career. Her affection accommodated his private and public teasing over her boyish figure. Thorneycroft has been described as tough. She thinks of herself as possibly too sensitive.

Since the eighties, she has lived and worked in Winnipeg where she teaches sessionally at the School of Art of the University of Manitoba. Her life partner, and occasional collaborator, who has softened her judgment of Christianity, is the artist Michael Boss.

SCREEN HISTORIES

From this background emerges a woman artist whose methods and motifs refer to the Western art histories of Surrealism, Symbolism, the Grotesque, and by literary analogy, the Fantastic. Surrealism is an avowed influence; the real, however one defines it, lives behind a Surrealist screen. The rogue element, the mole in the system, is always called "memory," thus placing an autobiographical construction on the products of Thorneycroft's imagination.

In its classic definition, Surrealism is a combination of doctrine and technique: belief in, and facilitation of, the release of the unconscious. André Breton's first manifesto privileges the imaginative realm of the dream state whose corruption begins the moment the dreamer awakes and becomes "the plaything of his memory … Memory alone arrogates to itself the right to excerpt from dreams, to ignore the transitions, and to depict for us rather a series of dreams than the *dream* itself."[13] Waking is a point of crisis, memory stepping in as a stern gatekeeper, blocking access to our primordial, unchained state. Contrast Benjamin's account: "When we awake each morning, we hold in our hands, usually weakly and loosely, but a few fringes of the tapestry of lived life, as loomed for us by forgetting."[14] The source of memory might bring us concordance: "The mind which plunges into Surrealism relives with glowing excitement the best part of its childhood," writes Breton. Childhood memories and "a few others" are held to be different because of their freedom and fertility: "risk-free possession of oneself."[15] In this sense, Surrealism puts the most positive construction on Freud's writings, which are littered with the psychic wreckage of childhood; what Surrealism retains is childhood memory's veridic status, especially those early manifestations of desire before they are bludgeoned by

parental disapproval and, later, just as effectively censored by the conscious mind. Surrealism is thus in equal parts revolutionary and nostalgic. A woman artist who ventures into this realm may change the gender bias and focus of the revolution – the future may be hers – but she cannot shake the nostalgia for some kind of lost, preconscious Eden. The Surrealist process leads her to the realm of collective myth, a place generally inhospitable to women; once through the gates, she may feel the need to clean house.

Surrealist historian Mary Ann Caws installs Thorneycroft in a community of self-imaging Surrealists, such as Claude Cahun, Dorothea Tanning, and Cindy Sherman, whose art is a means to survival. "Women artist inventors," writes Caws, "are the ones who have remembered how to forget so as to go on."[16] What are they forgetting? Violence and vulnerability, and all the dualities in between. Remembering how to forget is an act of female representation that makes the chaos and the confusion visible to the subject, and interpretable by herself and others. Access to this psychic realm is a woman artist's birthright; her individual life history is a moot point, or so it is left by Caws, in the dark.

Caws's is an essentialist Surrealism, applicable to woman-in-general, and to no-woman-in-particular, missing something essential about Thorneycroft in its wide intertextual embrace: her deep-seated curiosity about herself. Thorneycroft may colonize Surrealism, just as she colonizes male corporeality, but her part in the collective unconscious is decidedly that of an autonomous mind-body, and one split between action and self-observation. Simply put, her stories, the particulars of her nostalgia, count for her even if she cannot recount them. Her methodology makes this absolutely clear: she sets traps for her memories.

Thorneycroft's working methods are mixed: substantial planning sets the stage for an automatist process whose products are then subject to a perfectionist's conscious selection. The planning phase (the maintenance of a studio, the construction of sets, the fabrication of fantastic props, the stripping and positioning of the self before the camera), the creation, in other words, of a self-dedicated laboratory, is every bit as important as the improvisation and accident that leave their trace on the film. Each tableau is enacted again and again until: one, the pose and the gestures of exposure begin to feel fluid and spontaneous; two, there are enough versions on film from which she can choose.[17] Is she obsessive or merely determined? She herself says, "Re-enactment is about control," leaving open the question of what she is controlling.[18] Neutrally, one could say that Thorneycroft has tried everything to bring her mental images to light. Surrealism is a liberating technique: automatism's mechanical, psychic, and surrational modes are all visible in the work, used freely and to excess.

Both the mechanical and surrational modes in Thorneycroft's work derive from her unusual photographic process. Her photographs, which can be mistaken for double exposures or combination prints, are in fact protracted single exposures in which she paints herself and her surroundings with a flashlight. Thus she traces her body, explores its crevices, highlights textures, and also writes in the air. The roving beam creates hazy highlights and murky zones that veil her images unevenly, as though a filmy curtain were billowing over the scene. The lighting technique creates a layer of lustre, emphasizing an aspect of photographic imaging that Mary Price, following Barthes, conceptualizes as a mask: in photographic process, "the film or skin of appearance … creates a mask by the act of removal" from external reality.[19] In the mask-images of TOUCHING: THE SELF, Thorneycroft's enhancement of the photographic epidermis polishes her skin, while the veil lends volume and

depth to her working space. In *a slow remembering*, painting with light contours the subject-body, pooling in absence and presence, casting shadows from the leaves and branches, scatching the surface of textures, silhouetting objects that have been strewn or hung across the visual field. Peering into this synthetic forest, a fanciful mind may see otherwordly bodies — the ghosts in Thorneycroft's machine — joining her in front of the camera.

The flashlight as writing instrument is also the source of productive accidents: a flick of Thorneycroft's wrist has left an erect phantom penis in *Self-portrait (Father and Child with Clouds)* (fig. 6.1). Invading the medium of representation, Thorneycroft's "cursive automatism" presents as direct line to truth, or so Breton might have argued. Surrealist historian Rosalind Krauss duly explains: "Automatism may be writing, but it is not representation. It is immediate to experience, untainted by the distance and exteriority of signs."[20] But in Thorneycroft's work, automatism's truths emerge in a thicket of signs. The cursive erection floats in front of a slender female figure wearing a *trompe l'oeil* father-mask, cradling a baby doll, and pointing a pistol at a printed backdrop of clouds and planes. There is more Dada here than we might have thought, the ghost of grandDADA perhaps, a joke to be shared with her cousin.

Impurity and laughter: should Thorneycroft be cast from the Surrealist temple? Not according to its priestess, Rosalind Krauss: stylistic bifurcation is not only admissible to photographic Surrealism, but essential to all its paradigmatic practices, Man Ray's, Dora Maar's, and even the doctrinaire Breton's, though his example, as we have seen, leads Krauss into the semiotics of collage/montage, paying particular attention to the codes of spacing and doubling.[21] But there is another strain of Surrealism, chronicled by Ian Walker, in which the appeal to the unconscious comes largely from fixating details and hallucinatory juxtapositions:

these pictures are stranger than fiction because founded in the real.[22] Thorneycroft's unmanipulated images are not strictly agglomerative in the manners described by Krauss, nor do they mimic immediacy in ways shown by Walker, and yet, unnervingly, they straddle the two. Thorneycroft's one-person *tableaux vivants* are combinations of impulses symbolized and improvised as protracted performances designed to *draw out* and *show* what is troubling her waking mind. The heuristic condition is contagious. Caws catches it in her essay as stream of consciousness; she introduces an ambiguous decoy of her own when she writes that Thorneycroft's "is a quest narrative taken over by the female sensibility, and documented by the image."[23]

Spectatorial performance has always been crucial to Thorneycroft's process; she implicates the beholder in transgression. For the 1997 installation, *slytod*, she literally passed the torch. Using flashlights, spectators picked their way through an unlit gallery whose floor was covered with a carpet of dry leaves. This metonymic forest (attached to the referent through texture, sound, and smell) recreated a childhood memory. *slytod* was Sandy Thorneycroft's name for a game of tag played with flashlights in the Black Forest after dark. Thorneycroft later learned that 'Tod' was the German word for death and recast their game in more sinister terms.

To the woods was added a hospital, places twisted together in dense spatial representation and, as the title suggests, fused in memory. Indeed, every component of this work is a hybrid: medical instruments fused with animal parts; hooves erupting from military equipment; gas masks bandaged to blind heads. The body is sometimes stretched, sometimes compressed: can it be she, behind the "deceased infant mask" in a baby carriage overflowing with fishes (fig. 6.2)? There are altered dolls in the pictures, as well as stuffed animals and carcasses. Objects worn in the

6.1 Diana Thorneycroft
Self portrait (Father and Child with Clouds) (1990).
Gelatin silver print, 74.4 x 73.1 cm

6.2 Diana Thorneycroft
Untitled (Deceased Infant Mask) (1997).
Gelatin silver print, 81 x 66 cm

6.3 Diana Thorneycroft
Untitled (Speculum) (1997).
Gelatin silver print, 63.5 x 61 cm

pictures were also displayed, some outside the darkened room as specimens in glass cases, others on wires inside the gallery. Jacklit, these strange objects doubled as shadows on the gallery walls. Also in the dark was a ward of armless baby dolls, lined up in a row with tubes coming out of their mouths, their female genitals scored and painted in.

The dolls represent, as Chris Townsend suggests, the boundary between life and death, as well as another, less common association: "Each 'child' breathes through an oxygen mask, as though the consequence of its sexual definition was an immediate encounter with mortality."[24] This troubling connection is also made in a number of images and very explicitly in *Untitled (speculum)* (1997) (fig. 6.3). In this photographic performance, a blindfolded female figure, seen in profile, has her mouth forced open by a medical instrument designed to examine (see into) the vagina. As though the discomfort of the instrument were not enough, the figure's neck is choked by a collar of thin wire.

In normal lighting, or in reproduction, the intricacy of the "speculum" set-up is visually every bit as interesting as Thorneycroft's tormented head. The speculum is attached to a stand; the whole apparatus occupies two-thirds of the image; it is a presence, shiny, vertical, buttressed, and studded with bolts. The background of the image may be indistinct, but it sparkles like shrubbery caught by headlights. The photograph has clear boundaries; it exists as a unified statement in a frame.

As presented in the darkness of *slytod*, the experience of the work is significantly different. The edges of the image are indistinct. The flashlight draws in on the lit areas of the print. The beam courses horizontally along the silver speculum until it enters the mouth; the figure becomes the focus of attention, while the rest of the detail is largely atmospheric. The silver image thus becomes another kind

of "speculum": a "reflective surface" for the beholder's exploring light. In point of fact, the smooth surface of the photograph is the *only* functional speculum; the medical speculum, viewed from the side, is for all intents and purposes dis-functional, a blind alley.

Faced with these sealed, mute surfaces, Townsend confines his speculations to the ontology of photography in general and, following Siegfried Kracauer, to the instability of this photographic personal history in particular: "There is no coherent narrative inside the mnemonic space of *slytod*, neither in its arrangement, nor in the way we view it. Even if the space was fully opened to the light, as we might imagine the unconscious opened by psychoanalysis, there would be no transparency to the images it contained." Townsend, as observer, is confined by the fragmentary nature of the visual evidence served up like a Benjaminian memory in "flashes of light." The installation brings its performing observer to "an awareness of the possibilities of history that have never been developed," by which Townsend means, "one person's history," the "sexed, gendered, performative subject," here performed by Thorneycroft.[25] And by developed, he surely means "brought to light" as a piece of photographic evidence, a framing of the "spatial (or temporal) continuum" – a piece of history. In a photograph, says Kracauer, "a person's history is buried as if under a layer of snow."[26] In Thorneycroft's installation, the photograph is covered in darkness; darkness is the spatial and temporal continuum covering subjects, objects, and spectators. With invisibility the norm, plain sight becomes the insight, the rupture.

For Caws, *Untitled (Speculum)* captures the duality of exposure and torture. She inscribes Thorneycroft's art under "the sign of double exposure," reiterating the "paradox" that Thorneycroft herself has framed: "If it's medical, it

should be healing; if it's torture, it should be hurting."[27] This dichotomy is one of Thorneycroft's decoys, for there is no paradox here, but merely the crude contrast between good and evil, between promises that calm (and coerce) the patient and threats that terrorize (and freeze) the victim. Thorneycroft has misspoken: the speculum does not heal, but affords the healer *vision*. In Thorneycroft's tableau, it does not torture, but creates *pictures* of torture, of instrumentalized rape. The victim here is blindfolded and strangled by wire; she cannot see, she cannot speak, she cannot identify herself, her torturer.

MASK AND BLINDFOLD

In the performing and visual arts, the mask is a hardy and flexible symbol, cultivating both visceral reaction and learned response. Thorneycroft's masks are of three kinds: photographic portraits, hybrid assemblages, and surgical wrappings. She has been making masks and wearing them in her photographs since the late eighties when her research on sexual identity formation led her to feminist theory and psychoanalysis.

The mask seen through Joan Riviere's psychoanalytic theory of masquerade encodes all kinds of sexual and spectatorial instabilities that feminist critics, such as Laura Mulvey and Mary Ann Doane, have identified as cinematic tropes.[28] The carnivalesque mask, seen by and through the feminine, is open to questions of necessity and will that have been raised by Mary Russo in *The Female Grotesque*.[29] These are ordinary, commonsensical questions like, Who is enjoying the show? or Who has the last laugh? Jo Anna Isaak's response would be "woman" on the condition that carnivalesque transgressions be radically regenerative or,

properly speaking, generative of *new* forms of social and political action that are controlled by women and sustained by their productive laughter.[30] The GrandDADA erection floating in front of the "father" fits this category to a T.

The marvel of the mask is its defiance of symbolic degradation. It always works; it always thrills; it always means something. In both sacred and secular use, the mask represents what it mechanistically effects, which is secret transformation. Declarativeness, shamefulness, and immutability thicken its ironic attitude and intensify its magic. As a Mithraic emblem of the sun, the mask seals the face in darkness; as an instrument of evasion, the mask is direct about only one thing, its concealment of the particular.[31] The wearer's distinct and expressive features have been replaced by an unchanging, ambivalent sign; an inquiring beholder might be forgiven for turning his or her attention to the body.

In *TOUCHING: THE SELF*, the masks are made from portraits of Thorneycroft's family; she photographed them expressly for this purpose. As photographs within photographs, and emblems of lineage, the masks are prime examples of Gide's *mise en abyme* (they are indexical heraldic shields). Wearing the familial mask, the upper half of the artist's face is missing, replaced by a facsimile of her family member's eyes, brow, and ears. Thorneycroft explains that she wanted these masks to alleviate her discomfort at being nude before the camera. She was alone in the studio, bear in mind; in fact, she was alone in the dark. However modestly conceived, the masks cast the work in the vein of a masquerade in which Thorneycroft adopts the guises of her (typical) family, crossing the boundaries of gender, age, and culture. At the same time, the *photographic nature* of the mask as the only *true* representation of the secondary subject (the father, mother, sister or brother) inflates it with

mimetic authority. Not Thorneycroft, then, but her father, mother, brother, and sister are looking back at me. The affiliative group constituted by family is thus met through Thorneycroft's part-object portrait; a coded family look returns my curious stare.[32]

The effect of this device is perverse, or at least, socially and psychologically disruptive. As a second skin, the mask situates and incites a silent debate between the blinded, seeing eyes of the artist and the blind, simulacra eyes of her kin. The photographic (scopic) field is cleanly divided between one which I can fully enter (the domain of the body) and one which is circumscribed within another psycho-social order (the domain of the eyes). These self-portraits document Thorneycroft's confinement in a very private, photographically sealed space. Only her family can see her; they return her stare through the camera. But that look (that torch) has been passed to me as well, so that her family now stares blankly back at me. The artist's attempt to hide from her own nakedness is thus a success: behind the mask, she is blind to me and I, caught in the light of her family, am blind to her. This criss-crossing of affiliative and strange looks makes the mask a powerful co-presence. At some level, Thorneycroft's kin are more present than she. Fragmenting her body, flicking it with light, refracting it through the members of her family, she recreates the conditions that have formed her multiple sense of self, what sociologist Celia Lury would most certainly recognize as "experimental individualism."[33]

Lury's psycho-social theory illuminates Thorneycroft's project. Synthesizing Barthes, Baudrillard, Sontag, Adorno, and a multitude of product advertisers, Lury argues that individuality has become a function of its potentiality, and that this continuous action of self-division and recultivation begins at home:

[T]he contemporary photographic practices of the family album are making it possible for an individual to discard old selves, to try on personae and compare the multiplicity of subject-effects of retrodictive self-transformation. For some, but perhaps not all, this is an opportunity. Individuation and individualisation are intricately inter-twined here, but the individual does not necessarily disappear: rather, through a process of repetitive dis-internalisation, he or she may be reconstituted — inside or outside a remade family — in the exercise of choice.[34]

Thorneycroft's travesty of the family album thus recreates the usually safe ground of childish experimentation. Going behind the familial mask is going back, remembering and reconstructing her identity from behind the walls of the affiliative look. It is in that sense both nostalgic and ironic. For who are these Thorneycrofts? A conventional family whose rules for daughters (get married; have kids) and sense of propriety (keep your clothes on in front of a camera; marriage is for life) came under frontal attack by a daughter whose spirit was close to breaking under the yoke. And yet, her first public sign of rebellion was the reassumption of her father's name as the banner under which she would present *TOUCHING: THE SELF*. There is no small irony in the recognition that to rebirth and remould herself, Thorneycroft had to pass back through the family fold and re-select the traits that she needed to go forward. She cannibalized her life; her process became "retrodictive prophecy."[35]

The personifications of her family — a reordering of memory — was the first step in her emancipation. The next body of work, *a slow remembering*, reclaimed the territories of dreams and waking fantasies. These are the most veiled prints, and the head covering is correspondingly diffuse,

explicitly bridal in one case, sexy in others, and as a bag over her head, plainly dangerous in *Untitled (Snare)* 1994. Around the same time, and not for public consumption, Thorneycroft was systematically mutilating an extended family of dolls. These became upsetting little creatures, bearers of scars, burns, paint, body hair, blinding, and tattoos of automatic writing, that seem to whimper helpless resistance. Altering the dolls, giving them female genitalia, Thorneycroft experienced feelings of sexual arousal: "I identified with both victim and abuser."[36] In making her escape (her departure), Thorneycroft seems to have opened a Pandora's Box of memories whose elements began to manifest in her work. Her fundamental program remained the same: an experimental self-recreation; an assertion of that self as self-made and self-possessed, even in the face of self-doubt and self-recrimination (the demons of female regret).

In *a slow remembering*, when we glimpse Thorneycroft's eyes, they are shut, reminding us of Odilon Redon's Symbolist icon, *Closed Eyes* (1890), and even more intriguingly, of the late nineteenth-century migration of the "closed eye" theme from idealist to vitalist conceptions, from the stirring of the soul to the suffering of the body. As Petr Wittlich explains,

It was a shift that apparently represented a move away from spiritism's attempts to communicate between the distinct realms of the living and the dead, to far more comprehensive visions of spiritual life. But the more this new feeling – which introduced into art much more concrete notions, such as psychological suffering – gained in strength, the more complex the question of sublimation became. For the new suffering, whose source was outside art, it was in art that new expressive forms were to be discovered.[37]

Thorneycroft's work invites us into the realm of suffering. But consider also two other realms likewise bracketing Redon: spirituality (the closed eyes of modesty and piety that we see in the depiction of Madonnas and female martyrs); autonomy (Magritte's instructions to the Belgian Surrealists when he sent them to the photomaton machines to have their portraits taken – closed eyes "to suggest an inner life which photography could not reach").[38]

When Thorneycroft began having trouble breathing, when her body began to remember episodes of suffering, she began to make the assemblage masks. There are numerous precedents for such objects, from First Nations ceremonial masks to the powerful sculptures that fellow Winnipeg artist Don Proch began making in the 1970s. Proch's monstrous helmets are apocryphal. According to political scientist Arthur Kroker, "Proch's masks visually represent the impact of industrial technology massaging the human brain, and suppressing both organic matter and human vision. They are almost *suffocating* images of life in contemporary society."[39]

Thorneycroft's assemblage masks are truly suffocating. They are physical assaults on the wearer, intended to be seen and viscerally felt as biological extrusions and choking invasions of the body through the mouth (fig. 6.4). Though some of her materials, such as gas masks, derive from the military, her work is essentially apolitical, if the personal were ever so. Her brother the pilot has supplied her with obsolete equipment; for visual inspiration, she keeps a photograph of her test pilot father, wearing his oxygen mask, in her studio.

In the vulnerable space created by her work, Thorneycroft is upheld by the example of other artists. She cites photographer Joel-Peter Witkin as an early inspiration, one that crept into her imagery through unconscious emulation, otherwise known as memory. Hans Bellmer's use of

dolls gave her licence as her own history with dolls was quite limited. Hieronymus Bosch's *The Garden of Earthly Delights*, and especially the monstrous and musical right panel, resurfaced in Thorneycroft's fusion of biological and instrumental parts, and in the repeated forced entry through her mouth. Her poses draw freely and ambiguously on a repertoire of Western pictorial types; her *"Pietà"* melds the lifelessness of the Christ with the seductive languor of an Odalisque.

PERSONIFICATION AND BODY

TOUCHING: THE SELF expresses Thorneycroft's sense of alienation from the conventional imaging of male and female identities. Androgynous by appearance, hermaphroditic by design, Thorneycroft announces herself as a fake, or a freak, in both the men's and the women's camps – her body is denatured, stripped down, and prosthetically brought to the fullness of its biological history and transgendered potential.

In *Untitled (Father Mask Water Dream)* (1990), for example, Thorneycroft takes flight. The shallow set is strung with toy planes – she holds a model plane in her mouth and a doll on her lap. The vantage point is from above: Thorneycroft's arms spread, she crouches on her grandmother's quilt, a backdrop that she chose to suggest the pattern of fields seen from a cockpit. Freud suggests that a plan or map that appears in a dream reveals on closer inspection a representation of the human body, "the genitals, etc." whose recognition makes the dream intelligible. Freud's *The Interpretation of Dreams* has been banging on the door of this chapter. As an iconographical system, it cannot be kept out, especially in *a slow remembering* which is overpopulated by symbolic male genitals: snakes, lizards, fish, and so forth. In 1911, when

6.4 Diana Thorneycroft
Untitled (Cloven Hoof Mask) (1997).
Gelatin silver print, 66 x 53 cm

Freud admitted the airship as a "quite recent symbol of male organs in dreams" the dye was cast for *Self-portrait (Father Mask Water Dream)*.[40] Thorneycroft's references to Freud are impossible to ignore; in surfeit, in internal competition, they verge on parody. Hanging from wires, out of focus, doubled into soft shadows, these crafted archetypes lull and simultaneously taunt the decoders of the collective unconscious. As details, they are, as Allen S. Weiss puts it, "always susceptible to the libidinal oscillation between banality and overdetermination ... both trope and trap."[41] They challenge us to brush them aside, to rend the curtain, to lay bare the performing body, to consider its pose.

In *Untitled (Family Self-portrait)* (1990), Thorneycroft dons the mother mask and false breasts. She creates a patterned backdrop with what looks like a quilted bedspread (fig. 6.5). She brings in a chorus of dolls who also wear masks that she has made from portraits of her two siblings and *herself*. Here is a significant difference: in this work, the artist's presence is doubled; her gaze is incorporated into the work. Most of the dolls are naked with the pointed exception of one dressed in Ukrainian national costume, this one having come from an aunt on the Pura side. Thorneycroft's body forms a curve just off the centre of the square frame. She is actually lying back, but with her right leg drawn up, she looks like she is sitting, an effect heightened by the layering of dolls on what would be her lap. She raises her arms expressively. The gesture is arresting and, in combination with the props, remarkably similar to the representation of a mother in the *Massacre of the Innocents*, a fresco in the Lower Church of St. Francis of Assisi, a figure catalogued by Moshe Barasch in *Gestures of Despair*. While the massacre goes on all around, while another mother rends her garments in crazed grief, this mother with a dead baby in her lap half-raises her

arms in an ambiguous gesture that Barasch interprets in two ways: "It was probably meant as an expression of unbridled, high-pitched mourning, but the modern beholder can understand it also as a gesture of resignation and submission to fate."[42]

When I asked Thorneycroft to take a look at this image, nothing clicked. It sparked no recollection at all. I found that curious, given the other points of resemblance, specifically the fresco's display of dead babies flowing off to the right, just like Thorneycroft's dolls. Did she forget the source or is this merely a coincidence? Again, there is no reply. The image becomes one among many clues and connections that are either signs of psychic trouble or pictures that encourage such speculation through the dark glass of Western art, our culture's long fascination with violence and suffering.

Over the course of this investigation, Thorneycroft thought she remembered another massacre of the innocents by Dürer. From a trained printmaker, this seemed a promising lead, and so to Dürer, where I ended up staring at the reproduction of an extraordinary chalk drawing of St. Apollonia (1521).[43] Shown in three-quarter profile, the martyr's eyes are closed, her head gently inclined. The pose subtly concentrates the figure's deeply internalized suffering on her mouth. Apollonia's martyrdom was through the mouth, her teeth extracted one by one with a pair of tongs that are her attribute. (There is grim humour in her designation as the patron saint of dentists.) Returning to Thorneycroft's *Untitled (Speculum)* I am accompanied

6.5 Diana Thorneycroft
Untitled (Family Self-portrait) (1990).
Gelatin silver print, 98.3 x 97.5 cm

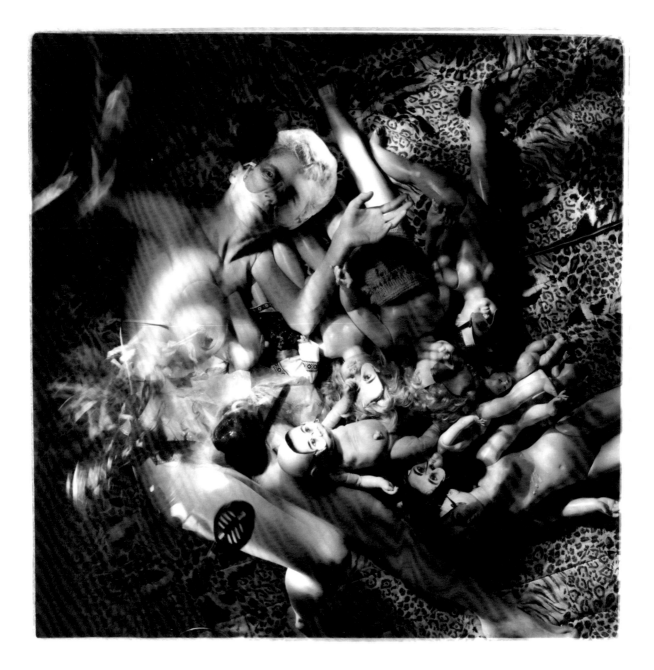

circle of encoding, conflating, and reconstructing memories of extreme pain and extreme banality. Fraser finds her system of causation, and perhaps Thorneycroft has too, in the painful rebirthing journey that she undertook when she reinvented herself as an independent woman artist. The "common locus" may thus extend far beyond the parameters of her life and autobiographical memory, and its symbolic repertoire may effectively incarnate Thorneycroft's desire for communion with earlier explorers of the psyche, Bosch, Dürer, Bellmer, Witkin, and others, who helped her to fashion her "retrodictive self-transformation."

The development of Thorneycroft's work and its interpretation through the era of memoro-politics suggest that we need to incorporate false memory into our study of photography and memory, not to suggest that Thorneycroft was propagating falsehoods about her past, but rather to argue that the facts of her life, those facts that were *made to matter*, may be nothing more than creative constructions that penetrated the public consciousness because they fit certain systems of belief and disbelief then at loggerheads in our society. By exhibiting intuition, guesswork, and provisional truths, Thorneycroft's work accommodated this clash of systems. Her display of suffering — a series of punishments inflicted on herself and her surrogates — thus becomes the autobiography of a female subject-in-particular who has failed purposefully and spectacularly to separate her own pain from that of others. As Weiss explains, this is the fate of "the body [that] *is* memory, where the wounds inflicted in initiatory ceremonies and vindictive punishments become the scars that remain the trace of one's own suffering, a suffering that creates both self-consciousness and its ethical double, social consciousness."[52]

Thorneycroft's recent transition into a typological framework — her photographic travesties of history paintings — thus seems entirely natural, not an abandonment of self-consciousness, but a brighter exposition of its "ethical double," her social consciousness of Western culture's insatiable appetite for victims. Thorneycroft has been fed by her complex of memories. Now she bites the hand that feeds her.

PART TWO

SCISSORS, **PAPER**, STONE

7 | MEMORY AND IMAGINATION

Imaging is not having shadowy pictures before some shadow-organ called 'the mind's eye'; but having paper pictures before the eyes in one's face is a familiar stimulus to imaging.
— Gilbert Ryle[1]

The work of Geneviève Cadieux speaks to the notion that the body remembers; she gives architectonic stature to these memories. Photographing close to a telling detail – a scar, a healed incision, a bruise – Cadieux enters what Laurence Louppe calls "body sites."[2] These anonymous body parts are then grafted to architectural wholes, whether the skin of a building, a partition, or a gallery wall. The symbolic function of these hypertrophic images dominates description; the reference is imprecise, yet somehow indelible.

Blues (1992) is an expansive photographic surface, divided vertically between flesh-coloured and bruised skin on the left, and almost total obscurity on the right (fig. 7.1). The darkness is relieved by a few blond body hairs catching the light and thus confirming that the body site does fill the frame, but is somehow partially eclipsed. These planetary proportions, yet larger is not plainer; on the contrary,

the big picture pulls in two directions, toward abstraction and toward hyperbole, neither of which seems to the modern mind either scientific or coherent. To understand *Blues* is to reawaken the imaginary of the nineteenth century, reviving the influential theory of organic memory. Laura Otis explains the migration of this scientific hypothesis into art: in the writing of Emilia Pardo Bazán, Thomas Hardy, and Émile Zola, "the past appears to resurface in bodies just as ancient monuments recall past violence and local legends."[3] Is there a novel in Cadieux's *peau parlant*? Is there a story written on this body?

Memory and imagination are closely connected, the differences between them not very clear. Phenomenologist Edward S. Casey calls them "psychical partners," returning to Aristotle's conjoining of the two in experience and acknowledging their similarities in terms of vivacity and mental activity. Nevertheless, Casey is able to identify five features of memory which distinguish it from imagination: rootedness in perception; a link to the past; retentionality; familiarity; and belief.[4] I consider these aspects below, finding that only the slightest elaboration is needed to make the connection between memory, a mental image, and photography, a mechanical one. But as this exercise unfolds, it quickly becomes obvious that imagination is actually pulling the strings, making objections, proposing variations, and effectively complicating the relationship between memory and photography that seemed so simple at the start. Philosophical agents of these complications are brought in from Kendall L. Walton's studies of mimesis and photographic realism.

Students of Walton's aesthetics may be somewhat startled by this approach, for his conception of photographs as "transparent pictures" – ways of "seeing through" – makes perception, not memory, the psychical partner of imagination. Photographs, by his reckoning, are both representa-

tions and "aids to vision" that busy the beholder with "imagining seeing." This is not a species of the genus "seeming to perceive," as Gilbert Ryle characterizes the viewing of a snapshot, but something explained by Walton as a fusion of *indirect* seeing (through the photograph) and imagined *direct* seeing (without benefit of photography).[5] Walton is particularly concerned about the differences between the beholder's experience of a painting and a photograph, as we will be here, when direct seeing of a painted surface and direct seeing of a photographic surface are compared. The photographic works examined under *Paper* exploit and explore such differences. These are photographic works about the persistence of mental images and the representation of this continuity in the language of pictorial convention – works in which perception, imagination, and memories of material culture are interleaved.

Reality is part of the picture, though the transparentness of Walton's window will be questioned, patiently, not in a flash. Memory creeps in by comparison and reconsideration. Imagination says, Could you not see this picture another way? These are also works that summon the imagination to *slow*, and sometimes *interrupt*, the flow from perception to memory, to *supplement* the link between memory and photography. Imagination never takes over completely (if we can imagine such a thing); this is a book about memory, after all. But our memories are replete with mental images that show us very little, yet inform our processing and retention of sensory perception.

Photographic theorists often point to the Renaissance as the fountainhead of photography's invention: the Albertian window; the ascent of naturalism; the parallel ascent of the ideal; the desire for mechanical helpers in the idealization of nature. Memory was vigorously exercised by the Renaissance artist, but so was the imagination, especially the "deliberative imagination," defined by Aristotle as the

7.1 Geneviève Cadieux
Blues (1992).
Chromogenic print, 168 x 249cm.
Collection: Canada Council Art Bank,
Ottawa. Photo: Louis Lussier. Courtesy:
Galerie René Blouin, Montreal.
Original in colour

capacity for constructing one image from many, seen or unseen.[6] As Mary Pardo displays the mental powers of Leonardo da Vinci, the external world is supplemented, and even anticipated, by internal fashioning: "If *memoria* is a control, informing judgment and insuring the persuasive consistency of the artist's vision, *ingenium*, normally identified with innate intuition and problem-solving ability, is a natural ally of fantasy, a faculty endowed with a kind of excitability not present in either intellect or sensation."[7] And, we might say, a faculty underestimated in the photographic regime of the real, while absolutely essential to its production of images and our understanding of them. We

make much of photography's secure preservation of the past, but this is an alibi for less Calvinist pleasures. Photography, like memory, is precious to us because it lights the dusky corners of our minds and allows us to speculate, appropriate, empathize – whatever term you like – in relative mental and physical safety. We enter the "that-has-been" or the "given-to-be-seen" performatively and thereby remake it, barely conscious that we have left our bodies.[8] Or, given our knowledge of photographic technology – knowing that anything is possible in the digital world – we accept all images as creative constructions and readjust our use of photography accordingly. We no longer say, This was so, but,

What if this were so? Photographic reception is thereby changed from reading photographic documents to assessing one's own agency: the ethical bar may be raised in the process.[9] Have we embarked on some fantastic voyage? Perhaps, but we've brought our world with us. The photographic is always tethered to the external world, however remotely, however mediated the link. Photographic imagination is not limited, but sparked, by that fact.

Under *Scissors* we looked at images cut from the real world, whether taken or collected. We formed ideas about photography and memory with the photographic act, and actor, very much in mind. The photographic was seen to bridge temporal gaps, looking back, but also looking forward. We know that picturing memory is a storehousing operation; we also know that part of the operation is projective — remembering ourselves looking forward. That aspect of memory grows stronger under *Paper*, as we delve into the shadowy world of images that arise from the complicity of memory and imagination. Their union is transformative: the trace of that-has-been becomes the image of that-might-be; the internalized given-to-be-seen is externalized as made-to-be-photographed. All this occurs when perception, memory, and imagination are activated in concert, and when the spectator feels the differences in their touch.

Drawing freely on Casey's phenomenological comparison of memory and imagination, I want to correlate these mental activities with processes of photographic reception.[10] Casey stresses memory's basis in perception; this condition parallels photography's indexicality, its dependence on the external world. So tight is this relationship that a revision of memory involves a correction to prior perception: when we discover that things were not as originally perceived, memory is adjusted accordingly. Likewise with photography: we may read a photographic image differently when our understanding of the conditions under which it was produced changes, but we are inserting new data into a fixed visual record. *Imagine a photograph of an apparently empty room in which, we later learn, there was a thief hiding under the bed.* Our perception has been altered by new facts, but did the existence of a banal, evidentiary photograph not prompt certain suspicions? This was Walter Benjamin's comment on the reception of Eugène Atget, that his photographs of deserted Paris streets looked like crime scenes.[11] This is also our fascination with W.G. Sebald's low-key use of photographs in his novels.[12] Draining a photograph of drama incites a dramatic response; as spectators, we infill.

Memory is the persistence of perception; Casey shows that the original perception and the content of memory are joined across time, linked through the rememberer's experience. A photograph is locked into a spatio-temporal matrix; it originated sometime, somewhere, and as spectators, we are connected to its origins, whether we can identify them or not. *Imagine finding a packet of holiday photographs on a street and passing them off as your own.* To possess this episode, to persuade people that it is part of your life history, you will have to implant it in the continuum of your life, be able to tell what happened to you before and after the pictured times. The photographic moment is always bracketed by the "before" and the "after." *Now imagine that you win a one-week, all-expenses-paid trip to Paris.* This sort of daydream has no temporal restrictions. It is conditioned by certain factors drawn from reality, what you know about Paris, what you know about yourself, things that Walton calls "mental furniture."[13] In this case, memory is supporting imagination without dragging it down into too many particulars. A photographic mode that deals in *pastness*, rather than *the past*, has been invaded by this kind of imagining.

Memory puts former experience at our disposal, whether or not we are conscious of its agency; whether or not we

remember how we learned what we have retained. A memory comes with what Casey calls its "retentional fringe," a mental field through which it comes and goes, and the source of experience's "felt continuity." Photography is by nature an instrument of record or retention. The retentional fringe of a photographic image is photographic process, that being anything that has caused the photographic image, from the invention of the medium to the intentionality or accident that trips the shutter. We need not know the history of a photographic image to know that it has a history without which it could not exist. We need not know the history of art to apply its conventions to the deciphering of a photographic image; we need not be conscious of doing it.

Memory implies personal acquaintance with the content of remembrance, whether through experience or education. Familiarity is so crucial to memory, and so unnecessary to imagination, that this distinction alone has satisfied some philosophers, Casey obviously not among them. Still the point is essential, and seems to strengthen memory's hold on photography, almost to the exclusion of the imagination, unless our responses to pictorial conventions are fully taken into account. As spectators, we are familiar with the act of beholding. Imagination refreshes the act, allows us to view a photographic landscape as though we were there, to assume the experience along with the view. Photography cultivates this kind of day tripping, from which we return with imagistic experience that we process through memory. We may forget the cultural source, sometimes seeking it in nature; a work of memory may ensue.

Memory is the assertion of a belief that perception has occurred. Our confidence in the content of our memories depends on a set of beliefs about the way that memory comes. A photographic work that depicts memory is persuasive to the degree that the incidental content of memory is shaped by the features of memory: its basis in perception, attachment to the rememberer's past, translation of the retentional fringe, and so forth. Imagination, roughly stated, is the opposite assertion: disbelief is the key. To imagine is to know that one is doing so; it is otherwise hallucination. Both memory and imagination can be misdirected and misrepresented, and frequently are in creative works. But an art gallery is not a courtroom; the burden of proof, if this is even an issue, rests on the spectator's shoulders. Our recognition and separation of memory-works from imagination-works depend on our very rough translation of their similarities and differences into photographic language, by which I mean both its formulation and interpretation.

Imagine a photographic representation of someone who never existed? Not hard, for many of us have seen one: a *Time* magazine cover girl, "The New Face of America," a composite image, based on statistics and projections, of the racially blended American face of the future.[14] Our knowledge of electronic imaging, or even the most rudimentary understanding of photographic process, gives this paper person credibility as something more than a product of the imagination, something passing every test of memory that we have considered thus far. She is both futuristic and familiar. We know where she comes from and we believe that she, or someone very like her, will someday exist. She is the daughter of "psychical partners."

Now I want to proposes a counter-example. *Imagine that a photograph were no more than a mental image passed wordlessly and inexpressively to another, perfectly copied and received by a mind momentarily identical to the originator's.* Impossible. Science fiction. And not very far from the clamour that greeted the invention of photography: claims of fidelity to nature captured in Oliver Wendell Holmes's rather literal metaphor, "the mirror with a memory"; claims expanded in Walton's notion of "transparent pictures."[15]

Depictions, non-photographic pictures, are props in viewers' perceptual games of make-believe. They belong to a larger category of representations that are fictional, that is, entered through the imagination, through a portal of pretense. This is the crux of Walton's argument in *Mimesis as Make-Believe*: "The viewer's visual game of make-believe is crucial." I began this book with those words, Walton's words, a rather quixotic gesture on my part since *Mimesis as Make-Believe* actually contains very little about photography. To flesh out what is said, we must return to an earlier article on the ontology of the medium, "Transparent Pictures" in which Walton attempts to explain what distinguishes photography from other pictorial media. Here, causation is crucial – mechanism rules – but the instruments are not cameras, but their products, photographic objects: "pictures through which we see the world."[16] For the viewer, photographic experience is a *seeing through*, a new mode of perception that is fictionally direct. All photographs, crude or accomplished, are included; indeed, there is heightened illusion in crudity, or simulated crudity as in the snapshot-effect, because the photographic process of "seeing through" is more forcefully asserted. Photographic systems of mediation are means of "*maintaining* contact. Viewers of photographs are in perceptual contact with the world." Photographic experience may be fictional, even fantastic; it may leave us with questions. "A view of a domestic scene from directly above" may prompt us to wonder: "How did we get attached to the ceiling above the domestic scene?"[17] But even as we see *through*, Walton insists that we frame our answer in terms of technical prowess and photographic literacy.

Defining photography essentially as a transparent picture through which we imagine that we are actually seeing reality leaves very little room for flights of the photographically prodded imagination, and even less time for memory.

Walton consistently stresses the *immediacy* of photographic experience; his seeing takes place in the *now*. By his account of photographic reception, a global impression, something like light striking film, is rapidly followed by an inspection of the details. We look at a photograph of our aunt, and having identified her, we recognize her grimace – she is grimacing. That she is long dead makes the present-tense observation into a fiction.[18] We can agree with Walton to this point, but there is surely something to add. That we, the relatives, would recognize the aunt's facial expression as a grimace, rather than an accident of photographic timing, or a touch of indigestion, suggests that we remember the aunt as someone who hated to have her picture taken, or was just generally unpleasant. Or, following the rule of intersection, that she was a delightful woman whose grimace in the photograph is pure accident, a memorable moment shared, preserved, and brought forward from the past. Memory tutors this kind of *seeing through*, and where we have no personal knowledge of the subject, memory teams up with the imagination if given enough time.

Time is of the essence in all kinds of perceptual interpretation. The ambiguous duck-rabbit figure, beloved of philosophers and experimental psychologists, can be decoded instantly as either a duck or a rabbit. When subjects are given only five seconds to look before the image is taken away, the identification holds firm. But when the image is left in front of the subject for an unlimited time, "reversals" begin to occur; the duck and the rabbit continue to alternate as long as the image is displayed.[19] Seeing is not just culturally biased; it is also inconstant over time.

Defining photographic reception in terms of visual identification and naming is probably adequate to our daily consumption of pictures. That's a duck; that's a rabbit. The definition fails miserably in a cinema or a gallery, where we expect not simply to be informed, but to be transformed by

the art experience. *Mimesis as Make-Believe* makes those expectations clear. And yet, with respect to photography, Walton's game world differs dramatically from mine.[20] So why do I bring it up at all? Because his lucid description and detailed analysis bring us again and again to the brink of the photographic imaginary. He stops, but we can go on.

Consider Walton's example of the photographic "view of the domestic scene from directly above." The extreme angle, or unexpected point of view, is not restricted to photography, but the Modernist movement toward New Vision made it something of a photographic specialty – the photo-eye seeing the world as beautiful, or at least interesting, from myriad, well-chosen points of view. An immediate global impression of such a scene might indeed raise the question of how it was done. The angle is not *natural*, so questions are.

But as Michael Snow's bird's-eye-view of a living room demonstrates with a shock, there is a meeting of *awarenesses* in the photographic image that interrupts "perceptual contact with the world" as a spatio-temporal unity. In Snow's "Object-Image-Memory," the theatricality is overt; perceptually, we attend to a photographic image of a carpet that is lying (like a rug) on the floor; imaginatively, we hover above a carefully designed set. We are prompted to what Walton, in *Mimesis as Make-Believe*, calls "psychological participation,"[21] but – and this is important – without the willing suspension of disbelief that constitutes our surrender to fictional genre such as theatre or cinema. Fiction of another order is operative here, one that depends on the spectator's curiosity about the limits of representation and the photograph's capacity to test them. Photography allows one to *see through* a plainly opaque object, and to feel oneself doing it. Photography makes time and space for serious mental play. Both memory and imagination are quickened in the process.

The photographic spectator's psychological participation begins with his or her projection into the photographic act. Mechanism does the trick, invites you to replace the camera operator. The fictional seeing of the pictured object is only a small step away from the fictional taking of the picture. Walton sees participation in relation to other forms of fiction as an identification with the character. The invisible presence of the photographer is just such a character whose body we snatch to see through to the photographed scene. This is powerful identification because it functions automatically; we only become aware of our vicarious feelings when we are astonished, or shocked by, a picture, when its creation seems far above or far below us – oddly enough, the maker's prodigious technique or lack of moral fibre excites the same spectatorial response. As Walton suggests, though with non-photographic examples, feelings generated by artistic fiction may be amplified by feelings imported from the real world, and they may continue when we are no longer in the presence of the work.[22] These feelings cultivate visual habits, or is it the reverse? Are we drawn to certain kinds of images because they present perceptual conditions that we find compatible? The works of Michel Campeau and Sylvie Readman are performative images of imaging the landscape. They rehearse nineteenth-century and Modernist models; they take us down "Persistent Paths." *Seeing through* is seeing through the tissues of photographic history to collective memory. For Thaddeus Holownia and Robin Mackenzie, the process is embodied in seriality. The spectator walks these persistent paths with growing appreciation for the thickness of the Jamesian present.

Seeing through allows us to traverse time and space. We are aware of our capacity to do so, even when our minds feel fully engaged by the photographic image on view. Some artists make room for us to extend the journey by incorporating gaps and exit points into their work, by creating

"Exchange Places." Michel Lamothe instills an abstract sense of pastness in his work by his use of the pinhole camera. Time is slowed, light emanates, darkness beckons, bodies are caressed by a blur; these things are palpable and recuperable in terms of our own sensual experiences. Greg Staats makes poetic photographic images and organizes them to speak the language of loss and recovery. Brenda Pelkey's photographic combinations of cinematic techniques and half-remembered stories set up an expectation of narrative that we yearn to fulfill, if only to push back the darkness, the end of our ordinary days.

There are, as Walton says, "enormous differences among representations"; he divides the depictive from the verbal.[23] As spectators we enjoy the tussle between images and words: a picture's title is the very best example of aspect-seeing because it sets up a kind of exploratory resistance; seeing more than what we are instructed to see is one of our simple pleasures in visual art. Pelkey's sites of memory — composites of image and text — spark our imaginations because the connections are faulty, misremembered, perhaps, or possibly transposed from another place and time. Translations from one language or medium to another undergo a rebirth, according to Benjamin's rule: "For in its afterlife — which could not be called that if it were not a transformation and a renewal of something living — the original undergoes a change. Even words with fixed meaning can undergo a maturing process."[25] Translation is a trope for the exile experience; so is modernity; so is the city; so is appropriation; so is mimicry.[26] Jeff Wall bundles all these elements together in his conflations of modernity, imagined from the perspective of the urban *flâneur*. Works by another restless traveller, Jin-me Yoon, layer figures of the Korean diaspora onto the glossy mechanical reproductions of the Canadian canon, recasting cultural authorities in new

hieratic forms. Nourished by memory, Wall and Yoon are highly imaginative "Mimics."

Semiological research serves the intertextuality of these works, but phenomenological analysis does too, and exposes more plainly the dialectic of memory and imagination that is the source of their epistemological mobility. In Casey's readings of Edmund Husserl and Freud, he finds parallels between the sign and the image in terms of structure and function. In Husserl, "both [image and sign] mediate experience ... both image and sign perform an *indicative* function ... They take us to what is not now present to the senses or to recollection by indicating — making a sign toward, 'signing' — an object or state of affairs that exists only *in absentia*." The Freudian piece of Casey's equation is a syntactical system for dream-images, "clothed in imagistic form," and constituting a script. Freud speaks of the original and the translation — the dream-thoughts and the manifest dream mediated pictorially by image-signs. In Freud, "the manifest dream (the dream that we experience and remember) is neither a pure image — a non-signifying 'simple image' in Husserl's nomenclature — nor is sheer sign (an abstract sign without pictorial content). It is precisely an *image-sign*, an ideogram of unsuspected symbolic significance."

Casey calls both these image/sign relationships "bound imagining," and their affinities set *him* to imagining a closer relationship between phenomenology and psychoanalysis, a dream somewhat troubled by the fusion of image and sign in Freud's psychical structure, and broken beyond repair when he compares their notions of the symbolic.[26]

Still there is something left for us in Casey's attempt, for along these corridors of "bound imagining," we are prepared to navigate the photographic between denotation and connotation, between "the thing itself" and its proliferating

meanings, between memory and the waking dream. For "bound imagining" should not be taken as a euphemism for limited imagination. Penny Cousineau-Levine's book-length study of photography's expression of the Canadian psyche exemplifies its possibilities. *Faking Death: Canadian Art Photography and the Canadian Imagination* develops a coherent symbolic system, framed by national borders, that vastly expands our understanding of community.[27]

As spectators, we need to recognize our participation in photography's representation of the real and, especially, the oscillation between acts of memory and acts of imagination that make photographic experience matter. Put another way, if photographs were merely paper memories, they would not interest us as much as they do. Ryle has this to say about "recall":

[L]ike 'reciting', 'quoting', 'depicting', and 'mimicking', it is a verb of showing, or is at least affiliated to such verbs. Being good at recalling is not being good at investigation, but being good at presenting. It is a narrative skill, if 'narrative' be allowed to cover non-prosaic as well as prosaic representations. That is why we describe recollections as relatively faithful, vivid, and accurate, and not as original, brilliant, or acute. Nor do we call people 'clever' or 'observant' merely because things come back to them well. An anecdotalist is not a sort of detective.[28]

The photographic spaces *that we create* between original and translation are filled with purposive imagining: we are sometimes pointed toward change. Works such as Wall's and Yoon's want us to reimagine our communities, which is why they are positioned in this book on the border between *Paper* and *Stone*.

Can I characterize the nature of my inner experience during such moments of being lost in thought? I know I cannot. They are not clear. For every image there are several partial and unrealized movements toward image. For every visualization there are a multitude of unvisualized yet assumed images that contribute to the feel of dense imagining. For every contemplated word there are scores of other words which never reach consciousness but which have been part of the movement of language. And so the account continues, with each and every element that goes into the making of self experience.

– Christopher Bollas[1]

Photographs help us to remember by prompting thoughts of the invisible. Going through a box of snapshots that correspond to my childhood, I see a snapshot of my mother, broadly smiling, standing under a Broadway marquee. *Where was I when you and Daddy went to New York? You stayed with your grandmother.* There are no pictures of my grandmother and me, sitting in her tiled sunroom (her winter garden), listening to the Saturday evening radio broadcast of the recitation of the Rosary, but I remember.

The photographic works examined under *Scissors*, and especially the last, express the co-presence of remembering

and forgetting as a contest for psychic and visual space. Even the dreamer's pillow may be conceptualized as an arena. But the relationship between remembering and forgetting is not always so embattled; indeed, as my little story shows, it tends to the pacific. The relegation of lived experience to the unconscious is a normal part of everyday life, as is the re-awakening of memories whose significance is not immediately clear. Such memories quicken the body, as well as the mind; *pace* Benjamin and Breton, they are not unlike dreams, and their interpretation is every bit as challenging, perhaps more so, given their incongruous banality.

Psychoanalyst Christopher Bollas attends to the dream-like quality of waking life:

During the day, we have hundreds of psychically intense experiences when we conjure ideas from an inner medley of body experience, unconscious memories, and instinctual response. Each experience is fragmented by the associations it conjures up: we bring together many factors only to find that whatever lucid ideas we have are broken up in the process. Psychic life during an ordinary day, then, is an endless sequence of psychic intensities and their subsequent fragmentations.[2]

A photographic work that intensifies our awareness of ordinary days creates places of conscious and unconscious communication by instilling a sense of what Bollas calls "unconscious freedom" in the spectator. Such a work of art can be added to Bollas's list of mental contexts, "dream, memory, story," an image whose public presentation releases "latent (and future) contents, creating lines of meaning," breaking up "hegemonies of content to re-form them, to reshape them into new and differing compositions of meaning."[3] Such a photo-graphic work offers the freedom to build, destroy, and rebuild psychic structures into productive new forms.

Every photograph contains the seeds of its re-creation in another form of communication. I am concerned here with photographic works that cultivate that response in the spectator, works that insist on improvisational in-filling at the first stage of reception. These are works to which the spectator gives internal voice, or tries to. Bollas's description of the collaboration between analyst and analysand as an intertwining of two unconsciously searching minds is a useful parallel. When the analyst drifts into thought and the analysand lapses into silence, a vacuum is created, a fertile space of forgetfulness: words and images rush in from somewhere below awareness.[4] The analysis of such encounters is subtle and involved, but their occurrence is common. Gaps are part of everyday conversation, and they frame many things: experiences too ordinary to elaborate; experiences too embarrassing to relate; things we don't understand. They are spaces of intuition and unfounded speculation, exchange places for the "inner medley" of experience, memory, and imagination.

The photographic works of Michel Lamothe, Greg Staats, and Brenda Pelkey are replete with such productive spaces. Their images translate between the languages of photographic immediacy and extended intermediation. They encourage the spectator to speculate, to invent beginnings and endings for clusters of images and fragments of stories. Their works form invisible connections *between* images, as well as the ambiguous passages and suggestions *within* images. Deceptively deep, these gaps are the very core of their photographic structures, their life force. How these spaces are entered, how they inhale the spectator and exhale memory, is the subject of this chapter.

Michel Lamothe's photographs bring many words immediately to mind: atmospheric, romantic, sensual, fecund, harmonious, emotive, poetic, and luminous. These are all adjectives: perversely, one is reminded of Roland Barthes's "infinite series of adjectives," shadings of presence and absence that he felt keenly, yet chose to *omit* from his elegiac essay on photographic reception.[5] The dense predication of Lamothe's work accrues to a description — at first blush, subjects, objects, and genres tend to be forgotten. Or at least, this is how the unconscious conversation begins.

Lamothe, I know, photographs his garden, though it seems more accurate to say that he makes photographs *in* his garden, or *within* his relationships, or simply *on earth* (fig. 8.1). The essence of Lamothe's photography is a condition that wreathes his imagery in qualities that only an addiction to naming would insist on attaching to *something*. To write or speak Lamothe's photographs is to invert his photographic language in which the pretextual subjects (the nouns) seem to qualify and intensify the pictorial conditions (the adjectives). His images are about the most garden-like fecundity, the most sky-like luminosity, the most facial emotiveness, and so on. They depict without recording the particulars of one garden, one sky, or one face. Certain persons, objects, or places are important to Lamothe, and he means me to sense the strength of his attachments. But these are sites of common understanding, nothing more; I *should* say, nothing less. They are the shadowy spaces of intimacy.

Intimacy conditions this work and protects it. Intimacy is its translucent second skin, over wrapping the "psychic envelope" that Serge Tisseron has identified as photography's capacity to integrate fully the subject, author, and spectator.[6] Intimacy here finds a photographic idiom. It is expressed in distorting proximity, the erasure of identity,

the smudging of the trace. Lamothe's self-conscious abstractions of intimacy *move* me and *remove* me to the space between envelope and skin. Emotionally, I am still bound to the work, though alert to the effects of Lamothe's subtle mediation.

This is a strange state of affairs for photography, the medium that is supposed to point, differentiate, survey, and certify. Lamothe's photographs do none of those things. Instead, they draw a very wide circle around experience, and specifically, private photographic experience, by referring to its common emblematic devices: the pinhole camera, the home movie, the snapshot, and the photographic album. Common, but hardly current: these photographic instruments are archaic; their products refer to a time when the photograph was a crafted object, handmade. Thus Lamothe combines two visual histories, photography's and his own. The work is the biography of its making. Un-events — the familial looks, gestural habits, and everyday occurrences of Lamothe's life — are made into public and permanent works of art. Such rehearsals of experience are not without risk. They tend to reveal those "blank spots, blurry areas, [and] domains of dimness" that Vladimir Nabokov uncovered in his original version of *Speak, Memory*.[7] Lamothe seems perfectly at ease with the fragility of memory; indeed, he cultivates visual expression from memory's lacunae.

Lamothe's photography has always appealed to me viscerally. It is all the things that I have already listed; it is beautiful besides. Lamothe constructs a picture-world that somehow reconciles itself with mine. His pictures are imprinted on my memory. Is this simply a game of art history, my recognition in his work of certain simple motifs and old-fashioned photographic manners? No, for that alone would be kitsch. Lamothe does not romance the past, he activates memory with a form of photographic art that

positively structures unconscious communication; he actively invites my imagination in.

Lamothe's photographic work consists of black and white prints, some of which are large and absorbing, while others are small objects of close, individual inspection. The largest pictures come from the most primitive instrument, the pinhole camera, or camera obscura. This picture machine comes to us from the nineteenth century; while photographic inventors like Nicéphore Nièpce and William Henry Fox Talbot were conducting their experiments, the camera obscura, and its more portable relative, the camera lucida, were dazzling them with sun-pictures, teasing them with the promise of preservation. The pinhole camera extols the simple craft of photography, its noncommercial kitchen chemistry. As signs of the amateur process, Lamothe includes the outline of the film holder as a black border, these areas occasionally inscribed as nineteenth-century photographers were wont to do.

The long exposures of the camera obscura yield luminous prints whose deep, dark passages – eyelike, earthlike, or somatic-poetic (the lines of Lamothe's hand) – seem to waft and billow like smoke against the sky. Philippe Dubois has emphasized the haptic nature of Lamothe's work, pointing out that the lenseless camera obscura means working virtually blind. The images are composed from external reality and photographic experience in the artist's imagination. The feathery results, so soft and mysterious, invite imaginative palpation.[8]

Dubois's reading has been inspired in part by Lamothe's portraits in which the artist's and his subjects' eyes become dark pools, blind windows to the soul. The allusion is rather grim. Lamothe's figures, frequently self-portraits, leave ghostly, gestural traces on the film. This is a function of slight movement during the exposure which translates, in the language of photography, to an inchoate sense of the

8.1 Michel Lamothe
Sans titre, photogramme (1999).
Gelatin silver print, 6.7 x 9.2 cm

past melancholically displacing the present. The figures are there, and not there, at the same time. The photographer's blindness, figured in his portraits, becomes ours – our visions turn inward. In the spirit of Georges Didi-Huberman, Dubois suggests that we touch these images with our eyes, dreamily caressing the spectral image.[9]

On exhibit, the pinhole images are often presented edge to edge in sequences or clusters, mounted in a line or a grid. When these are portraits, they present as a procession of unformed identities, wordlessly appealing *revenants*. In Lamothe's groupings of still lifes, the urge to free associate poetically or to string the images into a narrative is more insistent. There is little to go on but one's feelings, though these are somehow encouraged by the homeliness and simple craft of the composite images. The creative process – his and mine – feels both spontaneous and sincere.

The smallest images, *"Les photogrammes,"* are smaller than most snapshots. Grainy and dense, they are frames from 16 mm or Super-8 mm film, enlarged on a generous sheet of photographic paper so that the diminutive image floats on a white field. Here again, an abstract sense of time passing, time mourned, invades the work, for the selected frames are literally fragments of daily life caught in motion. There is an autobiographical aspect to the work: Lamothe is a filmmaker as well as a photographic artist. Over twenty years, he has experimented with the instruments and materials of both media; he has varied the scale and presentation of his work, and these differences are not insignificant. Still, this is an oeuvre of remarkable coherence, made within a repertoire of recurrent motifs, though here again I would stress not subjects but circumstances, meaning the right occasion for a picture, when photographic process and the real world feel somehow synchronous. The timing of such an event – the activation of favourable conditions – is more delicate than might appear. A single detail, one image from *Camera obscura no. 2* (1984) exemplifies Lamothe's sensitivity (fig. 8.2).

The picture has been taken out-of-doors in a style reminiscent of early photographic experiments – working at the outer limits of the medium, eager to see results, so sticking close to home. The genre is not quite still life; one could call it a domestication of the landscape. Here, as so often with this artist, the dominant element is an atmospheric glow. The effect is synesthetic: I *feel* warmth coming into the day. An improvised banquet table has been set between a backyard swing, a potting shed, and the camera. Seating for about twenty people has been cobbled together from several generations of garden furniture and dining chairs. A light-coloured cloth and white plates are signs that the laying of the table has begun, but this work has been inter-

rupted, perhaps because the light and partial arrangement of the setting have reached the mark of sufficiency. There is no one in the picture. This is not emptiness but absence as represented by an object draped over the back of a chair, a jacket thrown off in the heat of preparing for the banquet, or the picture, we do not know. The photograph memorializes its own making. It is about the pause. It is about anticipation and it contains the memories of the event that lies ahead. Will it or did it rain? Did the meal come off? Will the guests be pleased? Could a child fall from the swing and cry? Will his parents go home early, and did they eventually drift apart? Why are we doing this? Are we as happy as we were then?

The entire sequence of *Camera obscura no. 2* – a vertical line of four images (an urban rooftop, the domesticated landscape, a still life of a potted plant on a balcony, and a self-portrait) – is an intriguing alternative to linear pictorial narrative. The arrangement expresses a layered and associative mnemonic structure. The code is both personal and open, not universal but, in William F. Brewer's term, *generically personal.*[10] The imprecision of the data – photographic signs of an extended process – leaves the record unfinished and therefore receptive to my thoughts. They fill the ellipses of this photographic stream of consciousness.

Some of these thoughts feel like secrets. I feel part of a photographic circle. Lamothe's visible, temporal signs are all internal to the photographic process: blurring figures, wind-softened stalks and branches, the movement of the sun across a body, a posing figure (Lamothe himself) holding a clock. Emulating the amateur, he photographs in private situations that lack historical markers. The pastness of the work – the detachment of these images from the present – derives from his techniques. By reviving the camera obscura, Lamothe leads us to the origins of photography, a

8.2 Michel Lamothe
Detail from *Camera obscura no. 2* (1984).
Gelatin silver print, 76 x 86 cm

8.4 Greg Staats
auto-mnemonic six nations (2005).
6 gelatin silver prints, 76.2 x 76.2 cm each

formal fact. Sheets of plywood block my entrance to an unidentified building. They are oddly totemic, and so different one from the other; each piece is different in grain and marks of usage; as objects, they seem to remember the forest and the sawblade. A screen of leaves and branches is silhouetted against a barely discernible group of buildings. And finally, a vestige of human habitation, rough and crumbling, stands protected by the saplings that will henceforth inhabit this place.

For Staats, these works are studies of "the emotional architecture of shelter." Found in both urban and rural settings, specifically including landscapes of the Six Nations of the Grand River territory, the images represent the need for shelter to protect against vulnerability, but also to allow a certain degree of uncertainty. "Without a direct connection and exposure to the natural world, I can easily lose the ability to accept the disturbances of life as an open door to growth and change."[26]

The connection between landscape and memory has been explicated by such writers as Raymond Williams and Simon Schama, cultural historians prompted by physical signs and incomplete knowledge of their own histories.[27] Reading the Northhamptonshire poet John Clare, Williams recognizes his own attachment to place, understands the loss of "Nature" as "the loss of a specifically human and historical landscape, in which the source of feeling is not really that it is 'natural' but that it is 'native.'"[28] The same desire for connectedness shapes Lucy Lippard's *The Lure of the Local*, making itself visible in the autobiographical text that runs across the top of her book as the writer's voice, her personal register.[29] The difference between the collective memories of the First Nations and the personal memories of these native writers will not be passed over in silence: I cite Williams and the others to find some common ground, as Staats seeks to do in his images. In 1991,

Staats wrote that he did not want his work to be "limited by an ethnocentric expectation of 'Indian' subject matter. My boundaries are free from hierarchical influence and tend to encompass the whole, be it woman, sky or community."[30]

To be *from* somewhere, to return, to recognize, to relearn speech, to bodily memorize place: the *auto-mnemonic six nations* preserves those possibilities. The shelters and passages in Staats's imagery figure his desire to carry "core beliefs from one system to another," creating "an interchangeable space for personal re/creation."[31] His photographs document this ongoing process.

LANDSCAPES OF IMMINENCE

Lamothe and Staats beckon me visually to partake in remembering; their images stir mnemonic acts of faith. By contrast, Brenda Pelkey's work incites me to remember. She challenges my beliefs in the photographic act with a title such as *Oblivion*.

Oblivion is an impertinent title for a photographic work. *The state of being forgotten? The state of forgetting or of being mentally withdrawn? Official disregard, or overlooking of offenses; pardon; amnesty?* No dictionary definition seems to fit. The denial of memory is the stumbling block. If photographic meaning has shifted off centre, or if the photograph as document has lost some of its official lustre, the link between photography and memory has only grown stronger in the process. Photographic theory has redefined both memory and photography by analogy and family resemblance. Photographs and memories fade. Photographs lie, and memories are false. But the idea of memory still carries a certain authority, and the photograph does too. Memory, as opposed to history, rings true for us now as an unauthorized version of events, something an elder told us, a seed turned over and

over with our tongues until it sprouted in our own words. The photograph likewise germinates stories, reproduces itself from a matrix of inconclusiveness. Memory (photography) is porous (translucent), immediate (transparent), and fecund (multiple). Photographic memories, as we understand them now, are likeably flawed, unstable, possibly badly fixed. But we trust the patchiness of frayed connections, we respond to their stuttering power as corresponding directly to a consciousness of the past. And Pelkey does not? Her title insists on a more penetrating look.

Such independence is not out of character for an artist who in 1994 challenged the received idea of photography as language by characterizing her own photographs as "mute." Close and multiple readings of surface reality did not yield deeper meaning – that was her argument. She herself was not being informed. What she was interested in exploring was the "untold and unable to be told," a curious departure, one might think, for a former documentary photographer.[32]

Brenda Pelkey's work was then, as now, hard to classify, or calcify, in any genre. Her tools and talking points, even at the height of her so-called documentary phase, were theatrical. In its manifestation as landscape, her practice lives somewhere on the outskirts of photography as a combination of prints, texts, and tapes. She switches, or seems to switch, between autobiography and fiction; her sense of place has a cinematic air. She is skeptical of heroes, her actors are extras. Her work has emerged in an era of hybridity, but Pelkey's unconventionality indicates more than Postmodern fashion. In fact, it indicates the opposite: a lifetime aversion to categories or cadres, especially in art; a complementary interest in sidebars and unofficial stories.

Always in her work is a pull to the outsider, with the attendant desire to pull him or her inside-out. In *"… the great effect of the imagination on the world,"* a series of panoramic assemblages from the 1980s, Pelkey began to experiment with the psychic landscape, her test case the fantasies and obsessive natures of those neighbourhood pariahs who decorate their lawns. Flamingoes and whirligig daisies are the low end of this cottage industry which has spun theories from folklorists, historians, and critics. Pelkey was naturally most interested in how the phenomenon might be framed as a picture. Restricting herself to Saskatoon's urban lot, she found outstanding examples of private theme parks which she heightened dramatically by photographing at night with movie lighting and splitting the view into a fragmented panorama. These energized landscapes were also portraits of the artists, folk somewhat dwarfed by the magnitude of their enchantment. Their religious shrines and worldmaking pastiches, shining out of the dark, were taken by Pelkey as expressions of internal realities, states of being rather than social statements of kitsch and outsider economies. The story that Pelkey was after was an old one, the archetypal expression of subconscious desires. She serialized this *Hansel and Gretel*, shifting thereafter to the Grimm workings of her own mind.

The setting remained the outdoors and, through *Dreams of Life and Death* (1994), she continued work in and around Saskatoon. *Memento Mori* (1996) and *Oblivion* (1997) took Pelkey away on photographic expeditions (necessitating a caravan of lights, generators, and a sanguine assistant) to the Canadian east, beginning with places in the Maritimes remembered from her childhood. Only some places, for Pelkey, like Thorneycroft, was a child of the Canadian military and her family moved around in Canada and Europe. The place that she identifies as home is Havre Boucher, Nova Scotia, where she first struck out on her own. As she later explained, her return after twenty years to Havre Boucher precipitated a rush of autobiographical memories

and tragic associations. She incorporated those *Dreams of Life and Death* into a suite of elemental landscapes.[33]

The photographs are very simple. Their "great effect" is the eerie illumination that Pelkey had developed with movie lights in the dark. Also retained is the fragmentation of the image into three or four panels, one now considerably smaller, isolated from the assemblage, and overlaid with text. By any rule, and especially by comparison with the decorated gardens, these are restrained compositions. *yard* (1994) is little more than the flash of headlights on a white clapboard facade and an aluminium door, car bumpers and grilles, the back of a red pickup truck, the outline of a shed, and an unclipped hedge (fig. 8.5). Brilliance and deep shadow alienate these elements from each other. None of it, in any case, seems real. The foreground, a driveway strewn with brown leaves, is extended into the text panel, an arboreal setting for the following:

I never knew that he beat her.

She wept in my kitchen.

She was away.

I looked after the children. He came home drinking. We all got into the truck and drove for hours to homes of strangers. I can only remember clearly the next day.

I-he-her-she-she-I-he-we-I, the children and the strangers. A little snapshot of private life, a little violence, a few tears, a little craziness, a little risk, a little shame – episodes witnessed or imagined by the artist, and recalled ever after by exposure to a certain constellation of elements, by a certain *type* of site. The voicing is personal, but

8.5 Brenda Pelkey
yard, from the series *Dreams of life and death* (1994).
2 panels: Ilfochrome, mounted on sintra, 127 x 101.6 cm, 127 x 76.2 cm.
Original in colour

the combination of words and images strengthens the spectator's implication in ways that come clear in *telephone booth* (1994) (fig. 8.6).

The work is an urban panorama composed of three vertical prints, with an additional text panel of white letters on a photographic field. The view is of an intersection at night, lights picking out certain elements: read left to right, a telephone pole, a stop sign, the silhouettes of parked cars, a low building, a mailbox, a telephone pole, a newspaper box, a telephone booth with posters, a brightly lit building, and a streetlight. The impression is of a street corner, not on Main Street, in a small town after dark with most of its inhabitants safely at home. The effect is almost eerie, but not quite. As a large, public work of art, referential in its shape and pictorial values to cinema, this banality becomes instantly suspenseful.

Analysis translates into a retelling. In my own idiom, the story goes something like this:

Imagine yourself at some mid-point in life, home after the usual kind of dulling day, and you're dulling yourself still further by watching something on TV, when you remember that there's not enough milk for the kids' cereal. Complaining, though secretly pleased, you rise from your chair, grab your wallet, and head out to the local store. You drive because you're kind of tired, and your mood right now wants to skim along rather than gaining some cardiovascular credit from what you have seized from a shrinking quiver of straws as a private moment, a chance to be alone, and neither exercise, nor think. You pass a brightly lit telephone booth, and it freezes as a standing stone on the mid-point of your horizon, the whole scene set up by the gods to throw you back to something you haven't thought about for years. You don't stop, you keep driving, because you've gotten everything you needed at a glance.

That for me is the picture and this is Pelkey's text:

No one knew why he killed himself. He was engaged to be married and had just built a house.

He borrowed a gun from his cousin.

Two weeks previously he had invited me to see his new house. I had admired the kitchen taps and seen the bedroom where he later died.

When we had dated briefly he told me that he would not live beyond thirty. I thought perhaps he had been too influenced by "the movies."

He loved to honk his horn while driving by telephone booths. He told me that the person could be talking to someone in Ontario and that his truck horn would be heard in Toronto.

The wide screen that is the picture, the turquoise spill of light across the asphalt, the human scale of the booth, the triumph of sound over time and space in both image and text: photographs and stories together always play with degrees of presence and pastness, but this series of moves is particularly adept. Pelkey is grappling with a calamitous event by placing before the spectator a full spectrum of ordinary, and clearly happier, possibilities, the *what if*s that make the final outcome so cruel. Michael André Bernstein has presented a model for this way of thinking (his example is the Shoah), insisting on what he calls "a prosaics of the quotidian" to give contour and shadow to lives flattened by a catastrophic event. If this is history as speculation, if these memories are unrealized, they are no less attached to the real, as Bernstein explains in the most graphic terms: "Only the brightness of an actual event can cast sufficient

8.6 Brenda Pelkey
telephone booth (1994).
3 panels: Ilfochrome,
mounted on sintra,
total dimension of
101.6 x 205.7 cm.
Original in colour

shadow for sideshadowing to matter, and only the felt force of a life can give impetus to the counterlives that seize the imagination."[34] This is also the beauty of Pelkey's work, that it crystallizes the terrible moment in its many points of promise and reflection. Her work muses and meanders through time and place in a very human way, at once vulnerable and defended.

Work gathered under the titles *Memento Mori* and *Oblivion* further refines this constellated style. More romantic in subject matter and composition, the landscapes refer to forests, country roads, and the sea, some affixed with the place names of Nova Scotia and the Shetland Islands, layers of pastness in these toponyms alone. The photographic treatment is Pelkey's remarkable formula of enrichment –

the darkness, the lights – which benefits from installation on dark walls. In some of the *Memento Mori*, a separate text panel of white letters on a black field hangs below the pictorial image. In *Oblivion*, the texts are no longer separated from the main panels but emanate from the image, as though part of its natural rhythm. As ever, beauty and calamity intertwine.

The stories that haunt these fields and shorelines are first-person accounts of death by sickness and disaster. Tenderness and torment, avowal and shame, shape gothic expressions of longing:

His love had been larger than any she had ever known
she keeps his boots still lined up by her bed

As he was nearing the final stages of his illness
her ex-husband shot and killed his dog

Whose love story is this? The speaker is invisible, unnamed. All I see are deep ruts in white gravel, a bright-lit road to blackness lined with greenest and brownest of evergreens. I am informed that these stories were told to the artist by the women of the district. Pelkey's recollection of the stories is naturally more central to my thoughts as I contemplate her work. If children's nonsense rhymes and survivors' tales of the sea haunt her work, they have touched her, or scraped at her more likely, because they echo and predict the circumstances of her own life. In the women's circle of spin-storying, she hears their stories and I hear hers in her pained and partial repetition of words and images. In sympathy and hunger for sympathy, I complete her unfinished sentences.

bush (1997) brings Pelkey's melancholic participation very near (fig. 8.7). The photograph, thrice presented on a horizontal line, is a long view of a cultivated field whose lines curve into the backdrop of a gently rounded screen of trees. The setting sun naturally blends the colours – the ochre field rusted, the thicket warmed to grey, the sky a vestigial blush. The effect is soft and sensual. Detail has been restrained to the absolute minimum, adhering to the nineteenth-century principle of "sacrifice." The sacrifice implied by *bush* has a sharper edge. There is no text until the spectator approaches and hears it spoken. The voice of woman, pulsing like the images, like a heartbeat: "Goodbye."

Pelkey's *Dreams of Life and Death*, the chronicles of *yard* and *telephone booth*, are the antitheses of screen memories, for they offer no shelter or substitution, but rather the blinding flash of memory as a composite of dashed hopes and dumb facts. What is remembered, what is inhabitable only in memory, is a place that existed only in the imagination, a fiction too ephemeral to last, too prosaic to memorialize. The *Memento Mori* are more direct expressions of grief and yearning, lived, seen, heard, walked, and driven into the landscape by Pelkey's informants, the women up ahead. They are performative works, theatres of unspeakable common knowledge. *Oblivion* signals the condition of memory suspended, a state of wilful forgetfulness of what will be. The experience is both exalting and terrifying – the ordinary and the particular striking with the force of the sublime.

IN BETWEEN

The movement between association, fragmentation, and reconstruction is so fluid, so much a part of ordinary existence, that the beauty of this acrobatics tends to be overlooked. Lamothe, Staats, and Pelkey underscore these mental processes by accommodating the spectator's "inner medley of body experience, unconscious memories, and instinctual response," indeed, by paralleling its complexity and coherence in the construction of their work. The elements of this ecology have been established, as has its dynamic of performative reception. I have stressed to the point of confession the subjectivity of spectatorial response and the necessity of surrendering to one's inner voices to experience these works to the full. It could be argued that every work of art offers the opportunity for empathetic, improvisational interpretation, and no one would disagree. This book wants to raise those possibilities at every turn. At the same time, there are artists who, consciously or unconsciously, leave more room for spectatorial action; Lamothe,

Staats, and Pelkey are three. This action takes place in the spatial and temporal gaps between delineated spaces and specific moments; in the fields of photographic sacrifice. These fields are neither natural, nor neutral; they exist only within a system of contrasts, pictorial and processual. In Lamothe's case, the "blind" use of the pinhole camera gives his images a fuzzy, accidental quality which flies in the face of what we know about him and his photographic process: his mastery of two media; his directorial control (and frequent repetition) of subject. Staats works within a repertoire of personal and collective motifs: materializations of memory; performances of memory; *fragments* that do not feel fragmentary because of his consistent formal treat-

ment. Both Lamothe and Staats are deeply involved in the editing and sequencing of their work; their dialogue with their imagery is protracted.

Pelkey, for her part, goes to extraordinary lengths (geographical and technical) to make pictures of unremarkable sites, ordinary homes or country roads, to which she attaches a jagged piece of prose, words ostensibly heard and reworked by the author to emulate speech. The relationships between words and images are obscure, and deliberately so. Nevertheless, they are transcribed, just as the objects in her pictures are picked out by movie lights against an inky sky. The initial impact of these artists' works depends on their careful allocations of description and obfuscation,

8.7 Brenda Pelkey
bush, from the series *Oblivion* (1997).
3 panels: Ilfochrome, mounted on aluminum, each 101.6 x 127 cm.
Original in colour

Pelkey's inferences tending to the social, Staats to the natural world, Lamothe's more metaphysical, but each is playing in the other's backyard despite the formal differences in their work.

Visual abstraction, or sacrifice, is their common ground. This territory is illuminated by Jacques Derrida's curatorial essay, "Memoirs of the Blind," in which he considers "the two great 'logics' of the invisible at the origin of drawing." The "transcendental" depicts the possibility of drawing; the "sacrificial" symbolized by the representation of blindness, demonstrates drawing's impossibility. There are, in Derrida's philosophical argument, many intertwining factors, all derived from his imaginative reconstruction of the draftsman's blighted vision at the very moment that he makes his mark:

The night of this abyss can be interpreted in two ways, either as the eve or the memory of the day, that is, as a reserve of visibility (the draftsman does not presently see but he has seen and will see again: the apperspective as the anticipating perspective or the anamnesic retrospective), or else radically and definitively foreign to the phenomenality of the day. This heterogeneity of the invisible to the visible can haunt the visible as its very possibility.

Drawing flows not from nature, but from memory, as Charles Baudelaire argued in *The Painter of Modern Life*.[35] These theories belong to the ontology of spectatorship, and specifically, to the curious nature of spectatorial pleasure, which Bollas has already helped us to define. Keith Broadfoot relates Derrida's proposal to another unrepresentable object in memory, Jacques Lacan's *"objet a,"* a subject of consciousness arising from a "sacrificial economy of separation and loss." *Objet a* fans our desire to be desirous, it symbolizes an original loss, it is pure abstraction.[36] We seek this object even in representation as the measure of our own existence.

This short detour through the disciplines of drawing, painting, philosophy, and psychoanalysis has a point which returns us to photographic expression and our three artists. It serves as a reminder that the presence of memory can be felt keenly — that is, sharply and mournfully — in works of art that re-create photography's myth of origins, its original struggle to seize the ground between light and dark, to strike a line between the future and the past. This struggle is hard to see in images of mimetic transparentness, though it is present in other ways. Here, at the point of sacrifice, our senses are sharpened. We are all threatened with blindness; figures of romance and ruination seem equally fated to disappear. In these landscapes of imminence, forests, and winter gardens, dramas of unconscious communication are staged. Images are exchanged. Memories beget memories. We reinvent photography in our own image.

To perceive is not to experience a host of impressions accompanied by memories capable of clinching them; it is to see, standing forth from a cluster of data, an immanent significance without which no appeal to memory is possible. To remember is not to bring into the focus of consciousness a self-subsistent picture of the past; it is to thrust deeply into the horizon of the past and take apart step by step the interlocked perspectives until the experiences which it epitomizes are as if relived in their temporal setting. To perceive is not to remember.

— Maurice Merleau-Ponty[1]

Michael Snow emerged as a painter, sculptor, and musician in the 1950s. He made his first film in 1956. To these interests he has since added photography, installation, holography, "foldages," mixed-media, "found sound" recordings, two-sided projection, video installation, performance of improvised music (spontaneous composition), and critical text. Unifying this immense body of work is Snow's interest in process and its precise description. To paraphrase Merleau-Ponty, Snow's work initiates the experience of "phenomenology for ourselves," an impression of recognizing what we have been waiting for.[2]

When Snow explains what he is about, his analogies are appeals to memory and imagination that remind us of our habits of attention even as they refresh perception. I have two categories of mental habit in mind. The first is cognitive, our ways of receiving stimuli which in photography can be referred to as visual perception. The second is cultural, our ways of recognizing what we receive. Cognition and recognition: for the sake of art, not science, Snow intertwines these activities then pulls them apart, a process that is both informative and transformative. The spectator understands better what a photograph is, and it is never the same again.

Within the realm of Snow's ontological project, parts of the photographic equation that we tend to digest without thought – the translucence of a slide or the opacity of photographic paper – are elevated in importance, while the documentary value of a photographic image – illustrating or commenting upon world events – is correspondingly diminished. The photographic pillars of time and place are reordered in the process. The moment at which the photograph was taken – the very basis of its evidentiary value – takes second place to the duration of the taking. The place is understood as the real or virtual studio. When? and Where? are thus replaced by How long in the making? and Under what conditions?

The impact of these shifts is conveyed by critic Chantal Pontbriand's discussion of Snow's photographic piece, *Plus Tard* (1977) (fig. 9.1). The title refers to temporal displacement; the imagery refers to painting. *Plus Tard* is composed of twenty-five medium-scale Ektacolour photographic prints which are presented on a single horizontal line. These photographs were taken at the National Gallery of Canada in a room dedicated to the early twentieth-century northern landscape paintings of Tom Thomson and the Group of Seven. The images are not mechanical reproductions, i.e.

static, frontal pictures in which the presence of the photographer and the duration of the exposure are suppressed. They are oblique attacks on the exhibition space: time and motion are expressed photographically; they compete with the paintings to be subjects. The camera is very active as it sweeps the gallery walls; the photographer is moving around the space, but also toward the paintings and away from them, sometimes halting on a single work, sometimes encompassing a line of canvases, the beige walls, and the emergency exit. "There are a lot of different gestures involved in it," explains Snow. "Sometimes it's very fast, sometimes the camera moves, and then it holds for a little bit of time, so that you actually get an in-camera superimposition."[3] The initial idea was to use old paintings to make something new: the gestural exposures are photographic brush strokes that mix the paintings' colours; vitalism flows through mechanism's blurs; the effect is urgent and sensual. Pontbriand responds in kind: she is absorbed by Snow's mobile painterly approach; at the same time, her analysis is thoroughly grounded in photographic process. Her senses sharpened, Pontbriand emerges from *Plus Tard* with a will to redefinition, though the genre that she redefines is neither painting, nor photography, but autobiography.

Pontbriand's reasoning proceeds from the nature of the medium. Any photographic work is autobiographical "because it consists in the recording on film of a situation that the photographer necessarily has witnessed." *Plus Tard* is autobiographical because it is performatively reflexive: the mind-body engaged in its making is recorded as a signature; the author, narrator, and main character are one; the photographs give proof of the subject. The temporal framework is complex: present-based movement through space makes a visible recording of the past while prefiguring the author's death.[4] Pontbriand is fascinated by the work as a record of bodily displacement. The duality of the piece

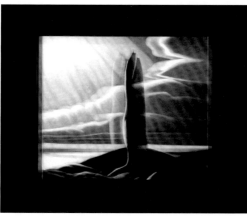

9.1 Michael Snow
Plus Tard (1977).
Installation view and detail. 25 framed Ektacolour prints,
each 86.4 x 107.2 cm. National Gallery of Canada, Ottawa.
Original in colour

brings out her own inner voices, her interests in visual art and dance. For Snow, at least on reflection, the correspondence of time and memory becomes the most interesting part, and the spark of more creative thinking: "It's almost as if every photograph being a memory carries the time that was taken in it, literally every photograph. After that we have to get into distinctions between those that amplify that, and others that don't."[5] *Every* photograph: instantaneity really means of *very* short duration.[6]

This chapter deals in depth with two photographic objects: *Midnight Blue* (1973–74) and *In Medias Res* (1998). I begin with close descriptions of these objects, in the spirit of Snow's definition of photographs as "events-that-become-objects." The actors in these events are "the manipulable variables of photographic image-making."[7] I take account of those variables, considering both the has-been and might-have-been as traces of memory. Snow's work expresses his perception, memory, and imagination in material objects, and also sends mental images into the world. Looking at *Midnight Blue*, I form my own memories of its creation through an act of the imagination. This vivid experience in two times is illuminated by Henri Bergson's account of "false recognition." Entering the virtual space of *In Medias Res*, I search for memory's hiding places; my confidence that memory is secreted in the work and the tools used to find it are explained through recourse to philosophical studies of imagination by Jean-Paul Sartre and Mary Warnock. I stated at the beginning that Snow is devoted to the "specific physical existence" of the image, to drawing out a medium's intrinsic possibilities.[8] His photographic oeuvre is built on a framework of what Edward S. Casey calls "intentional memory," a state of consciousness whose relation to imagination is explored in the chapter's conclusion.

TWO OBJECTS

Midnight Blue is a multi-media assemblage that has been discussed in terms of memory since it was first exhibited in 1979. Snow cultivates comparative thinking as a way of teasing out perceptual difference; *Midnight Blue* is exemplary as a photographic work in a three-dimensional structure (fig. 9.2).

The panel is constructed of rough spruce planks laid horizontally; a narrow shelf fixed to the bottom edge gives the object its L-shaped profile. The wood came from a sawmill in Newfoundland where Snow was then building his summer home, a rustic cabin. A colour photograph is affixed to the back panel; the other elements involved are acrylic paint, Magic Marker, and wax – a lumpy residue at the crossing of three lines drawn on the shelf. The photograph occupies most of the back panel, mounted flush with the shelf. The image is of a burning candle whose position in the frame creates the fleeting illusion that it is an actual object standing on the shelf. This illusion is reinforced by the correspondence between the background of the photograph and the wooden support. The photograph depicts the candle's illumination of a grainy texture; the joints between the planks and their photographic simulation are perfectly matched. The colour of this photographic field is a very dark blue, almost black, except in the immediate range of the flame where the image glows red. Where the edge of the photograph meets the back panel – top and sides – there is a lighter blue border painted in broad, fluid strokes.

To complete this inspection, there are several more lines to consider: two are drawn on the diagonal axes of the photograph; they pass through the upper blue border and wooden field to the top of the object. The perimeter lines of the photograph are extended by dark lines that run to

the edges of the back panel and laterally along the shelf, forming rectangles at the top corners and on the outer edges of the shelf. These lateral shelf lines also close the two triangles whose apexes meet under the waxy residue. *Midnight Blue* is a carefully crafted object: my immediate impression is of a homely construction made *unheimlich* by artistic intervention.

The sources of this uncanniness are many. One can attribute them generally to a pervasive feeling that things are not as they appear. The title is a cue, being both romantic and rational. On a purely perceptual level, as I try to make sense of what I see, the work is plainly divided between the display of three-dimensional objects and their representation – the remains of a candle on a shelf and the photograph of the candle burning. Within this relationship alone, there is a temporal split: the photograph was not taken of the spent and extinguished candle, but of the candle sometime earlier, an hour, a day, or a lifetime ago. My knowledge of candles suggests that the time difference is short, but I have no way of knowing whether the candle was snuffed repeatedly and relit, or indeed, whether the candle in the photograph is the one whose remains are on the shelf. The simplest thing to imagine is that a lit candle was used to drip wax on the shelf to provide a secure setting. The candle was then photographed and allowed to burn down, at which point it was blown out before the wooden shelf caught fire. This is pure spectatorial invention, but sticking with my story, I am able to return to the visual analysis of a piece whose making I have begun to construct as a memory based on personal experience of candles and photography. I am aware, however, that the story is mine, concocted because I have already decided what Snow was up to that day in the studio. So if some of the details are incorrect – if, for example, he was called away to the telephone during the exercise

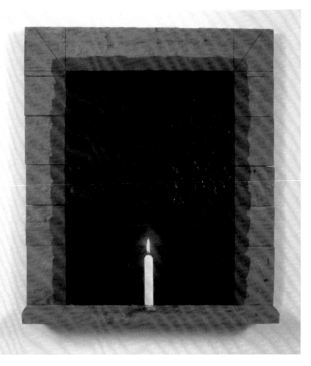

9.2 Michael Snow
Midnight Blue (1973–74).
Wood, acrylic, colour photograph, wax. 73 x 66 x 12.5 cm.
Musée National d'Art Moderne, Centre Georges Pompidou, Paris

and blew the candle out – it does not concern me. I repeat, *real time* does not concern me because I am interested in time only in the simplest abstract sense, as a way of thinking about the past as it persists in the present. To be able to think clearly about this object and its relation to time, I have to suspend my normal relationship to time and submerge myself in an alternate temporal order, that of the artist's studio where time stands still, albeit intermittently. I am then able to hear Snow when he says, "There are particular still works, like *Midnight Blue*, which point out that there was

a specific time when the photograph was taken, that things are not constant, that light changes and that a choice of a certain kind of light was made."[9] Light is the agent of change; Snow is the agent of light – he heightens my awareness of reality by casting it in ideal, experimental conditions. I will never see the light as he saw it, but if I am attentive, I can follow its mutations, or rather reconstruct them as a hypothesis for these concrete results.

In the same way the authenticity of the photograph does not concern me, by which I mean that discovering that the candle in the picture is not the candle that spent itself on the shelf would in no way affect my understanding of the piece. I assume that it is, which is another way of saying that I make it up, supplying the connection that the piece itself has not made firm. Louise Dompierre supplies the connection when she writes convincingly of the photograph as the memory of a particular moment in the life of a particular candle whose remains, "set against a photographic memory of itself," refer simultaneously to its past and present states.[10] But if I decide that the remains of the candle are not those of the candle in the picture, if I snip the cord between object and object-image, if I imagine instead that a helpful assistant scoured the shelf after the picture was taken, and that Snow (after he fired the assistant) had to drip more wax on the shelf to simulate his process, what does it take from the work? Its creation story is vulgarized, its purity diluted, but its purposive framework is uncompromised. In fact, Snow's aim of bringing me up against my assumptions has been enhanced. He uses the remains of a candle to initialize a process, encouraging me to enter the piece through my own guesswork about its creation, and from there, to rehearse the differences between then and now, presence and absence, object and image. At that point, I become susceptible to the snare of another perceptual problem which is the work's articulation of space.

I will assume that a candle, or *the* candle, was photographed in the position indicated by the waxy remains. The artist wants me to assume this: he has left the residue and he has drawn three lines on the shelf to reinforce the spot. A photograph has been taken that includes in plain sight the painted wooden back panel whose joints, deepened into shadow by the source of the light, correspond perfectly to the actual panel. To achieve this, the photograph has been enlarged to the exact life-size of the panel, which means that the candle in the picture is larger than life-size. If I want identity between object and object-image, the 5 cm space between candle and back panel has to be mentally eliminated. One might say that Snow is encouraging me to forget about it, though not to propagate an illusion, but to instigate the mental exercise of restoring it – uncovering this discrepancy reminds me to mind the gap.

I begin to understand that an enlargement has been required to make the wood grain in the photograph correspond exactly to the wood grain below, and that the enlargement has been calculated with the thickness of the photographic paper taken into account. Another spatial nullification has taken place, and it is unsettling because it raises other questions about the construction of the piece. The blue field: does it continue under the photograph? Yes. Was it the subject of the photograph, and are we thus expected to understand the shift between the bright blue of the border and the inky blue of the photographic field as the difference between candlelight and gallery light? Yes. Is it all a function of agency? Of course. Have I forgotten that one is acrylic paint and the other chemistry on paper? I should not, but it is difficult. The photograph wants to dissimulate difference, to have me take it for what it conceals. The crossing lines double-cross the illusion: they affirm the surface of the print, yet continuing beyond it, suggest that they are also inscribed below, thus *in* the photograph as

well as *under* it. Continuing in self-contradiction, the X upon the work performs another useful function which is to cancel any suggestion of looking *through*, say, a window, an allusion that the work perversely seems designed to make.[11]

Snow has gone to great lengths to overcome our culture's predilection for art as an Albertian window.[12] In 1978, commenting on the effect of thinness achieved by his two-sided film projection, *Two Sides to Every Story* (1974), Snow said, "The work escapes from the idea of looking out a window that usually happens when films are projected on a wall or when anything is put on a wall with a frame around it. It's amazing how windows are influential. They seem like metaphors for the eyes in the head; when you're in the house you're looking out the eyes and we are the brains." The association is hard to shake. In the same interview, Snow called the part of *Midnight Blue* that I have been calling a shelf, a "ledge."[13] Thinking of the projection as a ledge, and considering the lumber's raw state, gives the object over to architecture: a ledge implies a window, though here again I must contend with a reversal since instead of looking out, I am looking in, and following Snow's metaphor, looking into another mind where the candle, though in reality spent, still burns brightly. "I'll leave a candle burning in the window," is the waiting lover's promise. The meaning of *Midnight Blue*'s candle is not so hopeful; it is first of all a blind window, blocked by self-referentiality (the photograph). The work is also associated in Snow's mind with "death, corpse and memory,"[14] connecting to the tradition of northern Baroque still life, to the paradoxical iconography of the *vanitas*.

As a memento mori, the candle, softly burning, is "a symbol of the transience of life."[15] The candle "petering out" conveys the same sober message.[16] Conversely, the lighted candle can be a "symbol of individuated light, the life of an individual as opposed to the cosmic and universal life."[17] In this case, there is the duality of a lighted candle and its extinguished remains, or perhaps just the latter, since the work emphatically makes the point that a photographic representation is not a candle. Whether autonomy or transience is implied by the work, the candle, slightly larger than life, stands in for the body. The emblem has been retrieved from Dutch seventeenth-century still life and placed in a photographic version of the genre's "curiously indeterminate space" whose measurement is almost impossible.[18] There are parts of *Midnight Blue* in which flecks of light foster an atmospheric impression of immeasurable depth, a cosmos at whose edge the "candle" flickers. This effect is caused by the reflection of a central source of light, a candle, on the rough planks. This artist's material was once a tree, a living thing; its transformation into a work of art is a death of another sort. Such romantic musings are nurtured by the tactile qualities of the painted and unfinished surfaces; they are held in check by the seamless photographic memory; this is *Midnight Blue*'s ecology of sensuality and conceptual rigour.[19]

I now turn to the second object, *In Medias Res*, a large colour photographic image which is presented on the floor (fig 9.3). Technically, the work is an assemblage, comprising six panels that form a unified photographic field, but the seams are subtle. In terms of subject matter, *In Medias Res* can be assigned to two photographic genres, the descriptive architectural interior and the narrative directorial mode. In terms of photographic style, the work is strung between temporal signposts, one emphasizing process and duration, and the other transparentness and instantaneity. Before pinning these oppositions down, I had better explain the perceptual dilemma that I am placing you in, as a reader of this book.

The bird's-eye view of *In Medias Res* offered by a printed reproduction is both faithful to the process and a cheat;

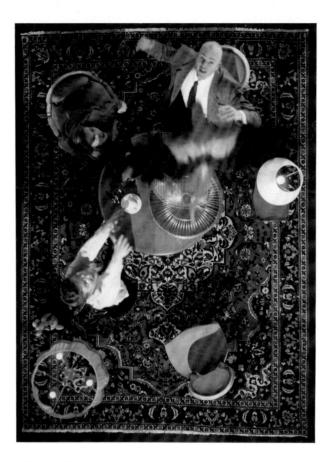

Above **9.3 Michael Snow**
In Medias Res (1998).
Colour photograph presented on the floor, 260 x 360 x .5cm

9.4
In Medias Res (1998) and *X60* (1979).
Colour photograph presented on the floor, 260 x 360 x .5cm and colour
photograph 123 x 220cm. Exhibition view, MAMCO Musée d'art moderne
et contemporain, Geneva

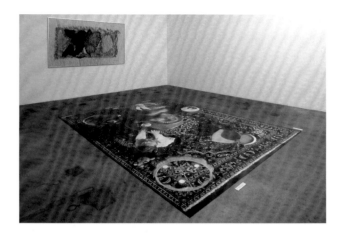

only the camera "sees" the work from this perspective. Within the gallery, where the work was intended to be viewed, single-point perspective is a meaningless concept; there is no correct visual distance from which to begin describing this piece (fig. 9.4). In fact, the first thing one might say is that the ideal spectatorial position is continuous motion, around and around the perimeter, fixing on the object from a series of oblique angles. The spectator who stops to consider the shape of the object in relation to the eye is confronted with a tipping pyramid.[20] With this work, Snow has succeeded in creating a photographic image that obviously does not translate to any other medium, even the printed page, without fatal distortion. That is of course his argument for all of his work, that each object is medium-specific; in this case, there is no getting around it, or rather, one is obliged to.

Moving around the perimeter, I take the measure of a work whose scale has been determined by the size of one of the depicted objects, a rectangular Persian carpet. On the long sides, the photographic work extends just beyond the bound edges, and on the short, just beyond the fringe. The

all-over design of the Persian rug – the weaver's *horror vacui* – increases my visual restlessness, an effect enhanced by the camera's tight focus on the pattern. The other elements of the composition – people, furniture, and a parrot – fall out of focus from the ground up, as their parts draw closer to the camera. The people's hands as they gesture make useful points of comparison; in the language of photography, they speak.

The elements coalesce into a domestic interior. Furniture arranged on the carpet includes three chairs, two lamps, and two side tables, as well as the largest piece, a round table around which a conversation group has formed of three figures, two male, one female. Their clothing and grooming suggest that they belong to the middle class or higher, the woman confident in red, the men both wearing ties. There are books stacked on the table. A modest bouquet of tulips sits off to the side in a vase. Refreshments are in the offing. Occupying about a third of the table surface is a birdcage whose door is open. Hovering above the scene, wings spread, is a parrot. From the startled, upturned faces of the figures, their rising bodies, and the male's reaching arms, I take it that the bird has just escaped. Its proximity to the camera throws its plumage into brilliant abstraction.

What I have just described is the setting of this photographic play, as well as the development of its characters, main crisis, and plot resolution. They are compressed into a single moment, just as the figures, furniture, and parrot have been compressed into an object, a photograph, no thicker than the rug. The artificiality of the scene is overt; the lighting, theatrical; the social dynamic, rich. Everything has been brought together for this moment of release, including the actors whose energetic expressions do little to allay my suspicions that the parrot is, as the French say, *naturalisé*, that is, stuffed. By describing the escape, I could be conspiring in a deception, or perhaps I am simply deluded.

For why have I assumed that the bird, alive or dead, is ascending? Its direction might be downward, making the scene a modern-day Pentecost. Or the truth might be that the object is a sculpture hanging on a wire. I am speculating on the evidence of unfocused camera vision – from the perspective of the gods, there is no way to distinguish upward or downward motion from stillness thrown out of focus; a blur is a blur. I have to accept it on its own terms; I have to decide first of all what those terms should be. As Sartre suggests, "A hare vaguely perceived is nevertheless a specific hare. But a hare which is an object of a vague image is a vague hare."[21] What we have here is a specific image of a vague parrot. However caused, it is both moving and immersive.

The Latin title, *In Medias Res*, translates into English as "in the midst of things." Homer, for instance, began his story in the middle of things, without a preamble. The possible nature of these things is outlined by the OED in its general introduction to the English word "in" as "a preposition expressing the relation of inclusion, situation, position, existence, or action within limits of space, time, condition, circumstances, etc. In ancient times, expressing also (like Latin, *in*) motion or direction from a point outside to one within limits." In and/or into the middle of things: the title captures the work and its reception, as an exploration of internal relations from within the work's virtual space – a room-sized rectangular base whose sloping walls rise up to the apex (the all-seeing camera eye). The three-dimensionality is of course purely notional – Snow's very point is that "the whole scene is now flat on the floor."[22] Where does that leave me? In the middle of things, and looking into things, erecting and entering a space of creation and recreation.

This is where I meet Snow. Considering the importance of memory in his work, Snow makes an intriguing link between *In Medias Res* and the linear sculpture of Alberto

Giacometti. Intriguing because Herbert Read once defined linear art as "a memory image"; he drew his examples from the Lascaux caves.[23] Snow's own recollection of Giacometti's work is vivid and situated in a spatial dynamic: "It really is about making the space, the actual surrounding three-dimensional space, hook into and invade the structure." Sometime in the late 1990s, with no particular work in mind, he began thinking about his own purifying approach to photography as having some connection to Giacometti.[24]

One term for the linear tendency in sculpture is "spatial-cage" or "open cage" construction. Giacometti's *The Palace at 4 a.m.* (1932–33) consists, according to Read, "of the outlines ... of buildings with one or two symbols for human beings or birds suspended within the scaffolding." In later works, such as *A City Square* (1948), Giacometti has eliminated even the skeleton of the building. Read notes that the elements "seem to weave a concept of space by their indicated directions, which are opposed, away from each other. They do not seem to have a common center, and by this ambiguity they create an impression not of perceptual space but of metaphysical space."[25] I have persisted with Read to draw out the dynamics of Snow's two-dimensional spatial cage. For the figures of *In Medias Res* do relate to perceptual space; they relate vigorously to a colourful common centre. They are enclosed within the scaffolding of an implied architectural space: they are *in camera*. Snow's tensile structure of perimeter and centre draws our attention to the virtual bars of a photographic cage. Rosalind Krauss's discussion of Giacometti's *Suspended Ball* (1930–31) seems almost to describe what we are seeing in our mind's eye:

[Giacometti] is able to make it [the object within literal space] an ambivalent participant in the space of the world, in that, while its movement is obviously literal, its place in that world is confined to the special theater of a cage – it is boxed off from the things around it. The cage functions, then, to proclaim the specialness of its situation, to transform it into a kind of impenetrable glass bubble floating within the spatial reservoir of the real world.[26]

Snow's open-cage construction translates these spatial inventions to photography, or rather, he makes me aware of myself as a spectator, looking into a space. He inflates the glass bubble, then bursts it by leading me to "the true extreme thinness of the image."[27] My movements are in and out of the cage, *in medias res*, between the camera and the carpet. It is a surreal space of ultimate compression and spectacular release. Surrealism and the unconscious being what they are, it is interesting to consider that Giacometti's open-cage construction, *The Palace at 4 a.m.*, was a memory palace, its minimal signs of eroticism and terror decoded by the artist in a romantic autobiographical text.[28] Likewise, in *In Medias Res*, the images within the image make sense by personal association; the only way back is through Snow's mental reconstruction of his process, his re-erection of the scaffolding of memory. In *In Medias Res*, accident plays a part, a kind of orchestrated Cagean accident – conscious or unconscious, is this another of Snow's famous puns?

IMAGES

Examining *Midnight Blue* and *In Medias Res* separately conforms to Snow's views about media. Within the traditional categories of art, these objects are opposites, or one might say, mirror images of each other. *Midnight Blue* is a sculpture: a sculptural analogy for photographic illusion. *In Medias Res* is a photograph: a photographic analogy for sculptural experience. Photography is visibly their common ground;

both objects articulate photographic process by making us conscious of the photographic transformation of reality, especially the factor of compression (three-dimensions flattened onto "paper"). As Snow explains, "I think people generally look through photographs to the subject with the kind of primitive faith that they are being shown the subject. I'm involved in a certain kind of skepticism that is just pointing out that the photo is a shadow of some subject, and also a section of it. It's also something that is very distantly related to that subject, it's a photograph that has other kinds of values."[29]

On a basic level, recognizing the differences between photography and reality enriches visual experience. Comparing these photographic works yields even more. *Midnight Blue* courts the eye with colour, highlights, and texture; *In Medias Res* explodes with photic energy in a contrastingly even field. Neither work is sentimental, though each frames memory in a domestic sphere. Of the two, *Midnight Blue* is the most overtly retrospective; it coaxes the spectator back and forth through the stages of its production. *In Medias Res* seems powerfully in the present, though a present that demands some explanation, some fragment of background. Both works, as I have shown, are temporally unstable; one could also say that they command a surplus of time, *moments* secreted into the moment of the photographic exposure.

This is true of any photograph, of course. Photography involves both planning and previsualization. A photograph that has been previsualized is based on a mental image developed from memory — visual experience and technical knowledge — and pre-processed by the imagination. Previsualization as a technique is both predictive and corrective, allowing the photographic artist to adjust light and exposure so that each element of the scene, however bright or dark, falls within (can be squeezed into) the range of photographic materials. In a still life, or in a *tableau vivant*, previsualization is part of the conception of the work, a mental process that precedes its execution *in situ* or in the studio. The photographer anticipates the results and manipulates equipment, film, and chemistry to bring the registration of the scene in line with his or her vision of it as a photograph.

Snow has been previsualizing photographically since he was a child. In *Michael Snow /A Survey* (1970), a bookwork that incorporates reproductions of Snow's paintings and sculptures with personal photographs, we find a snapshot of the author at age six, taken from the soles of his feet upward. Snow's memory is that someone told him that a photograph of a person taken from this unusual angle would make the subject's feet look enormous; he asked his sister Denyse to take one of him. In sharing this personal anecdote, Snow sends two messages: first, that he has been thinking about object-images for a long time; second, that photographic distortion for its own sake is child's play.

As a mature artist, Snow is involved in the more serious game of disentangling, or freeing, mental and photographic images. In a work such as *Plus Tard* he records what *only* the camera could have seen. Human vision might be said to fix and blur, but not both at once, in the same sense impression. Snow is the agent of these simultaneous in-camera effects, he causes them to occur and to be recorded, but even he is not seeing them in the moment. Rather he is presciently present, sometimes emphasizing that fact in the work, leaving traces of himself as *homo faber*. This is the case of *Plus Tard*, and the explicit intention behind Snow's presence in *Authorization* (1969) and *Manifestation (Autourisation of 8 faces)* (1999). But in *Midnight Blue* and *In Medias Res*, the ghost behind the machine leaves only mental traces. These works are synthetic images of mental images that, being photographic, are becoming the memories of their making. They form, in other words, a temporal loop.

In the meditative *Midnight Blue*, the loop stops and starts and stutters, as the mind disassembles a constructed work, *step by step. In Medias Res* is a shell game; it hides its history behind startling instantaneity.[30]

In a 1972 interview, Snow commented on the differences between information and the illusion of knowing:

Information has so many levels. We describe our minds as being divided up so that you can say that one aspect of it is imagination and another aspect, history or memory. Of course, we can't operate at all without memory. That's very important. On the other hand, there really isn't ever anything except now and one is carrying this residue which makes it possible to go into the future. But all the contents of the mind that deal with the past can be described as fantasy in that they're unprovable.[31]

When information presents itself in the form of a photograph, the illusionism is persuasive. Snow accepts that, even as he puts it into question; he is a skeptic with a cause. Making people aware of the differences between camera vision and human vision prompts them to think dialectically about the formation of all the things we call "images."

In *Midnight Blue* one is struck by contrasting representations of space, the depth of the shelf versus the "mysterious illusionism" of the photograph. The actual candle and its supposed likeness present different points of a singular existence simultaneously, though on discontinuous planes. The recession of the photographic image creates a faintly disturbing spatial void. I look at the image of the candle and I am urged to recognize what I have never actually seen, the burning candle on the ledge. The spectator of *Midnight Blue* rehearses a condition that psychologist Henri Bergson has defined as "false recognition."[32]

The circumstances of false recognition are quite ordinary: a person is overwhelmed by the conviction that he or she is reliving some episode of his or her past life; the feeling sticks. Bergson cites a very lucid informant: "I was a spectator of my own actions; they were inevitable." The illusion memory springs up with immediacy, yet it is anchored to no particular moment: "it dwells in an indeterminate past – the past in general." The phenomenon is described as "being clearly a recommencement of the past, a *twofold* phenomenon, which is perception on one side, memory on another." For the psychologist, the interest lies in the identity of these impressions: "false recognition implies the very real existence in consciousness of two images, one of which is the reproduction of the other."

Underpinning Bergson's interest in false recognition is his axiom that memory is formed at the same time as perception: "Step by step, as perception is created, the memory of it is projected beside it, as the shadow falls beside the body. But, in the normal condition, there is no consciousness of it, just as we should be unconscious of our shadow were our eyes to throw light on it each time they turn in that direction."

The mind that becomes conscious of its normal processes of perception and memory may grow confusedly aware of what seems a "memory of the present," deeming it a repetition of past life, even as it unrolls. Oscillating between simple perception and perception doubled with memory splits the personality into an actor with freedom of action and a spectator watching himself helplessly from the stalls. This is different from ordinary recollection in which the circumstances are not fixed, but fluid. I can remember myself watching the same play, in the same theatre, by the same company, but I am not the person I was before, and I know it. In false recognition, the frames are fixed: "I am present at the same play with the same sensations, the same preoccupations, I am at this very moment in the same posi-

tion, at the same date, at the same instant of my history where and when I was then." This recognition is paralyzing.

An episode of false recognition may arise from uneven attention: Bergson speculates that a mind, suddenly conscious of its own discontinuity, attributes one of two images, possibly the weaker or subconscious perception, to memory. What is puzzling is that the memory-image and the perception-image continue to run in tandem, jostling for attention as they do in a dream. Bergson is naturally interested in the exact condition that will allow this feeling of duplication to occur in waking life. He ultimately defines false recognition as an interruption in the psychical flow, a form of arrest that detaches the mind from its normal preoccupation with the future, and attaches it to memory as it is forming in the moment. "As soon as the arrest occurs, false recognition overtakes consciousness, covers it for some instants then falls back, like a wave." The phenomenon is harmless, in fact, quite possibly beneficial as a slight shock, homeopathic in its effects on a mind teetering on the edge of what is properly a dream state.

Midnight Blue captures all the nuances of false recognition and translates them into the discourse of photography. The brilliance of the piece is its assimilation of mnemonic structure and the specificity of its insights, for what is presented is not memory, but *illusion memory*. Its expression is not found in the photograph or the candle *per se*, both of which are tangible objects, but in the void, the liminal space of luminary transformation, day passing into night, perceptions and memories passing into dreams. *Midnight Blue* coaxes the spectator back and forth across the ledge. Snow's correlation of photographic and mnemonic imagery underlines their shared shadowy qualities. At the same time, he shows how easily a photographic image can be mistaken for direct perception.

The iconography and mood of *Midnight Blue* direct my attention to memory, and I find its expression in the space of oscillation that opens up between the object and the mirror-image of its original state. This, I repeat, is a measurable space. This point marks a difference with another memory-image, this one nested in *In Medias Res*.

This *tableau vivant* is a colourful study in arrested movement. The scene is realistic, though the circumstances leading to the main action are rather imprecise. At the same time, the work allows no slackening of attention; it is forcefully present. The gestures of the players and the dynamism of a blur direct our eyes to a bird-like shape hovering above an open cage. Mentally, we enter a space in which there is "action above" and "action below" – ironically, the intensity increases in direct proportion to the camera's loss of focus. The work's occupation of space has an upward thrust, an illusion fostered by the force field of the drama and the perambulations of the spectator. *In Medias Res* presents as a work of creative imagination, its spontaneity carefully rehearsed. Film theorist Regina Cornwell once borrowed a phrase from Marianne Moore to describe Snow; she called him a "literalist of the imagination."[33] What Snow literalises in this work of the imagination are its raw materials, the sense images derived from earlier perceptions. He cannot picture them because to do so is to replace them with a tangible image, a falsifying facsimile. He can, however, show us how and where to look. *In Medias Res* photographically describes those caches of memory.

Snow begins with a fully integrated photographic image whose scale – the perfect equivalence of the carpet and the photograph – and immediacy – the capture of a moment – conspire to lull the spectator into a false consciousness: the image seems real. At the same time, and I mean this literally, we become conscious of photographic language, the expression of space and its compression onto the photographic surface. The way that the photograph presents, the

way it impresses itself on the mind as whole and spontaneous, the way its actors and their actions colonize real gallery space: these factors are to a degree persuasive. But they are met with equal force by indices of unreality, beginning with the staged quality of the piece, the omniscient point of view, and the necessity to infill a suggestive, but sketchy, plot. *In Medias Res* makes us highly conscious of the struggle that occurs before any photographic representation, by setting up the internal relations that characterize a mental picture, and dismantling them in the same stroke. It is not that this photograph fails the test of reality, for Snow offers it not a chance. The work goes directly to a much more rigorous test for which it qualifies and fails spectacularly: the activation of pure perception.

When we inspect a photograph, whether for a second or an hour, our imaginations go immediately to work, infilling from memory the passages we cannot see. We extend the visual information and also pry it apart in an effort to reconstitute the sensorial conditions of the original. We are hardly conscious of this effort, and thinking about it, we may feel a little naive. And yet we persist, though not because we believe in the ultimate truth of the photographic image, but because we enjoy the interplay of perception and imagination, a process that is continually taking place in our minds, and whose partial rehearsal and frame of social intercourse is offered by photographic experience. Mary Warnock explains the mental image in her philosophical study, *Imagination*: "The image *is* our attempt to reach the non-existent or absent object in our thoughts as we concentrate on this or that aspect of it, its visible appearance, its sound, its smell."[34] However symbolic its terms of representation, the photographic image teases us with the idea that we are grappling with a closed, therefore manageable, set of visual relations and might actually get to the bottom of them. Methods of perception, imagination, and memory all come into play.

Sartre's phenomenological study of imagination is an attempt to isolate the imaginative consciousness from other kinds of mental activity. The imagined object must be isolated from reality; it must be grasped as both distinct and absent. The text is replete with examples, one with particular resonance for us here. Sartre considers how we think about the hidden arabesques of a carpet that is partially covered by furniture. "The legs of the arm-chair which stands before the window conceal certain curves, certain designs. But I nevertheless seize these hidden arabesques as *existing now*, as hidden but not at all as absent." A consciousness of the real has been established by the way in which he grasps the continuation of the pattern: "I *perceive* the beginnings and the endings of the hidden arabesques (which appear to me in front and in back of the leg of the chair) as *continuing* under the legs of the chair." The carpet that continues invisibly under the chair cannot be perceived, but neither is it imagined. What occurs instead is an *intentional* act that relates both to recollection and anticipation.

This is Sartre's imaginative act of memory: "In a word, just as when I want to *see* actually the hidden arabesques under the chair I have to look for them where they are, that is, remove the chair; so when I recall this or that memory I do not *call it forth* but I betake myself where it is, I direct my consciousness to the past where it awaits me as a real event in retirement." The hidden arabesques were fully present before they were covered by the chair; their continued co-presence is tinged with the past. A sense of memory combines with prediction based on the visible form: "The arabesques hidden by the chair are also the real complement of the gesture by which I remove the chair as the present and latent existence hidden by the chair. All real existence occurs with present, past and future structures, therefore past and future as essential structures of the real, are also real, that is, correlatives of a realizing theme."[35]

As Warnock points out, Sartre wants to assert the freedom of imagination – its total emancipation from the real. His determination leads him into certain inconsistencies, notably his extension of perception to the invisible. Warnock disagrees with Sartre's sharp distinctions between memory and anticipation, and memory and imagination. Helpfully she suggests that Sartre's acknowledgment of the *thought-element* in perception – "a gap into which the imagination might fit" – opens the door to Ludwig Wittgenstein's notion of *aspect-seeing*, a concept that admits recollection and perception into the same image. In this light, Warnock proposes a general rule: "Forming mental images, creating or understanding works of art, understanding the real world in which we live, are all of them to some extent dependent on the *same* mode of thought." Any differences reside in the degree or detail of the analysis, and for this subtlety, we can be grateful to Sartre. We need such close observation, for as Wittgenstein says, "We find certain things about seeing puzzling because we do not find the whole business of seeing puzzling enough."[36]

In *In Medias Res* our eyes are drawn to the focal plane of the photograph which is the patterned carpet. No further recession is possible; nothing is hidden "behind the photograph"; the visible jostles with the invisible within a space created by the dynamic rebound of the surface. So our eyes linger on the carpet, tracing mental pictures in the pattern, completing these pictures in the fields that the furniture conceals. Memory is thus activated in a state of anticipation. In the middle of these things are three human figures formed by radical compression of volume and definition, figures that are flat, but also craning, pushing up, reaching into the spatial cage. There is room within this system to move; there is indeed considerable dialectical space for Snow and his express desire "to make seeing palpable."[37]

The figures are our guides. Their gestures can be interpreted in three ways: we recognize that they are not at rest; we interpret their body language in light of pictorial conventions; we *feel* viscerally what they are doing. This last point is most important, as it strengthens our sensibility to the virtual space and stakes our place in it. Our perceptions are thus tutored by both cultural and somatic memories: we experience what Herbert Read has defined as "haptic sensations that take place inwardly" – not just touching, but stretching, contracting, swallowing, experiencing the body from within as an empathetic response to a sculpture.[38] For Read, images of touch and sight are antithetical; sculpture and painting are different kinds of experiences, different kinds of art. For Snow, different media are dialectical, mutually informative, in constant touch. It is true that we cannot attend to all media in the same way, just as we cannot digest all the elements of a single work at the same time. Snow heightens our awareness of the relational structure of perception, of absolute distinctions and family resemblances. *In Medias Res* is a photograph that presents as a global impression – immediately, on impact – and in successive impressions – step by step, by accumulation. The latter is both an analogue and activation of memory. Snow's earliest awareness of this can be traced, as I have argued elsewhere, to his relationship with his father who progressively lost his sight as the result of an accident.[39] This consciousness-framing experience was crucial to his development as an artist, though he rarely thought in those terms. In 1971, Snow wrote,

Am I learning anything? I'm not learning much because there's so much to learn and there's so much to remember, I feel sure I forget a lot. I often have a kind of wrap-up intuition of the nature of an event, simultaneously aesthetic, psychological, biological, philosophic, political ... leaving a vaguer record than simpler experiences ... and

memory being somewhat selective (who really knows the mechanics of its choices?) the residue of this recently added "stuff" when sieved through the records of previous experience for re-examination often seems to consist of somewhat familiar particles. Recollections are (naturally) "stylized" … and … perhaps excess memory can spoil while stored. So in a way I'm pleased that I apparently have a poor memory. Infantile freshness. What a strong wind! Reality was and always is a form of memory even at the moment of perception of perception …[40]

MEMORIES

Snow conceptualizes the photographic act as follows: "That cameras are mirrors with memories is the first important understanding. That 'subjects' are transformed to become photographs is the second."[41] The nature of these 'subjects' must be absolutely clear. As a member of the culture, Snow responds the way most people do to their personal photographs: he takes them, preserves them, and enjoys looking at them in albums, largely because of his fondness for the people and places shown. He is equally attached in a different way to the 'subjects' in his photographic works of art: the qualities and colours of light, the traces of time and motion – what the mirror is capable of remembering. For the artist, the photographic act is a movement toward remembering.

Casey's description of intentional memory stresses the importance of content: "*what* we specifically recall is typically more conspicuous than *how* we recall it."[42] Considering Snow's 'subjects' one might jump to the conclusion that he is simply reversing the natural order, and that would be wrong. Rather, one might say that the *what* and the *how* are the same. *How*, according to Casey, is by varying degrees of clarity, density, texturality, and directness. These are terms

that might also be used to qualify the relationship between a documentary photograph and its subject – they belong to a different photographic order. Snow's *what=how* can be defined as the materialization of a performative attitude. The content of his work is the optimization of photography's promise to remember. Snow's involvement of others in that promise is what makes his work so compelling.

Snow involves us in a variety of ways that coalesce in *Midnight Blue* and *In Medias Res*. He signposts his process, opening pathways that carry us back to the genesis of his work, including both intuition and the inspiration of other artists. He uses motifs that have symbolic resonance, such as the candle, the tulips, the tipping cups, and the hovering bird, to immerse us in the poetry of Western visual language. For even in the seventeenth century, "no object stood for any single aspect of reality, but rather for a whole complex of ideas."[43] So these elements confirm, rather than carry, the intentions of the work. Generally, Snow reminds us that our apprehension of the world is mediated by associations that we are barely aware of, indeed that we tend to neglect as members of a present-minded species. He activates our awareness of remembering by creating object-images that are analogical to the process. His activation-acts create activation-content.

The awakening consciousness becomes alert to a photographic apparatus that relates to Casey's "memory-frame" and "aura."[44] The memory-frame consists of four factors that identify a mental image as a memory. They are not all necessary, but remarkably, all four can be accounted for analogically in Snow's work.

The first is what Casey calls "worldhood … the embrace of an environing world." The remembering mind shifts to another setting with specific surroundings: "an arena in which the scene and the specific content can emerge and unfold." It should be clear by now that Snow's setting is

conceptual, that he endeavours in his work to release the spectatorial mind from actuality and to make the spectator mindful of this process. At the edges of the frame are the surroundings – the context of the event – factors of conception, production, exhibition, and reception. These are by no means negligible: on the contrary, a concomitant awareness of the complexity and fluidity of context enhances our experience of Snow's work. We have to know, for example, how photography is ordinarily received to read the signs of false recognition in *Midnight Blue*. On a much subtler level, we can enjoy a subversive detail, such as the electrical cord that snakes onto the carpet in *In Medias Res*, breaching the perimeter of the art. This audacious little power line reminds us of the umbilical cord between photography and reality. *In Medias Res* supports that level of dialogical play.

The second feature of Casey's memory-frame is "self-presence": a consciousness of being at the scene remembered. An immersion in process is the equivalent of "being there." Snow sometimes injects himself into the work as a mark of presence, something like the painter's brush stroke, but the absence of the artist can be just as effective by relinquishing the re-creative making to the viewer.

Casey remarks that the third and fourth factors are often indissociable; the translation of real space and real time into the spatio-temporal framework of remembering. Spatial characteristics can be quite varied: schematic, sensorially complex, capacious as the landscape, or confined to the individual body. Throughout this book, there are photographic images that capture the close association between place and memory, whether personal or collective. In the case of Snow, suspending closure is essential; spatial references must remain indeterminate. In my encounter with these works, I was sensing the "clustering tendency" of *Midnight Blue*'s emblematic still life, the "compressing effect" of *In Medias Res*'s layered surface, and in both works, a kind of "gappi-

ness" that, Casey says, is more faithful to space remembered than space experienced as a continuum. Our recollection of time tends similarly to be vague, despite the reminders offered by modern technology. Chronology is complexified by clusters of association that knot, compound, or distend memories into manageable, retrievable forms. The very nature of photography as a time-based medium creates a certain tension within Snow's activation-acts, one that he exploits in *Midnight Blue* by emphasizing the temporal interval between the representation of the candle and its residue on the shelf. *In Medias Res*, as I have shown, erects a spatio-temporal cage in which the blur caused by the shallow depth of field heightens the viewer's belief in the dynamism of the scene, its superabundance of instantaneity.

The component that Casey calls the "aura" relates to Bergson's assignment of certain kinds of mental images to a "zone of indetermination," a kind of seedbed for action, as opposed to reaction, that expands in direct proportion to the development of human consciousness.[45] As Casey explains, the aura's "intrinsically diffuse nature" nevertheless can be distinguished in two forms: the "margin" and the "atmosphere."

The margin, or "blurred fringe," is the penumbral zone that surrounds the specific content and memory frame, a space of emergence and vanishing. Casey compares it to the nondescript border of imagination: "an obscure perspective without horizons, without limits." In *Imagining*, Casey had cautioned that the term "margin" might be a bit misleading, because the zone is neither discrete, nor distinct, but integrated and on the same frontal plane as the imaginative presentation.[46] The zone is difficult to describe because it lacks content; it is pure process. It is perhaps easier to say what the space between memory and imagination is not: an abrupt stopping point. Rather the image dissolves, according to Casey, into "a terminus without

determinate dimensions." Between memory and imagination, there are differences in our awareness of the margin; memory tends to blend into a context of actuality, while the "imaginal margin" remains intact as a place in which our minds continue to wander. Atmosphere is the emotional state that accompanies memory; we know it because we feel it. The ebb and flow of imagination and memory – our susceptibility to confusion in this field – are suggestive ideas, especially when nurtured by emotion.

There is just such an occurrence in *Midnight Blue*. The work's oscillation between past and present extends beyond the photographic image into a blue painted border whose particular qualities we have, to this point, ignored. The border displays the painted surface that is depicted by the photograph; the photograph and the border occupy the same plane. In terms of information, the edge of the photograph is porous, in the sense that visual data and certain qualities flow back and forth between elements that are not "the same." Gazing at the work, I see the difference between a painted blue surface under gallery lighting and a photographic image of the same surface lit by a candle. But the same determination would have been possible with any extension of the painted rectangle; the border might have been a hard-edged stripe. What there is instead is a lovely blue wave lapping at three sides of the photograph.

The retrospective atmosphere of *Midnight Blue* licences a certain degree of romanticism. A constellation of ideas is met in this work, as well as an inchoate nostalgia. To make a work of memory, Snow had to be immersed in memory, and he was. He was building his Newfoundland cabin. He had recently completed a major survey of his work for the Art Gallery of Ontario in which a recurrent motif was the beautiful natural setting of a summer home that he had loved as a child, his maternal grandparents' cottage on Lac Clair (fig. 9.5). The siting of this building was, and still is, truly

MICHAEL SNOW / A SURVEY

9.5 Michael Snow
Michael Snow/A Survey (1970).
Cover of artist's book, published by the Art Gallery of Ontario in collaboration with the Isaacs Gallery, 22.3 x 21 x 1.2 cm

extraordinary. It occupies a whole island, so that the water surrounds it completely. One can only imagine the quality of the light. Snow felt then, and we can continue to feel, the power of its influence.

The stream of thought flows on; but most of its segments fall into the bottomless abyss of oblivion. Of some, no memory survives the instant of their passage. Of others, it is confined to a few moments, hours, or days. Others, again, leave vestiges which are indestructible, and by means of which they may be recalled as long as life endures. Can we explain these differences?
— William James[1]

It is a commonplace of English landscape studies that young John Constable was inspired by contemplating Claude's *Landscape with Hagar and the Angel* and that he projected this vision on England for the rest of his productive life. This is the same Constable whose spontaneous oil sketches of clouds seem to have anticipated Impressionism. That one artist could be fascinated with transient, atmospheric effects, obsessed with topographical detail, and also in the grip of a Picturesque formula should surprise no one; the human mind is a mill of contradictions. Constable has been held to account for perpetuating an image of East Anglia as a cultivators' paradise when the economic realities of East Anglian labourers were anything but.[2] Figuratively speaking, Constable viewed the troubles through a Claude glass while he went about his memory's business.[3]

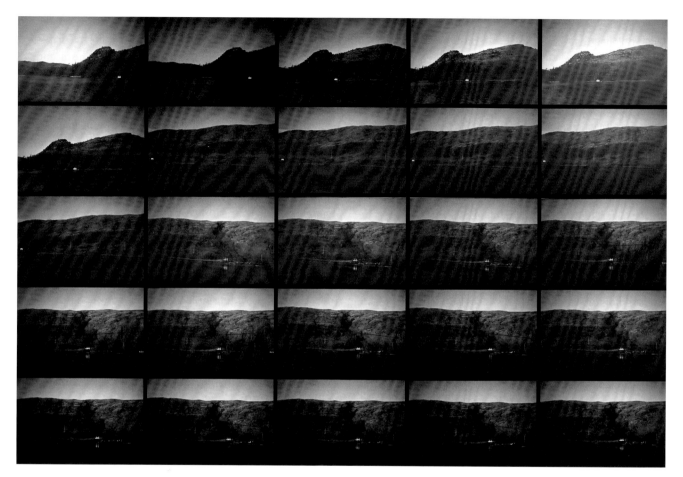

10.1 Robin Mackenzie
Far Side/Near (1975–76).
25 colour photographs, 40.64 x 60.96 cm each, overall 203.2 x 304.8 cm.
Photograph by Eberhard Otto. Original in colour

The beauty of *The Principles of Psychology* is James's illumination of mental habit. He stresses its determinativeness and tries to shake it up, all in one breath. Thus his analysis of the stream of consciousness allows the reader to sense its unstoppable flow, while breaking it down into objects of thought: "These lingerings of old objects, these incomings of new, are the germs of memory and expectation, the retrospective and the prospective sense of time."[10] One might think of a stream of consciousness as cinematic, but that analogy falls short of James's concept, at least materially. For it is not a question of one frame succeeding another so quickly as to simulate unity and flow; the stream of consciousness is more like a panoramic assemblage of still photographs in which each frame carries something of the one beside it, so that the sweep across the horizon is composed of images that reprise slightly and move forward in rhythmic waves.

James's example is schematic and temporal: your "present thought" A B C D E F G will be succeeded by B C D E F G H which will be succeeded by C D E F G H I. I need a picture of this, so I imagine myself on a shoreline. I scan the horizon, left to right, constantly orienting myself with a bit of detail – how far the wave travels up the beach, a bit of driftwood, a seagull, a distant light. Some markers are fixed, like the lighthouse, while others are changing in predictable and not so predictable ways that summon the entire sensorium. The view is both continuous and composed, a series of deep plunges into space, controlled by reference points, the most important, my viewpoint (our individual bodies). As I scan, I post the view with mental markers, so that I know where my eyes have been. In this state of heightened alertness, memory seems almost visible, an afterimage that bridges outgoing and incoming sensations. In fact, what I

am sensing is memory's crucial role, for this exhilarating experience is also a basic exercise in survival.

I have projected James's schematic into space, but it is important to understand that his own application is to time, and specifically the units of duration in time's flow. His seven-character representation of a "present thought" fits with his notion of the "sensible present" – E.R. Clay's "specious present" – having a certain breadth that includes the *very* recent past. James also refers to this time unit as "the intuited duration." He writes: "the original paragon and prototype of all conceived times is the specious present, the short duration of which we are immediately and incessantly sensible."[11] Short, yes, but not instantaneous, as I insisted in the discussion of Snow: the "specious present" is the unit we call "now" whose content includes the overlapping edges of the past and the future. Our concern here is with the former, and specifically as this temporal edge takes form in Robin Mackenzie's photographic projects of the mid-1970s.

Mackenzie's photographic work can be situated in a broad context of land art projects (realized and unrealized) and environmental sculpture, though his photographic pieces move far beyond the documentation of remote earthworks exhibited by American contemporaries, such as Michael Heizer and Robert Smithson. In Mackenzie's case, a predilection for technology runs in tandem with his interest in the earth. His work in the sixties involved sophisticated electronics and cybernetics; he subsequently switched to logs and bales of hay, adopting the rhythms and materials of his rural inheritance.[12] In 1971, he sowed rice, bean, and oat seeds in wet cement, photographically recording the sprouting that eventually tore apart the dried concrete. In the early seventies, he was recording paths cut by cows that had been herded across the snow, and photographically simulating the different levels of awareness that

might be involved in watching the movement of cows in a pasture. Expressing his attachment to the rural environment and sharpened by minute observation of its systems, Mackenzie's sculpture and photography held human time and instrumental time in balance. Camera vision seemed a way of implanting himself on the earth, demarcating the view, and extending the "specious moment."

The memory pieces, and other related works by the artist, have been painstakingly analyzed by Peter Perrin, who brings a composer's intelligence to Mackenzie's visual structures.[13] *Untitled Memory Piece No. 1* (1975–76) is described as four five-part series of photographs, each 40 x 50 cm.[14] Two series are in colour, two are in black and white. They are arranged in two long horizontal rows forming a double line about 6 metres wide. Scanning left to right, the top row is a series of five colour prints, followed by five black and white prints. The bottom row reverses the order of the series: black and white, bottom left, and colour, bottom right. These bottom series are also the reversals of the images above. So running my eyes across these rows, I have on the upper row A B C D E (colour) and F G H I J (black and white), and on the lower row J I H G F (these characters should be flopped because they now represent mirror images of the black and white) and E D C B A (likewise mirror images of the colour). All the photographs are mountain views, taken in the west Highlands of Scotland.

Mackenzie must have remembered, but I do not know from looking at the work which is the "correct" series, and which is the mirror image. I only know that there is a mirroring effect, that one series is a reversal (a memory image in reverse) of the other. Within each series, memory is also expressed in partial reprise created by overlapping exposures (repetitions of the edge information) that create a kind of mnemonic pulse back and forth across the synthetic horizon.

Untitled Memory Piece No. 2 (1975–76) is composed of a smaller number of prints (twelve), but a larger number of series (three) (fig. 10.2). Perrin plots the permutations and their directions on a chart; this is helpful, for the organization of this second piece is more complex. Two series (one black and white, one colour) are each composed of paired images that are married by a slight overlap and, as in *No. 1*, re-presented in reverse. A series of four colour images appears to sweep the horizon left to right, then, in reverse. In this sequence, we are made conscious of the photographer's segmented pan along a fence line, as well as his slightly irregular movement toward it and back from it. The uneveness of the terrain impresses itself on the view.

In the framing and organization of these memory-works, Mackenzie locates the tension between the camera's decisive moment and the specious present – the thick moment – which is basic to experience. This present includes a memory of the "*just* past." As James explains,

The objects we feel in this directly intuited past differ from properly recollected objects. An object which is recollected, in the proper sense of that term, is one which has been absent from consciousness altogether, and now revives anew. It is brought back, recalled, fished up, so to speak, from a reservoir in which, with countless other objects, it lay buried and lost from view. But an object of primary memory is not thus brought back; it never was lost; its date was never cut off in consciousness from that of the immediately present moment. In fact it comes to us as belonging to the rearward portion of the present space of time, and not to the genuine past.[15]

By attending to the edges of "the present space of time," Mackenzie achieves in these works a sense of enriched presentness. The views are presented as they are being con-

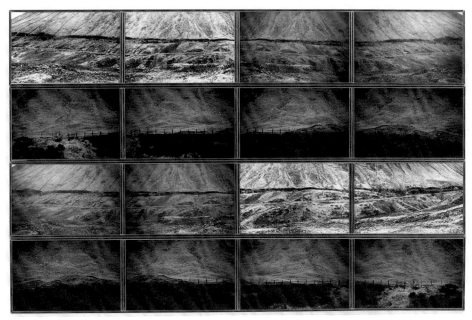

10.2 Robin Mackenzie
Untitled Memory Piece No. 2 (1975–76).
12 colour photographs, 4 black and white
photographs, 40.64 x 60.96 cm each,
overall 132.08 x 243.84 cm.
Photograph by Henk Visser

templated, as they are passing from earthly matter into the matter of memory. The delicacy of this process is underscored. Human presence and the efficacy of human memory are measured against these prospects of solidity and equilibrium. What is remembered? Vast space and the intuited duration of its encoding. What is communicated? The possibility of intensifying one's relationship to place by abandoning the pretense of inscribing history, or even memory proper. The body is but a speck on this extraordinary vista. One proprietary gaze will not contain it. Mackenzie's structures are the intersections of individual time and mythic time. He allows the spectator to feel his or her way into and across this terrain because he incorporates the nature of this progress: hand over hand, marker to marker, slowly, tentatively, always feeling to remember where we are.

LAND DIARY

The photographs for Mackenzie's memory works, as well as the related *Flow Piece*, *Three Spaces*, *Far Side/Near*, and the *Drone* pieces, were all taken over a six-week period. It is clear, however, and important to the work, that the photographs flow as successive impressions of a mind/body receiving the view. It is, in that sense, episodic on an epic scale. The next body of work to be examined reverses that relationship. In Thaddeus Holownia's extended landscape projects, *Rockland Bridge* and *Jolicure Pond*, transcendence is immanent in the local; the pleasures and terrors of sublimity can be found, quite literally, in one's own back yard.

Born in Bury Saint Edmunds, England, Holownia came to Canada as a child. He grew up and pursued his studies in

here. The shattered remnants of the bridge have becomet-wo earthy mounds separated by the tide, their union dissolved. Yet, some things do not change. Beyond the bridge, a water-chased and tarnished surface gradually rises to a field, then higher into rolling hills, finally giving way to the slightly overcast sky. These horizontal bands are bound together by the recessive thrust of the central axis, something between nature and architecture, and belonging to neither. The Rockland Bridge is almost a memory, its passage from function to sign recorded with simple fidelity. Where it used to bridge space, thereby connecting communities, it now bridges time. As Eviatar Zerubavel explains, bridging memories "establish *historical continuity* between virtually *non*contiguous points in time … transforming an assemblage of utterly disconnected 'successive perceptions' into a seemingly coherent, *constant* identity." In effect, Holownia's photographs are the materialization of the "connecting historical tissue" that fills temporal *and* cultural gaps.[19]

One can guess that Holownia is the primary witness of this disappearance within a shrinking community of re-memberers. As the bridge disappears, those who still remember it will start to forget, then they too will disappear. Holownia may one day be the sole possessor of the site. He may one day have trouble locating it. These photographs are strange acts of memory, for their subject is erasure. They belong to the Romantic tradition of theatrical landscape and picturesque ruins. They translate contemporary concepts of history and monuments into the vernacular.

J.B. Jackson explains: "A monument can be nothing more than a rough stone, a fragment of ruined wall as at Jerusalem, a tree, or a cross. Its sanctity is not a matter of beauty or of use or of age; it is venerated not as a work of art or as an antique, but as an echo from the remote past suddenly become present and actual."[20] Western society's fascination with these objects belongs to a creationist myth, according to Jackson, a collective yearning for the golden age that begins "where active memory ends – thus about the time of one's great-grandfather." Jackson cites "the new and widespread interest in the industrial landscape – 19th Century mills and factories and railroad stations and bridges and mines." These objects have passed through the "interval of neglect" that fits into a mythological cycle of birth, death, and redemption. They are symbolic of a desire to reconnect with the environment, to live cleanly and innocently in what Jackson calls "a born-again landscape."[21]

Holownia's images of *Jolicure Pond* (1996–2004) seem to suggest that he has found such an earthly paradise quite literally in his own backyard (fig. 10.4). The nominal subject of the series is an artificial pond that the artist photographed in colour over the course of eight years. The work takes the form of a grid whose installation underscores both atmospheric and topographical changes. The multiple views are reminders of Impressionism's affair with transient, atmospheric effects, and more specifically, of Claude Monet's way of working in series.[22] Meyer Schapiro points out that Monet was active in a period in which the moving image was emerging as a real possibility, with proto-cinematic images documenting the mobility of objects in space. The Impressionist Monet had always been interested in scenes of transitory effects, but in the 1880s and 1890s, in his series of grainstacks, he seemed to change direction, opting for a stationary object that he painted in multiple versions under changing conditions.[23] In Holownia's *Jolicure Pond*, a certain spatial template is established in that the camera is roughly in the same position for each view. But there are differences that can be measured in the allocation of sky which occupies between a quarter and a third of the visual field. Holownia's distance from the pond also varies a bit; this can be confirmed without a ruler by counting

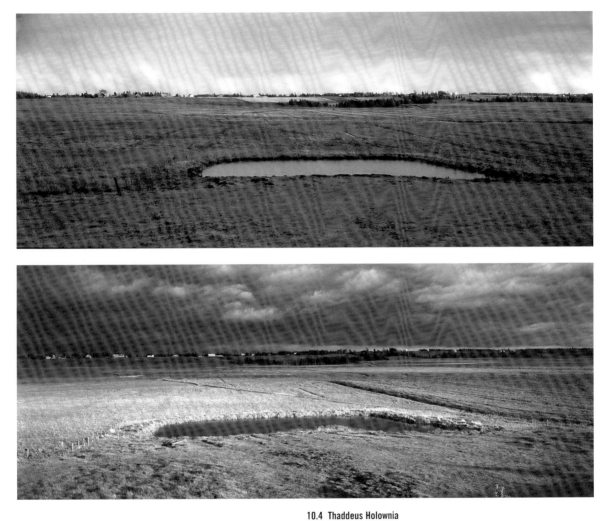

10.4 Thaddeus Holownia
Details from *Jolicure Pond* (1996–2004).
2 untitled chromogenic contact prints, 16.9 x 42.4 cm each.
Courtesy Corkin Shopland Gallery, Toronto. Originals in colour

fence posts. Searching the view for these tiny clues – comparing one set of conditions to another – brings me into the photographic act. I stand at the edge of a prospect whose distant horizon line, the boundary between earth and sky, is a string of buildings and trees. Once-cultivated fields and pastures fill the rest of the image, a wide band softly divided by fences and furrows, the artificial pond, "earth's eye," mediating between earth and sky, or a Cyclopean eye, of monstrous camera-vision.[24] All around are the marks of human cultivation. My spectatorship is another kind of cultivation, transforming this image into an experience of land and light.

The eye wants to scan such a wide view, so if this description travels from the top to the bottom of the image, it is perhaps because the quality of sky seems to influence Holownia's composition, or even dictate that a picture be taken *right then*, for the possibility was always open to him. Indeed, the proximity of this site was part of the work's conceptual core. Holownia decided to photograph the view from his home. Knowing the spot and the weather, he might have projected exactly what was needed to make the series complete. But the camera yields a different harvest, and by force of looking at the results, Holownia saw the view as he had not before. Working toward a series, Holownia had to strike the right balance between fleeting impression and stability. As the photographs accrued, did he begin comparing natural phenomena to pictures? Did the view thus become a potential photograph, connected to other photographs in the series, and did it also intensify Holownia's sense of place?

Comparing Holownia's series, we find that *Rockland Bridge* partakes in collective experience, while *Jolicure Pond* conveys a singular feeling of possession through the eyes and the camera. This is something that James insists upon, that memory attaches to a particular past, not just identi-

fied, placed, and dated, but owned.[25] *Jolicure Pond* transfers that sense of ownership to the spectator, not literally, but by example. We see through another person's habits and responses – through a theatre of landscape – what it means to live on a piece of land and to learn it. In Mackenzie's multiple views, photography and memory guide us across spaces too vast to be singularly possessed. Holownia's repeat visits to *Rockland Bridge* and *Jolicure Pond* activate the state of memory that we call *belonging*.

REINSCRIBING

There are different ways of sensing an attachment to place. The feeling can grow over time or can arrive with a shock of recognition – *I knew this was where I belonged*. This pleasant feeling of homecoming, often described as a sense of relief, is easily distinguished from the garden-variety déjà vu, or the more extreme case of false recognition, discussed in relation to Snow. The last occurrences are troubling, or we give ourselves trouble when they occur, because they come into the mind with such convincing claims. We believe that the past is repeating itself, that we have been to such a place before, and we are disturbed because the facts of the matter, names, dates, and so on, seem to be eluding us. A happier consciousness of place, and our place in it, is free of such demands. The sensation is abstract and accepted as such, rising smoothly from the unconscious and fitting nicely into many systems of belief, both secular and religious. No wonder that real estate developers try to exploit these emotions with billboards that welcome tired commuters "home."

Nation builders and cultivators of nationhood are the sources of such rhetoric. Descriptions of Canada are replete with references to European landscape types, similes

10.5 Sylvie Readman
excerpt from *Petite histoire des ombres* (1991).
First image in a series of 8 gelatin silver prints,
51 x 61 cm each

deployed to develop a hardy strain of familiarity and awe in armchair travellers. In *Canadian Life in Town and Country* (1905), Morgan and Burpee cast the Canadian landscape as a patchwork quilt of European landforms. Thus having established a vision of the Nova Scotian valley of the Gaspereau as "combining the quaintness of a Dutch landscape, the serene loveliness of a bit of rural England, and just that touch of wildness which marks it as part of the American continent," these virtual travellers continue west to the dykelands of the Tantramar Marsh where they find what their readers have been encouraged to expect, "the same type of Dutch landscape."[26]

"That touch of wildness" is, as Jonathan Bordo suggests, a quality transformed into a state or condition: "*Ness* comes to hold the wild as in a nest or niche, as if the wild were contained or the core of something."[27] And that something is *ideology*, or better, *ideological impulses*, defined by landscape theorist Alan R.H. Baker as a network of struggling ideas, contradictory to the core: "they seek permanence and continuity but argue for change ... perform a stabilizing role while perfecting transformation; they are simultaneously loaded with inertia and pregnant with change." Baker distinguishes "actual" landscapes, which he calls "contructions," from "ideal" landscapes, "conceptualizations." At the same time, Baker argues, "'actual' landscapes are moulded by ideologies and ideologies are themselves fashioned by 'actual' landscapes: the relationship is reciprocal, the product is a dialectical landscape which is a resolution of nature

and culture, of practice and philosophy, of reason and imagination, of 'real' and 'symbolic.'"[28] To that list, I would add, for emphasis, the dialogue between history and memory that further thickens the meaning of landscape by admitting both visible and invisible signs.

Since the early 1990s, Sylvie Readman has been thinking about the dialectical landscape and its translation into the different dialects of photographic language. Her first projects in this vein – *Les traversées de l'image* (1991) – were combinations of nineteenth-century imagery, both paintings and photographs, with her own views of the landscape. The source paintings belong to American Romanticism, also known as the Hudson River School, the Luminist movement, and the American Sublime.[29] In *Petite histoire des ombres* (1991), the photographic sources are documents from the geological surveys of the American southwest, now considered masterpieces of nineteenth-century American photography (fig. 10.5).

The implications of Readman's references are almost overwhelming. The Romantic paintings brim with pictorial precedents, philosophical associations, and ideological confrontations – they are songs of predestination, celebrations of the wilderness and its ultimate subjugation to Progress. The time of transcendentalism, Ruskinian aesthetics, Darwinism, historicism, and Manifest Destiny was also photography's originary moment. As a movement, Romanticism lacks coherence, or rather its emphasis on individual style (genius) fosters an atmosphere of reciprocal influence between the sister arts. Photography may have started out as the handmaiden of painting, but in a positivist culture, its influence grew. As Joel Snyder explains, photography was equated with vision; the landscape photograph was judged by its fidelity to nature; this was the photograph's power whose application by scientists and engineers is easy to understand. But painters of the American Sublime also called on the authority of the photograph, using it as scientific corroboration of their work. As Snyder analyses the photographic landscapes of Carleton Watkins,

These photographs did not escape landscape conventions; they adopted and reformulated them. This is clear not only from comparing photographs like those made by Watkins to drawings, prints, and paintings by Keith and Bierstadt but from the critical literature of the period, which continually commends photographers for having achieved pictures faithful to nature that *coincidentally* share specific compositional and pictorial features with landscapes wrought in other media. In other words, such criticism congratulated photographers not for their use of landscape conventions but for their coincidental scientific or mechanical corroboration of them.[30]

When Readman began to look at the works of Watkins and his contemporaries, she was participating in a photo-sculpture workshop, therefore immersed in ideas of interdisciplinarity and intertextuality. She had just completed a work of photographic deconstruction entitled *Inventaire d'une image* (1989). The source image was Readman's picture of a rented house. Over a week's holiday, Readman had photographed the rooms; the images were just records, as she herself says, "rather banal," but over time, their interest seemed to grow. They were reminders of things that she had barely been aware of, subtle signs of the absent owners holding their own against the visitors' presence; these little things began to play on her mind.[31] She chose a view of the living room and began visually to parse it, using a photocopier to enlarge certain details, a process that introduced grain, texture, and contrast into the visual fragments. These copies were then photographed and dramatically enlarged on colour paper. The results are impressionistic, replete

10.6 Sylvie Readman
Reflux ou les herbes fraiches (1995),
from the series *Reviviscences*.
Gelatin silver print, 124 x 166 cm

with memory-effects of intersection. The homeliness of the base image persists. It is, as the artist herself recognizes, the inexhaustibility of the base image that is so intriguing, as it ascends generation by generation into an abstraction of memory. This is the spirit that informs Readman's appropriation and transformation of the American Sublime.

In *Petite histoire des ombres*, the nineteenth-century source images (the ideal) and her own landscape photographs (the actual) are very delicately combined. Technically, one negative must be superimposed on the other, but the planes read as interleaved, the spatial depths seem equivalent. The ideal past does not dominate the actual past, rather

the two times and two places cohabit the image in harmony. The works are expressive of the relationships between history and memory, culture and nature, or if you will, collective memory and autobiographical memory. These same relationships are explored in an exquisite distillation, a mixed-media work entitled *Entées* (1990–91). The title is a Derridean double entendre: the English word is "grafts" which is the poststructuralist term for an intertextuality that is two separate texts in productive parallel. *"Entées"* is also a homonym for *"hanté,"* meaning "haunted," invaded by spirits. A single word neatly summarizes Readman's equivocal relationship with this culturally inscribed landscape.

The source images are two unidentified details from Hudson River School paintings. They were photographed from projected slides. The details are vignetted in a black field, as though viewed at great distance through a telescope. The framed photographs are small enough to stand on a shelf and the spectator is invited to inspect them through a magnifying glass that is delicately inscribed with Readman's title. Inscription (*l'écriture*) is a cornerstone of Readman's photographic oeuvre. Casey's explanation of the memorability of engraving also describes Readman's work: "An engraving fixes this scene in its literal traces. Like human memory itself, such a representation exists between perception and reflection; it both depicts and guides – and, again like memory, it does so by means of a network of traces."[32] In *Entées*, the spectator sees the word etched into the optical device and also sees through it into a shimmering pastoral illusion. The magnifying glass, a naturalist's or print collector's simple tool, is also associated with photography, and it is doubly interesting to know that when the American Luminist Frederick Edwin Church exhibited his "spectacle-picture," *The Heart of the Andes* (1859), visitors were supplied with "viewing tubes through which details of the picture could be examined separately." It was also suggested that spectators bring "opera-glasses to peer at the vines and humming-birds, pilgrims by a wayside shrine or figures on a distant road."[33] A painter's presentational values, borrowed directly from the performing arts, turned the spectators into actors in a theatre of landscape.

Modes of appropriation, which loom so large on the landscape of Postmodernism, have greatly expanded the definition of direct photography. A mountain range; a landscape painting; a landscape photograph; a lithograph of a painting; a duotone of a photograph; a 35mm slide of a painting; a slide projection; an advertisement for a mountain lodge; a military photograph of a suspected terrorist's cave; a map of

the Andes; anything on this list that is scanned and posted on the Net: these things are not the same, though they may share certain characteristics, but they are equal in one respect, that is, their visibility in the external world. If I can see it, I can photograph it, and I do so directly, even when I aim my camera at a screen. While we can be reasonably certain that Sadakichi Hartmann and Alfred Stieglitz would have seen things differently, there is no going back to their definition of straight photography.[34] Ironically, this drives us back even further, and outside the medium, for a term that captures the activity of taking photographs outside.

In 1995, Readman found herself working as a *plein-air* photographer of the landscape. Drawn to places that reminded her of images that she had previously appropriated, she was struck by her unshakeable visual habits and forced to consider the possibility that her theoretical investigation had somehow been driven by lifelong attractions to certain visual formations, that she had in effect been working from memory at every stage. She wrote, "If most photographers seem certain of the provenance of their images, some live with doubts. They are seized with foreboding, the suggestion that their images are coming from elsewhere, indeed, reversing their steps: they are *returning*."[35]

The photograph as revenant emerges clearly when the first image of *Petite histoire des ombres* is compared with *Reflux ou les herbes fraîches* (1995) (fig. 10.6). The extract from *Petite histoire* is a composition divided by a solitary tree which rises from the bottom of the frame. A man stands at the base of the tree, gazing at a vista of mountains made atmospheric, and somewhat ghostly, by the doubling of the negatives. His presence is accented by a cleft in the textured middle ground which holds him solid against the sublimity of the view. He is its measure and its master. In *Reflux ou les herbes fraîches*, Readman revives a trope of the Western landscape, a single plant standing still before the

turbulence of wind-swept grass. The rigid stem exerts more power than the surrounding moving field. It occupies a liminal position, springing from the bottom of the frame in perfect alignment with the vertical edge. The stem, like the man, becomes a proxy for the spectatorial body.[36]

Such similarities of construction are no coincidence. In the 1995 series, *Reviviscence*, Readman is continuing to work in layers of memory, only her technique has changed. She expresses the impulse of memory in a single, direct exposure. In photography, nature is never seen plain – it is the photograph that we see – but a straight photograph often carries the illusion of singular immediacy. Readman interferes with that illusion to make the spectator more conscious of photographic process, and thereby more aware of the workings of her mind. She impresses on each image a sign of mediation, photographing through a screen, or a streaked windowpane, to express the mnemonic membrane that both defines, and separates her from, the landscape. Memory leaves its fingerprints on the negative, its winding channels on the print. This photography in two moments and two manners captures the reciprocal arrangement that has fascinated Readman from the beginning, a Heraclitean dialectic of fluidity, a Derridean interstice of inscription.

PRINTED PICTURES

Direct exposures of photographic images have been part of Michel Campeau's repertoire since he shifted ground from the documentary and social commentary of the 1970s and early eighties. His autobiographical bookwork, *Les tremblements du coeur* (1988) is a narrative built up from a collection of his own lyrical photographs, copies of photographic reproductions, movie stills, and Campeau family snapshots. These elements have been selected and sequenced for presentation in a book – this process alone summoning and imitating memory – but in addition, the individual images have been reworked, sometimes overtly (reproduced as negatives, rather than positives), and always symbolically, because the design refers to the photographic album (the images are all set in a dark grey field, surrounded by a white border – an amateur album within an artist's book).

The intertexuality of Campeau's book project is illustrated by a single double-page spread (fig. 10.7). On the left, a slightly enlarged snapshot of a woman and boy in bathing suits, posing on the beach with a vast body of water behind; underneath, in pale grey letters, "Vagues incessantes" (Endless waves). On the opposite page, a picture of a man and a woman sunbathing in a field of flowers; this is a self-portrait with the artist's partner, Nicole, the mother of his children. Under this picture is a negative image of Robert Frank's renowned portrait of his wife, Mary; a single word, "Fantasmes" (Phantasms), is printed below. The compilation thus combines snapshot memories and intimate portraits with a canonical Modernist image and short phrases, more like utterances than texts, in a net of visual associations. As Richard Baillargeon writes in the introductory essay, "[Campeau] speaks of things in which we all find ourselves: life and death, unresolved childhood, our own as well as the ones to which we have given birth, and the love relationship."[37] He creates, in other words, an authentic family album in which type characters and typical situations breed an illusion of familiarity which is arrested in a serpentine narrative of the compiler's life. Campeau's story includes his passionate engagement with certain image-makers – Robert Frank, André Kertész, Ralph Gibson, Josef Koudelka – and avant-garde filmmakers – Wim Wenders, Jean-Claude Lauzon, Fernando Solanas. Organization by visual association underscores certain motifs, such as angels, found in real-

10.7 Michel Campeau
Les tremblements du coeur (1988).
Detail of artist's book (Québec: VU.
Centre d'animation et de diffusion
de la photographie, 1988)

life processions, cemeteries, and stills from *Wings of Desire*. Campeau's homages to public works of art accentuate the mysteries encoded in his mother's snapshots. Full of tenderness and inchoate yearnings, *Les tremblements du coeur* is a photographic folktale of origins.

Les tremblements du coeur was quickly followed by another book, *Éclipses et labyrinthes* (1993), in which Campeau and two essayists, Jean Arrouye and Elizabeth Wood, circled the problem of identity-making in an image-world. Here I want to pursue the meaning of Campeau's landscape photographs, as they have continued to emerge in *Lecture/écriture du territoire*, a work-in-progress that began in 2001 with a remarkable first chapter, *Humus*. There are three characteristics that relate to memory: first, Campeau's appeal to Modernism, and specifically to the Modernist

photographic book; second, the siting of this activity in a natural setting, and its relation to "old photographs"; third, the expression of kinship with the author/fathers of the referent works. The context of *Humus* needs first to be established since it represents a kind of eruption in Campeau's work.

For all the passion, evident in *Les tremblements du coeur*, for taking pictures, whether from life or from art, the book betrays a crisis of faith in picture-making, or rather points to another way of thinking about photographic process, one that emphasizes the hermetic activity of sifting and organizing pictures into visual texts.[38] Gradually, and for many reasons, Campeau had stopped taking photographs and immersed himself in his archives: his photographic library, images he found on the street, and an unruly collection of

images that he obtained by sending disposable cameras to friends. This was not an unproductive period, and it was driven by sincere commitment, but the results were unsettling, belonging to a Postmodern order that was curiously devoid of Postmodern irony. Campeau's rejection of taking and making "original" pictures was, in fact, almost sentimental in its recollection of a lost photogenic world. In 2000, Campeau re-entered that world in a heartbeat. It was just as predicted in *Les tremblements du coeur*'s citation of *Wings of Desire*. The artist-angel reached for reality and literally fell to earth.

His return to *plein-air* photography began with *Arborescenses* (2000–01), five separate suites of colour photographs and digital images made in an urban garden. These photographs were extravagantly beautiful. Critic Robert Graham exults: "And the sky! The first time I turned the page onto that deeply coloured sky, I laughed out loud. This was the happy appearance of a creamy blue sky that now, when I see it in nature, I think of as being 'Campeau blue.'"[39] But as this tribute suggests, the series was very much about the act of looking. To see a flower surrounded by "Campeau blue sky" means adopting the point of view of another plant, or an insect, or a crawling infant. It means getting down on the ground, and in the next series, *Humus* (2001), this posture is precisely what Campeau shows. *Humus* is, by contrast, very sombre, taking the form of black and white self-portraits in nature.

Campeau depicts his photographic rebirth, appropriately set in the spring in a New World clearing replanted with natural and cultural cuttings. The artist's body features in almost every work, recumbent, covered with rotting leaves or twigs, eventually surrounded with spring flowers. One does not need to know Campeau to understand that these are self-portraits made without an assistant; he signals that fact in the way that his body juts into the frame, or more literally, by photographing his own arm gesturing or holding an object. The vision in this case is of two orders: external, in the previsualization of an image that must be framed without the figure; internal, behind the protagonist's closed eyes as he feels his performing body in nature, the hard ground, the lines of the filtered sun, as he also remembers the art that has sustained his life until now. Past, present, and future are one; from seeding through flowering to decay, the natural cycle is respected. For if the self-portraiture of *Humus* expresses a certain morbidity by committing the artist's decomposing psyche to the enrichment of the earth, the gesture is Osirian, in the sense that resurrection occurs. Campeau's soloist choreography in nature emphasizes the interiority of photographic process. The cycle is a return to his photographic seedbed.

The printed picture stands for memory. The artist carries photographic books into the forest – books by Dieter Appelt, Bill Brandt, Josef Koudelka, and Lee Friedlander – and reinscribes them in a Book of Nature that he is writing with light (fig. 10.8). The images are at once wrenched out of context, I have to say, *déracinées*, torn up by the roots, and replanted in a new body of work. Still, they carry their lineage as Modernist icons, and doubly so, as leaves from photographic books. For many artists of that generation, Friedlander a beacon, the book is a kind of original. It is the form in which they imagine their work, and this for reasons of "privacy and specificity, and perhaps even the matter of secrecy," as John Szarkowski explains: "a picture that is held in the hand, as in a *Book of Hours*, or a magazine, that speaks to one person (or to one person at a time) and thus can speak in a more confidential, and perhaps in a more dilatory, elliptical, or conversational tone, because the message is not being shared with all those others."[40] Campeau's homage is equivocal; he celebrates the intimacy of his relationship with these precursors; he takes comfort from their

imagination stood in for modern life. Their protocols and poetics are equally hard to grasp. And there's the rub, as well as the appeal of *recreation*, whatever the spark: creation *anew* and creation *about*. Creation *anew*, *about* the history of art, is what Terry Atkinson calls "the recapitulatory model"; specifically, he refers to painting "*about* the continuing of painting as defined in terms of its material technique," whether cyclically or progressively charted.[10] *Anew, about*, also explores affinities with earlier conditions of art practice.

Thomas Crow locates the re-creative trend between the studio and the academy as art production that is part of an emergent social history of art, though he also takes account of certain interdisciplinary shifts, notably art theory's appeals to anthropology and literary criticism.[11] Justly so, for traditional art history will not supply a sufficient, and sufficiently neutral, term for the phenomenon I have in mind. Nor can post-structuralism quite cover it, because the works in question are designed to make us aware of this school's Scylla and Charybdis, the dangerous moral passage between paradox and paralysis. So I've adopted a literary term, now current in computing: *conflation*, the fusion, or binding together, of two texts. The point is to avoid the biological determinism that Atkinson stumbles over in "recapitulation," as well as some other traps: the biographical structure of "influence," the academic rigour of "quotation," the aggressiveness of "appropriation," the temporary nature of "borrowing," the economic implications of "debt," the adulation of "homage," and the utter dismissal of "pastiche." None of these words fully express the doubled temporality — the reciprocal relationship between memory and imagination — that interests me here. With a conflation, one text necessarily precedes the other, but the second, as a variation on the first, effectively rewrites the earlier work; it can never be read quite the same way again; memory is the medium of

this merger; imagination furnishes the characters, the setting, and the plot. This is the condition of any text, as the post-structuralists rightly insist, but conflation as a performative mimetic act (something for the spectator to do) reinstates something that Derrida disallows: a plotted point; the illusion, at least, of a new beginning. For the moment (this textual moment that we share), and without going into a particular work, I want to sketch some basic characteristics of the conflater's art.

The first thing is to distinguish conscious strategies of conflation from dream-like free associations or half-conscious repetitions of forms and motifs. The work now rising to my mind's eye is both deliberate and concrete, the product of an artist critically engaged with material culture. This is art-making as the outcome of observation and contextual research; an art-historical project framed by the urgencies of the present; a genre with its own history and philosophical debates.

Wall and Yoon explain their activity from their knowledge of artistic precedents as a mode of dialectical engagement. Their efforts are inscribed in the Postmodern project of re-evaluating Modernism, dismantling the avant-garde's claims of autonomy, originality, and purity of expression, while perpetuating the values of aesthetic experience. They also participate in cultural theory's social and political re-readings of Modern art, putting the past through a Benjaminian "maturing process" of translation that is both transformative and renewing.[12] They seek to understand the cultural underpinnings of certain well-established genres through a process that Jerry Zaslove sees as "determined by the forces of memory and the retentive powers of genres that resist both the demands of a forced continuity in art and the lures of discontinuity."[13] In other words, their imagery abjures novelty for its own sake, favouring *telling* difference; it reopens the past by constructively critiquing the culture's

valued representations, reawakening interest in the source practices and practitioners through transference into present-day conditions. This is memory work, as Susannah Radstone explains it, very much concerned with lived experience.[14] Here, memory-work's catalysts are works of the imagination, that is, works of art.

It should be obvious, but must be said, that their source images are neither randomly, nor sentimentally, chosen; they are works of enduring, or reignited, interest whose subject-matter and style deliver both socio-political codification and semiotic instability. Sifting the evidence, the new work reopens the case of the old. Each re-examination is tacitly justified by the tenets of social art history: that the conditions and aspirations of artistic labour have been insufficiently understood; that contextual art history, taking into account the conditions of production and reception, can recuperate meaning and restore social agency to visual form. In this respect, conflation is redemptive and remarkably optimistic about art and society. But not every critic sees it in this light.

In an essay published in 1982, Marxian theorist Hal Foster condemns the making of art after art as a form of capitalist consumption, once legitimate, but no longer: "Modern art *engaged* historical forms, often in order to deconstruct them. Our new art [the pluralist's art] tends to *assume* historical forms – out of context and reified." For Foster, this is "a profoundly *a*historical enterprise," a pastiche that he damns with a call to the authority of Benjamin Buchloh: "aesthetic pleasure as false consciousness, or vice versa." Foster insists that the specificity of an art form *must* be respected: "To see other *periods* as mirrors of our own is to turn history into narcissism; to see other *styles* as open to our own is to turn history into a dream. But such is the dream of the pluralist: he seems to sleepwalk in the museum." Taking Foster *à la lettre*, we must accept that *conscious*

analytical activity is the only responsible state of mind in the museum: he is interested in art that burrows into the political processes and apparatuses that control art production – a different art about art, to be sure. To be awake in the museum is to interrogate institutional histories.[15] Imagination should be checked at the door.

The contested space of history is not merely disagreement over the outcomes, but a historiographical dispute over the nature of what Bhabha calls "the projective past." Bhabha turns to Raymond Williams to articulate the "political space" of the "social imaginary": it is "non-metaphysical and non-subjectivist."[16] To understand better what kind of history is thus implied, I consult the *OED* of Marxian cultural studies, Williams's *Keywords: A Vocabulary of Culture and Society*.

Williams explains that "history," in its earliest English usage, refers to legends and myths, as well as epistemological quests. Fantasy and knowledge co-mingle until the fifteenth century when histories of imagined events are channelled into stories, and history is dedicated to the real. This division holds, though the notion of history as a string of *observable* events is complicated in the early eighteenth century by Vico's attention to cycles of human self-development – those invisible problems of identity, or subjecthood, that so irritate Foster. Modernity then whips up a maelstrom of temporalities and systems, such as Marxism's "historical forces – products of the past which are active in the present and which will shape the future in knowable ways."[17] In the name of the future, imagination returns, though not at full throttle, but constrained by the rule of plausibility – What if? always tethered to the *real*.

This Marxist notion of "historical forces" conforms nicely to Foster's program of engaged historical deconstruction. It insists that the rules of engagement be Realist, that is, transparent to the people whose stories will be told.

This brings me back to memory, and I wonder, How does Williams's "History" relate to "Memory"? There is no entry in *Keywords* by that name. "Imagination"? Is not a keyword.

Gaps are always illuminating. Here the lamp shines on the British New Left, its sense of urgency for social reform in a "post-1945 crisis of belief and affiliation."[18] It was the best of times (for realists), it was the worst of times (for abstractionists): so Williams's omissions would suggest. Social change exacts its price: Zaslove charges that post-war Marxian cultural studies, led by Williams, Frederic Jameson, and Terry Eagleton, sidelined British theorists and artists who were investigating the visual language of the unconscious through surrealism and abstraction. This, according to Zaslove, was the death knell for a certain kind of Marxist anarchism whose utopian project was the efflorescence of individual agency – he remembers Herbert Read.[19] Eagleton's widely adopted *Literary Theory* includes phenomenology, hermenueutics, reception theory, structuralism, semiotics, post-structuralism, and psychoanalysis, but he wrings "the sensuous textures of lived experience" out of these systems, fatally in some cases, with the express intention of burying literary theory as a discrete realm of inquiry. For Eagleton, and his readers, political criticism which absorbs all other methodologies is the way to become a "better person" in a better world.[20] How, without *personal* reference points (memory and imagination), one might describe this happier condition, or even recognize it, remains open to question. As a flawed character in my own novel, I am moved to seek some middle ground.

For the rigour of Marxist criticism has yielded some tremendous gains, not just for the social and economic histories of art, but also for the phenomenology of reception. After Jonathan Crary's correlation of photographic spectacle and human mechanization, there is no going back to pure rapture over the invention of photography and its

effect on the observer.[21] I now see my ancestors (cultural and biological) on the epistemological production line that he describes. At the same time, there are other ways into the period that are equally indispensable, that place more emphasis on "aesthetic pleasure," and also grapple with the transformative internalizing of the external world through an awareness of the self as seeing and being seen. As Geoffrey Batchen has argued, these forces are not mutually exclusive. His account of photography's origins, "true to the parasitical logic of the supplement," interrupts photographic history's forced march to the present by posing questions about the various states of mind along the way.[22]

Asking similar questions about Jeff Wall's and Jin-me Yoon's photographic re-visions of art history causes both memory and imagination to rise to the surface of their work – this is very clear in interview, a fact which subtly underscores the dialogical features of their work. At the same time, their work stands up to rigorous political criticism and also functions as such. So without losing sight of history, indeed by placing it just ahead in this book, I want to attend to the forces of memory and imagination that propel the art-historical conflations in five of these artists' works: Jeff Wall's *Mimic* (1982), *Eviction Struggle* (1988), and *The Giant* (1992); Jin-me Yoon's *Souvenirs of the Self* (1991) and *A Group of Sixty-Seven* (1996).

INTERSECTIONS

Considering Wall and Yoon together places an accent on Vancouver where their individual life experiences meet, though are, of course, quite different.

Vancouver is where Wall was born in 1946, and, apart from stints of studying, lecturing, and other professional activities in Canada and abroad, a place where he has lived,

taught, and made his work. Vancouver supplies Wall with an economically divided and racially mixed population; inner-city and suburban environments; great vistas, urban decay; prosperity and despair. All these conditions can be believed of Vancouver, even if Wall makes up the particulars. Through his work and his writing, Wall has also helped to promote his native city as a centre for advanced art practice. As Ian Wallace explains, Wall's international reputation has shifted the once marginal concerns of the West Coast conceptual movement into "a place of centrality as a focus of questions of ideology, authority and representation; that is, at the critical point of modernism."[23] Thus, while Wall justly sees his major contributions as distinct from photoconceptualism's anti-commodification, seriality, language games, and ironic regionalism, the West Coast photoconceptualists are his cohort. Roy Kiyooka, N.E. Thing Co. (Iain and Ingrid Baxter), Rodney Graham, Michael DeCourcy, Chris Dikeakos, Ken Lum, and Wallace himself continued to develop along photoconceptual lines, while Wall took the turn toward representation. His invented realism and colleagues' photoconceptualism nevertheless still cohabit in cultural memory.

Vancouver, for Yoon, is another environment, the Canadian city where she was brought as a seven-year-old child when her family emigrated from Korea in 1968. She entered the first grade; her name was anglicized, a change that she would reverse in university where she majored in psychology. She then spent a year working and travelling in Asia before enrolling at the Emily Carr College of Art and Design in Vancouver. Drawn into the discourse of conceptualism and feminism, Yoon cites the influence of Mary Kelly, Griselda Pollock, and Martha Rosler. At Simon Fraser University, she attended workshops with Kelly, Victor Burgin, and Jo Anna Isaak – she was beginning to consolidate concepts of feminism and psycho-

analysis with her visual art practice, a process that continued through the next stage of her education at Concordia University in Montreal.[24] Yoon has lived in many places, but Vancouver remains her city of adoption, a place to which she returns to work and teach, while maintaining the core restlessness of an exile. Conceiving her photoconceptual practice in terms of gender, race, ethnicity, and autobiography, Yoon accepts commissions that turn her into a tourist, travelling across the country to Banff, Calgary, and Prince Edward Island. She treats these places as tropes in the Canadian imagination, a phenomenon that she observes and also cultivates in herself and others. Nevertheless, when Yoon participates in the Vancouver cultural scene, her practice is addressed in terms of relation *and* resistance to the photoconceptual movement, or rather, its persistence in the communal psyche.[25] Criticism is encrusted with learned references and stylistic comparisons to non-photographic works of art. This is a denser mode of Realism, one that shows how untransparent photography can be. Wall's work of the 1980s helped to set the dials for this kind of thinking.

MIMIC

Wall's *Mimic* (1982) is a large cibachrome transparency in an aluminium display case illuminated with multiple fluorescent light fixtures (fig. 11.1). Set on an urban street in the late afternoon, marked by a warehouse or small factory, a street lamp, and a deep recess of the street, the image describes a split-second encounter between three figures, two men, an Asian and a Caucasian, and a Caucasian woman. The Asian man, fashionably groomed and neatly dressed in a pearl-grey, short-sleeved shirt, and dark grey pants, walks alone close to the curb, his right hand thrust in pocket,

11.1 Jeff Wall
Mimic (1982).
Transparency in lightbox, 198 x 228.5cm.
Collection: Fredrik Roos, Zug, Switzerland.
Original in colour

his left arm at his side. A vertical figure, frontally posed, the Asian character holds centre stage, though his head is slightly turned to the left and his face seems to be changing expression. Walking almost parallel to him on the wide sidewalk, and leaning toward him, the Caucasian man is using the middle finger of his right hand to push his right eye into an almond shape. In one economical gesture, he is giving the Asian man the finger and mimicking his "slant" eyes. The Caucasian man, who has longish hair, a beard, and a moustache, wears a denim vest over an orange T-shirt

and brown pants. He holds the hand of the woman, though his action is pulling them apart. The woman is stocky, tough, and tartishly dressed: she wears red shorts, a loosely laced bustier, a white jacket, and high-heeled sandals. She looks straight ahead, squinting into the sun which is casting long shadows on the sidewalk behind the figures.

The picture is big and bright. Within Wall's oeuvre, it belongs to his early, declamatory phase of realism, which he adopted as a way of representing his society and its problems. We need to look carefully at these scenes, for as Wall

himself has noted, and John Roberts reasserts, Wall "is concerned with how the gesture, small and compulsive, dramatic and aggressive, can function as a signifier of the external social relations of which it is a symptom." In *Mimic*, the gesture is a symptom of racism; the gravity of this condition "becomes comprehensible through the anecdotal."[26] But a story, however short, is not reducible to a single gesture. The plot must develop over space and time, before we can plan our entrance. With *Mimic*, this is not so easy.

The Asian man's expression suggests that he has seen what the Caucasian man is doing. His apparently rising anger is a source of suspense. But the arrangement of the figures is a bit confusing. Following the lines in the sidewalk, I see the Caucasian man's toe meeting the line that the Asian man, his foot clipped by the lower edge of the frame, appears to have already crossed. The Asian man is therefore ahead of the other, so how can he see what is going on? He cannot, unless he has just overtaken the couple and passed them, catching the Caucasian man's gesture out of the corner of his eye. His upright pose discourages that reading. He is not walking very fast, though this is, of course, relative; perhaps the other man is being slowed by his high-heeled companion. Could there be more to this frozen moment? Is the Asian man reacting to a word, a racial slur represented in a still photograph as the silent underpinning of relations on the Vancouver street? Or is his angry expression coincidental, one of those facial blips that photography seizes and overburdens with meaning? Or is the force field of this mimicry more complicated still? Is the Asian man instead being overtaken by the couple, and is this action thus occurring behind his back, only visible to an approaching pedestrian – the recording I? The tight framing of the photograph encourages that thought because the spectatorial zone is not free; the Asian man's foot is crossing into the spectator's space. In this street theatre, you and I, joined at the hip in this pictorial moment, have a part to play. Our options are laid out by the embarrassed woman: to react or not; to cling to, while straining away from, the atavistic aggressor; to pass by; to pass over the event in silence; to close one's eyes. James Elkins explains this last condition as a common occurrence on the street:

Glances can be even closer to blindness when fear is involved. We glance at dangerous-looking people when we're scared. We glance at strangers as we approach them on the street – a brief look, and then we avert our eyes. That's a way of *not* seeing, an urban strategy for avoiding eye contact … Glancing is a strategy in the arsenal of blindness, a way of skipping over the surface of the world and taking in almost nothing.[27]

Mimic is designed to bring these processes to a conscious level, to make the spectator aware of the dangers in a glance. These are introduced by the scenario's potential for explosive violence: most people would agree that it would be safer all around if the Asian man were oblivious to the gesture, blind to it, not rising to it, as he seems to be. By extension, one may fear for the community represented by these actors: Vancouver, 1982, a booming Pacific Rim economy in which certain classes and traditional workers are being passed over. As Roberts explains, "the subjects of his pictures are shown caught up *in* the historical process. They are neither victims nor self-conscious agents, but individuals struggling fitfully within a system that seems abstract and unfathomable."[28] Hence the frustration of the ill-educated orange-shirted man, slowed down by his cumbersome companion. In her *démodé* red-and-white costume of seduction, is the woman a personification of Canada?

I cannot step into this image; I can only look at it. And that puts me on an equal footing with the actors who are also trapped in their roles. This is a post-Cartesian morality play of characters manifesting themselves to others through the eye. Post-Cartesian, because it bears the imprint of the old modern self as "a locus of representations," and tries (we have to decide how successfully) to move beyond it. Charles Taylor calls this "the cul-de-sac of monological consciousness," a fitting formulation for the street theatre here in question. The post-Cartesian body wants to break out of it, but *Mimic* insists that we first break into it, let ourselves be caught in the net of representations; we have no other way of formulating our agency except to speak with the actors who, in this case, *are actors*, and furthermore actors who will never speak to us because they are actors in a photograph. If, as Taylor says, "we define ourselves partly in terms of what we have come to accept as our appropriate place within dialogical actions,"[29] then *Mimic* is an even more troubling encounter. As a spectator I look, therefore, I think, and think I see myself mirrored in the expressions of others, hovering helplessly just outside the scene.

The encounter seems immediate and fresh – photography does that – but this tight interlacing of glances is also troublingly familiar, and has been made more so by critical assertion. In 1984, Wallace drew a parallel between *Mimic* and the work of nineteenth-century French painter Gustave Caillebotte.[30] Crow later made the same connection, using Wall's *No* (1983) to show him keeping pace with social art historians, notably T.J. Clark.[31] Wall had been reading Clark since the early seventies; he was very interested in the discourse, but resistant to any theory that excluded aesthetic judgment.[32] His insistence on formal issues supports Wallace's comparison: it is *Mimic*'s composition that carries the memory of Caillebotte. At the same time, it seems important to acknowledge that Caillebotte was being "rediscovered" by many schools of art history, and with particular acuity by Kirk Varnedoe and Aaron Scharf, both making a connection to photographic media.

Varnedoe published his first article on Caillebotte's *Le Pont de l'Europe* in 1974. Twenty years later, he was still pondering the "indelible" quality of Caillebotte's urban views, whose force and economy of means seemed "to foretell the devices of later cinema."[33] In his earlier article, Varnedoe had tarried on the photographic qualities of Caillebotte's work, crediting Scharf's *Art and Photography* for pointing him in this direction. Wall's doctoral research at the Courtland Institute in London of the early 1970s must have exposed him to the same ideas. Scharf catalogues the aspects of Caillebotte's paintings that photography might have influenced: unusual vantage points (the view down from the balcony onto the street), as well as the deep space that delighted both photographers and amateurs of the stereograph. He attributes great perspicacity to Caillebotte and compositional audacity that only a gifted amateur could have risked.[34]

Mimic shares many of the features of *Le Pont de l'Europe*: the massive trellis of the iron bridge is echoed in the windows of the industrial facade; the deep perspective of the street, the elongated shadows, even the light standard are traceable to Caillebotte's painting. These formal connections remind us of Caillebotte's coded narratives of social and sexual transgression in which the flow of bodies approaching and passing each other in public are passing as types and passing each other messages. Modern art historians confirm what the Impressionist circle knew, that the figure of the *flâneur* on the bridge is Caillebotte's self-portrait. More ambiguous, however, is the direction of his gaze. Is his attention caught by the fashionably dressed courtesan whom he is just passing, or by the worker leaning over the bridge? For Norma Broude, *Le Pont de l'Europe* is Caille-

botte's "'coming out' piece," and she supports this claim with a detailed description of pictorial structure – the painting's criss-crossing lines of locomotion and looks – making analogies with the social and psychological constructions of Caillebotte's life and times.[35] Broude may be right, though her evidence is purely pictorial; Caillebotte's sexual preferences are not known. Still, the constellation is suggestive, and considering the power relations between the gentleman Caillebotte and the anonymous worker, one is also put in mind of something Wall said in a 1990 interview: "Nietzsche said that the most instructive epochs were the ones in which masters and servants slept with each other. Pleasure is a means by which antagonists in a social struggle gain precise knowledge of each other."[36]

To gain knowledge from *Mimic* one must look, and not just at it, but in and out of it, along its visual axes, that is, imaginatively recreate the web of glances that constitute intercourse on the street. This is the lesson of *Le Pont de l'Europe*, repeated in *Mimic*, with a supplement in the main character, the Asian man, who seems to step out of another Caillebotte, a more rigid composition, *Paris Street; Rainy Day* (1877). The strength of this painting is its clean division between openness and compression, two modes of modernity here neatly separated by a lamppost. A linear composition of planes and reflective surfaces forms the left side, while the right is defined by the imposing presence in strict verticality of three walking figures. This painting too is about passing: a couple walks toward us, their gazes averted, while a male figure cut in half by the right edge of the painting enters it, thus carrying us bodily into the scene.

Like Caillebotte, Wall organizes a play of gestures and glances in a social space where the mere co-presence of types is a volatile mixture. Where we place ourselves in relation to his images is a major point of interest and the site of a moral dilemma. *Eviction Struggle* makes this point very clear.

EVICTION STRUGGLE

There are two parts to *Eviction Struggle*, a large transparency in a light box and a video installation on nine screens set into the reverse side of the wall on which the light box is mounted (fig. 11.2). The still image and the moving images cannot, therefore, be seen at the same time, but for comparison must be held in memory. The still image establishes the setting, which is a Vancouver suburb of post-war vintage, built mainly of modest, one- or one-and-a-half-storey homes on small lots. The view is taken from above, a crane shot familiar to cinema-goers as the establishing shot – the place and time of day at which the action will begin. In Wall's still photograph, the action is already underway, just to the left of centre, on the front lawn of a small modern house where three men are fighting, one of them a policeman whose angled car, stopped, rather than parked, helps us to locate the crisis at the core. The title explains it, and all the auxiliary elements fall into place: the woman with outstretched arms running from the house; the sprinkling of neighbours watching carefully from a distance; the kitchen chair near the curb where the otherwise unemployed owner was possibly standing guard; and the most ominous sign, a larger modern house on the adjacent lot, just completed and up for sale – the outcome of the last eviction struggle and the way of the future.

Wall is impatient with the idea that all of his work derives from nineteenth-century pictorial sources, and justifiably so. His formation in Western art bursts out of different periods, and sometimes conflates them, as he appears to have done with the two Caillebottes. In the case of *Eviction Struggle*, we are immersed in what Zaslove deems to be Wall's "Bruegelian pastoral grotesque," a vast field in which speech, if not exactly heard, is intuited through image, thus inscribed in history as a picture. For Zaslove, Wall's "new

historical vision of space and time" is "one which is full of the transformation, disjunction and registering of moments of destruction of something we are not quite certain of because we do not have a solid memory of it anymore." New forms of storytelling – vestiges of defeated cultures – revive "long vanished chronotopes of renewal."[37] The compression and resistance of the two times – two ways of telling and remembering – give structure to *Eviction Struggle* on both macro and micro levels. The two versions, back to back, blind to each other, establish the principle of duality, which is then echoed in the subdivisions of the video loops. Each monitor delivers a portrait, a single character from the drama seen from two vantage points, one approximating the angle from which the character is seen in the photograph and the other from a position within the space described by the photograph. In other words, one perspective is in-frame and the other is out-of-frame: these conditions alternate in slow motion, pulling and pushing the spectator in and out of the scene. The tension is between inner space (the minds of the social actors) and outer space (the vast landscape in which their drama is played out).

An essay by Rudolf Arnheim on the psychological dimensions of the built world underscores the stresses in Wall's world-making view. Impressed by the "visual detachment" of pictures of Earth from outer space, Arnheim considers the way that we experience space, as extensions of the surroundings that we can see and touch. To grasp the endlessness of the universe, we try somehow notionally to confine it, using instruments of record and measure that effectively replicate the conditions of the domestic box.

When in the fifteenth century Western painters began to define realistic space, they preferred to give their subjects the form of a boxlike interior. Such a confined space facilitated orientation. It reduced the spatial dimensions to

the vertical and the horizontal, and it supplied a dynamic counterpoint between the self of the viewer and the walls of the box. The viewer's self occupied the center, from which it sent out expansive energies from all directions. Instead of losing themselves, however, in endless space, these centrifugal energies were met by the counterforces rebounding from the walls. The self found its powers defined by an inner space.[38]

Wall's light box performs the same basic function – it frames, thereby taming, the vast space that he describes – it subjugates by subdividing it. As spectators, we float above the earth, gazing down on its neat divisions into roads and lawns and distant highrise apartments. As Arnheim continues, "In outer space [architecture] roams without boundaries through a world it fills at its own best judgment with neatly defined, surveyable units and whose interrelations it controls as the ruler. It defines our world as a social organization, in which we are not alone."[39] This is the dream of the suburban subject: the modern dwelling, reduced from household to box, is a protectorate. Here and now, before the Great Architect's unblinking eye, the dwelling is being denied the dwellers: they are being expelled. As spectators, we are fused to the all-seeing eye and also fractured by projection onto the neighbours. Their equanimity is also ours, as well as the author's. In *Eviction Struggle*, the role of the observer is borne with particular authority by a character who stands in and out of the frame. A woman, whose stare is aligned with the axis of the road, poses where we might expect the signature of the work, her feet cut by the bottom edge of the frame.

Mimic and *Eviction Struggle* place the mind-body in an ethical dilemma in relation to the scene – who am I who is seeing from this vantage point or these omniscient vantage points? *Eviction Struggle* represents the loftiness of the latter.

11.2 Jeff Wall
Eviction Struggle (1988).
Transparency in lightbox, 229 x 414 cm.
Collection: The Ydessa Hendeles Art Foundation, Toronto.
Original in colour

the postcards is a performance for the camera in which she occupies the foreground.[46] Consistently costumed, buttoned up in her Euro-folkloric cardigan, Yoon stands straight as a poker and po-faced. As an act of mimicry, it is sublime. Indeed, Kaja Silverman might be describing Yoon's piece when she writes:

this subject does not always wait passively and unconsciously for the gaze to 'photograph' him or her in the shape of a preexisting image. On the contrary, he or she may give him- or herself to be apprehended by the gaze in a certain way, by assuming the shape of either a desired representation or one that has come through less happy circumstances to mark the physical body. When this happens, the subject does not simply hold up the imaginary photograph in front of him or her, but approximates or attempts to approximate its form. In this sense, the mimicry which Lacan and Caillois discuss might be said to constitute three-dimensional "photography."[47]

As occurs "naturally" in tourist snapshots, Yoon's body covers at least part of the point of interest; in this case, the interference seems purposeful; it can be felt. Her look at the camera (at me) spurns the majestic backdrops and cultural settings. The frontality of the pose is insistent; the figure is flat, like a large paper doll, cut out and overlaid on a real souvenir photograph, mimicking it and masking it at the same time. This tension is confirmed when the card is turned over and read. The text offers an official, boosterist version of the site (exhortations to marvel, indulge, explore, feast your eyes, be charmed, come and enjoy), as well as unofficial insights into the character's thoughts. Or, I should say, the character's modes of thought: "She," the figure, looks and imagines, remembers, discovers (both history and geography), browses for souvenirs (unsuccess-

fully), and ultimately wishes other travellers a safe journey home. These different statements, printed in English and French, are accompanied by vertically arranged captions, in Japanese, Chinese, and Korean: "We too are the keepers of this land."[48] Yoon's Asian-character-selves and the sights of Banff are photographically compressed; on the other side of the card, a mixture of promises, memories, and claims conflates the histories of the First Peoples, and all the subsequent people – discoverers, settlers, labourers, healers, developers, tourists, and artists, each with their legends of possession.

Yoon's pose and implacable expression trigger just as many visual associations. Most obvious are the connections to popular culture, the snapshot conflated with the postcard. As carriers of meaning through function, each of these is also doubled. Kang, following Susan Stewart's distinction between "souvenirs of exterior sights" (postcards) and "souvenirs of individual experience" (photo albums) notes that Yoon's hybrid form is "blurring and mixing … distinctions between public and private, between multiple reproduction and authentic original."[49] Yoon's intervention works for Kang because it creates categorical confusion that raises parallel questions about authenticity and authority.

In fact, what Yoon does is *correct* Stewart's misconception about the souvenir, the tendency to calcification and rigid distinction that weakens her work. Yoon's visual and textual embodiments of the touristic experience are inclusive because they remember the rules of the game, especially the first rule which is imaginative re-creation of the self and others. The intended function of the souvenir image is determinant, but also flexible (like race). The snapshot, which is a fixed record of the moment, becomes a visual prompt for stories to be told ever after, in ever changing versions, after the traveller returns home. Yoon's look falls on the future listener, in effect, flows through the person

who is operating the camera. The postcard is an instrument of communication; unsent, it becomes a souvenir. This is another level of conflation. The unsent postcard carries the whiff of unfulfillment – a certain melancholic loss. I pick up an unsent card from my stack and I am reminded of the person who never received it, who might never again receive a card from me. Emotions runs high when memory is activated in this way. There are other, less personal, reminders: Watteau's sad clown, who carries the legacy of the commedia dell'arte, and who is himself remembered in Manet's collective portrait of stock characters, *The Old Musician*; ethnographic documents and the reformist photography of American Lewis Hine; August Sander's objective and encyclopedic portrait of the German people between the two world wars (a project wittily emulated in the seventies by a Canadian West Coast artist, Nina Raginsky); the decay of New Objectivity in the copy-cat ethnography of American fashion photographer Irving Penn; the curious echo of an anonymous news photograph (known in Japan as "The Photograph") of American General MacArthur's first meeting with Japanese Emperor Hirohito, in September 1945, with both men frontally addressing the camera. This widely circulated image was controversial because of MacArthur's casual uniform; it marked the Japanese defeat while symbolizing some kind of future role for the Emperor.[50] As the document of a performance, and Yoon's project must also be seen in that light, *Souvenirs of the Self* reminds us of the *photographic documentation* of American artist Adrian Piper, whose stolid street performances, sometimes in stinking clothes, made her body into a lightning rod for bigotry. Yoon's self-presentation is forceful, strangely enough, because of its neutrality; she makes herself a scrim for cultural projections of all kinds.

Souvenirs of the Self exists in two versions: the postcards in a perforated strip and an installation version which combines mural-sized enlargements of the postcard images with poetic texts and direct references to the Canadian landscape tradition. At the Edmonton Art Gallery, in 1991, Yoon's concept was expanded to include a special installation of Lawren Harris's painting, *Athabasca Valley, Jasper Park* (1924). Harris's painting is dominated by the figure of a solitary tree, a Western pictorial convention for the solitary spectatorial body, as discussed earlier in relation to the work of Sylvie Readman. This seems a good place to stop and compare Readman's appropriations of nineteenth-century landscapes and Yoon's conceptual conflations. Both projects were completed in 1991; both involved photography and painting, and specifically, the mythologized mountainous landscape. Both appeal to memory and imagination.

In terms of intention and meaning, the two artists' works have little in common. Readman's interests lie in photographic language, its structure and materiality, and she is fascinated by the ways in which we, individually and collectively, come to language. Yoon is interested in the products of these processes – material culture, oral tradition, and literature – how they affect both solidity and hybridity, how we manipulate them to communicate (and enforce) complex issues and sensitivities, especially notions of identity. Readman is hardly blind to these matters – she is a Quebec artist, after all – but her contributions to the debate are manifestations of the stages in her own movement toward language, those distillations and magnifications of visual forms that may remind us of episodes in our construction. In works being compared here (there are other sides to this artist), Yoon positions herself as an observer of the culture and its constructions. How ironic is this, you may be thinking, for *she* is plainly seen to be the subject, but what is really at play is the subject-spectator – the I who sees and names the figures, the I who estimates this Self's claim on these

Canadian sights. The depth of spatial configuration is dictated by its visual signposts and barriers. When Readman re-frames the landscape, I assume her view; I follow her mind's eye into the picture; there is fusion. With Yoon, my gaze rebounds; I look at Yoon looking back at me; I am conscious of the construction. In *Souvenirs of the Self*, the *self* teeters on a temporal bluff: the present-based culture mimics a never-was natural past.

A GROUP OF SIXTY-SEVEN

In 1996, Yoon was commissioned by the Vancouver Art Gallery to make a work for an exhibition entitled *topographies: recent aspects of b.c. art*. This exhibition was to follow the VAG's presentation of *The Group of Seven: Art for a Nation*, an exhibition organized by the National Gallery of Canada to mark the seventy-fifth anniversary of the Group's inaugural show.

Yoon's concept drew this celebration of art and nationhood together with another milestone of multiplicity: *A Group of Sixty-Seven* marks the Canadian centennial year, which was also the year that the Canadian government lifted immigration restrictions on certain East Asians (fig. 11.4). The autobiographical impulse of the work and its feminist grounding are quite clear: Yoon arrived in Canada in January 1968, a moment of separation and re-creation: her father had been studying medicine in Canada, her mother had been working in another Korean city, and Jin-me had been brought up by grandparents, first by her maternal grandmother who died when the girl was four, then in her paternal grandparents' extended family. The death of Yoon's beloved grandmother, which occurred in 1976 on a visit to Canada, brought an end to a certain kind of storytelling that had maintained connections to Korea.[51]

Yoon's concept for *A Group of Sixty-Seven* must have rebuilt those lines: storytelling is certainly implied by the work. Sixty-seven members of the Vancouver Korean community were invited to dinner at the VAG during the Group of Seven exhibition, and after the meal, each person was photographed twice with a painting as backdrop: the figure faces the camera, standing in front of Lawren Harris's *Maligne Lake, Jasper Park* (1924); the figure turns away from the camera, toward Emily Carr's *Old Time Coast Village* (c. 1929–30) (fig. 11.5).[52] Reference to Carr anchors the work in the collective memory of the West Coast. Emily Carr

11.5 Emily Carr
Old Time Coast Village (1929–30).
Oil on canvas, 91 x 128 cm. Photo: Trevor Mills.
Collection: Vancouver Art Gallery, Emily Carr Trust, VAG 42.3.4

Opposite **11.4 Jin-me Yoon**
Detail from *A Group of Sixty-Seven* (1996).
137 C-type photographs, 40 x 50 cm each. Photo: Trevor Mills.
Collection: Vancouver Art Gallery, Acquisition Fund. Original in colour

(1871–1945) was not a member of the Group of Seven, but a contemporary, living in Victoria; Harris, a founding member of the Group of Seven, met Carr in 1927; their affinities spurred her production, and his perspective on her work would later shape its representation by the VAG. Carr's paintings of Haida artifacts and forest landscapes are featured by the VAG in a semi-permanent rotating exhibition; *Old Time Coast Village* corresponds to a period of transition into her most purified, metaphysical expression. Here is a curious conflation: Yoon's positioning of the figure retrospectively anticipates Carr's stylistic shift by eliminating the putative subject matter of the painting, the remains of the village and the Haida canoe. That is certainly *our* perspective; we are blocked. We are also off-centre, that is, the figure who occupies the centre of the photograph is not positioned at the centre of the painting, but to the right of centre. The symmetry of Yoon's picture is achieved by cutting a considerable slice off the left side of *Old Time Coast Village*. The billowing forms and verdant richness of the trees are all that is retained, enough to swaddle the figures.

Yoon's treatment of *Maligne Lake, Jasper Park* follows the pattern of *Souvenirs of the Self* by placing an outward gazing figure between the spectator and the monumental view. Harris's forms are minimally detailed thrusting peaks that

contrast vividly with Carr's swirls and curves. Allusions to the birth of B.C. Modernism as the issue of these masculine and feminine forms cannot be ruled out.

As Grant Arnold has noted, Yoon's work should not be reduced to a critique of Harris and Carr: the formal beauty of Yoon's work, especially its brilliant colour, accords with Modernist values.[53] Ironically, through this act of mechanical reproduction, the Benjaminian auras of the original paintings are restored: *A Group of Sixty-Seven* depends on our understanding that these people were invited into the actual presence of the work of art (posing the community in Yoon's studio in front of reproductions would not have yielded the same meaning); the two paintings, that represent the art of our nation, surround these sitters with the nimbus of nationhood. Yoon's use of the grid reminds Arnold of a later generation of Modernist art, the Minimalist sculpture of American Donald Judd.[54] I also see references to Canadian Modernists: Michael Snow's use of the Group of Seven installation at the National Gallery to make his photographic work *Plus Tard*; Arnaud Maggs's multiple portraits (front and side views, organized in a grid) of members of the international art community, in *48 Views Series*. Yoon summons these memories knowingly, anticipating their recitation as part of the reception of the work. *Familiarity* frames her ideas. Familiar themes are conflated with pressing issues: the terms of familiarity are thereby challenged; defamiliarization is risked; and mental shifts, philosophical and political, are precipitated in the process. These modes of spectatorial involvement form new auras; the process begins with the activation of memory through imaginative reworkings. As Yoon puts it, "[I]n the imaginary, past, present and future are mutable. By re-working the representations of the past, by re-visiting history in the present, we necessarily implicate the future."[55]

The meshing of past, present, and future as a process of conflation is very clear in the works that I have discussed so far. Out of a seedbed of learned and popular references, a realistic scene is imagined and mounted for the camera as a field of narrative which the willing spectator tills. Roberts writes of Wall something that applies equally to Yoon, that the realism of the work and its production of a totalizing effect builds a sense of spectatorial "participation *in* the social spaces of the modern world."[56] We can take Vancouver as the social space; we can also consider the dialectical framework of these practices as a social space where ideas are bumping up against each other, jostling each other in the street. Roberts acknowledges both Williams's and Zaslove's accounts of Modernism in his reading of Wall, though he comes down in the end for social realism, to the visible. But what is this "visible"? Thierry de Duve has grumbled that readings of Wall that attend to the sources of his images fail to acknowledge that he is making "the painting of modern life" in *photography* — he is right, of course; the choice of medium is radically important in the construction of meaning.[57] In the same spirit, however, I want to stress that Wall (and Yoon) make their photographs up — they are staged events, therefore fictitious. Roberts may write that "Wall is invoking a multiplicity of voices, he is making visible the topography of the new capitalism,"[58] but in point of fact, what Wall is doing is proving, spectacularly, that this topography is *not* visible to the naked eye without an artist's imaginative intervention. Likewise for Yoon; the "multiplicity of voices" that forms a community at the VAG is there at her behest, and would not be there otherwise; she is the founder of this new Canadian myth, this *Group of Sixty-Seven*. Roberts writes: "As a buoyant Pacific Rim economy with extensive Asian immigration, a growing working class and a politically conscious native population, Vancouver reveals the extent

to which European-type modernisation and conflicts have come to dominate so-called secondary cities."[59] But, in fact, Vancouver reveals nothing of this, at least not in a way that can be seized, either in a decisive moment (Wall) or drawn out in a series of portraits (Yoon). Memory and imagination work in tandem here, or nothing works at all.

THE GIANT

I want to conclude this chapter by looking at a work in which imagination is plainly dominant, a work in which the unconscious takes form as the visible foundation of a social construction. The social space of intersection shifts from Vancouver, or even a ficto-Vancouver, to the realm of the unconscious. This possibility is clearly signalled in Yoon's statements: "I am deeply committed to the idea that through artistic practices, unconscious impulses can enter public discourses and effect social change."[60] Wall leaves the interpretation of his work open, thereby admitting some degree of mystery to his otherwise controlled process. He speaks of dreams – his own dream – as the springboard for his grotesque photographic "machine," *Dead Troops Talk (A Vision after an Ambush of a Red Army Patrol Near Moqor, Afghanistan, Winter 1986)* (1992), but the revelatory work, both in its construction and explication, is *The Giant* (fig. 11.6).

In any installation of Wall's work, *The Giant* stands out because of its small scale. It asks to be approached. Wall's general category for this work is "philosophical comedy," allowing for reflection on human imperfectibility, while holding up the hope of learning. *The Giant* fits with Wall's earlier personifications, such as *Abundance* (1985) and *The Thinker* (1986); in these analogue works, scale and vantage point create the effects of centrality and monumentality that are constructed digitally in *The Giant*. The figures are projects for imaginary monuments; Wall refers specifically to "the Surrealists' proposals for reconfiguring some of the familiar monuments of Paris."[61]

The titular Giant in Wall's work is an older woman, vigorous in mind and body, her historiated body nude, her eye fixed on a slip of paper that she holds in right hand. This monumental figure stands in the open stairwell of a modern university library. I count some forty miniaturized figures in the space, ascending and descending the stairs, working at carrels, watching and listening to recorded materials. The space glows – a golden beehive of learning – with The Giant at the centre, pausing as she goes about her work. Petra Watson has read *The Giant* as the personification of Alma Mater, the school or university which one has attended. Wall was not conscious of this reference when he made the work, though he did not reject the connection when Watson reminded him of it.[62]

Another source, conscious or unconscious, must be the Belgian Surrealist René Magritte's *La Géante* (1929/31) (fig. 11.7). This small painting is held by the Museum Ludwig in Cologne where Wall might have seen it.[63] *La Géante* is set in a bourgeois living room where the nude figure of a woman stands, her hands clasped behind her head. Everything in this tidy room, with its raking perspective, is to her monstrous scale; she looms over the small dark figure of a man who comes into the pictorial space from our space below, his head level with the vanishing point and the giantess's knee. Jean Roudaut discusses *La Géante* in a study of Magritte's literary and pictorial citations; there are interesting parallels between Magritte's painterly references (David, Manet) and his literary references (Baudelaire, Poe) and Wall's conflations. In the case of *La Géante*,

PART THREE

SCISSORS, PAPER, STONE

Memory is the raw material of history. Whether mental, oral,
or written, it is the living source from which historians draw.
Because its workings are usually unconscious, it is in reality more
dangerously subject to manipulation by time and by societies
given to reflection than the discipline of history itself. Moreover,
the discipline of history nourishes memory in turn, and enters
into the great dialectical process of memory and forgetting expe-
rienced by individuals and societies. The historian must be there
to render an account of these memories and of what is forgotten,
to transform them into something that can be conceived, to make
them knowable. To privilege memory excessively is to sink into
the unconquerable flow of time.

— Jacques Le Goff[1]

Unless the stone bursts with telling, unless the seed flowers with
speech, there is in my life no living word. The sound I hear is only
sound. White sound. Words, when they fall, are pock marks on
the earth. They are hailstones seeking an underground stream.
If I could follow the stream down and down to the hidden voice,
would I come at last come to the freeing word? I ask the night
sky but the silence is steadfast. There is no reply.

— Joy Kogawa[2]

Kafka already said that the things presented themselves to him
"not by their roots, but by some point or other situated toward the
middle of them." He doubtless said it to express his distress, but
the philosopher who frees himself from the myth of the "root"
resolutely accepts being situated in this midst and having to start
from this "some point or other." This restraint is the sign of his
attachment, and it is because he submits to it that the hope is

given him of progressing from one domain to another, in the interior labyrinth where the frontiers of the visible fade, where every question about nature leads to a question about history, every question of this kind to a question about the philosophy of nature or of history, every question about being to a question about language.

– Claude Lefort[3]

Scissors cut paper; paper covers stone; stone blunts scissors. In this metonymic game, stone seems almost overpowering in its unity and symbolic lode. "The hardness and durability of stone have always impressed men, suggesting to them the antithesis to biological things subject to the laws of change, decay and death."[4] Stone is the antithesis of the human body. Once dead, we sleep with the enemy. Our stones endure while we turn to dust; our histories become the markers of our memories. Or so we might stupidly hope, as Pierre Nora counters: "Museums, archives, cemeteries, festivals, anniversaries, treaties, depositions, monuments, sanctuaries, fraternal orders – these are the boundary stones of another age, illusions of eternity."[5]

The boundary stones that we will consider here are photographic images produced and organized to function as repositories of collective memory. They are photographic translations of memories that have been transmitted to the artists as versions, rumours, and myths. As memories, they are mutable – the pictures that we have are but one stage in this process – and they are also marked for preservation, destined to become histories. The photograph is part of that metamorphosis, impressive, though limited in its powers: photography is never more than the authorized version of its own history. All we can hope for, then, in this search for expressions of memory, is imagery from the middle of things, imagery that belongs to both memory and history, and perfectly serves neither. *Scissors* stressed the fragmentary construction of the personal; *Paper* erected a bridge between perception and pictorial convention; under *Stone*, I want to explore the photographic monuments that we erect in the name of memory, stones that "burst in the telling."

PERFORMING MONUMENTS

Conventional monuments – cenotaphs, statues, medallions, and so forth – capture the soul of a nation, or community, in three times: as objects of remembrance; as expressions of core values; as models for future generations. War memorials are good examples as projects designed to honour the dead, heal the living, and mythologize the gain. The rhetorical function of monuments demands a certain level of decorum or distance from the rabble: they are instruments of inculcation whose siting, scale, materials, mottoes, personifications, heraldic symbolism compose a message understood by the adepts, legated to their descendants, and eventually, as a last-ditch effort against oblivion, inscribed on an interpretive plaque. As Andreas Huyssen has observed, "the permanence promised by a monument in stone is always built on quicksand."[6] As symbols of power, the very idea of monuments excites public debate which tends to raise the ideological temperature of the host society. In modern Germany, an aversion to monolythic histories is expressed in what James E. Young calls "'counter-monuments': memorial spaces conceived to challenge the very premise of the monument."[7] These works of art (permanent and temporary installations) employ a language of absence,

rather than presence: their present-day core values abjure awe and heroism; they are provisional and participatory.

If the counter-monument is the way of the future, there are decisions to be made about the symbolic detritus of the past. Certain precedents come to mind. In Judeo-Christian history, the Iconoclastic Controversy is a classic example of ideological recall. From a skeptic's seat of judgment, Robert Harbison offers another:

A history of removal and destruction of monuments would be revealing. There are photographs from the 1930s of depots in Moscow where hundreds of statues of Lenin and Stalin sit waiting for distribution to public squares across the Soviet Union. Somewhere on the outskirts of Budapest, this scene has been reproduced in reverse, as unwanted monuments from the Soviet period are re-collected in one place. Today, to sufficiently detached observers, they constitute an ironic zoo of obsolete sentiments and demoted heroes.[8]

Monuments that are not swept away by counter-revolution will remain in place as objects of curiosity, visual backdrops, meeting points, perches for pigeons, and lightning rods for debate. Architectural historian Daniel Abramson argues for preservation on the basis that monuments are statements that may wound, but whose principles can be vigorously debated.[9] For photographer Jeff Thomas, this is as it should be. Communities need to interrogate and deconstruct the emblems of the past. Individuals need to find their place in this process.

A member of the Onondaga nation of Six Nations, Thomas adopts the perspective of an urban archaeologist, drawing on personal experience as a First Nations person in the city who is *Scouting for Indians* (1998–2000). In 1994,

Thomas shifted his field of inquiry to the Canadian capital where he found signs of Aboriginal representation on the facades and ceremonial entrances of major buildings, such as the Bank of Montreal and the Department of Justice, as well as a cigar-store Indian on Ottawa's Bank Street. On National Capital Commission parkland at Nepean Point, Thomas got involved with the image of an Anishinabe Scout at the foot of the *Champlain Monument*. For Ruth B. Phillips, this was a pivotal moment in Thomas's work: seeking "to revise a historical discourse that has silenced indigenous memory, while countering an art historical discourse that has constructed the indigenous artist as a primitive, and therefore as outside modernism."[10]

The monument is the work of sculptor Hamilton MacCarthy (1847–1939) who completed it in two stages. The principal figure, Samuel de Champlain, depicted high and dry, holding an astrolabe upside down, was unveiled in 1915 to mark the 300th anniversary of Champlain's second trip up the Ottawa. The scout, originally conceived to show how the First Nations guided Champlain through the treacherous waters, was supposed to be shown kneeling in a canoe; however, the citizens' committee having failed to raise enough money for the craft, the *Anishinabe Scout* was installed in 1918, his pose, costume, and position on the monument instead expressing subservience to the European navigator. So the situation remained until 1996 when the Assembly of First Nations organized a demonstration at the site to protest both its message and inaccuracy. Covering the statue with a blanket, leaders advocated its removal.[11]

In Thomas's images of the monument, he uses framing and vantage point to alter the spectator's relationship to the figure, effectively cutting Champlain out of the picture. The photographs sometimes include his son Bear as a contem-

porary counterpoint and surrogate self-portrait. Taking the monument as a perfect distillation of Canada's treatment of the First Nations, Thomas disagreed with its removal, instead proposing the addition of a plaque explaining the issues. The National Capital Commission nevertheless decided to move the statue which is now installed at the north end of nearby Major's Hill Park overlooking the river. There is still no canoe and a loin-cloth is still the figure's only clothing. In Thomas's mind, this decision fits the usual pattern; he responds with a long photographic view that includes both statues, entitled *Why do the Indians Always Have to Move?* He performs his own reinstatement by photographing Bear sitting on the bare plinth. Visiting the *Anishinabe Scout* in its new surroundings, Thomas documents its muscular chest, noting that the new arrangement has only heightened the statue's erotic charge.[12] For Phillips, Thomas's photographic interventions enact a "tricksterish, perspectival shift." For those who experience these works, she writes, "the monuments they call into question will never be the same."[13]

Thomas's interventions insist that the meaning of resistance cannot be reduced to binary oppositions. Cultural products that enshrine history in terms of "us" and "them" are obsolete. Furthermore, as Rebecca Solnit shows, attempts to use such monuments as illustrations of racism tend to half-measures that only lead to more confusion and anger. In San Francisco, debates over the Pioneer Monument's depiction of the Spanish missionary movement "pitted two relatively disenfranchised groups [Native American and Spanish/Mexican] against each other." At Devil's Tower National Monument in northeastern Wyoming, a government call for a voluntary moratorium on rock climbing every June to allow the Lakota and the Kiowa to conduct ceremonies at their sacred place flared up in accusations of reverse discrimination, competing notions of

spirituality, and a constitutional debate over the separation of Church and State. In other parts of the United States, public artists such as Edgar Hachivi Heap of Birds have made counter-monuments which have raised awareness and revised the historical record. But, as Solnit concludes, these works do not "reconcile or conciliate" groups clashing over contested sites.[14]

Thomas's archaeological approach – his photographic dig in the urban environment – is a thought-provoking alternative. His process does not replace one history with another, but instead focuses on cultural memory, the stories and images that represent history-in-the-making. His photographic images and considered statements place the spectator at a safe remove from violent conflict where understanding has chance to grow. Photographing the *Samuel de Champlain Monument, a Jesuit and Two Indian Men* (2003), Thomas sets up his camera below the monument and behind the muscular back of a crouching Indian (fig. 12.1). Through his lens, I assume the perspective of the Native figure who protects me from the ideologue at the centre, the Jesuit missionary pointing skyward at the source of his power. Thomas points his camera at the visual evidence of belligerence, ignorance, and racism, making a space for discussion that begins, Where do we go from here?

STONES OF MEMORY

Boundary stones are bursting in the telling. According to Nora, modernity's sweeping social and political changes have accelerated history, divided memory, and infiltrated its traditional environments. The workings of memory have been so altered in the process as to make them almost indistinguishable from history's representations.[15] Ironically, it is

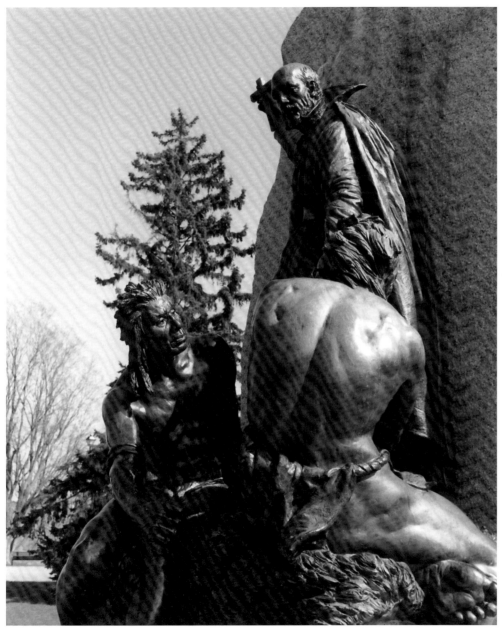

12.1 Jeff Thomas
Samuel de Champlain Monument,
a Jesuit and Two Indian Men,
Orillia, Ontario (2003).
Chromogenic print, 76 x 50.8 cm.
Original in colour

Western society's mobility – its auto-expulsion from the realms of memory [*lieux de mémoire*] – that has encouraged those preservationist tendencies that are ultimately fatal to memory's flow. We have grown attentive to memory, says Nora, because we have almost killed it with attention: the compulsive need to keep everything, resulting in the explosion of the archive and the growth industry of genealogical research (the roots of families, as well as other groups, including the professions); the heightened sense of memory as duty and a concomitant fascination with one's psychological capacity to participate fully (leading to what Nora will later call "commemorative bulimia," bemoaning the fact that his work has fed it[16]); the demand for authentic experience of the past, to *be there*, whether physically or imaginatively, via simulation. Historians are not immune to this disease; indeed they have come to embody it. Nora observes that society "is forced to give an increasingly central role to the operations that take place within the historian."[17] The historian himself or herself becomes a *lieu de mémoire*.

Interrupting Nora for a moment, we might consider how the photographer participates in this culture of professional reflexiveness – the strengthening of objectivity through self-examination – in the guise of personal historian. We saw such works under *Scissors*: Raymonde April's twenty-year embrace of her community; Karin Bubaš's "small museum of everyday life." Under *Paper*, Greg Staats revisited Sour Springs. Now returning to Nora, and substituting our agent, the "photographer," for his "historian," the activity of some photo-biographers comes even more clearly into focus:

a changing mode of perception returns the historian [photographer], almost against his [her] will, to the traditional objects from which he [she] had turned away, the common knowledge of our national memory. Returning across the threshold of one's natal home, one finds oneself in the old abode, now uninhabited and practically unrecognizable – with the same family heirlooms, but under another light; before the same *atelier*, but for another task; in the same rooms, but with another role.[18]

The common knowledge of our national memory: it seems important to emphasize that Nora's project is the recovery of French identity through its *lieux de mémoire*. The national character of his research is often overlooked, and we run the risk of overlooking our own sites of memory if we linger too long in Nora's realm. His historiography is specific to a dateline that includes the Franco-Prussian war and awards a major victory to "German science and pedagogy,"[19] to the hegemony of German positivism. Nora's first example of a rapidly shrinking repository of collective memory – peasant culture – might seem remote to Canadians, and happily so to those of European stock who chose emigration over starvation or industrial enslavement, then nearly froze to death in the new Promised Land. As twenty-first-century North Americans, our grasp of oral tradition is likelier to be informed by the legacies of African slave cultures whose traces are all around us in music, literature, and visual art. In Canada, collective memories are not lost, but enshrined through the efforts of the Gitxsan and Wet'suwet'en First Nations who, in 1997, won the right in the Supreme Court of Canada to have their oral histories heard and taken into account as part of their land claims. What we should retain from Nora and seek to understand better from his examples is his definition of *lieu de mémoire* as a site, or object, that is a pure sign of self-referentiality "created by the play of memory and history"[20] in which the material, the symbolic, and the functional always co-exist. This definition brings his history-work closer to memory-work. At first

glance, there are many ways in which Nora's history project mimics memory: its collaborative structure that evokes community and polyphonic tellings; its copiousness and repetitiveness; its construction of a state on a rubblework foundation of minutiae. Nevertheless, it is *history* that is being *written*.

As Jacques Le Goff explains, the methodology of the *Annales* School of historiography through which he and Nora were affiliated is "historical anthropology," in which historians reach "the deepest levels of historical realities, whether these be material, mental, or political, while taking care to preserve the structured unity of humanity and of knowledge."[21] In Le Goff's preface to the 1986 edition of *History and Memory*, he elaborates the relationship between history and science, noting two simultaneous, and seemingly contradictory, tendencies: on one hand, the historical science's preference for explanation, rather than narrative, and on the other, much influenced by the media, a renaissance of first-person witnessing of events in the mode of "immediate history."[22] It is easy to recognize photography in this category of "immediate history": this has been our training since photographers were first invited into theatres of war, and no amount of skeptical analysis will completely destroy our interest in photojournalism. We have learned that a caption can amplify or distort photographic meaning; still, we look at photographs to see what we can see.

But following the life-cycles of certain images, the different contexts in which they appear, underscores a change of function, or domain, which is of vital interest here. In *Remembering to Forget: Holocaust Memory through the Camera's Eye*, Barbie Zelizer shows that the most shocking photographs of atrocity, used repeatedly and generically to illustrate evil, quickly become symbols of memory, recyclable under diverse circumstances as visual prompts *to remember*. Her concern as it relates to the Holocaust is with

the loss of particular histories in a sea of images whose overwhelming realism has been abstracted at every stage, from first release to appropriation.

Zelizer's point complements art historian Ernst van Alphen's identification of a "Holocaust-effect" in the work of French artist Christian Boltanski. Van Alphen's notion is derived from the non-referential aspect of Boltanski's photographic imagery – one might say, from its oblique referentiality. In Boltanski's installations, portraits of people who *might* be victims are grouped close together and placed at one degree of separation from the spectator who sees these subjects through a conceptual scrim of media (postwar press photographs of survivors), documentation (lists of victims), or institutionalization (photographic archives): literally and metaphorically, these forms of record-keeping overshadow the human subjects as the true objects of Boltanski's attention.[23] The recession of the victim sets up a terrible schism in the spectator who is experiencing the deadening of his or her visual acuity – the parallel with forgetting is obvious, but so is the blurring of vision of the person who might see, but refuses to see, what is going on. The work thus conflates different moments in time and conflicting roles. The degradation of the image is fixed at an indeterminate point between action and inaction.

The photographic legacy of the Holocaust, like its vast and instructive literature, has influenced the representation of other crimes and tragedies. Oblique references and monuments of invisibility are photographic tropes for *certain kinds* of recurrent events and conditions: genocide, ethnic cleansing, exile, sectarian violence, environmental poisoning, unrelieved poverty, and untreated disease. When we think of photographic documents, and their potential meanings, we need to recognize the dissemination of these tropes through popular culture and public commissions. In the representation and reception of his-

toric images, they form a layer of visual literacy and discrimination that many theorists and historiographers fail to take into account. The "history of mentalities" that images help to explicate includes the history of imaging mentalities, and it is a complex history. Simply put, people have visual habits and opinions, as well as inner drives.

As a historiographer, Le Goff is witnessing and participating in a history of mentalities; he is also protecting his patch. Unprocessed, unrefined collective memory *(raw material)* threatens to overflow the banks of history "as both a form of knowledge and a public rite."[24] Photography, both public and private, is part of this flood, building up, though still contained in its designated spots: archives, libraries, museums, cemeteries, monuments, commemorations, pilgrimages, anniversaries, emblems, manuals, autobiographies, and associations.[25] As repositories of memory, Le Goff signals recent developments in "oral archives" and "ethnotexts"; he recognizes statistical methods and information theory as "quantitative history," made possible by the use of computers. These factors and others complicate the historian's task by opening up adjacent fields of "historical realities"; different temporal constructions are also in effect, including "the old time of memory." Historical science insists on the substrata of *longue durée* – factors that change at imperceptible rates – beneath the surface of events. This is more than attention to context; it treats our addiction to closure, to writing history in three acts. It also frames different kinds of visual representation, as we shall see in the visual histories of workers' memories by Carole Condé and Karl Beveridge.

Narrative is not going away, and by Le Goff's account, the historiographical plot only thickens when the ideology of progress is confronted with a history of failure, stretching from the Enlightenment to the atomic bomb, and is declared "practically dead." The last flicker of hope for the linear, or evolutionary approach, comes into history from the natural sciences, that is, biology.[26] Why not a history of nature? Le Goff asks, though immediately acknowledging how culturally determined such a project would be. Le Goff's prime directive is that "Every history should be a *social history*."[27] Here again, most people would agree, and reach for their snapshots to prove the point.

Histories are shaped by human needs in the present. Nowhere is this more apparent, or worrisome, than in the harnessing of history to national myth-making and territorial sandbagging. As Edward Said puts it, "The invention of tradition is a method for using collective memory selectively by manipulating certain bits of the national past, suppressing others, elevating still others in an entirely functional way. Thus memory is not necessarily authentic, but rather useful."[28] Assuming, of course, that the body politic can learn to forget, though this seems almost automatic, according to Benedict Anderson: "All profound changes in consciousness, by their very nature, bring with them characteristic amnesias. Out of such oblivions, in specific historical circumstances, spring narratives."[29]

In "Qu'est-ce qu'une nation?" (1882), French historian Ernest Renan systematically eliminates race, language, religion, mutual interests, and geography from his criteria for modern nationhood. What's left? A sense of fusion based on a rich common storehouse of memories; consent, continually renewed, to live together; and the will to perpetuate an inherited system of values: these things constitute the soul of a nation. Renan speaks of memory, but his definition of nationhood also embraces forgetting; indeed, he claims that forgetting and historical errors are essential to nation-building, adding that the reckless pursuit of history can jeopardize the future of a nation. The essence of nationhood, according to Renan, is the dual proposition that all its individual members hold many things in com-

mon and have also forgotten many things. Renan's example is the massacre of Saint-Bartholomew's Day; if you want to be a French citizen, he says, you'd better forget it. Anderson takes up this point in *Imagined Communities*, and deepens his analysis in a chapter appended to the second edition, entitled "Memory and Forgetting."

Anderson is struck by the paradox in Renan's prescription: that the collective memory which is associated with nationhood contains provisions for selective forgetting. We have seen the pairing of remembering and forgetting already, and found an advocate for forgetting in Friedrich Nietzsche. Renan's prescription is quite different. In Nietzsche's critical history, the sources of conflict are fully exposed, torn up by the roots and scrutinized, so that they can be discarded. In Anderson's reading of Renan, forgetting is essentially a change of perspective. Divisive histories are reimagined from the standpoint of the present-day unified nation. Regardless of how the adversaries defined themselves *then*, their descendants are *now* fellow citizens. Old massacres are thus reclassified: they now belong to the order of "fratricide," a regrettable family quarrel. The so-called amnesia is not total: since forgetting is a conscious act that contributes to the imagining of nationhood, Renan's *oubli* is more like a demotion. The troublesome memories are not entirely erased, they linger in the collective consciousness, and are available to spring back.[30]

Writing history from memory means constant revision of assumptions. Catherine Merridale's study of death and memory in Russia and Ukraine, based primarily on personal interviews, is a catalogue of contradictions. When did the violence of the twentieth century begin? She writes:

The whole process was prolonged through several generations, extending for more than fifty years. The roles of perpetrator and victim were frequently confused, too, so

that the ethical issues, the questions of good and evil, were not reliably clear-cut. Even memory has not been consistent, for the meanings of many deaths have changed over time, especially as Communism collapsed, and there are conflicts still about what constitutes a hero, what kinds of sacrifice deserve reward, and what kinds of killing cannot be condoned.[31]

Merridale went to Russia and Ukraine prepared by the literature of the Holocaust to measure the psychological damage taken by these other populations over a century of death. She found that mental illness was still largely taboo and that even medical doctors rejected ideas of trauma and post-traumatic stress syndrome that have long been current elsewhere. Russian and Ukrainian societies are not backward in this respect, or that is not Merridale's conclusion. For a myriad of reasons, specific to Russian and Ukrainian experience, sadness is more easily borne than victimhood. Between long periods of silence, by a process that only resembles common consent, the storytellers have put the accents on stoicism, fear, luck, and survival.[32] The survivors' memories are personal; their collective rites and memorials are predictably syncretic: things are evolving, though not necessarily toward the vocabulary of the West.[33]

Modern historians feel the need, and have thus seen fit to speak of histories, rather than History. Since the mid-1960s, English-Canadian and Australian historians have evidenced another need: to sever nationalism from history. Canadian historiographer Carl Berger cites his Australian counterpart, Graeme Davidson: "Historians … no longer see themselves as the interpreters of national character or purpose. If they champion a cause it is more likely to be that of a class, a party, an ethnic or racial group, a locality or a gender than that of the nation as a whole."[34] Postcolonial identity is another sort of wholeness, of course, but one that,

in Canada at least, builds on the condition of fragmentation, which partially explains why photography, the medium of *miettes*, has been so central to Canadian cultural expression. This line belongs to the historiography of Canadian photography, which I raised at the beginning of the book, and will return to at the end. The histories wanted here are those that shed light on the works under discussion.

This book is the result of many decisions. In this section, I am aware that my choices will be seen to reflect not just on my arguments about photography and memory, but also on my views on Canadian history, culture, and identity. The corollary is true, though it should be clear that my approach is by no means encyclopedic. Many topics have been left out, some because they have been treated with great depth by other writers: Clément Chéroux's *Mémoire des camps: Photographies des camps de concentration et d'extermination nazis (1933–1999)*, dealing with documentation, falsification, manipulation, the ethics of representation, and the construction of postmemory is an exemplary contribution to Holocaust studies. Canadian photographic artists and documentarians who have addressed these problems – Judith Crawley, Edward Hillel, and Marie-Jeanne Musiol come to mind – are working on a solid theoretical foundation within a broadly accessible visual repertoire. So while I have been moved by these works, their expression of memory does not require my interpretation.[35] The other factor is simply *l'embarras du choix*: the visual representation of community and collective memory by Canadian artists could not be contained by one book, much less a third of a manageable volume. I have concentrated on five categories of photographic memory-work that respond to the shift from history to histories, and from histories to memories, that I have adumbrated above. If the examples that I have chosen prompt memories of other bodies of work, I'll consider the framework a success.

Almost all the episodes referenced by the photographs under *Stone* are marked by a significant level of contestation, both in the moment and in subsequent relations of the facts. There are multiple versions of every event, to be sure, as proven in clinical testing, as well as on the street, by the common experience of hearing two or more accounts of a traffic accident.[36] I was particularly interested in photographic projects that attempted to deal with stories of long duration, struggles which occupied the memories of several generations. Such projects involve not just faithful recording, but imaginative recreation. The first chapter, "Agit-prompters," thus bridges the realms of imagination and history. I discuss projects by Carole Condé and Karl Beveridge in which memory and imagination intertwine to make striking and persuasive images of Canadian labour history. By correcting our memory of history, Condé and Beveridge advance the social and political arguments of the labour movement. Theirs are activist memories – the memories of the activists and the memories that will activate resistance. In "Repossessions," I look at another area of contestation here represented by the multi-media works of First Nations artists Carl Beam and Robert Houle. Issues of identity and self-determination are expressed photographically through visual strategies of symbolization – formal and semiological – that draw on the colonial archive and repossess it. In this chapter, I am indebted to recuperative histories and postcolonial scholarship for opening my eyes.

For the point about contestation is not that the pictures are dramatic, but rather that history and memory are, or have been, plainly divided. The winners having written the document, the unofficial version had to be preserved in other forms: stories, photographs, and other personal documents. Some of the people photographed might thus be considered "moral witnesses" – the living embodiments

and tellers of stories that Canadian society might otherwise have been able to forget.

In his study of the *Ethics of Memory*, Avishai Margalit is concerned with the "moral witness" whom he defines precisely as a person who has experienced persecution first-hand; who has been at personal risk; who has a moral purpose in testifying; who personifies hope and courage, yet whose morality may have been compromised for the sake of surviving to tell the tale; who is both sincere and authentic.[37] Robert Minden's meetings with Japanese-Canadians and Doukhobor-Canadians in British Columbia, here essayed in "The Pictures That We Have," are encounters with moral witnesses to the federal government's racist resettlement policies during and after World War II and to the protracted troubles of the Doukhobors in Saskatchewan and British Columbia, communities punished for their nonconformity. In both cases, the destruction of families, whether by physical or psychological separation, has been used as an instrument of social control. The prime Canadian example of this strategy is the notorious system of residential schools whose legacy erupts in the work of Beam and Houle, and also haunts Minden's work on the Doukhobors, as well as Marian Penner Bancroft's as she delves into her own family history.

The intertwining of individual and collective memory subtends the projects under *Stone*; the theme is explicit in the work of Stan Denniston, who goes to the sources of memory in the intersections of truth and fiction, or in photographic terms, direct and mediated experience. His paired photographs, *Reminders*, evoke the surprising persistence of memory as it shapes our appehension of space. His *Dealy Plaza* is similarly inspired by a shock of recognition felt on the site of American president John F. Kennedy's assassination in Dallas. But Denniston's memory-work is deeply rooted in Canada: the essay entitled "Flashbulb Memories?" questions Canada's colonization by American media, making the connection to Canadian local history and one Canadian mind-body quite clear. The other examples under *Stone* are all "Made in Canada," many conceived as visual antidotes to the Canadian version of blind patriotism which is smugness. As Marita Sturken shows in relation to American history, trauma is a reliable producer of memory.[38] In Canada, shameful and traumatic memories adhere to sites of exile and erasure, places of absence that contemporary artists have sought to reinvest with presence.

In the last chapter, "Markers," the very different photographic images made by Bancroft, Marlene Creates, Evergon, and Arnaud Maggs have this in common: their treatment of subjects as monuments of contingency and reconsideration. Working within the broad notion of place-memory to reinvent the monument, these artists create photographic "Markers" that refer, by their very nature, to multiple and changing perspectives. Paper covers stone.

The communities visited under *Stone* all have stories to tell; their transmission as photographic imagery results from the intervention of an artist. Some of these projects are consensual, and even co-operative, though the identities of the moral witnesses are sometimes withheld, as in the theatrical work of Condé and Beveridge. In all cases, the conventions of representation hold true, in the sense that three active agents are involved in the constructions of meaning: the image-maker, the subject, and the spectator. The subject is sometimes visible, sometimes proxied, and in one particular case (Evergon's), implied as a presence behind the camera, guiding the artist to places of memory hidden in the landscape. Formal expressions – syncretic vocabularies of continuous and continuously refreshed imaging – situate these works in the realm of memory, but the stories that they tell are shifting the boundaries of history.

Memory attaches itself to sites, whereas history attaches itself
to events.

— Pierre Nora[1]

Struggles are landmarks around which memory of the past
is articulated.

— Marianne Debouzy[2]

Agitprop is cultural material produced for incitement and
propaganda. The English word derives from a Russian ab-
breviation for early twentieth-century Communist efforts
to win the hearts and minds of the people for revolution.
Involving artists, writers, musicians, and theatre people in
Weimar Germany and elsewhere, agitprop's interests are
stated in the title of a workers' theatre production of 1926,
Yesterday and Tomorrow.[3] The artists to be considered in this
chapter evince the same interests, with the essential differ-
ence that their *yesterday* is history seen through the optic of
memory.

Carole Condé and Karl Beveridge have been working col-
laboratively on the representation of workers and labour
issues since the late seventies. Their work has addressed
social, political, and economic issues in various sectors and
industries, projects that they classify under labour, environ-
ment, social action, and health.[4] *Maybe Wendy's Right* (1979),

a photo-novella about a working-class family facing a strike, was their first attempt to translate labour issues into photographic art. It was completely invented, a work of the imagination informed by their own political awakening, or, arguably, its allegorical representation. *Maybe Wendy's Right* was highly innovative: its structure and motifs have often reappeared over the course of Condé and Beveridge's prolific production. Through this project, the artists became, and still are, activist art directors. But one key feature has never been repeated: a storyline fully formed in its authors' imaginations. Since 1980, Condé and Beveridge have been basing their work on research and interviews. An important aspect of their activity has been the recovery and dissemination of unwritten and unpictured histories of the Canadian trade union movement. Theirs is an archaeological history, and my approach to their work is somewhat the same.

My aim is to explore the many types of labour history and collective memory referenced by Condé and Beveridge's early work. These include: oral history, and especially, the collective memory of workers; the photographic archives of labour, ranging from the heroic to the abject; the visual culture of labour, both high and low; and — where it makes sense to start — the story of the artists' own progress from visual artists to art-workers. Looking at the framework established by their early projects, I want to show how the power of memory is evoked as an authoritative source of knowledge that urges us to join the artists in their critique of capitalism's official stories. The organization of the photograph does part of this work, as do the gestures and expressions of the actors in Condé and Beveridge's theatrical tableaux, but the real authorities are invisible, off stage, prompting recollection of their working lives. Condé and Beveridge gather data and chronicle events toward the revision of certain histories, but more significantly, they show us how and where neglected histories can be found, thus inciting curiosity and training others to pursue similar investigations.

ENTERING THE FRAY

Carole Condé and Karl Beveridge, who are life-partners as well as artistic collaborators, trace the raising of their political consciousness to the eight-plus years that they spent living in New York City. Arriving in 1969, they were effectively swimming against the tide of American war resisters and a considerable number of artists and intellectuals who were leaving the United States out of disillusionment with foreign policy and internal strife. Condé and Beveridge took up residence in a country fractured, traumatized, and politicized by the Vietnam War, the Civil Rights Movement, and the assassinations of its political leaders. The American art world, then centred in New York, was polarized by quarrels about the very nature and purpose of art. In 1969, critic Barbara Rose saw two currents, Clement Greenberg's post-painterly abstraction and an odd couple of Pop and Minimalism, which she valiantly traced back to the American school of Precisionism.[5] Running countercurrent to these relatively well-established, object-oriented movements were Conceptualism (sometimes called "Idea Art") and Performance Art ("Happenings"), both committed to the dematerialization of the object. None of these tendencies were immune to the charms of the other; cross-fertilization was to be expected. A further complication was the emergence of experimental film as a testing ground for perception, thus admissible to Modernism and Conceptualism. In short, philosophical conflicts raged, though at a dull roar, as compared with the volatile, political scene in which there were, of course, activists who were artists. Then as now, stylistic affiliation was not a reliable indicator of

conscience. The artist-members of the Emergency Cultural Government Committee, a sub-group of the New York Artists Strike Against Racism, Sexism, Repression and War, who withdrew their work from the 1970 Venice Biennale, included both materialists and dematerialists, artists as different as Sam Francis and Robert Rauschenberg. But the radicalization of American visual culture, especially in New York, grew over a series of engagements with the philosophies and capitalist agendas of mainstream museums and galleries.[6] Dot Tuer has traced the politicization of Condé and Beveridge through this period: Condé's participation in the ad hoc Women Artists' Committee, through discussion groups and demonstrations; Beveridge's association with Art and Language, a Conceptual collective that was growing increasingly politicized. The partners' joint involvement in Art and Language's fractious debates can be tracked through issues of *The Fox* and *Red Herring*, the latter featuring a comic strip by Condé and Beveridge: "Thinly veiled autobiography, the cartoons underscore the tensions experienced by artists whose advocacy of a theoretically inspired socialism contrasts starkly with their day-to-day lives as middle-class consumers."[7] The cartoon, published in 1977, complements the Art Gallery of Ontario exhibition and publication of 1976, *It's Still Privileged Art*, which marked the partnership's decision to return to Canada. *It's Still Privileged Art* is a cross between a romance comic and a manifesto. Characters based on the artist-couple ruminate over the ethical and practical dilemmas of producing political art within the system.[8] The work fits into a history of visual art propaganda, usually made in an accessible Realist style that breaks ranks with the avant-garde and the art bureaucracy by attacking their complacency and hypocrisy – it nuzzles, then bites off the hand that feeds it.[9] By 1976, Condé and Beveridge had recast their roles as collaborative

and political, but they were still preaching to the choir, and they knew it. Different sites and sources were needed. With their photo-novella, *Maybe Wendy's Right* (1979), Condé and Beveridge began to use photography and memory to close the gaps between art and labour, feminism and Marxism, culture and politics, folklore and history (fig. 13.1).

Maybe Wendy's Right steps out of the realm of high art. The work is steeped in what historiographer Raphael Samuel calls "unofficial knowledge," knowledge preserved in forms that historians have tended to overlook. "Popular memory is on the face of it the very antithesis of written history. It eschews notions of determination and seizes instead on omens, portents and signs. It measures change genealogically, in terms of generations rather than centuries, epochs or decades. It has no developmental sense of time, but assigns events to the mythicized 'good old days' (or 'bad old days') of workplace lore, or the 'once upon a time' of the storyteller."[10] *Maybe Wendy's Right* is a story told in a seventeen-panel series of photographic tableaux vivants, colour prints overlaid with text. The stereotypical roles are played by Condé, Beveridge, their daughter and her friend. The setting is a working-class family home. The scenario is as follows: Alice (pretty in pink) is an underpaid working mother who frets about meals, mortgage payments, and her marriage, even as her independence grows; Bill is a husband, father, and disaffected worker who worries about plant safety and a looming strike; Wendy is their daughter whose reading of history and political theory sharpens her awareness of worker exploitation, leading her to challenge the authority of her father and the stability of the family; Tim, the son and brother, whose marks are flagging, is yet unaware and staring down the barrel of trade school. The sets are semiological, consumerist carnivals: Kraft dinners, tabloid newspapers, monstrous price tags,

posters for the labour movement, and images of dream vacations. Fifteen tableaux are set in, or around, the home, and many take place around the kitchen table. Television is presented as a way of "Forgetting the day's problems"; in a formal family portrait pasted over the TV screen, they are "Seeing themselves as the boss sees them" (fig. 13.2). The text overlaid on each image takes the form of two statements that pull against each other: a bulletin about contract negotiations is juxtaposed with news of a co-worker's mutilating accident on a machine. The domestic front and the workplace jostle for attention. Though the tension mounts, there is no real crisis, and nothing is resolved; a fictional window into the working-class home opens and closes; we see its inhabitants, and as the point of view suddenly shifts and becomes Bill's, we enter the mind of a fictional subject and storyteller as he remembers a strike and envisions action.

Maybe Wendy's Right has been criticized for its adaptation *without consultation* of the workers' struggle. It's been called a "cartoon";[11] a more accurate word would be "blueprint." Critic Clive Robertson notes approvingly that Condé and Beveridge subsequently made a rapid shift "to a reciprocal process of dialogue and exchange that gives their efforts a distinctiveness."[12] He means, of course, that there were other artists developing the same themes, with varying degrees of political and visual distinction, and that the artists' new-found approach to collaborating with their subjects was of paramount importance.[13]

Condé and Beveridge's relationship to their subjects is unquestionably important and, since 1979, they have perfected their art, improving their research, building networks, and polishing their productions to appeal to a broad spectrum – to beat consumer and political advertising at its own game. Oral history is a significant component of their practice, thus cultivating and preserving the memories of

13.1 & 13.2 Carole Condé and Karl Beveridge
Details from *Maybe Wendy's Right* (1979).
Chromogenic prints, 40.2 x 61 cm. Originals in colour

their informants – turning their stories into material culture. But the grain of the work, so rough in *Maybe Wendy's Right*, is its expression of ideas growing within an individual and a community – *Maybe Wendy's Right* examines the first site of contestation, and its ongoing arena, which is the mind of the social actor. The work of Condé and Beveridge is distinctive because it maintains contact with the complexities of individual memories within the collective memory of a crisis and seeks to insert them into the historical record. This is a delicate process that balances collective memory, oral tradition, labour history, industrial archives, and both private and public photographs. A short detour through the literature of oral history underscores the possibilities and pitfalls that characterize the field.

WORKERS' MEMORY

French historiographer Marianne Debouzy's study of *la mémoire ouvrière* concentrates on oral history projects in France with comparative reference to research conducted in Britain and the United States.[14] The French experiment has not been perfect, which is what interests Debouzy and recommends her study to me. She begins by reviewing the philosophy behind the French oral history movement, already referenced in its many aspects through Nora and Le Goff. Debouzy places her accent on time and memory, as theorized by Maurice Halbwachs, Pierre Janet, and Georges Gurvitch, showing that these ideas have been percolating for almost a century. Halbwachs began to publish on collective memory in 1925, and Janet's work quickly followed. Debouzy suggests that the reinvigoration of their ideas was stimulated by France's relatively late move toward modernization, something that "fascinated and frightened people."[15] Her survey of the field finds a whiff of scholarly nostalgia that she refuses to overlook. Also specific to France is the institutional base of oral history which is the academy, not the grassroots collective. Debouzy contrasts this structure with Britain's example of autonomous oral history projects: "Hackney [the People's Autobiography group of Hackney, created in 1972] is a famous example of this attempt to reactivate collective memory through collective action and to enable people to interpret their own past."[16] Note that it is "People's," not "persons": the Hackney group is founded on the principle that "individual experience tells us little about the forces which shape our lives," insisting on "collective action … for the recovery of collective memory."[17] She notes that British oral historians often interview on a collective basis, while French researchers drawn to the "living past" seek "traces of memory in autobiographical material, life stories, oral testimonies, work habits, forms of socialization and organizations."[18]

The *mémoire ouvrière* movement has been vigorously criticized within French historical circles for its insistence on life experience, its overvaluation of passivity, undervaluation of struggle, its stress on the individual, rather than the collective. Politically suspect oral historiography has undergone considerable scrutiny in terms of content and specificity. Debouzy suggests that the researchers' findings are best understood as general principles, tailored to the group. The content of memories is very much determined by present conditions; the hardships of apprenticeship are forgotten by those who become bosses; those who remain workers *never* forget. Workers' memories are, like everyone else's, discontinuous; there is a need to reawaken them, with a concomitant need to understand better when and how this is done. When the workers speak, personal and social elements, both real and imaginary, are combined in

memory, and reconstructed into meaning. "The central themes of workers' memories appear to be work, struggles and the public aspects of daily life … a number of things do not appear in interviews: drinking, private life, personal problems, sex."[19] (Note that there is no drinking in *Maybe Wendy's Right*, but the rest of these taboos are acted out.) Some French labour historians have called *la mémoire ouvrière* a memory of the body, so deeply engrained are labour's rhythms and repetitive actions. Working conditions are remembered and, especially, acts of discipline – more so than the imposition of technological or procedural change, milestones that the researchers consider important and seek to revisit. For a group of miners, "What survives is … the tyranny of productivity and their efforts to resist it."[20] The rest fades.

But the miners are particular in their cohesiveness; other groups are more fissured. French researchers have noticed "a difference in the structuring of militant and non-militant memory": in the militant's memory, a strike action is part of a continuum, while in the non-militant's, it is considered disruptive.[21] This kind of observation moves closer to the individual, and the shift is crucial, especially in industrially advanced countries, where the work force is heterogeneous, racially mixed, and mobile. In Debouzy's view, collective memory loses its cohesion under nomadic and rootless conditions. Three levels need to be distinguished: "domestic, group, and local memory, each with its own coherence."[22] Industrial labour researchers have found that while individual workers tend to speak for the group, their memories are actually fragmented, though complementary. This dynamic is what constitutes their collective memory. Debouzy cites a 1980 study: "Each individual memory takes its place in a group memory that does not exist by itself but lives through the whole made up of these

memories that are at the same time unique and interdependent."[23] Not just community, but conflict figures in this network, with labour organizations seeking to impose official memories of events toward continuity: "The role of the labor movement is to unify workers' consciousness by giving them a coherent historical consciousness, but this means suppressing contradictions and conflicts which make up this consciousness."[24] This streamlining is at its most effective in places where intergenerational transmission of memory is interrupted or made irrelevant by the mobility of the population. American labour historians have found telling examples of oblivion and self-censorship linked to fears of reprisal and shame, these factors conditioned by episodes of repression, notably the McCarthy era, which is full of amnesic gaps.

Debouzy's study warns against the reification of *mémoire ouvrière*: "the tendency is to study workers' memory very selectively, to cut memory off from its roots, from all the phenomena which shape it and from which it cannot be disassociated because it is based on complex relationships among self, class and society and made up of interacting experiences and identities."[25] In particular, she signals the "many layers of memory, especially among immigrants, and women workers, and those of rural origin."[26] Debouzy's fascinating study shows that it takes nothing from the importance of workers' memory – it is both respectful and correct – to treat it specifically as a unifying force that comes to a point in the struggles of the workplace. At the same time, individual voices must be heard, and in the case of Condé and Beveridge, seen within the particular conditions of their working lives.

In the 1980s, Condé and Beveridge moved into the realm of oral history. Debouzy shows that there are different schools of thought and, within them, alternative approaches to

gathering data and recording workers' memories. It follows that the representation of workers' memory will be shaped by the processes of rekindling it, and this corollary reveals a great gap in our understanding of Condé and Beveridge. A Debouzy would pepper them with questions. How formal are their interviews? Do they ask set questions or simply open the floor to a person who wants to tell a particular story? Where do the interviews take place? Do they meet with individuals or groups of workers, and do they ever interview their families? Where do those interviews take place? Are the interviews taped, and if so, what happens to that material? To whom does it belong? Condé and Beveridge have clear answers to all these questions.[27]

ADAPTIVE METHODOLOGIES

Their initial response clears away any concerns about reification. "The interviewing process has changed over the years and is often adapted to the particular situation we're in." Most of their labour projects of the late 1970s and early 1980s draw on specific histories. The most ambitious, *Oshawa, A History of Local 222, United Steel Workers of Canada*, CLC (1982–84), chronicles five important chapters in Canadian labour history, some highs, some lows. The work includes fifty-six images divided into five series: 1937, the year that the United Auto Workers won its first contract from General Motors, marking the entry of the CIO (Congress of Industrial Organizations) into Canada; 1938–45, chronicling the effects of the war, including the hiring of women and their post-war banishment to the home; 1949–64, a renewal of militancy, culminating in backlash during the red scare; the 1970s, representing the rise of women's issues in the plants; 1984, the current issues of changing technology and affirmative action. In

the publication that accompanies the work, Condé and Beveridge explain their framework as follows:

As the title implies, this is *a* history of Local 222; one among many possible histories. Although most of the information was checked against archival sources, we relied primarily on the oral history we collected. Two major concerns directed the development of the work. One was the role played by women within the Union Local; the second was the attitude of members towards the Union as a social/political entity. In this regard, the majority of those interviewed were, to varying degrees, active in the Union.[28]

Preparing themselves by reading accounts of working-class life, histories of union organizing, and studies of working women, and informed by their own experience and family history, Condé and Beveridge "plunged in" to their oral history project. They interviewed about fifty people, mostly in groups, though some individually, because of distance or age. Meetings took place in union halls and people's homes. Instinctively, they followed the British model of group interviews, keeping them informal, as opportunities for collective storytelling, rather than recitations of facts:

In a group people would bounce off each other and interact to fill in details. It also developed a more conversational dynamic in which we participated rather than just asking questions. We would also include our own experience and opinions in a discussion – opening with an introduction about our lives as artists and cultural issues and understanding as well as explaining the scope and intentions of the particular project.[29]

It bears repeating that they nourished these discussions with their own experiences and histories, including their

New York years and their respective backgrounds, which they have parsed in terms of similarities and differences:

We've had to temper our lower middle-class upbringing. (Carole's father was a self-employed garage mechanic and while her mother worked at home, she came from a working-class background. Karl's mother was a single mom who worked as a copy-writer and her parents were working class immigrants. Both of Karl's parents were members of the CP [Communist Party] in the '40s (his father left when he was two.) An initial focus of our earlier work (70s–80s) was on working women's experiences. When we talked with and interviewed women, it was often focused on their experience as women which inevitably brought up family.[30]

The *Oshawa* texts are all excerpts from interviews, thus very personal and vivid memories of events relived. Photo albums were used by the "retirees and older folk … to remember people and names," the pictures mainly depicting union socials, rather than the workplace proper, or any noteworthy events. The albums thus prompted stories rather than documenting the labour histories in question. Condé and Beveridge were conscious of the fact that they were recuperating stories that might otherwise have been lost, and their tapes have subsequently been deposited with the National Archives.

Their use of this material in the form of first-person accounts underscores the duality of memory in industrial labour forces – cohesiveness obtains when competing interests are either accommodated or, more commonly, set aside for the good of the collective. In *Oshawa*, this process begins in the very first frame which shows two couples gathered around the kitchen table listening to a third man (fig. 13.3). The text identifies that man as a former miner – an

I had to get out of the mines; the coal dust, you know. I'll never forget the moment I arrived: the CPR station was just a little shack affair. If I'd had the money, I'd have gone right back.

13.3 Carole Condé and Karl Beveridge
Detail from *Oshawa, A History of Local 222, United Steel Workers of Canada, CLC (Part 1) 1937* (1982–84). Azo dye print, 40.1 x 50.5 cm.
Original in colour

exile from a cohesive community – whose first glimpse of Oshawa almost sent him home. This character figures as a local leader whose reminiscences include the recruitment of an experienced organizer from Detroit and the adoption of American models, such as the soon-to-be, militant Ladies Auxiliary. The first two chapters of *Oshawa* are set in kitchens whose backdrops frame pictures of the memories summoned by the text. This device allows one setting to represent Debouzy's three internally coherent and complementary modes of memory: "domestic, group, and local." In particular, the ascendance of women's issues in this photo-narrative is signalled from the beginning through the poses

of a central female figure; she wears her apron and does her chores, but she is always alert, always listening.

Condé and Beveridge's deliberate emphasis on women is even stronger in *Work in Progress* (1980/2006) and *Standing Up* (1981–82), a series of prints later published as *First Contract: Women and the Fight to Unionize* (1986).[31] *Work in Progress* represents no particular community, or rather, it represents many as a series of constructed snapshots of the lives and labour of women from 1895 to 2006. The set recreates the domestic interior of *Maybe Wendy's Right*, though with one major difference: the back wall is pierced by a very large "window" in which a documentary photograph establishes the politics of the decade, thus forging a link between the domestic and political fronts. In the 1909 image, the woman at the table is a recent immigrant, doing piecework; her calendar illustrates piecework in Canada; the framed portrait is of her extended, possibly now scattered, family; the photograph in the window documents the slave trade. In 1979, the South Asian Canadian woman seated at the table proudly presents a picture of union women – her kitchen work must be as a union organizer. She is backed by a picture of women celebrating Zimbabwe's independence, a calendar picturing a woman working in a data processing room, and a portrait of her single child. In between, 1956 is personified by a retail or service worker fading into the background of her home, while the Hungarian uprising is graphically depicted in the window: the ghostly figure is Condé reprising her earlier role as working mother. The artists explain that the project was devised in the 1980s "to talk about the split between class/socialist and feminist politics that was happening at that time."[32] For a 2006 commission, the artists built a new first image around the character of a late nineteenth-century Tsimshian woman, and also brought the work up to date. The expanded series concludes with a disturbing combination of so-

called "guest workers" in the West and the ongoing occupation of Iraq. Condé's cameo appearance in the series implies the need for self-implication in piecing together political representations; we should see *through* the artists' intentions. This argument is made entirely with images – no voices, real or imaginary, are heard, though the piece is saturated with memories.

By contrast, *Standing Up* and *First Contract* contain textual memoirs, first-person accounts of the struggle for equity by women whose fears about being identified led to the decision to use actors. Reprisals from the company were the most obvious threat, but the women's statements also reveal aspects of their private lives – strained relationships with their fathers and husbands, fights with their kids – that complicate their emotions and toughen their resolve. As the artists explain, "The book mixes art, labour, women's issues, and oral history, with the lines being blurred."[33]

A historiographer might suggest that *Oshawa*, *Standing Up*, and *First Contract* are the only oral history projects in the Condé and Beveridge oeuvre. Since completing these works, the practice of systematic interviewing has largely been superceded by informal interaction, sometimes because of the sensitivity of the material – their project on the nuclear power industry, for example – and sometimes because the artists were working as part of a "union rank and file team," therefore woven more closely into the community than they could hope to be as "visiting artists." They have found, naturally enough, that socializing and chatting brings people out in ways that a tape-recorded interview does not; afterward, they hurry off to take notes. "If and when we needed specific information (or quote lines), we would do short interviews to gather that information."

The shift is crucial, marking a level of acceptance within the union movement. Condé and Beveridge have always insisted that their goal is to be working as part of that commu-

nity. Recognizing that they cannot become "working-class," appropriate workers' experiences, or assume another person's economic or racial perspective, they have endeavoured to create a "common meeting ground – a place where we can 'negotiate' our relationship with the people we work with." On this common ground, union members are introduced and won over to the idea of contributing their stories to a photographic statement about their working lives. Their memories, and the artists', are part of the negotiations.

On one hand, if Debouzy is right, union leaders are striving for continuity and coherence, even if it means suppressing the contradictions and conflicts that make up the dynamic of the group. A photographic project might be seen as an occasion for cohesion; the artists are trustworthy and they are "pro-union." On the other hand, Condé and Beveridge evince an interest in meeting a cross-section of the work force, including "women, older and younger workers, minority workers, people in different job areas"; they are open to unexpected topics, such as "apathy"; they are prepared to put their own hopes "to create a living culture that affirms life and labour" on the table, even if it makes their hosts and hostesses smile.[34]

Storytelling always has a point, and in this context, the potential for photographic representation is the point. Condé and Beveridge are not social or political scientists reporting on conditions; they are artists seeking to make art about a certain set of beliefs to which they subscribe. Clearly, they want a better deal for women and racial minorities, both inside and outside the factory walls. Their memories as nomadic cultural workers and individuals drawn to the union movement are part of the conversation; they cannot be separated "scientifically" from the memories of their subjects. And if these artists are part of the union movement – the breadth and *longue durée* of their production supports this claim – then their work overall must be classified as part of the material culture of *mémoire ouvrière*. This is another realm of memory that their work both represents and deconstructs.

PICTURING LABOUR

Strictly speaking, the kind of work that is recorded by Condé and Beveridge is cultural work. That is, the images are the products of historical research, theatrical design and production, writing and art direction, photographic production and dissemination, including exhibition project management, contract negotiations, public relations, and education of both visual arts specialists and non-specialized audiences. The labour involved in picturing labour is part of their subject matter, as are the histories of its representation. Condé and Beveridge are primarily concerned with the trade union movement, but the sources of their imagery – the visual memory that is the subject of this book – are diverse representations of work, and with striking frequency, forms of work to which other labour historians have been blind.

Workspotting involves a certain visual acuity that is not given to all. Samuel's account of his awakening to material culture is very telling:

I had been brought up in a bookish, religiously Communist family: one which, though my mother was (in her spare time) a musician, had no space for visual pleasure. Our own home was bereft of it, and by the standards of the present day unbelievably bleak. There were the Van Goghs and the Renoirs which I bought my mother for Christmas or for birthday presents. There was the bust of J.V. Stalin on the kitchen mantlepiece, and one of Beethoven in my mother's room. Otherwise, nothing: not a single ornament.[35]

tions because, as an instrument of progress, it symbolizes their cause. Photographic repossession leaves a splinter in Canada's collective eye.

But rehearsing this cultural history is not, strictly speaking, what Beam and Houle are about. Photographic evidence of the past is juxtaposed with forceful references to the present. Indeed, photography's story-like capacity to bring the past into the present is fully exploited. Temporal and spatial conflations – fresh chronotopes – capture the artists' complex relationships with nations, cultures, and systems of belief. Distinctive visual constructions, their works challenge categories of convenience, such as authenticity and hybridity, through the sheer force of their formal cohesiveness.

Consider the work of Robert Houle. He is a painter and mixed-media artist who uses photographic elements in his work. *Kanehsatake X* (2000), a multi-media work in memory of the 1990 Mohawk action at Oka, is an instructive example (fig. 14.1). Curator Peggy Gale describes it as follows:

Kanehsatake X is a work of parts. There are two oil-painted panels, seven by two feet: French ultramarine blue as both Mohawk and Québécois colours, and cobalt and Prussian greens for "The Pines." There is also a slender "caution" panel in Indian red and yellow, with a digitized photograph of the Plains arrowhead, front and back, scanned onto two of the coloured sections. "The Pines" is closest to "caution." Finally, a metal X (completing "caution"): etched in memory onto permanent ground, accompanied by the memory of fragile rock, old as forever.[2]

Houle's statement is this:

As a people, our notion of time is delineated by our aboriginal languages. As a painter, preparing surfaces, colours and images, I use a mnemonic code, *me uhpé* (an Ojibway phrase), to express anxiety and delirium, but particularly to feel an event which resonates. When creating this multi-paneled mixed-media work, I used *me uhpé* to time and to remember what happened ten years ago. The blue panels recognize the cardinal directions, the greens evoke "The Pines" of Oka and the arrowhead pays homage to the endless endurance and remarkable patience of the Mohawk people in preserving and protecting their land.[3]

These statements are complementary in terms of painterly process and iconography, while curiously divergent in terms of photography. Gale's precise technical description refers to a digitized photograph of the Plains arrowhead; its two-dimensional image on the canvas is three stages, or generations, from the three-dimensional object. Houle addresses the mnemonic aspects of the painting, as well as its symbolism; he explains its complex system of linguistic and heraldic codes. But he refers directly to "the arrowhead" as though it were present to the spectator, rather than represented by an image – the wording seems to support Kendall L. Walton's notion of photographs as "transparent pictures."[4] Houle's identification with the object – the arrowhead is his and it comes with a story – may account for this, though other explanations come to mind. The arrowhead was found on Saskatchewan farmland. By stressing the factuality of the image, by treating it as evidence, Houle underscores the First People's prior occupation of that land as hunters. That way of life belongs to the past, but the arrowhead is still present, and its photographic image is a sign of enduring presence. It should prompt memory, but it will not be relegated to memory. Houle's description of his work serves here to introduce one in a multitude of paradoxical connections between First Nations artists and photographic images.

14.1 Robert Houle
Kanehsatake X (2000).
4 oil on paper mounted on masonite,
111.8 x 57.2 cm / 2 oil on canvas, 213 x 61 cm
/ Photograph mounted on masonite,
30.5 x 213 cm / anodized aluminum,
19.1 x 19.1 cm. Photo credit: Guy L'Heureux.
Courtesy Centre international d'art contempo-
rain de Montréal/La Biennale de Montréal

The place of photography in the history of the First Nations has been analysed in depth by cultural theorists and photographic historians, such as Tom Hill, Richard William Hill, Carol Payne, Ruth Phillips, Loretta Todd, Andrea Walsh, Alfred Young Man, and many others, some to be cited here, as well as artists and curators who have interpreted the photographic elements in their work. The field is growing and diversifying, as postcolonial notions of alterity, mimicry, and hybridity are revisited and tested by emerging scholars. Uses of photography by contemporary aboriginal artists are semiotically rich, embedded in history, and frequently ironic. Their critical stance relies on the competence of spectators to recognize (and reject) colonial stereotypes. Artists who incorporate archival photographic material into their work play double parts: in general terms (Barthes's *studium*?),they are evincing their engagement with the history of photography, thereby participating in its critical analysis; in the particulars of their work (its *punctum*?), they are exposing their own photographic memories. Furthermore, and this applies specifically to Beam and Houle, when the photographic element is only part of a multi-media assemblage, the histories of indigenous painting and sculpture are raised as well, and these histories bring along the social, political, and environmental contexts of cultural production and reception. None of this background is irrelevant, and some of it, especially the struggle for self-representation, weighs heavily on the photographic memory-work to be examined here.

Both Beam and Houle deal with stereotypical images of the First Peoples. This history begins long before photo-

graphy, with fanciful images based on the explorers' descriptions of exotic beings, indissociable from the wilderness. Affixed in the European imagination, these images persisted in nineteenth- and early twentieth-century photographers' portraits. Lynn A. Hill writes starkly and movingly of the period's complicity and complacency: "artists, anthropologists, government agents, and missionaries [who] believed that they were witnessing a significant moment in history – the last of a dying race."[5] Cultural genocide and mechanical reproduction walked hand in hand, from sea to shining sea, with photographers, amateur and professional, hastening to seize the shadow of noble savagery on their plates. Hill cites the most famous example, American photographer Edward S. Curtis (1868–1952), whose "posed, staged, and retouched" images reached heights of romanticism and falsification by propagating an image of "pan-Indianism"[6] that erased the diversity of the First Nations and, it follows, the differences between the individuals who posed. But expressions of individual difference were totally beside the point. The portraits were aimed at an audience transfixed by the exoticism of the subject, whether African, Asian, or "American."

As Gerald McMaster explains, the zeitgeist of the "Wild West" is alterity: "Europe's Other is the Indian; conversely, the white man is the aboriginal American's Other." Alterity is often theorized in terms of growth and possibility. For McMaster, the reality is quite different. He agrees with New Historicist Stephen Greenblatt that the European's desire for total possession of the American Other's land, objects, and identity served "to deny any effective reciprocity of representations."[7] Canada's experiments with alterity camouflaged repressive laws and illegal acts, including forced relocations to reservations and religious residential schools – exiles – designed to shatter the First Nations's structures of kinship, spirituality, and language. No student of genocide will be surprised to learn that the exiles were photographed as they went.[8] In the meantime, sacred objects were being confiscated or 'acquired' at fire-sale prices to be safeguarded for future generations in faraway museums. Photographic documents supported these acquisitions, showing the objects as they were *in situ*, while prejudicial photographs of the people emphasized their custodial incompetence, whether as beggars, defeated insurgents, or entertainers.

Hill traces the effects of the late nineteenth-century ban on sacred and ceremonial ritual and the government's subsequent channeling of Native creativity into industrial-training programs to produce handicrafts for the tourist market.[9] Anthropologist Nelson H.H. Graburn calls this arts and craft production a "'cash crop' for minority groups that have little else to sell," and he stresses the relationship between the destination of the objects and the sources of their form and content. The conquering society slips into the role of consuming society, and the producers of these arts and crafts are thus subject to the whims of the market.[10] In the 1950s, the shouldering of these economic pressures coincided with some relief from the most oppressive legal measures. Freedoms of language and ceremonial expression were restored. The children of the residential schools were allowed to return home on holidays, and eventually, with the closing of the schools, the abuses committed there began to surface.[11] Psychological damage aside, the intergenerational passing of knowledge – the First Nations' oral tradition – had been interrupted by the children's loss of their language. The vitality of traditional forms had been stifled by separation from the life source of dailiness and ritual.[12] There was much to relearn, and with the importation of the children's Christian education, there were many streams of knowledge to reconcile or reject. Beam, born

1943, and Houle, born 1947, both attended residential schools: their fluency in different symbolic systems and self-identification as cultural intermediaries bear the marks of their schooling.

When I turn to public collections for photographs of this generation's formative years, I am conscious of looking into other worlds through well-polished windows. In a boosterist vein, contemporary artists and art movements, including the so-called Renaissance[13] of Haida carving and the nascent printmaking of the Inuit, are documented by photographers working for government agencies, such as the National Film Board, and the liberal press, *Canadian Art* and other illustrated magazines. Amateur photographers capture their Native country neighbours and their guides to the wilderness, and preserve these pictures in their family albums. In 1971, Southern Canadians are charmed to learn about Peter Pitseolak, an amateur photographer living in Cape Dorset, who has been photographing his life for forty years. Social documentarians, such as Richard Harrington, and photographic artists, such as Tom Gibson and John Max, are visiting the same fields, though their findings are comparatively bleak. The evolution of Canadian social documentary photography, from subjectivity to inter-subjectivity, is a long and complicated story, a strand of which has already been visited under labour. In the industrial arena, mirroring can be seen to be a factor: the worker and the art-worker are reflected in each other. In the 1960s and 1970s, as concerned photographers turn their attention to the First Nations, we find another outbreak of alterity, for driving many of these social documentary projects is the non-Indian flower child's search for enlightenment. Terry Goldie has bluntly listed the "semiotic embodiments" sought by the dominant culture from the "indigene": they are "sex, violence, orality, mysticism,

the prehistoric." The novel gains currency with these stereotypical "commodities";[14] the same forces can be detected in social documentary photography.

This magic moment is also mirrored in the institutions: the introduction of photographic education in art schools and research universities; the opening of photographic galleries; and the establishment of public collections. Part of this efflorescence is the reissue of nineteenth- and early twentieth-century topographical and ethnographical surveys as monographs, among them Curtis's monumental oeuvre, re-edited and published in 1972 as *Portraits from North American Indian Life*.

In this sumptuous publication, Curtis's own words are used to explain how the "vanishing race" first met him with hostility, then grew increasingly co-operative: "they have grasped the idea that this is to be a permanent memorial of their race, and it appeals to their imagination."[15] Catching the spirit, essayist A.D. Coleman senses the "romanticism" of Curtis's vision and turns to *Webster's* for a definition: "signifying … the spirit of chivalry, adventure, and wonder, the preoccupation with picturesque and suggestive aspects of nature, and with the passionate in life." According to Coleman, "the Indian world view was also quintessentially romantic in the very best sense of the word." Thus he defines both subject and photographer: "Curtis was not imposing his romanticism on his subjects, but rather mirroring their own."[16] Alterity *redux*. Coleman's effusions represent well the critical vogue and the ethical alibis as nineteenth- and early twentieth-century ethnography was *rediscovered* (remembered; recovered; reframed) and placed before the public as disinterested works of photographic art. To put it bluntly, these works were entering the art museum, when Native artists' contemporary art works were not.[17]

While First Nations contemporary artists of the 1960s – Norval Morrisseau, Daphne Odjig, and the Anishnabe painters – combined traditional forms with Modernist style and technique, the perceived impurity of their work was initially confusing to the cultural gatekeepers. Gradually, it gained recognition as contemporary art.[18] Making a place for Native art in the art gallery, rather than the ethnographic museum, was one problem; interpreting the work was another. Art historian Ruth B. Phillips has traced the history of institutional validation, from the earliest recourse to alternative methodologies (anthropology, ethnography) to the adoption of revisionist frameworks (structuralism, semiotics, psychoanalysis, poststructuralism, Marxism, feminism) that, despite their European roots, offered curators and critics both the tools and the confidence to address non-European paradigms.[19] As concerns us here, the challenge of pluralism incited curiosity and insisted on new skills to deal with oral history and its foundation in memory.

Beam and Houle were students during the seventies. The contemporary art world, as experienced by Condé and Beveridge, was also theirs, though with different issues and inflections. Their generation was political and vocal, as Hill explains, while their work reflected their "personal experiences and individual histories" in expressive combinations of symbols and images from traditional and contemporary culture.[20] We see this in the syncretic production of Beam, especially in his incorporation of self-portraits – fragmentary, often whimsical, autobiographical references.[21]

Beam, the son of an Ojibwa woman and a non-Indian father, was born in West Bay on Manitoulin Island. Beam left his residential school after ninth grade, continuing his education through correspondence courses as he moved around, working as a skilled labourer, and eventually, in British Columbia, as a logger and ironworker. Self-taught as a painter, his formal art training began at the Kootenay School of Art, from which he transferred to the University of Victoria in 1973. In addition to painting, printmaking, and sculpture, Beam, in collaboration with Ann Beam, has created pottery that combines the ancient styles and techniques that he studied in New Mexico with photo-mechanical reproduction.[22] His oeuvre also includes a reconstruction of one of Columbus's boats, as well as the design and construction of an adobe house.[23]

Houle, who is a Saulteaux, a Plains Ojibwa, from St. Boniface, Manitoba, was educated for twelve years in Roman Catholic residential schools. He studied art history at the University of Manitoba and art education at McGill University in Montreal; he then taught at the Indian Way school at Kahnewake reserve.[24] Houle is an educator, a curator, and a theorist whose art work has been categorized as Abstraction, Conceptualism, and Postmodernism (a movement dismissed by the artist as "sophistry").[25]

Beam and Houle are very different artists, so generalizations about any aspect of their work will only carry us so far, but it is fair to say that both are interested in photographs as signs of temporal and spatial displacement. For Beam, photographic language is pure plasticity – meaning is never fixed – and he shows this by using the same images over and over, in new configurations. Houle's arrowhead images are exilic icons, stripped of their surroundings, wrested out of space and time, and inserted into a painting. In the rest of Houle's oeuvre, as in Beam's, the photographic elements are often appropriations; they are public images whose takeover, according to Robert S. Nelson, should properly be considered as personal, "giving the process conceptual power, but also semiotic instability."[26] The capacity to shift aligns these photographic images with myth and memory, and because they are generally historical images, the course is set for ambiguity and a surprising rapport between realism and its alternatives.

MARKING TIME

Photography is supposed to represent a moment in time. Beam uses photography dialectically, within and against its temporal specificity. His seizure of the archival image is part of his fight against temporal apartheid: "Time distancing is the model used to displace Native people from contemporary reality by making us into museum pieces. It's at the crux of a lot of problems. If Indian people can be made to inhabit an inauthentic time, to seem to not belong to the present and be living outside our time, then it's easy to believe we have no real title to our land in the present reality ... So in my paintings I show that we're all living in a cyclical time, with things fading in and fading out. I put the contemporary in a box and give it some distance." Developing this understanding, stepping outside the discoverer's single-point perspective of history, is crucial, according to Beam, and not just for the First Nations, but for Canadians as a whole.[27]

The primary vehicle of Beam's time-travel is collage, which he uses as a means of mobilizing the image. Wary of the lure of history – the glories and the grievances – Beam believes in the continual refreshment of myth and ritual. In a 1989 radio broadcast, he said,

The artist has a unique chance to say something in the collage format – it is actually like a dream time that exists in your mind – it wipes away your previous history to that time in a linear way, and it gives you events that happened in time as monuments in real time, without the written history – the written history being secondary to the raising of the event."[28]

Appropriated images are the instruments of re-creation: he adopted this strategy in the mid-1970s.

Through analog copying and transfers of photo-emulsion, Beam combines photographic reproductions with copies of European and Euro-American works; he complicates these encounters with an idiosyncratic iconography drawn from Native mythology as well as Western and Eastern religions; he further appropriates news pictures from the media and adds his own family snapshots; self-portraits and family pictures are set in parallel with Curtis-type images from the archives; he injects broad references to semiotics from linguistic signs to traffic lights; he integrates these elements with organic and calligraphic marks, paint, ink, and crayon poured or worked onto the surface of the handmade paper or canvas; he also makes compartmentalized assemblages. Comparisons with Robert Rauschenberg's monumental photo silkscreens and Warhol's variations on disaster are inevitable, if somewhat insistent on the socio-political. The psychological aspects of Beam's assemblages are no less important, reminding us of Joseph Cornell's intimate Surrealist boxes (flat, as they appear in reproduction, and three-dimensional, as they really are). To draw such disparate comparisons is to show how unclassifiable Beam's work is. Call it a series of very broad transcultural and transtemporal statements, embedded in the artist's life course.

The notion of parallel timelines, adumbrated by Tamara Hareven and applied in the last chapter to industrial life, also informs Beam's production. His use of the archive and the newspaper morgue expresses his belief in the integration of cyclical time, historical time, and individual time. These dimensions are coeval in *The North American Iceberg* (1985) (fig. 14.2).

The title of this painting refers to a catalytic event in Canadian art history. *The European Iceberg* was a major exhibition presented at the Art Gallery of Ontario in 1985 to expose the Canadian public to the resurgent importance of contemporary European art. The exhibition included the

14.2 Carl Beam
The North American Iceberg (1985).
Acrylic, photo-serigraph, and graphite on plexiglas, 213.6 x 374.1 cm
(assembled). Collection: National Gallery of Canada. Courtesy of Ann Beam

commissioning of a permanent installation from German artist Lothar Baumgarten: *Monument for the Native People of Ontario* (1984–85), consisting of a list of tribal names inscribed on the decorative frieze of the museum's Walker Court.[29] The controversy that ensued is explained by Robert Houle. Baumgarten's gesture, enshrined by the AGO, was an affront that rationalized, romanticized, and patronized the First Nations, giving the *other* a voice, while violating oral tradition: "The process of objectification still prohibits the

'authentic' voice from being heard, because its proper name has been appropriated, thus making the silence deafening."[30] If Baumgarten's work seems merely shallow, the depths of its Euro-centrism can be measured in a single sentence from Johannes Gachnang's essay for the catalogue: "The tremendous American challenge of the fifties and sixties was afflicted with all the signs of a juvenile attack, emanating from a land without a real history and directed against the bastions of a largely shattered occiden-

tal culture in the old European centers."[31] The dismissal of a culture whose surviving "art objects" date back over 5000 years could not be passed over in silence.[32]

Beam's artistic response harvests the legacies of "the old European centres," correlating the conquest of North America with eruptions of violence in the Middle East. Translated to his surface are newspaper reports of the capture and escape of a nineteenth-century warrior, Geronimo. Equally prominent is the dramatic picture of Egyptian President Anwar Sadat's 1981 assassination, which Beam had used before in other contexts. A hymn to progress and enlightenment through photographic technology is offered as a quotation from Eadweard Muybridge's stop-action imagery of a bird in flight. Beam's own multiple presence in the work insists on the presentness of his being and defies subjugation to a Euro-centric single-point perspective. Stencilled on the surface are the words "The artist flying still." And populating the field are portraits of nineteenth-century men and women, figures released from the colonialist archive.

A recurrent motif in Beam's work is the representation of what he calls the "Imaginary Indian," figures that he encountered in photographic books.[33] Beam's utilization of such portraits takes nothing from their formal qualities, nor from their factuality, though the latter must be seen as encompassing many different truths rotating about each image in gyroscopic motion. Authenticity is a developing situation when it is known that Curtis, for one, carried a bag of wigs, primitive clothing, and abalone shell nose rings to costume the more modish, short-haired Natives of the Pacific Northwest.[34] Beam reclaims figures from other sources as well, notably American frontier photographer Will Soule, active at Fort Sill, Oklahoma, between 1869 and 1874. The Soule archive is in many respects different from Curtis's elegiac index. In the words of Robert A. Weinstein,

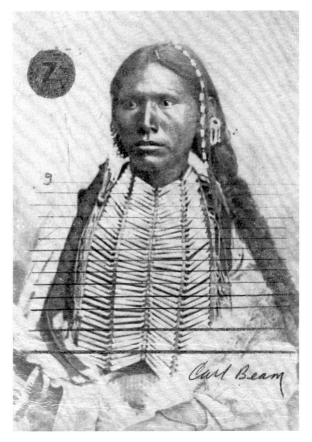

14.3 Carl Beam
Z, from the series *The Columbus Project* (1991).
Photo emulsion on paper with coloured crayon and coloured ink,
26.1 cm x 18.4 cm. Collection: Canadian Museum of Contemporary
Photography/National Gallery of Canada. Courtesy of Ann Beam

14.4 Carl Beam
Time Dissolve (1992). Photo-emulsion and acrylic on canvas, 270 x 210 cm.
Courtesy of Ann Beam

These are the Indians whom the white men justly feared.
The portraits are not of pacified, over-dressed, 'carnival'
Indians with whom the white man could feel comfortable.
These were warriors in every sense of the word, able and
deadly … defenders of their families, their homes, their
tribal rights, and their traditional tribal lands. These are
the Indians who died fighting the white man, not those
who surrendered to be imprisoned and to die on govern-
ment reservations. The names of these warriors are still
uttered with pride by their living descendants.[35]

And so it follows that their portraits are valued.

But how are they understood? Nineteenth-century por-
traiture is posed, therefore consensual – a social contract –
but the terms of this contract are very difficult to recon-
struct. In *Framing the West*, Carol J. Williams argues that
portraits of Native people were understood quite different-
ly by the subjects and the settlers.[36] Colleen Skidmore has
conducted research on the production of a German immi-
grant photographer, working on the eve of World War I, in
Edmonton, developing the characteristics of a "common
historical space" on which converged "two discrete lines of
sight."[37] Anthropologist Elizabeth Edwards encourages
such research with the idea that "the most dense of colonial
documents can spring leaks." Not gods, but "points of frac-
ture" are in the photographic details.[38] Still, we must con-
cede that much of this encounter has been irretrievably lost
– can only be imagined.

Back at the Fort, when a skilled warrior allows his portrait
to be taken by a fumbling camera operator, what kind of
encounter is this? Wherein lies the balance of power? These
two people's understanding of each other is so skewed and
their bargaining positions are so unequal as to annul any
social contract that they might have negotiated in the mo-
ment. The notion of trust, so often invoked when a sitter

appears relaxed before a camera, is absolutely meaningless, because his or her hopes are unfathomable. And regardless of the operator's or the subject's motives, photographic power ultimately rests on the use of the image which could hardly be controlled, or imagined, by either party. We are contemplating one of these unimagined uses now.

In *Z* (1991), from *The Columbus Project*, a single photographic portrait commands the field (fig. 14.3). The figure comes from Soule, identified in a 1969 monograph as "Brave in War Dress (probably Koi-khan-hole)."[39] Beam's copy crops the figure close to the body, eliminating the graceful hand, as well as the studio backdrop that placed the sitter against an incongruous painted landscape. Beam's intervention operates in the camera operator's and spectator's shared space, in the foreground. Red and black lines drawn horizontally across the surface suggest the scientific measurement of the figure, while nullifying the illusion of three-dimensionality in the photographic image. The dominance of Western perspectivalism is thus overturned, and the tension between systems of art-making can be felt; there is *reciprocity* in that the spectator's confidence in the photographic image is also shaken. I'll state this in Beam's and my shared language, the language of Euro-American art. The photographic image that colonial practices and contemporary photographic histories have legated to us as *real* becomes *surreal* through the optic of a First Nations artist who sees genocide through the mists of Euro-American Romanticism, who is called to admire the nobility of an ancestor's photographic performance while grieving the image's existence – these split-second recognitions could explode the psyche, but they are instead *faced* in every sense of the word.

The historic photograph re-presented – brought closer in time – splits into cyclical time and individual time, implicating the spectator in the same way that Beam intends

contemporary news photographs of violence or disaster to function in his work: "if you have your own face next to the Sadat assassination, this, to me, implies that one … has to have personal responsibility for world events."[40]

Descriptions of Beam's work risk failure: words fail because cataloguing his signs and sources substitutes a list of so-called "incompatible knowledge systems" for his fully integrated interventions. On a single surface, Beam might place images of Sitting Bull, Martin Luther King, himself, Muybridge's running elk, Beam's mother, his grandfather, a horse, a residential school "reunion," a rocket, feathers, a Pietà, Christopher Columbus, the turtle who in Ojibwa legend bears the world on its back, or Eddie Adams's split-second report of a summary execution in Vietnam; these motifs, and others, are much repeated and refreshed by recombination; there are also indistinct elements, signs buried. *Time Dissolve* (1992) contains possibly a hundred figures gathered together from old photographs; the pearly wash that unifies the surface expresses a struggle to remember names, dates, places; red circles snatch particular lives from the collective life course (fig. 14.4). Connecting all the dots seems rather facile compared with Beam's fluent handling of his conscious and unconscious impulses.[41] At the same time, emphasizing the playfulness of Beam's allusions and the delicacy of his mark is understating the sturdiness of his work. For if canonical and personal images are disappearing behind Beam's spidery paint, they are being replaced by combinatory expressions of memory that are anything but fragile because they are multiply bound: formally, linguistically, temporally, and performatively. Released by re-collection, Beam's photographic collages function as Jacqueline Fry once wrote about an earlier generation's translations of myth and nature into paintings: "[they] are not simply 'stories.' They express the logic proper to a culture, illustrating its social and moral organiza-

tion through images and words taken from the community's environment and experience."[42] Or, as Gerhard Hoffmann writes, "The artwork acts as a depiction or, rather, a reflection of a thought *process*," and it stimulates that process in the spectator through "defamiliarization of the commonplace" and "the setting of riddles or puzzles that keep open spaces for reflection."[43]

MARKING TERRITORY

In Houle's work, the boundaries between sources of knowledge and places of experience are more clearly and precisely drawn. Spatial allocations are rife with meaning. Houle's artistic response to Baumgarten's *Monument* was a site-specific installation, *Anishnabe Walker Court: Part 2* (1993) which countered the global grandeur of the visiting artist's installation with a modest proposal of local, successive impressions. Houle's inscription of names in lower-case lettering encircles the Baumgarten installation. Placed at eye-level, Houle's response deflates the original's pretensions. As a temporary installation, Houle's work is preserved in photographic images that serve it well: to include Baumgarten's work, the photographer, as well as the visitor, must shunt it into the background.[44]

Houle's suite of five mixed-media works, *Premises for Self Rule* (1994), has been described by W. Jackson Rushing III as a "beautiful reification of Aboriginal political power."[45] Each work is a diptych, the left panel a square colour field and the right an equal-sized panel of text, reproducing an extract from colonial and Canadian legal history. In chronological order, the documents are: *The Royal Proclamation Act, 1763*; *British North America Act, 1867*; *Treaty No. 1, 1871*; *Indian Act, 1876*; and *The Constitution Act, 1982* (fig. 14.5). Imposed

on each text panel, blocking part of it, and throwing a shadow on it, is an appropriated photograph whose history can be traced to an actual event in Canadian history and to the European trade in pan-Indian popular culture. The source images are from postcards given to Houle by artist Faye HeavyShield.[46] Published in Germany as "Young's Canadian Series of Postcards," the pictures were taken on 30 August 1907, at a gathering of First Peoples at Fort McCleod. *Treaty No. 1, 1871*, which concerns Saulteaux and Cree territory in southern Manitoba, is accompanied by an image entitled "The Horn Society of Alberta Indians," while *The Indian Act, 1876* is surmounted by a card image of "Chief Running Wolf and Party of Blackfoot Braves."[47]

The left panel of each work alludes to American and European Modernism. Houle's choice of materials conveys his appreciation for the tensely divided colour fields of Barnett Newman and Kenneth Noland, and the rigour of Piet Mondrian's geometries.[48] Houle places no boundaries on iconography and morphology. As a theorist, he delights in the openness of certain Modern artists – Picasso, Pollock, Newman – to the forms and spiritual legacies of ancient traditions.[49] As a painter, he is vigorous and expressive, creating in the blue field of *The Royal Proclamation* whirlpools of darkness and unfathomable depth. Acknowledging this history – the free migration of philosophies and forms – eliminates any question of artistic debt. No one owns the sensuality of paint. No one can measure, or restrict, the travel of the mind over a painterly surface. The political implications of this autonomous, abstract gesture should be clear. And Houle's work as a whole is equally emancipated from Modernism and Postmodernism because of its deliberate and productive impurity; Abstraction and Conceptualism meet at the borderlines of the panels. Examining similar areas in other canvases, Susan Douglas sees in Houle's

border areas, not 'natural' divisions between categories, but "a strategic ground necessary to reach a given destination … a new geography for the imagination."[50]

On the right panels, Houle's extracts from the treaties are ethical prompts, blunt reminders that promises were made which have become the premises for First Nations's land claims and desires for self-government. As citations they are incomplete; they trail off. Situating these textual remnants in relation to Marcel Duchamp's ready-mades (c. 1913), René Magritte's *Ceci n'est pas une pipe* (1926), or Joseph Kosuth's *One and Three Chairs* (1965) is not going too far afield, because Houle is also testing the authority of language and clearly finding it wanting. The rapport between text and photograph is a form of silent reproach.

The photographic object floats in front of the textual plane adding another dimension, depth, to the work. Earlier we found that, in Houle's employ (in opposition to the painted surface), the photographic image is transparent. We are supposed to look through the photographic object, back to the horizon. Photographic illusion is allowed to stand; the past flows into the present; the "landscape" is seen through the photographic window to be occupied by the long-dead and their temporary, earthly dwellings.

Houle's allusions to North American cultural and historical capital operate on many levels. What resonates in this discussion of memory is the equal division between the irrational and the rational in Houle's territorial allocations. His painterly appeal to spiritual values holds the false promise

14.5 Robert Houle

Premises for Self Rule: Constitution Act, 1982 (1994). Oil on canvas, photo emulsion on canvas, laser cut vinyl, 152.4 x 304.8 cm. Collection: Genest, Murray, Desbrisay. Photography courtesy Winnipeg Art Gallery

An Act to give effect to a request by the Senate and House of Commons of Canada....WHEREAS CANADA has requested and consented to the enactment of an Act of the Parliament of the United Kingdom to give effect to the provision hereinafter set forth and the Senate and the House of Commons of Canada in Parliament assembled have Her Majesty requesting that H........ sly be pleased to cause a Bill t.......... Parliament of the United Kingd........ The *Constitution Act, 1982* set ou....... t is hereby enacted for and shall h................ nada and shall come into force as provided in that Act....2. No Act of the Parliament of the United Kingdom passed after the *Constitution Act., 1982* comes into force shall extend to Canada as part of its law.... This Act may be cited as the *Canada Act 1982*.... PART I. CANADIAN CHARTER OF RIGHTS AND FREEDOMS....25. The guarantee in this Charter of certain rights and freedoms shall not be construed so as to abrogate or derogate from any aboriginal. treaty or other rights or freedoms that pertain to the aboriginal peoples of Canada including (a) any rights or freedoms that have been recognized by the Royal Proclamation of October 7, 1763; and (b) any rights or freedoms that may be acquire

of Euro-Canadian texts (words and images) in check, within boundaries, or, one might say, behind blockades.

J. Edward Chamberlin points out that the primary function of blockades is to designate borders – borders that "function like the threshold of a church, or the beginning of a story." A consciousness of borders grows when something needs to be protected; what happens at the edges is necessarily fed from the core. Chamberlin writes:

The grammar of aboriginal hopes and fears, the logic that informs their stories and songs, is a spiritual grammar; it is not a social or economic or political or even a cultural one. It is grounded in a knowledge and belief in something beyond easy understanding, expressed in the stories and songs as well as the dances and paintings that speak about the spirits. And it pushes back against both the pressure of reality and the rhetoric of other people's imaginations. It is a blockade too, saying no to other ways of being in the world.[51]

Peggy Gale describes the barricade of women's bodies that she sees in *Premises for Self-Rule: Constitution Act, 1982* (1994): "a long line of Native women standing straight and firm, richly arrayed in shell-decorated dresses, with their backs to the camera. A residential school is visible in the background of the 1907 photo-document from Fort McLeod, Alberta." The viewer's gaze goes only so far. It is psychologically blocked by the women's bodies. Gale's reading suggests that those who would expect to draw close to the event through the photograph alone are, like her, non-Native outsiders: "despite our actions and history, we can be rejected and ignored."[52] Photography thus used by a painter might be thought of as a decoy – a consciously erected screen memory – that protects the work's intricate meaning from casual, or complacent, con-

sumption. Mixing media, Houle constructs his deadly parallel between the policies of the early twentieth century and the continued threat of cultural genocide through assimilation, to which he is passionately opposed.

Beam's work contains equally urgent messages. An early assemblage, *Contain that Force* (1977), includes a kind of memorandum to memory, urging whoever finds his message to keep hold of all forces in their possession: "you never know when they'll be needed."[53] In the paintings and paperworks that made up Beam's *Columbus Project*, his use of a "soft-featured Columbus" summons Richard Rhodes's childhood memories of the classroom, "at the breakpoint between where we leave off the embrace of the family world and enter into the larger awareness of a historical world." The image prompts Rhodes to re-enter the mind of a "naive child" and calculate his own investment in maintaining contact with his own "pre-moral experience."[54] He tells a story about himself, which may not be true, but nevertheless co-operates with Beam's image to prompt inquiry into the force of such iconic figures, and the force that we bring to maintaining the simplicity of our myths.

We hear and say a great deal about storytelling as a cohesive force, process of release, and move toward healing. Less often mentioned is the difficulty of telling some of our stories. This problem is addressed by Bonnie Devine in her essay on Houle's *Sandy Bay* (1998–99) (fig. 14.6). The title of the painting refers to the residential school at Sandy Bay on Lake Manitoba. Two small photographs are part of this work: a portrait of an Oblate father in his garden; an assembly of children on the day of their First Communion. Devine inscribes her own family history and responses to Houle's work in a structure of six tellings: telling as loss, as history, as lie, as remembering, as political process, and as painting, which is Houle's part: "a passage through memory which

14.6 Robert Houle
Sandy Bay (1998–99).
Oil on canvas, black and white
photographs on masonite,
300 x 548.4 cm. Collection:
Winnipeg Art Gallery; Acquired
with funds from the President's
Appeal 2000 and with the support
of the Canada Council for the
Arts Acquisition Assistance

begins with two photographs," "tells of the body's connection to land, memory and self; of the People's connection," this passionate telling in "the language of colour."[55]

At the beginning of this chapter, I invoked the authority of Barthes and the notion of the *punctum* to introduce Beam's and Houle's repossession of the colonial archive. I thereby confessed, or possibly boasted, that the smallest photographic insert in a multi-media piece acts on me as a hypertrophic hook, directing me to consider the history of its making and display, its classification and preservation in the archive, toward the deconstruction of its meaning. This is a kind of photographic myth, for the most acute subjectivity will not go the distance. We need polyphonic and polymorphous histories to prompt our memories and tutor our imaginations. This is what Beam and Houle, by their repossessions, show.

I'm arguing that the act of interpretation not only defines the
phenomenon but also produces the phenomenon. Making
interpretations is a defining process, a social debate that *is* the
phenomenon as we experience it, not separate from the phenom-
enon. We're talking about the relationship between photographer
and subject, or any social investigation really. This perspective is
a statement about the creation of social meaning: that meaning
does not exist independently of the observer, that the search for
the centre of gravity shifts the centre of gravity.
— Robert Minden, "Photographing Others," 1980[1]

In the 1970s, social documentary photography as practiced
in the West comprised a number of sub-categories, one of
which might accurately be labelled "the art of photograph-
ing others." Within this frame, we would find numerous
collective portraits of North American communities — pop-
ulations, small and large, distinguishable by economic,
ethnic, racial, generational, confessional, and/or political
affiliation. Many of the communities visited by Canadian
and American photographers would generally be defined as
traditional, that is, still living off the land or sea, in lean,
though viable economies, maintaining their language, reli-
gion, and social values, and, therefore, *to all appearances*,
stable and independent. Other communities, which might

be similarly described, would nevertheless be understood differently, as having been transformed systematically, or at some point in their histories, by persecution, marginalization, or other manners of exile. By their racial or ethnic labels (often hyphenated), we would know them as survivors and seek to read their histories in their faces, gestures, possessions, and surroundings. Photographic projects to portray such embattled communities appeared to revive and uncritically extend both the reformist aims and the pictorial qualities of nineteenth- and early twentieth-century documentation of the Other – the works of American photographers Lewis Hine, Paul Strand, Walker Evans, and Dorothea Lange come readily to mind. The inheritors of this tradition espoused a humanist philosophy and deep respect for the photographic craft of their precursors. In Canada, portraits of communities were produced by photographers working individually or collectively who adopted a dignified style of portraiture, with photographic qualities such as precision, luminosity, and archival permanence increasing the beauty and historic value of their work.[2] Respect for photographic process and materials, and respect for the subject went hand-in-hand; such portraits were said to have been made, not taken. When projects were conceived in sociopolitical solidarity, including both photographers and researchers, as in the case of the Montreal-based Groupe d'action photographique (G.A.P. founded 1971), the representation of the subject-community, Disraëli, Quebec, was unified philosophically and stylistically, with the aim of making a strong collective statement about community.[3]

This period of photographic production in Canada is paralleled by the growth and reorganization of national photographic collections under the aegis of the National Gallery of Canada, the National Film Board of Canada, the Public Archives of Canada (renamed in 1987 National Archives of Canada), and the Canada Council.[4] Responsibilities for photographic art and photographic documentation were divided among these organizations. Social documentary projects fit into both categories and were relatively easy to rationalize as acquisitions or commissions, especially under the National Film Board mandate of "showing Canada to Canadians." Collective portraits of distinct Canadian communities strongly appealed to the architects of Canadian multiculturalism, a federal policy urged as a counterweight to the restlessness of Quebec and the grievances of the First Nations. At the same time, institutional funds and publication opportunities were limited, while private collectors were virtually non-existent, leaving social documentary photographers in the same financial straits as other photographic artists. From the photographers' perspectives, social reform and public education were wanted on all fronts. The communities that they photographed had suffered persecution at the hands of Canadian authorities; in the 1970s, many ethnic and native communities were still waiting for apologies and compensatory settlements from intractable governments – for some, the wait continues. In many cases, the populations that interested the photographers were aging; certain ways of life were disappearing; folklorists and oral historians working during this period voiced the same concerns. The photographers saw their image-making as a contribution to the collective memory and a prod to the collective conscience.

Marxist and postcolonial cultural theory has since challenged the tenets of social documentary photography, bearing down hard on its apparently unexamined perpetuation of Modernist portraiture. Any whiff of typification, invasiveness, condescension, or projection is liable to censure. Attempts to record the memories of a community must demonstrate that they are reflexive, dialogical, and above all,

responsive to current realities. This discourse remains vigorous, opening our minds to problems of subjecthood in self-representation and more complex ways of picturing.

But the question remains: how shall we deal with the pictures we have? Should they be dismissed, set aside as naive or unethical falsehoods – as Modernist propaganda? Or, if not, what criteria should we bring to bear in analysing and contextualizing these images?

These problems become extremely interesting as memory-work begins to enter the archive and change its criteria. As discussed in the introduction to *Stone*, the admission of unofficial histories, such as private photographic collections and oral testimony, complicates museum and archive work with new epistemological frameworks, systems of knowledge with different codes and values. Unofficial histories supplement, and often contradict, our official histories, and institutions are having to learn to interpret them, taking the conditions of their making and the biases of reception into account.

This process will not be complete until new criteria and interpretational models are extended to the so-called official histories, not to diminish them, but to understand better the conditions of their making as contributing to their function in the present. The situation is not simple, as the work of Carl Beam and Robert Houle shows plainly: ancestral portraits have inestimable value to formerly colonized peoples, even though the impulses and ideology that sustained their making have none. These images are evidentiary *and* affective; their existence helps to sustain the intergenerational transmission of knowledge that is crucial to a community's survival.[5] If this is true of communities that have been threatened with cultural genocide, it seems likely of communities that have been visited by outsiders who sought them out because they respected their philosophies and their struggles.

In the 1970s and 1980s, Robert Minden photographed the surviving members of two Canadian exile communities, including their descendants: Japanese-Canadians and Doukhobor-Canadians. He also photographed families, his own and others. Prior to undertaking these projects, Minden had trained and practiced as a sociologist: his ethical position and a performative approach to portraiture were both positively and negatively inspired by this experience, as he stated at the time. To examine the afterlife of the social documentary photograph in the archive, I could have looked at a number of photographers active in the seventies and eighties. I choose to look at Minden for several reasons. First, because his approach to social documentary photography shifts the stress from historical documentation to considerations of *social* aspects as both the frame and the content of activities that produced photographs. Second, because Minden's social documentary projects were conducted some twenty years ago – he has some distance on his experiences, as well as the different perspective of a professional storyteller. Third, because of my own involvement in one of his projects, as the National Film Board producer of his exhibition, *Separate from the World: Meetings with Doukhobor-Canadians in British Columbia* (1979). Fourth, because Minden has never stopped sifting his photographic archives; his portraits of communities should be properly be considered "in-progress," rather than completed. He brings unseen work or fresh interpretations of his imagery to light each time he delves into the material; the centre of gravity shifts. Revisiting his work together in light of my research, our thoughts ranged over the different disciplinary conceptions of memory – the sociologist's, the photographer's, and the storyteller's. Our personal memories were also active as we tried to reconstruct the history of his projects, including the debates that they had sometimes sparked.

Considering this archive, and how it might live in collective memory, reminded me of John Berger's essay, "On the Uses of Photography," written in 1978: "If we want to put a photograph back into the context of experience, social experience, social memory, we have to respect the laws of memory. We have to situate the printed photograph so that it acquires something of the surprising conclusiveness of that which *was* and *is*."[6] Berger recommends a radial model of public presentation, a constellation of "personal, political, economic, dramatic, everyday, and historic" contexts.[7] In "Stories," Berger develops this model by comparison with storytelling; he conceptualizes the photo-story as an amalgam of protagonists, tellers, and listeners – this amalgam is Berger's "reflecting subject."[8] Among the tellers are the photographers. Without mystifying their roles – on the contrary, as a way of demystifying them – we should include the specific conditions of their practice and their histories as social actors in the "reflecting subject." In Minden's case, we need to understand better what he conceived of as photographic encounters and, especially, how the dramaturgical metaphor of his sociological training was translated into photographic performance.

PHOTOGRAPHER AND STORYTELLER

In performance, how does the meaning of a story unfold? The process is complex, and however traditional the vehicle, not wholly predictable. Oral communication in general, and storytelling in particular, is an improvised construction of utterance and response: meaning is negotiated out of meaning.[9] Meanings are not lost, though they may be misplaced, or overlooked, when the immaterial is estranged from our material culture. Walter Benjamin's fear of collective amnesia is the motive force for his essay "The Storyteller," an attempt at preventive conservation for what he saw as an unravelling form:

The storytelling that thrives for a long time in the milieu of work – the rural, the maritime, and the urban – is itself an artisan form of communication, as it were. It does not aim to convey the pure essence of the thing, like information or a report. It sinks the thing into the life of the storyteller, in order to bring it out of him again. Thus traces of the storyteller cling to the story the way the handprints of the potter cling to the clay vessel. Storytellers tend to begin their story with a presentation of the circumstances in which they themselves have learned what is to follow, unless they simply pass it off as their own experience.[10]

I first met Robert Minden in Vancouver in the fall of 1978. As a production assistant at the Still Photography Division of the National Film Board of Canada, I was travelling to work on confirmed exhibitions, such as *13 Cameras/Vancouver*, and to look at other work that had been proposed to the Division for purchase. Minden and I had agreed to get together over dinner; he picked me up at Nova Gallery where co-owners Claudia Beck and Andrew Gruft had been lecturing me on the importance of institutional validation for the art of photography and the photographic artists in their stable. I was very tired. The trip had been challenging and full of small ambushes, as the basis of my authority as a glorified gopher was questioned again and again. Minden took one look at me – a very young woman with one arm in a plaster cast – and took me to a Japanese restaurant where we sat down and he told me a story. Unaccustomed as I was to hearing stories, I initially did everything I could to sabotage his performance, simply by treating it as a conversation that could be interrupted, or possibly improved, by witty interjection. Minden was very patient and adept, digressing

as needed to credit my intuition ("That happened later."), picking up the thread and continuing his story until I stopped finishing his sentences and began to listen.

Minden had at that point been photographing the Doukhobors for five years. He knew many things about them, the Russian origins of this religious community, its migration to Canada and diaspora within Canada, its stubborn cohesion and episodes of fragmentation – as an interested outsider he had read the official histories, looked at the historic photographs, and talked to the people. This was not the story he told. He told me his story which I need not recount here since he had told it before, would tell it again, and write it down for the catalogue. Minden's story was an engaging account of his first fateful meeting with Bill Dutoff – a silent first meeting through the ground glass of the camera that flowed into a day at Dutoff's cabin, a day doubly marked by a picture and an oracular statement (fig. 15.1). Dutoff said (did he really say?), "We are given instruments to find out where we stand."

I asked him what he meant. Did he mean my camera? Now it was I who felt that sense of urgency but the more I pressed him the more evasive he became, beginning long monologues full of spiritual metaphors, an endless outpouring of fragments of stories and religious anecdotes. Each time I tried to interrupt and return to that statement about instruments, he continued with renewed intensity, dismissing my questions.[11]

If Minden learned no more about the instrumentality of photography, he received important instruction about telling stories, lessons of economy and openness that his dramaturgical instincts and academic training had primed him to absorb and put to use. He used them on this very story, for the version just quoted from the 1979 NFB catalogue is a creative reconstruction. Minden's journal entry of 2 August 1975, published in 1976 in *Sound Heritage*, sets the exchange with Dutoff in a Chinese restaurant.[12] The Japanese restaurant version, which Minden would later write up for the catalogue, conflates the photographic session and the enigmatic dialogue which the diary relates directly to photography. The later version sets Dutoff's statement free within the frame of an earlier photographic meeting. It is a better story, more memorable, because it engages all our senses in a crucial frame-building exchange:

It was night. The air smelled of summer and thistle. We looked at each other. I thanked him for letting me photograph and he handed me a brown crumpled bag filled with onions.[13]

Dutoff, the storyteller, had recognized Minden on sight. The instrument was not the camera, it was Minden himself. What Benjamin perceives as a "process of assimilation," not into the community, but into the story, had begun. As Benjamin explains:

There is nothing that commends a story to memory more effectively than that chaste compactness which precludes psychological analysis. And the more natural the process by which the storyteller forgoes psychological shading, the greater becomes the story's claim to a place in the memory of the listener, the more completely is it integrated into his own experience, the greater will be his inclination to repeat it to someone else, sooner or later.[14]

Ut pictura poesis ? Not exactly, but the first of many meetings between separate worlds.

Robert Minden trained as a sociologist, first at the University of Toronto, then as the graduate student of a famous and, within the field, controversial social scientist, Erving Goffman. Minden had not wanted to pursue an academic career. His father, a lawyer and businessman, had a deep commitment to the arts, but not as a primary activity for his male children. While Minden studied classical music and worked in the underground theatre, his father guided him firmly toward more concrete ambitions. Sociology was probably not the father's first choice, but it suited the son, so it flew. Minden made an early marriage and set up his home as a graduate student at Berkeley, then just on the cusp of the social and political radicalism that would broaden Minden's education. When his daughter Andrea was born, he got a camera. He began to take photographs in relation to his research, which was based on the interaction within families. He also filmed the student demonstrations at Berkeley.

Initially self-taught, Minden became interested in improving his craft, reading voraciously, attending exhibitions. West coast photography was still dominated by descendants of the f64 group, among whom Judy Dater and Jack Welpott were the leading portraitists. Minden was more drawn to the work of Diane Arbus, and when he saw that she would be teaching at the Apeiron Workshops in Millerton, he applied and was accepted. Shortly before the workshop was to begin, Arbus committed suicide. The sober group that gathered at Millerton was met by a landscape photographer named Paul Caponigro, then developing his series on the megalyths. This seemingly odd choice of a replacement for Arbus worked out very well. In Caponigro, Minden discovered a kindred spirit whose approach

15.1 Robert Minden
William Dutoff holding his wedding picture (1973).
Gelatin silver print, 32.2 x 26.7 cm

to photography was essentially dialogical – an artistic process of "communion," or "listening," or "reciprocal moments," as Caponigro would later explain his own work.[15] Minden would take other workshops from George Tice, Ansel Adams, and Marie Cosindas. These names evoke many projects and styles – environmental portraiture, the directorial mode, monumental landscapes, and patient studies of characters and communities; what they have in common is the view camera as instrument and an exacting attitude to the photographic print. For Minden, formal and technical training served to draw the viewer into the image and initiate a conversation. He looked for ways to simplify his photographs, to make them clear and lucid: "simplifying in the sense of saying, I want you to be able to see when you see this picture ... when you look at the picture, the picture should speak back." His training helped him to previsualize the image, to measure the possibilities of light, dark, and shadow, and disciplined him to move around a subject until he had these elements under control. The subjects themselves were another matter. They were not – could not be – controlled, but interacted with the photographer as he prepared to take the picture with a large instrument that was the locus of their "improvisational theatre"[16] (fig. 15.2).

Many photographers – indeed, many visual artists – conceptualize their work within a theatrical framework. In photography, especially, the analogy is stressed to counteract reductive ideas of photography as a purely reflexive response to visual stimulation; the staged photograph is an obvious response as a visual tableau that records "fake situations that actually took place."[17] I am not suggesting that Minden's work fits within that mould, either formally or philosophically, but there are other sorts of performances that do inform his work, and they are social. Minden's basic approach to photography did not come from the medium at all, but from his training as a sociologist within a section of the field that encouraged his interest in dramaturgical expression. To understand the workings of his mind, we need to look more closely at Goffman.

Erving Goffman's *The Presentation of Self in Everyday Life* opens with a quotation from George Santayana's *Soliloquies in England and Later Soliloquies*, a passage that begins, "Masks are arrested expressions and admirable echoes of feeling, at once faithful, discreet and superlative." Masks are layers between living things and the air: "Words and images are like shells, no less integral parts of nature than are the substances they cover, but better addressed to the eye and more open to observation." On this philosophical footing, Goffman constructs his sociological framework of theatrical performance: "I shall consider the way in which the individual in ordinary work situations presents himself and his activity to others, the ways in which he guides and controls the impression they form of him, and the kinds of things he may or may not do while sustaining his performance before them." His report isolates certain kinds of events: face-to-face interaction, "the reciprocal influence of individuals upon one another's actions when in one another's immediate presence," which could also be called "an encounter"; performance is defined as "all the activity of a given participant on any given occasion which serves to influence in any way any of the other participants ... the audience, observers, or co-participants"; a pattern of action is called a "part" or "routine."[18] Goffman's recognition of "front region" and "back region" behaviour and his essential point about fluidity – that neither roles nor settings are fixed – depend on close observation and accurate description. This methodology was his greatest contribution, according to Emanuel A. Schegloff:

Goffman's observations habilitated a domain of inquiry not so much via the analytic and conceptual apparatus

which they prompted him to develop; its fate seems to me more uncertain than the domain of inquiry itself. That domain Goffman helped constitute by noticing, and by knowing how to provide the first line of descriptive grasp of what he had noticed. He risked what his critics would call 'mere description': he saw how important it was, and how hard it was, to get ordinary behaviour descriptively right. He let us see – those who *would* see – that there were investigable things here, and important ones; and that it was possible to get an uncanny grasp of the head and heart of sociality by examining these occurrences. How many readers, and hearers, felt revealed and exposed, gave out embarrassed giggles at the sense of being found out by his accounts.[19]

In this succinct appraisal of Goffman's intellectual terrain, even the language suggests the possibility of a parallel photographic approach, as well as the inevitable risks involved. The phrase, "first line of descriptive grasp," inscribes both immediacy and superficiality. That Goffman "let us see – those who *would* see" underscores his remarkable acuity and technical ability to translate observation into text, a great talent which recorded with such transparency that the communication of his experiences carried with it both content and methodology. The possibility of vision was given to others, though not to everyone, but only to those who *would* see, who were willing to see and determined to understand what they were looking at. "*Would*" here presupposes some level of preparedness, literacy or familiarity with the codes. The "uncanny" placed within the grasp of the willing literate derives from a double reading of evanescent, homely occurrences – the very matter of Realism – close scientific description, and especially photographic description. To the "readers" and "hearers," we might thus be tempted to add "spectators," assuming com-

15.2 Robert Minden
Louis and Elsie Gritchen, Goose Creek (1973), from *Separate from the World: Meetings with Doukhobor-Canadians in British Columbia.*
Gelatin silver print, 25 x 27.5 cm

petence and empathy, though we know that we should not because the *revelation* and *exposure* of a human subject through documentary photography is not simply the mirroring and inscription of what Goffman called "small behaviours."[20] By picturing, not just characterizing, an individual, photography lifts the veil of anonymity that licenses Goffman's trenchant observations and allows his audience, decent people after all, to giggle at the social behaviour of others. Here again, Schegloff's description is right to the point (he trained under Goffman, after all). The

Without diminishing the significance of your work, it's after all just a photography project. But for us it's our life and not just for ourselves as individuals, but it's the life of our community.

The camera doesn't say of the picture you took of me, that picture there itself, it doesn't say this man believes that one should not kill.[42]

The identification of Minden's bodies of work with a group (Doukhobors), or groups living in a place (Steveston), is a convention of social documentary photography and a taxonomic convenience, but perhaps these are shortcuts we can no longer afford. Photography is an art of co-presence, which must be understood in terms of encounters. Perpetuating the pseudo-sociological framework of groups restores the barriers that collaborative photography breaks down, and perpetuates a misconception, that the social documentary photographer has a stake in the calcifying relegation to history of living communities, in the construction of an archive that buries the survivors alive. This is an outcome that any photographer needs to be aware of, but in Minden's case, at least, it is an after-effect of a quite different process. As he suggests, one has to "separate the act from the archive," not to protect or exalt the photographer, but simply to determine what he or she was about. *Portraiture*, as defined by Richard Brilliant, reflecting "the social dimension of human life as a field of action among persons" – human original, artist, and audience – is what Minden was about.[43] *Histories* interested him as well, including the histories of representation of the people that he was setting out to portray. He had visited the photographic archives of the Japanese internment (scores of fishing boats impounded; the rough barracks of the camps); he was aware of the photojournalistic records of the Doukhobors (older women stripping themselves naked in pacifist actions of civil disobedience; mothers and children staring at each other through chain-link fences).[44] He had also seen how the communities portrayed themselves, whether in photographic albums, framed photographs, or verbal images.[45] These histories acted on the work in the fluid sense that Greg Dening gives to their performance in everyday life:

Histories, transformations of the past into expressions, clothe, constitute, *are* a present social reality. Histories always have this *double entendre*. They refer to a past in making a present. The knowledge of the past that re-presents the past in story or account makes the structures of the present – such as class or identity – in the expressing. So histories in our poetic are not just the stream of consciousness about the past but that knowledge made dramaturgical in its forms of expression. Histories are fictions – something made of the past – but fictions whose forms are metonymies of the present. Histories are metaphors of the past: they translate sets of events into sets of symbols. But histories are also metonymies of the present: the present has existence in and through their expression. The present – social reality, the structures of our living – has being through representations of the past in coded public forms. We read or hear histories in this double way. We know in them both a present and a past.[46]

As a visual artist, Minden seeks to describe the intricacies of human relations, focusing on the signs of experience in a facial expression or gesture. The photograph's intensification of such performances is what draws him to the medium; the evanescence of such moments is what fascinates

him because it puts history into question, and the authority of any single moment at risk. Minden's memories of these photographic moments translate into vivid stories that bring the photographs into the present and decode them. He speaks of little things harvested from intense observation of people moving in and out of a pose, their masks softening and reforming as they shift between regions, their "small behaviours" photographically sparked and preserved. He replays his part in the making of these histories, and also questions their value, then and now.

The Steveston project, re-edited over the years into three substantially different editions, evokes many images. In a family portrait of 1974, Tsuneko Koko and her two children, Aaron and Gen, pose in a doorway whose sole ornamentation is an incongruous emblem of the western frontier, a horseshoe for luck. This trio is sombre, not reflective, but outwardly stern. Aaron's fist is clenched and Gen hugs the life out of her doll. If this fixed and decisive moment were the only existent portrait of this family, if this were the sum of their small behaviours, we would be left with an impression of defensive reserve, an unbreachable barrier, between two Goffmanesque teams: this mother and her children, and the photographer and his audience (the outsiders: ourselves). But a historical document can be used against iconic authority, and this is precisely how Minden uses his archives, as a site of reconsideration. Sifting through his archives for the third edition of *Steveston*, Minden remembered the nuances of the portrait session and grew dissatisfied with its condensed representation.[47] He created a double portrait by combining *Tsuneko and her Children, Aaron and Gen*, with *Tsuneko and Her Children, a few moments later*. In the second portrait, Aaron's head has dropped down on his smiling mother's shoulder, and Gen, warmed by her hood, leans against the door frame (fig. 15.5). The space cre-

ates a moment in between that evokes the participants' memories and beckons the spectator's imagination.[48] What words, what gestures, what unspoken notions of self, linger between the frames?

LOST SOUNDS

Minden has never claimed – he resists the idea – that his photographs are the complete records of his encounters, or that his intention ever was to supply our society with a history of a group or a place. In 2000, we grappled with this idea for some time, because however partial, subjective, fictional, or insufficient these photographic records, they are, as I kept insisting, the records that we have. The reproach that we make against ethnographic or social documentary photographs, that they somehow cheat us of knowledge, is the naive discovery that there is no omniscience. Truth is only partially delivered, the proof is not in the pudding, but in the processes of its making and in our competence as spectators and listeners to bring those conditions to life.

It is quite startling to hear Minden speak about his photographs in evaluative terms because the convergence of forces that he describes is at times more metaphysical than mechanistic. A photograph that works is a liminal experience that offers "a kind of revelation that you could not impose upon it." Revelation jostles with realism in the making and reconsideration of an image. "If you pay attention," he says, "you can have revealed to you parts of your consciousness which are not necessarily apparent." Memory plays a crucial role in this awakening by fending off the overbearing weight of history, by insisting that the story might be changed. The possibilities are arrayed by Benjamin when he distinguishes "the perpetuating

remembrance of the novelist" from "the short-lived reminiscences of the storyteller. The first is dedicated to *one* hero, *one* odyssey, *one* battle; the second to *many* diffuse occurrences."[49]

Minden has been a storyteller all his life, and performing professionally since 1981. "I want to tell you this story" is often how he begins an explanation of a picture. The story of the lost sound refers to the musical saw, an instrument that Minden first heard played by the legendary Tom Scribner, then living in Santa Cruz, California. Ironically, Minden's first impulse was to photograph Scribner – he would continue to photograph saw players wherever he found them – but what he really wanted was the sound whose fundamentals Scribner agreed to teach him while telling him the story of his life as labour organizer, a member of the Wobblies. Minden wrote a children's book about a young

girl, trained as a classical pianist, who wanted to learn to play the saw, a story that touched Scribner who immediately recognized it as Minden's own.[50] That story metamorphosed into a live performance, the first of a series of tours and recordings of musical compositions that find their sounds in bottles, hoses, toy pianos, in all kinds of domestic objects that the rest of us think of as mute and still.[51]

Minden and I wondered, Is there such a thing as a storytelling picture? The so-called transparentness and the evidentiary function of a photographic image would seem to inveigh against memory's "many diffuse occurrences." To sustain multiplicity, or even better, to nourish it imaginatively, a photograph must somehow be auto-subversive, "to reveal the presence of versions competing with each other." In our struggle with history, we seek signs of resistance and interruption in photographic works. We project these signs,

consciously and unconsciously, from our own repertoire of experience, as Barthes did his *puncti*.[52] We seek literal images of contestation: evidence of the personal or the private casting doubt on the master narrative — compelling evidence whose tabling leads to a reconsideration and revision, or correction, of the official record. This is what Berger is urging us to do. The storyteller, for his or her part, is looking for something else, as Minden explains: "If there are two hundred people in a room and it works, I think it means that there are two hundred stories co-existing in time in that room." They are not competing, but co-existing, "images floating and colliding." So the answer is no, there is no such thing as a storytelling photograph, but images from photographs that tell stories? Perhaps, but only if we allow for the germination of difference. From the dual perspective of a photographer and a storyteller, Minden writes, "There are images that sometimes rise to the active process of musing about a perception of a life, images that seem to beckon the viewer/reader to rhapsodize, images that form fragments of dreamscapes that later haunt us in their retelling, yet this process seems somehow different from that of attending to a storyteller in the present."[53]

One of the Doukhobor voices returns:

This is the generation that just looks at it ... You can never take it in unless you've lived in it. He will never really know. He will remember these buildings but he will never really know the feel of living in that colony and sharing ... and growing up in the group. He will only hear but not feel it — not really feel it.[54]

The descendant of the exiles, infused with postmemory, will never fully understand what the elders went through (fig. 15.6). A photographer, a stranger, knows better than we how little he or she has been able to take away. If that

15.6 Robert Minden
Rachel and Derek Makonen, Loresa Soviskov, Kim Markin, Glade (1975/2006), from *Separate from the World: Meetings with Doukhobor-Canadians in British Columbia* (previously unpublished), 26 x 34 cm

photographer has established a dialogical relationship with the community, he or she will also be told how little purchase on the past has been achieved. "We are given instruments to find out where we stand." Partial, fallible, mutable, ephemeral — these are the instruments, the memories, the photographs, the recordings, the stories that we have. If we want anything of these disappearing communities — and we may not — we must make room in our analytical frameworks for fathomless human encounters. That means thinking harder and with perhaps more feeling for the hopes and histories of our messengers.

Everyday life is flat and colourless, or so our memories would suggest. I have a great store of childhood memories, some pleasant, some not, but a forensic report of my experiences at École St-Pierre on Friel Street in Ottawa is fortunately beyond my recall. There are only two stories to which I can attach dates and approximate times, both by coincidence Fridays. The first is a classic case of social intersection and one of my earliest memories of an ethical dilemma. I had entered St-Pierre in grade three. I could read, write, and do long division; more significantly, I had taken first communion and been confirmed in the Roman Catholic faith at my previous school. My new teacher, a Grey Nun, took me aside and, summoning all her respect for Otherness, made it clear that since I was a *Protestant*, I would not be obliged to go with my classmates to First Friday mass. I could stay back with the other *English* girl. I can still feel the confusion of that moment, liberation from theology there

within my grasp, combined with the awful consequences of being found out. Fear triumphed, and I confessed, "But Sister, I'm Catholic."

The next memorable Friday at École St-Pierre represents another kind of memory altogether, one that I share with many more people, not in its particulars, but in its intensity. That was Friday, 22 November 1963, the day that John F. Kennedy was assassinated in Dallas. My recollection of the circumstances in which I learned of the assassination is very vivid. Kept back from recess because of a cold, I heard what seemed to be a radio broadcast trickling in through the intercom. The oddness of this intrusion struck me then, still strikes me now. The sound was patchy, a primitive signal, most unlike the morning's steady stream of Hail Marys, anthems, and daily announcements. I could not make out a thing and eventually gave up. There were other distractions. Another student had also been kept back, oddly enough, the same English-Canadian Protestant girl. She had just thrown up in the hall on the teacher's stockings and shoes. The janitor was putting resin down on the floor to clean it up, and I associate the smell of resin with what happened next. My teacher, Mlle Leduc, returned to the room; she was not wearing her stockings and she appeared to have been crying. Recess was suddenly over; my classmates filed in and we were told what had happened to the beloved Catholic president. A special art project that we had been looking forward to was cancelled; we did our homework for the rest of the afternoon.

These are my stories, two autobiographical memories, and this is what I think they represent. The first is a much embroidered *personal memory*, a good story based on a brief exchange with my teacher, told to my parents on the evening of the day to give proof of my devotion to the truth, rehearsed through the years as an advertisement for my French-language immersion, and ultimately assumed as

the first chapter of my alienation from Roman Catholicism. The second is a *flashbulb memory*, also much rehearsed and periodically tuned, but essentially unchanged – or so I believe. Every generation has its flashbulb memories. I was born in 1953, so I can answer the question, Where were you when Kennedy was shot? as readily as I answer this question, Where were you when you heard about 9/11? The key factors of consequentiality, emotion, importance, and surprise are the same. Psychologists interested in this phenomenon begin compiling data as soon as they recover from shock. In twenty years or so, we can expect reports on the persistence and/or decay of 9/11 memories. By learning to read the signs, we may also see imagery that reminds us of the work of Stan Denniston.

The title of Denniston's first major body of photographic work was *Reminders* (1978–82). His place in this book was thus assured. *Reminders* and other composite works, such as *Dealey Plaza/Recognition and Mnemonic* (1983), and *Instant Horizon* (1997), have been received as explorations of the workings of memory, its manifestation in visual images, and its manipulation by the media. But if Denniston's work were just that, it would not be as fascinating as it is. There is something more, as Jessica Bradley and Diana Nemiroff sensed as early as 1986, a tension between "matter-of-fact documentation, without a trace of authorship" and an exploration of identity, slipping "from private to public realms through a passage that originates in subjective associations and opens upon awareness of the self as subject."[1]

Denniston's work frequently refers to collective memory and its expression by the media. In *Dealey Plaza*, for example, Denniston appropriates images from the media to trigger memories of a traumatic public event. Many people would recognize the pictures that Denniston uses as photojournalistic lightning rods of the sixties and seventies. Those who do not would assume from the shocking nature

of the images that they were taken from magazines and newpapers, and therefore assign them to the public sphere. Titles, texts, and curatorial essays confirm these assumptions. Bradley and Nemiroff refer to the news images in such terms as "collective memories," "the reconstruction of history through photographic images," and "public imagery."[2] These pictures are contrasted with the more banal, "matter-of-fact documentation" that they assign to the private realm. Bradley and Nemiroff persuasively argue that Denniston's work displays the formation of personal identity as a function of mediation; they therefore inscribe Denniston in the Postmodern project of deconstructing these influences.

When does this process begin? Bradley and Nemiroff suggest that human development includes a stage of "innocent vision … lost as consciousness becomes loaded with memories and private recollections are further mediated by public imagery."[3] What we might expect from this stage is a cache of "innocent" personal memories, uninfected by the collective memories that public photographs purport to represent. Denniston's work shows us the opposite: it shows us the inseparability of his autobiographical and collective memories, and the virtual impossibility of telling their imagery apart. Photographic interest, or even picturability, is an unreliable measure of memorability. The traumatic event does not necessarily produce dramatic pictures. Battlefields and crime scenes can be disturbingly banal; a playground or a parking garage can be terrifying. Denniston's work is the photographic expression of his theories of memory. The propositions that he puts forward operate fluidly in two psychological realms, both of which are known to combine private and public memories. His photographic works are akin to, because they so strikingly resemble, two classes of mental images: flashbulb memories and screen memories.[4]

SHUTTERS AND APERTURES

Screen memories and flashbulb memories are different types of memory that nevertheless have certain interesting features in common. Both describe recurrent, or persistent, memories, often with strong visual characteristics. Both are attached to personally meaningful events, traumatic or ecstatic, which are inadequately represented: in the screen memory, obscured, and in the flashbulb memory, buried in anecdotal detail. The symbology in both cases is idiosyncratic. I may look at an intercom panel and think of the Kennedy assassination, but you do not. A person may remember yellow flowers, and put great stock in that memory for reasons deeply buried in his or her psyche, but you do not. Depending on the photographic treatment of the intercom, or the flowers, a spectator may recognize, or be prompted to recognize, the possibility that one kind of memory is standing in for another.

The very nature of what Freud called a "screen memory" – its essential service – is the camouflaging of traumatic, or shameful, experience.[5] The screen memory offers a more bearable explanation for the distressing memory that it is retained to cover. The screen memory may be constructed, but its building blocks are both personal and credible; the psychological alibi has to be airtight. The mental process works because one truth – one autobiographical memory – takes the place of the other. This is clear enough in the telling, but how is this layering of mental images to be represented in a picture? As already seen in the work of Diana Thorneycroft, ambiguity is the first level of visual expression – the spectator must sense that there is more to the situation than meets the eye. In Thorneycroft's case, one is seeking an explanation for her theatrical repertoire of grotesque objects, violent acts, and penumbral settings. Denniston's photographs are the very antithesis of Thorn-

eycroft's. His could be called banal, by comparison; it is in fact their ordinariness that disturbs and prompts inquiry.

A flashbulb memory, translated to photography, is no more transparent or legible. Cognitive psychologists Roger Brown and James Kulik coined the term "flashbulb memory" in the 1970s for a pattern of retention that they were noticing in popular accounts of the Kennedy assassination.[6] They defined "flashbulb memory" as a vivid recollection of the circumstances in which one heard surprising or important news, a historic event or something of personal import, and they were more interested in its stability than its accuracy. Brown and Kulik identified six "canonical" categories of recall: place, ongoing event, informant, affect in others, own affect, and aftermath. Subsequent studies began to attach flashbulb-type memories to highly emotional or traumatic personal events, and some explicators see flashbulbs whenever autobiographical memories are particularly sharp and bright.[7]

The photographic analogy can be a bit confusing. It is important to remember that it refers first and foremost to the instantaneous and anecdotal nature of the recollection, its clarity and incompleteness, and not to the presence of a blinding light. We associate flashbulbs with excitement; this one goes off in the mind under parallel, otherwise forgettable, circumstances. The memory thus encoded is not the news story, or even the mugging, per se, but what S.F. Larsen has called "the reception event" whose visual description or symbolization becomes an interesting challenge.[8] A flashbulb memory may be photographic in quality, but it is not necessarily very photogenic. The picture that I have drawn above is a useful example. What if I wanted to make a work of art about my own experience? Consider its lack of visual appeal. We have an almost empty grade six classroom, rows of desks, fluorescent lights, a few posters, and student projects on the walls. One uniformed student stands, ear cocked to the intercom. What would the spectator get from such an image? Perhaps a great deal, but nothing too specific. My concept would live by the caption, and die by the caption, as the generation that was shocked by the assassination disappeared or grew inured to the message.

This little example takes nothing from Denniston; by asking you to imagine a truly banal example, I am preparing to argue that Denniston's work both taps into and transcends circumstantiality. He creates a sense of familiarity that is intrinsic to flashbulb memory. He uses our common capacity to associate personal circumstances with momentous events, underscoring the randomness of such memories. He makes us aware of the formation of memory as something vital by conducting his own search for motive memories in a lifelong quest.

Denniston does not divide his work into psychological categories, but he has discussed his imagery in terms of autobiographical and collective memory, as well as history and fiction, since the beginning of his career. *Reminders* tested and documented his ability to recall. Public appreciation of *Reminders* depended on faith, or on willing suspension of disbelief, and the acceptance of the work shows that photographic audiences had this in abundance. Concurrent works in photography, text, and sound, *Kent State U./Pilgrimage and Mnemonic* (1982) and *Dealey Plaza/Recognition and Mnemonic* (1983), exposed some of the autobiographical and collective underpinnings of *Reminders*. Denniston's pilgrimages to American sites of history were designed to trigger flashbulb memories in the spectator, but it also transpires that there were other memories under cover in these projects. This chapter will show how Denniston's later visual games of truth and fiction maintain some of the trappings of flashbulb memory — a sense of authenticity that ironically depends on *not* having been there, but having read or heard — but also evince his generation's dilemma:

skepticism about the media and addiction to its products. Screen memories, ironically redefined, are also part of the psycho-social package. Freud's original concept of *Deckerinnerungen*, a compound of "cover" and "memory," leaves the clinic and enters the culture by association with the silver screen and Orwellian mind-control.[9]

MEMORY: CHRONOLOGY

From 1978 to the present, Denniston's photographic work has developed along consistent lines that facilitate general description. First, each project is based on a *pretext*, a surprising realization or a strange coincidence, that sends the artist on a search for more data, proof, or some other form of closure. Second is *repetition*, a tendency to see the world in patterns that shapes his work in pairs, layers, and other types of aggregates. Surrender to the pretext, to the idea that the external world exists in doubles, or multiples, that can be photographed, leads to the third consistent feature of Denniston's work, which is an emphasis on *location*. He locates his recollections in the external world, photographically combining distant places that are not only shown, but registered by name and date. These odd chronotopes manifest in a fourth aspect which is photographic mediation as a struggle between *truth and fiction*. This is a basic Postmodern debate, to be sure, but in Denniston's case, it also doubles as an internal struggle between recollection and misrecollection. The truth or falseness of photographic representation is presented as the artist's inability to tell the difference, therefore always embedded in the personal. The pretextual problem leads to many attempts at solution; many locations are involved and the process takes time. This brings me to the fifth key element in Denniston's work: *travel*, the photographer's term for the mythic quest. Den-

niston's earliest travelogues are products of a rigorous comparative process; his chronicles become more fantastic as the work evolves. The glue in all this is Denniston's memory, autobiographical and collective memories which Denniston is continually revisiting, refreshing, and recasting.

At least three different chronologies could be created to document Denniston's memory-work. The simplest and most conventional would be a full list of his solo exhibitions since 1980. In addition to those already mentioned, exhibition titles such as *How To Read* (1984–88), *critical fictions* (1992), *personal fictions* (1995), and a video installation, *stills* (2001), suggest the links between representation, memory, and imagination that are keystones of his work. An enriched chronology would list the statements, interviews, and articles in which the allusions to memory in his work are clarified in terms of intention and reconsideration. The third chronology, by far the most useful, would catalogue the milestones of life history, social memory, major events, and reception events that are woven together in the work and whose complementary instability, or lack of closure, keeps the work alive. A very schematic version of the third chronology follows. The information contained is all part of the public record.[10] One might call it a directed reading of the work, my sincere application of Denniston's ironic handbook, *Hard to Read*.[11]

28 June 1953: Stan Denniston born in Victoria, British Columbia.

August 1963: Murder of George Down, a young man from Denniston's neighbourhood. The murder remains unsolved. According to Denniston, the Victoria Police leaked the fact that the teenaged victim was a homosexual.

22 November 1963: United States President John F. Kennedy assassinated in Dallas, Texas. He is shot while passing through Dealey Plaza in a motorcade.

24 November 1963: Lee Harvey Oswald, presumed

assassin of John F. Kennedy, shot to death by night club owner, Jack Ruby.

4 May 1970: At Kent State University in Ohio, four students killed by Ohio National Guardsmen during demonstrations against the American invasion of Cambodia and U.S. involvement in the Vietnam war. Nine other students are wounded by gunfire. Victims include both demonstrators and students caught crossing the campus.

29 June 1971: On the day following his eighteenth birthday, Denniston tries to hitchhike across Canada. He is picked up in Chilliwack, only to be returned, against his will, to Vancouver. That night, near Williams Lake, British Columbia, he is caught in the middle of an armed stand-off over another driver's aggressive driving. The experience is very frightening; it changes his world view.

1973: Denniston moves to Toronto where he studies at the Ontario College of Art.

1978: Two childhood friends visit Denniston in Toronto. The stories they tell of their youth, including several incidents in which Denniston was involved, cause him great concern because he does not remember them. He begins working on *Reminders*, prompted by a stretch along Bathurst Street in Toronto that reminds him of a section of South Granville Street in Vancouver.[12] He develops a system in which he photographs the reminder (in this case, Toronto), then without processing the picture, photographs the place he was reminded of (Vancouver). Over months, then years, he zigzags across North America creating an exhibition of these pairs.

1979: First visit to Dallas where Denniston accidentally comes across Dealey Plaza. He not only recognizes the site, but finds it uncannily familiar. He is overwhelmed with collective memories and personal associations, including the murder of George Down, which he remembers for the first time in years.

February 1981: A massive police raid on four Toronto gay bathhouses, the largest mass arrest in Canada since the War Measures Act, sparks public demonstrations in which Denniston takes part.

1982: Extensive travel in the United States includes a pilgrimage to Kent State University.

29 April 1983: At the Earle Hotel in New York, critic and psychiatrist Jeanne Randolph finishes a ficto-critical catalogue essay on *Reminders* which takes the form of a travel diary set in a place of childhood memory – New Orleans. She writes: "To be there is like visiting a memory, afraid that it is remembered wrong, sad that it is remembered right and shows what is left behind and almost lost – except for stories."[13]

1986: Denniston reads in *The Globe and Mail* of a new air force base in Colorado, "camouflaged to match the surrounding landscape." Surprised that such a facility would be public knowledge, he decides to "look into it at the earliest opportunity."

1988: Denniston looks in vain on microfilm for the clipping about the camouflaged air base, but goes to Colorado anyway, where he searches for the site without success. He decides that he dreamed the newspaper story, finds a site that fits his image, and begins the series *critical fiction* with *"The Natural World"* (1988–91).[14]

1990: Denniston recognizes a connection between personal and public memories, reworking *Kent State U./Pilgrimage & Mnemonic* to incorporate altered photographs of the bathhouse raids.

1992: Denniston profiles Karen Soderlund, a remarkable woman who signals her awareness of domestic violence by inscribing the coulees on her land with the gruesome statistics on local women murdered by their husbands each year. He documents her outcry on the landscape in *"The Wild West"* (1992).

1995: Denniston exposes the controversy surrounding the psychiatric practice of Dr. Jeanne Randolph in a photographic statement composed of an environmental portrait and a text which reads, "Dr. Jeanne Randolph has pushed the parameters of psychiatric practice by developing a live-in family therapy. The College of Physicians and Surgeons is opposed to her longterm pro-active technique as it conflicts with established fee schedules. Prevented from speaking at conferences and from lecturing at the University of Toronto, Jeanne will teach her technique directly to other mothers and fathers." In *personal fiction*, Randolph is pictured with two people known in Canadian art circles to be her husband and son.[15] They pose in a total-immersion-therapy-pool.

1997: Denniston rediscovers a series of lithographic backdrops for model railroads that strike him as equivalent to landscape memories. Adapting the formula of *Reminders*, he sets out to photograph actual places that he associates with these synthetic *Instant Horizons*.[16]

There are gaps and emphases in this unfinished account, but Denniston's correlations of memory and history – the work's concatenation of private and public events – and his apparently gradual movement into fiction should be clear. The spark of Denniston's activity *as explained* is the friction between official and unofficial stories to which he responds differently as he ages and progresses in his work. His memory starts out as his muse and witness, and ultimately becomes his shield. We can substitute the word "photography" for "memory" and we are well on the way to understanding Denniston's translation of this mental journey into visual form.

REMINDERS

Denniston's *Reminders* come in pairs of black and white or colour photographs, each accompanied by a caption that gives the location of the view. *Reminder* #23 (1979–80) consists of two black and white photographs: on the left, "Waterfront, Lakeshore Psychiatric Hospital, Toronto"; on the right, "Waterfront, near Grafton St., Victoria, British Columbia." (fig. 16.1). According to the rule, Denniston standing on the waterfront in Toronto in 1979 was reminded of the Victoria waterfront. He took the Toronto picture and, without looking at this image, took the companion view of Victoria sometime over the next year. The work has been described as an illustration of déjà vu, which it is, quite literally, though without the uneasiness of unplaceable or false recognition. The very point of the project is that these memories are mentally connected with another setting at the very moment that they arise. Denniston has observed that the first reminders were of early childhood places: "I wondered whether this had something to do with viewing the world naively – without ego."[17] In 1978 a bunch of cactus along a road in Arizona reminded him of a tree-lined road in MacMillan Park, near Port Alberni, BC; a recreation park in Long Beach, California, put him in mind of Gorge Park in Victoria. Spatial aspects predominate; one grows conscious of the distribution and density of elements, this at the expense of content. As Denniston continued to travel, the reminders came from more recent experiences, and the familiar began to remind him of the less familiar: he went from Toronto to New Orleans, rather than the other way around.

Instant Horizons is also organized in pairs, and the approach is something of a reprise of *Reminders*. The significant difference is that the memory-triggering left-side image is a photographic copy of a model train backdrop, a

16.1 Stan Denniston
Reminder #23 (1979–80).
Left: Waterfront, Lakeshore Psychiatric Hospital, Toronto.
Right: Waterfront, near Grafton St., Victoria, British Columbia.
Paired gelatin silver prints, 27.7 x 35.3 cm each. Courtesy Olga Korper Gallery

generic landscape that Denniston remembered from his childhood. There are curious echoes of *Reminders* in *Instant Horizons*. Some of the real settings that Denniston had remembered and visited over the course of *Reminders* look very much like the train backdrops. These coincidences aside, the broader implications for Denniston's practice are intriguing. He wonders aloud about the connection between the American western dreamscapes of a fifties childhood and his insatiable desire to travel. So one may well ask, at what point did his collection of "reminders" begin?

Correspondence between fantastic and real places is accommodated in Denniston's mnemonic system because the pairings have been loose from the beginning. Granted, there are similarities between the sites, but matches are

generally imperfect, even in the later works when the initial encoding and reminder are closer together in time. The imperfection of Denniston's memory is the very reason that we trust him when he explains his rigorous methodology. *Reminders* is not a muscular feat of memory, but a display of its skeletal structure. As Barbara Fischer notes, "These differences show that memory cannot fully account for everything the pictures show; or perhaps on the contrary, it is the photograph that cannot render memory perfectly."[18] Different spectators make different sense of the experience. Both Fischer and Cheetham make special mention of *Reminder* #20 in which a flat, open stretch of prairie highway coming into "Edmonston, Texas, from the West" reminds Denniston of "Downtown Toronto from King St.

West." For Fischer, the comparison rests in the vantage point from the driver's seat, with some support from the relationship between streetcar and tire tracks. For Cheetham, there is a "profound similarity of feeling" that the formal elements help dramatically to focus. Fischer suggests that "a detail that pierced the imagination returns through memory in another photograph enlarged, oblique, displaced, and perhaps altogether out of sight."[19] But living where? Randolph is adamant that the signs are all visible: *"The* REMINDERS *do not mark where the Unconscious flows beneath the current of appearances* ... The REMINDERS *might be moments of parapraxis when the Unconscious sees only enough of the landscape to seize the symbol in it."* What is symbolized by a different element in each image may be the same across the series.[20]

There is nothing unusual in this pattern of mnemonic triggers. It is Denniston's response that is unusual, as Bob Sherrin remarks: "Denniston's zigzagging about the continent indicates how fascinated and troubled he is by a phenomenon that he ultimately experiences as one of loss at the moment of recognition, or more accurately, at the making permanent and static of memory." The loss reported by Denniston is that of the original memory: "What remains for him is the memory of the photo rather than the memory of the locale."[21] In other words, the photograph takes the place of the locale; it covers it. And Denniston repeats this loss-causing act at great personal cost, again and again. Sherrin sees *Reminders* as part of Denniston's ironic resistance to the objectifying nature of photography. There is something to that explanation, but not quite enough. Denniston's heroic efforts to picture his mental associations should surprise no one – he is an artist, after all – but in simple, human terms, we have to wonder why certain places trigger this response in Denniston, while others do not, and why he has pursued a program to flush out and rid himself of memory. These are not questions that either *Reminders* or *Instant Horizon* has to answer. These works are about the processes of memory, and specifically their manifestation in images and structures that are sufficiently compatible with photographic process to translate persuasively into permanent form. The form consists of two photographs mounted side by side. The space that separates them is blank, visually mute. We may construe this space as mysterious, even to the artist, or private, meaning none of our affair. Art that addresses the line between public and private matters can be divided into two groups; one that tries to penetrate, and thereby shift, personal, social, and political boundaries; another that underscores the existence of a private zone by displaying, without disturbing, its idiosyncratic codes. The cool, objectifying stare of the camera is especially suited to the latter task, and that is how Denniston uses it.

The dispassionate style of his pictures does not change even when he begins to make more of his own private motivations. He finds room for them on the world stage where they can be seen and overshadowed by momentous, generation-scarring events. The *Reminders* project was ongoing when Denniston produced the installations *Kent State U./Pilgrimage and Mnemonic* (1982) and *Dealey Plaza/Recognition and Mnemonic* (1983). *Dealey Plaza* was an extension of *Kent State U.*; the metamorphosis of the project coinciding with the twentieth anniversaries of Kennedy's assassination and the murder in Victoria of George Down. *Reminders* establishes Denniston's two-plus-one system of association, as well as his reputation as a traveller; *Kent State U.* and *Dealey Plaza* are more complex installations whose elements nevertheless break down into pairs whose symmetry is always somehow disrupted by a supplement.

TWO+ONE INSTALLATIONS

The original installation of *Kent State U.* (Mercer Union, 1982) consisted of paired photographic assemblages installed on facing walls in a narrow corridor. On one wall, Denniston had created a topographical record of the campus, a fragmented surface flowing out from the ground at his feet. On the opposite wall, he had assembled a Kent State reminder: a composite of images taken in Victoria and Toronto. Cheetham's analysis of memory in Canadian Postmodernism offers the following explanation: "In recreating Kent State with Canadian imagery, he is both personalizing the meanings of his trip and *placing* Kent State in Canada, allowing that in spite of the calm that seems to pervade both sets of images, the sort of rampant and indiscriminate violence that occurred in Ohio's past could be in our Canadian future."[22] Cheetham's logic escapes me, for in visual terms the very opposite is taking place: Canada's parts unnamed, the Canadian imagery is never more than a reflection of Kent State. Victoria and Toronto are under cover. The spectator who understands the syncretic nature of the piece and sources of the images is contemplating an assemblage whose message, IF political, is a condemnation of Canada's ambivalence. He or she assumes that position of ambivalence, in the corridor, in between. In that sense, the political in this work insists on getting personal. For if these triggers-turned-into-photographs function psychologically to purge Denniston of his Kent State campus memories, that outcome belongs to him alone. The rest of us are locked into a state of remembrance: on a basic level, the words "Kent State" are visually loaded; they have to mean something; the search through memory begins. Then, to compare the images (the real and the imitation Kent State), I have to hold them in my mind, commit them to memory.

This volatile combination of righteous anger, revisualization, and rehearsal is reinforced aurally by the accompanying soundtrack, the clicking sound of a camera or a gun.[23] With increasing precision, Denniston is communicating the processes of memory: the "Now Print" phenomenon of the flashbulb and the obscure associations of the screen. The photographer may be mechanically shedding these memories, but as the primary spectator of his own work, Denniston is immersed in reconsideration. His subsequent reworking of the piece — the addition of visual references to the Toronto bathhouse raids — only confirms what his photographic reprise of Victoria already suggests: the fear and fascination that returns to 1963, the private and public deaths that he cannot disassociate.

PROXIMITY

Of the rush of memories and associations, the most curious was the vague, though insistent, linkage of the Kennedy murder with that of George Down which had occurred in Victoria at some point in my childhood. I'd remembered it as if, when J.F.K. died, someone had disappeared from my neighbourhood.[24]

Dealey Plaza: Recognition & Mnemonic (1983) took a different form each time it was shown. At the National Gallery of Canada, it was presented on a single long wall of colour and black and white prints, some overlaid with text, and some separate text panels, one including the statement quoted above (fig. 16.2).[25] The images form curved and fragmented panoramas of urban settings that are echoed in smaller architectural reminders. Time is also fragmented: there are extracts from amateur film footage of the assassi-

16.2 Stan Denniston
Dealey Plaza/Recognition and Mnemonic (1983). Detail. Colour and black and white photographs, variable dimensions. Installation photograph at YYZ Artists' Outlet by Peter MacCallum. Collection: Museum London

nation, some of the "key shots" that keep the "grassy knoll" theory of a second gunman alive in the popular imagination. There are also references to Kent State: the National Guard advancing, the very famous image of a woman kneeling beside one of the victims. Images of portals (classical and fascist architecture) jostle with classical and Biblical references to the mortal dangers of retrospection. Bracketing these composite views are four photographs screened with text.

These four images are mounted in pairs. On the left extremity of the installation, in what is constituted as a prologue, Denniston has combined two press photographs of the murder of Lee Harvey Oswald with two personal stories of being in physical danger. Oswald was shot in the stomach by a man who stepped right up to him as he was being escorted through a basement by police. Not only was the event photographed up close (and, incidentally, with a flash), but the policeman knew the assailant, Jack Ruby, and spoke to him just before he shot. There was a bizarre small-town coziness about the whole event that has nursed conspiracy theories ever since. Denniston's texts are autobiographical memories of two instances in which he felt seriously threatened, both involving moving cars and travel, the second involving a gun. He communicates Oswald's vulnerability;

he remembers his own body folding up to contain his fear, "I just slumped down in the back seat." The introduction sets an unusual tone of shock and identification — empathy with Oswald was not the average reaction — and conflates autobiographical and collective memories with the historical record. Every detail of these recollections is sharp and nothing about their combination is clear.

At the other end of the installation is the epilogue: two photographs of buildings also overlaid with text. The top image depicts a suburban house that one supposes was the home of George Down. We read that Down's murder remains unsolved and that the Victoria police leaked the fact that he was a homosexual. The house pictured below in the same frontal style is the White House. The screened text states that the full truth of the murder has never been disclosed and gives the official story that the perpetrator was a deranged loner (fig. 16.3). What is public and what is private in this amalgam? These notions are always relative; in this case, they are wholly subjective, completely dependent on Denniston's internal response. Critical readings of *Dealey Plaza* usually place the Down murder on the private side of the ledger, as a rumour. It was in fact a shocking public event, well covered by the *Victoria Daily Times*.

In August 1963, the newspaper was a lively combination of international and local news: the Great Train Robbery, the American Civil Rights movement, and the Christine Keeler sex scandal are interleaved with sad reports of the death of the Kennedys' premature baby. Closer to home, near Duncan, BC, this story emerges: "Was Island Youth Scared to Death?" A fourteen-year-old boy climbed a fence to get away from other boys he thought were threatening him and fell, suffering a brain injury. The article is illustrated by a photograph of two Royal Canadian Mounties looking over the fence at the trampled grass.

16.3 Stan Denniston
Dealey Plaza/Recognition and Mnemonic (1983).
Detail. Photo collage: colour and black and white photographs, with text.
Collection: Museum London

Then, on 30 August 1963: "Youth Dies of Head Wound in Downtown Parking Lot": Down's body was found at 4:30 a.m. on Friday, 30 August 1963 at the bottom of a ramp leading from the top floor of the Hudson's Bay Co. parkade. The seventeen-year-old Down had been dead several hours; the back of his head had been smashed. The photograph captioned "Death Scene" shows the bottom of the ramp. In the picture, the blood stains are marked with an arrow.

Down's movements on the night of the murder are tracked in the front-page story and continue to emerge in reports released by the investigators over the next two months. Down had gone out for the evening; it was "known that he didn't bother much with youths in the neighborhood where he lived and met most of his friends downtown." He is last sighted by two friends walking past City Hall at 12:30 am. In "Lost Last Hour Puzzles Police" (5 September) it was noted that Down said that he was going to the Hudson Bay Co.; readers knew that the parkade officially closed one hour after the store closing. On 9 September, the last hour had been reduced to a "30-minute Gap" because Down had been spotted at the Mac's Java Cup shortly before he was murdered. Inspector Webb added, "We know something about Down's activities, enough to know some people must have noticed some activity or some persons in the area of the Bay." By 11 September, there was talk of several young men with Down at the coffee shop. On 12 September, Inspector Webb speculated that the trio "took Down for a ride." Three days later, Webb described Down as "a friendly sort of lad. He made friends easily and quickly. He might well have been with someone whom he met that evening for the first time." On 16 September, the story is overshadowed by the Birmingham church bombing that kills six black children. The story is illustrated with a picture of damaged automobiles. On 17 September, the

Down murder is back on the front page because the murder weapon, a steel bar, has been found in the collection box of a church. It is pictured, measured against a ruler.

The police continue to release information over the next six weeks. 18 September: "Murder Victim 'Shaken Up' for Threatening to Squeal." 19 September: "Tip Fizzles Out in Murder Case." 20 September: "'Respectable Murderer' Now Suspected." 21 September: "Police Hunt Youth in Murder Probe. Told Parents About Crime." 23 September: "Missing Youth Found, Police Check Threat." 24 September: "Setbacks Hit Murder Probe." 26 September: "Police Back to Interviews in Down Case." October 2: "Penticton Man Faces Quizzing." 3 October: "Youth Held in Slaying." The story continues until 8 October: "Young Escapee to be Charged." The fifteen-year-old detainee is charged with car theft. 1 November: "Murder Case Inquest Postponed … Police said today they had no idea when the investigation will be completed."

On 22 November, the headline is "Kennedy Assassinated. Shot in Head from Ambush at Dallas." The photograph of the motorcade features the same overlaid black arrow to point out what can barely be discerned: "Kennedy (Indicated by Arrow) Slumps After Shooting." Three days later, the photograph of Oswald's shooting appears on the front page of the *Victoria Daily Times*. Graphic, unsparing, it is the first clear picture to emerge from this violent period. The caption begins: "Bullet slams."

Denniston's statement that police released private information about Down implies that they were trying to cover up their incompetence and cultivate indifference. The Kennedy assassination is public and kept alive in the public imagination by conspiracy theories, by suspicions of a cover-up. The public event is also the catalyst for vivid personal memories of the reception event. The fluidity of Denniston's associations makes it impossible for the viewer

to rate these events in terms of consequentiality: they are inextricably linked. Denniston has even corrupted his own system of side-by-side reminders by stacking the photographs of the two houses. Which image is the reminder? Which image, unprocessed, sent Denniston on this journey?

When Denniston's work emerged in the early eighties, it was received with great interest as a critique of the dominance of "official versions" – their insidious replacement of "private memories." For Sherrin, being let in on Denniston's correlation of personal and public accounts is an encouragement to sustain his own version of things, to try to resist the historical account. He is initially pessimistic: "The more we try, the more we must acknowledge that we have accepted a memory made *for* us and not *by* us." He ends his article with a caution: "by our failure to create private memories we erase not our past but ourselves." Sherrin issues this warning in a discussion of a work about the Kennedy assassination, a public event that must be considered among the highest producers of flashbulb memories in the twentieth century. The definition of "flashbulb memory" bears repeating: consequential, emotional, important, and surprising *autobiographical* memory. Sherrin states that "We move into our private memories only to find them coated with the emulsion of the public."[26] In fact, the opposite occurs in flashbulb memory – the private dominates – and this is precisely what happened to Denniston. He stumbled onto a public site of memory and it reminded him of a coincident event in his own neighbourhood. The Kennedy murder that erases the Down murder from the public consciousness is pictured in the same nondescript visual terms. Readers are shown where to look with an *arrow*. This blunt instrument – this icon – will reappear in Denniston's work, as the cover image of his publication *Hard to Read* (1988).

TAKE COVER

For Cheetham, Denniston's work is a defining moment in the formulation of Postmodern memory which is by definition politicized, and in Cheetham's view, nationalized. Both Sherrin's and Cheetham's are compassionate readings; they are both attuned to certain kinds of struggle. But there is one place where they will not go, and that is biography. Cheetham makes this explicit: "I also attempt to question the conventional conflation of artists' biographies with the meanings of their works; to deny any necessary connection between biography and meaning, without ignoring either co-ordinate, is itself a characteristic of Postmodernism's challenge to received understandings of subjectivity."[27] To make this argument work, Cheetham steps over to the side of the authorities and closes the file on George Down's murder. Sherrin, for his part, is unintentionally condescending: "surely all of us have a 'local murder' in our past; all of us have experienced moments of vulnerability and physical threat."[28] Cheetham's and Sherrin's are important accounts of Denniston's work, reinforced by his own statements in the moment – they bring another official version (Canadian Postmodernism's version) to the fore. But with only the slightest rotation and reconsultation of the work, such arguments can be put into perspective and seen for what they are: theoretical camouflage. Postmodernism's erasure of the author offers Denniston another kind of cover, a place for him to nest his autobiographical memories while he continues to work them through. There is nothing dishonest in this approach: quite the opposite, *Kent State U.* and *Dealey Plaza* are about what individuals and societies do with painful memories; what Denniston does with his is make art.

Powerful, mixed emotions are expressed in the 1990 version of *Kent State*. Cheetham proposes that in 1982, when

Denniston made the first version of *Kent State*, "he had forgotten the bathhouse incidents through which we now [in the 1990 version] see this work."[29] The suggestion is preposterous. In 1990, Denniston saw the work as "unresolved" and sought to improve it by making its personal connection more clear. By 1990, he had reached the point where he could overlay graphic images of his own memories of protest and personal jeopardy on top of the facsimile Kent State. At the same time, he covered, or partially covered, his more oblique references to childhood memory. This double action was very much in the spirit of the new work that he was involved in at the time, his *critical fictions*. In the early nineties – the artist's late thirties – Denniston was growing into a "screen presence" who could transform his sense of loss and vulnerability into jittery laughter.

"The Natural World" – the scare quotes are Denniston's – is a transitional piece in which memory tilts at history, and effectively unseats it. Denniston entered this phase of his work through the landscape. He has extended the process in a heroic style of portraiture that, as Russell Keziere has written, encourages the subjects "to re-appropriate, through fiction, their own personal history."[30] Keziere's statement is efficient. This is the project that Denniston as subject has been developing all along.

The *critical fictions* are large colour landscapes framed in the now familiar elements of surprise, repetition, coincidence, and doubt. Each image is overlaid with a strange tale whose roots seem to run deep into the local culture: the visible covers for something invisible in each one. Denniston's pretext for *"The Natural World"* is an irrefutable document, a clipping from Canada's national newspaper, *The Globe and Mail* (fig. 16.4). As outlined in the Denniston chronology, the spark and photographic moment span two years, 1986 to 1988. It is noteworthy – Denniston notes – that he was not surprised that such a thing could exist, but only that he could

read about in the newspaper. The clipping is the pretext, or the prompt. It does not exist, so Denniston replaces it with a statement, always credible, especially when illustrated (repeated) with a picture. The photograph illustrates the text, and also, in this virtual world, gives old-fashioned proof of veracity by showing what is usually under cover, the film's sprocket holes. The title is twice scratched into the emulsion, a reminder of nineteenth-century topographics and an internal repetition: for the hard-of-seeing, large letters shout the smaller letters underneath. In *critical fictions*, the whole thing is made up, but the first-person narrative of an "'official' storyteller" leaves a seed of credibility: "I remember …" says the photographer … "An archaeologist from the dig sent me this photograph" … "Documents released under the Freedom of Information Act" … "Neither the City, the police, nor realtors I encountered would even acknowledge that anything was amiss." These are phrases that command respect and the pictures, in their neutral authority, do little to undermine it. It is the ease of discovery that foments doubt. Memory, history, and imagination fit together too comfortably into this photographic frame. Nothing is under cover: in our orderly society, such transparency is hardly credible.

Psychologists ascribe a number of functions to flashbulb memories that also apply to Denniston's work. On the most basic level, they preserve detailed and personal accounts which can also be seen as links between autobiographical memory and public history (the self and society). Though random and disruptive in the moment, events that concretize in reception events become the milestones of a life and a tool of communication as a point of common knowledge and comparison. They are, in that sense, the emotive and epistemological building blocks of personal monuments. Studies have shown that the possessor of a flashbulb memory has the advantage of credibility and persuasion –

I remember reading an article in the *Globe and Mail*, in 1986, telling of the opening of a new airforce facility in Colorado. The notable thing about this installation was that it was camouflaged to match the surrounding landscape. I thought it was odd that I was even able to read about it and made a note to look into it at the earliest opportunity.

16.4 Stan Denniston
"The Natural World" (detail).
From the series *critical fictions* (1988–91).
Laminated Cibachrome print, silkscreened text on acrylic, wooden frame, seashells, 48 x 50.5 cm. Original in colour

such accounts are held to be truthful, even if they are not. As Denniston shows, that makes flashbulb memories the ideal cover stories for traumatic events whose personal importance has yet to be understood. The autobiographical currency of flashbulb memories plays a part in developing interpersonal relationships; the key factor of consequentiality conveys the teller's response to an event that changed his or her plans.[31] Denniston's plans are shaped by memory: the ascent of memory over history triggers a process of photographic expression and identity formation. Denniston's work memorializes the inchoate fears that a whole generation recognizes but cannot ("for the life of me") place. The signs are everywhere; the problem is *How to Read* (fig. 16.5).

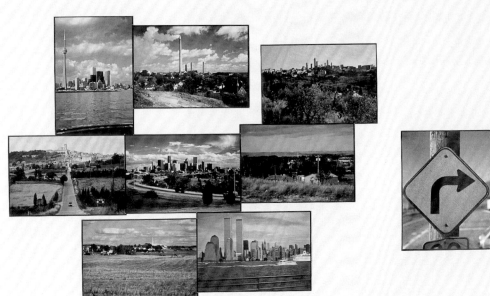

16.5 Stan Denniston
How to Read (1984–86).
Fourth segment (skylines), variable
dimensions. Original in colour

POSTSCRIPT: RECEPTION AS "RECEPTION EVENT"

Understanding of Denniston's work has been conditioned by a remarkable reading, Jeanne Randolph's introduction to *Reminders*. Framing her essay as a travel diary, Randolph inserts her interpretations of Denniston's work into a series of encounters and ruminations set in a place to that point devoid of associations with his work. New Orleans is Randolph's realm of memory. As she rehearses its pleasures and inadequacies, she remembers *Reminders*. The pictures come up before her in flashes of intuition; she imaginatively performs Denniston's process. Randolph's audacious personalization of criticism, her production of a parallel text, creates what she has called "the amenable object ... a view of the art object once the artist has left it in public." The amenable object partakes of tradition as its idiosyncratic refashioning. It belongs to reality, though the terms of this relationship are ambiguous; indeed the object fosters an atmosphere of incompleteness, leaves space for spectatorial play.[32] Randolph's pretext, her account of where she was when she learned about *Reminders*, cues us to the importance of locating our own reception events.

Port aux Basques is on the west side of the island, on the coast still called the French Shore, a day's passage from Nova Scotia. St. John's is on the east, on the Avalon Peninsula, a week's passage from Great Britain. The government had intended the railway to unite Newfoundland. Instead, over the years, the two railheads pulled the country in opposite directions. Europe was at one end of Newfoundland's world, North America at the other. And the railway brought something else to the country. It brought the landscape that always made my great-aunt weep. From the time the trains began to run, the middle of the island was on fire.
— David Macfarlane[1]

In Macfarlane's *The Danger Tree*, two charred landscapes become one: the Newfoundland interior, its carpet of spruce needles and birch leaves set alight by the sparks from the coal-fired engines; the fire line outside Ypres, the so-called Railway Wood, a grove of blasted stumps and bodies held in the fall of 1916 by the men and boys of the Newfoundland Regiment. These distant places are fused in the memory of Macfarlane's great-aunt. Her grief at the loss of three brothers smoulders in memory, bursting into flame at a view, even though there is nothing to see, *because* there is nothing to see. The landscape is spectatorially uninhabitable; its histories are unobtainable. Ulrich Baer describes

certain landscape photographs of Nazi extermination and concentration camps in similar chains of connection and disconnection:

The deliberately created tension between the print's landscape character as a setting for experience and memory and the abstracted depiction of inhospitable terrain puts the viewer into a peculiar position. We are allowed to enter a site that will not fully accommodate our view of it. The illusion of space in this picture does not engender, at all points, a sense of place; we are led into a site that, in the end, excludes us.[2]

Against this feeling of exclusion, we seek signs of reason, and when they fail to materialize, we erect monuments.[3]

Memory, imagination, and grief intermingle in the tears of the builders. In *Tangled Memories*, Marita Sturken sets out to disentangle these forces as they have led to a resurgence of memorial culture in the United States. Sturken's *cultural memory* is the manifestation of memory on the way to history; by Sturken's light, every image in this book – in fact, the book itself, as well as its writer and readers – falls within the realm of cultural memory which includes "memory-objects and narratives."[4] Collective memory, a term frequently used in this book, is not the same – it is a source, or more precisely, the *idea* of a source, rather than a process or a product. Sturken is most definitely product-minded: memorial culture is embodied in "cultural products – public art, memorials, docudramas, television images, photographs, advertisements, yellow ribbons, red ribbons, alternative media, activist art, and even bodies themselves."[5] These categories remind us of Pierre Nora's realms of memory, though Sturken sees a distinction, placing cultural memory *between* memory and history. Her realm of cultural memory is entangled in history, but needs

to be protected as a site from which alternative accounts of the past can emerge.

The recasting of history through memory is advanced by Foucault's validation of different sources of knowledge, as well as his recognition of the political advantages that accrue to those who take control of "popular memory."[6] A number of artists and theorists discussed in this chapter acknowledge their debt to Foucault, including Sturken, who nevertheless proceeds with caution: "Cultural memory may often constitute opposition, but it is not automatically the scene of cultural resistance."[7] What we should expect, however, is some level of conflict and debate, complicating the production and reception of cultural memory. This is a healthy sign for the body politic, according to Sturken, who adapts Foucault's "technologies of the self" to her memorial system of "social practices ... implicated in power dynamics" and "practices that people enact upon themselves" in relation to political structures. The body as "cultural product" comes dynamically into play: "Throughout history, the body has been perceived as a receptacle of memory, from the memory of bodily movement, such as walking, to the memory of past events in physical scars, to the memory of one's genetic history in every cell."[8] The camera, as the modern pilgrim's prosthetic eye, can be seen as extension of that body, thus doubling photography's power over memory and claim to memorial status. As Sturken insists, and in this she counters Barthes, photography has not replaced the monument; rather they co-exist. Between distant fires, and in advance of oblivion, memory on its way to monument is much photographed at every stage.

In this chapter, I consider "technologies of memory" that are embodied in their producers and embedded in cultural memories of place. The discussion focuses on images that symbolize *implacement*: monuments, maps, toponyms, blazes, and address books. These are images about finding

and marking one's place: they demarcate the boundaries of imaginary communities; they confess the histories of taking and making a place of one's own; they shelter memories and postmemories of displacement. All these instruments work in relation to the body: the scale is intimate; the gaze, level; the range, local.

To convey the forms and possibilities of photographic markers, I look at work by Marlene Creates, Arnaud Maggs, Evergon, and Marian Penner Bancroft. Each of the selected projects can be said to memorialize a particular community by awakening and reifying its place-memories. In Bancroft's memory-work, place is examined from multiple vantage points. Memory is embodied as the artist seeks places to stand, to give an account of her family and herself as the ground shifts under their feet.

This is the last chapter under *Stone*, and the last chapter of the book. The game of *Scissors, Paper, Stone* continues, but with smaller, more porous histories that the players hold cupped in their hands. Their meetings with scissors are less blunt, more open to imaginative decisions. In Bancroft's work, the personal photograph returns as a building block of cultural memory, indeed, as I have stressed more than once, as one of its cornerstones. Edward S. Casey describes "implacement" as "an ongoing cultural process with an experimental edge."[9] Bancroft's tremulous implacements function as mediations in the true sense of the word.

MEMORY MAPS

Marlene Creates's *The Distance between Two Points is Measured in Memories. Labrador 1988* is a suite of eighteen composite works, each consisting of two black and white photographs (a portrait and a landscape), a hand-drawn "memory map," and a short extract from the artist's con-versation with the subject (fig. 17.1). In addition to these four framed pieces, most of the works also include a three-dimensional element, chosen because it is mentioned in the text. This object is placed on the gallery floor.

Categorizing the work as an assemblage and organizing its description conventionally by medium, as I have just done, is a bit misleading. Taking each element as discrete and episodic – portrait, map, text, landscape, object on the floor – comes closer to Creates's methodology which was to visit a person in their home; to get them to talk about a place that they remembered and to draw a map of it; to follow the subject's directions to the site and to photograph it; and in thirteen cases, to collect a sample from the site, such as a burnt rock, a bough, or a log. Creates worked within a generational community: all the subjects, whether Inuit, Naskapi Innu, or Euro-Canadians (called Settlers) are elders in their Labrador communities which are (New) Davis Inlet, Hopedale, and Nain. Typically, for older people asked about their life experience by a younger outsider, their view is retrospective, sometimes rueful, sometimes nostalgic. Some express a sense of being "out of place," uprooted from their places of origin and sources of sustenance; their maps are designed to guide the photographer back to another place and time. Others express pleasure and pride in their memories of the land and forest, places of intense belonging and rhubarb beer, times of plenty, and times of want – high and low points of the past which the visitor's questions have summoned to the present. The distance between then and now is also spatial: the portraits are all taken inside, while the memory image is invariably a landscape.

The subjects' memories, maps, and statements refer to different kinds of places, such as hunting and fishing grounds, shorelines, woods, and settlements. As anthropologist and art theorist Jacqueline Fry notes, there is no basis in these eighteen testimonials to ethnologize the

subjects' representations, that is, to use Creates's findings to divide the Settlers from the Inuit, or the Inuit from the Innu. Fry is instead struck by the transracial cohesiveness of gender: "The differences seem to coincide with practices common either to men or to women. The men (with the exception of Bert Saunders ...) describe their hunting and fishing grounds. They draw long stretches of land and water. The women describe a territory defined by activities centred around the house and within a more limited geographic area."[10] And yet the people *are* divided and the texts preserve these divisions, in name at least, the Settlers different from the "Indians." "Naskapi Indians is what they call us. Mushuau Innu is what we call ourselves," says Gilbert Rich. And Sidney Dicker's life history begins, "When I was a young man I got married to an Inuk woman, forty years ago."[11] Fry's observation that such distinctions are not expressed in the drawings begs the question of what is represented by the maps, which brings us to the purpose that frames their representation of memory.

The subjects have been asked to draw and talk about a place that they remember; thus, we are led to consider what cognitive psychologist Barbara Tversky calls "the role of narrative perspective in mental models of environments ... too large to be seen at one viewing." We are immediately presented with two other alternatives, neither seeming to be inflected by race, gender, or other optics of power. As Tversky explains,

Typically, environments are described from one of two perspectives, termed route or survey. In a route perspective, the description addresses the reader as 'you' and takes the reader on a mental tour of the environment, adopting a view from within the environment and describing the locations of landmarks relative to the reader's left, right, front, and back, from the reader's changing point

of view. A survey perspective takes a view from above, and describes the location of landmarks relative to one another in terms of north, south, east and west. A route description is analogous to exploring an environment and in fact provides a set of procedures for navigating; a survey description is analogous to studying a map.[12]

Tversky is interested in the efficacy of written description, and the testing on which she reports indicates that survey and route descriptions are absorbed equally well; that is, they are equally well encoded by test subjects. In Creates's uncontrolled experiment, she is herself the test subject. The canonical axes (north-south, east-west) are nowhere inscribed on the maps, not even on the bird's-eye views; other information seems more pertinent. The memory-maps and verbal descriptions are complementary: landmarks are plotted on the drawing and Creates is also told about less tangible ways of negotiating the environment, how quiet it is, how long it takes to cross a certain expanse by dog team, how to know when she is getting close to the memory place. As Hilda Dickers says, "When you sees the woods my dear, you'll know you're getting handy to Kanagiktok Bay." Tversky points out that maps drawn from memory contain inaccuracies that can be traced to perception as well as judgment, and here she draws an analogy to social judgments, concluding that these and other factors make mapping a constructive process: "People's spatial knowledge is not only biased, it is also fragmented. There is no guarantee that these bits of distorted knowledge, when put together, will form a coherent picture, a knowledge structure consistent with a map." What does occur reliably in both memory and mismemory is the linking of objects in space and their disposition on the page according to the axes of the body. Spatial description reflects the experience of a real body in real time: "Salient events, public or private,

I was born in 1910 in Kanagiktok. It's a very very pretty place. It's a forest of trees. Oh that was beautiful my dear. I love that place. John would come down here to Hopedale to go to the shop in March, by dog team. And leave me alone. Say we was getting short of coal oil, lamp oil. Or we might be getting short of tea or sugar. And there was nothing I enjoyed any better my dear. And I'd go in the woods and all the trees was like arms around me. The trees was like company. I didn't feel alone. That's how I felt. I felt safe. Yes, beautiful, beautiful. This is the place where we lived. When you sees the woods my dear, you'll know you're getting handy to Kanagiktok Bay.

17.1 Marlene Creates
Hilda Dickers, Labrador 1988, from the series *The Distance Between Two Points is Measured in Memories. Labrador 1988*. Assemblage of two black and white photographs and one story panel, selenium-toned silver prints, 28 x 36 cm each, and memory map drawn by Hilda Dickers, pencil on paper, 22 x 28 cm each, 28 x 36 cm framed. Collection: Canada Council Art Bank

can serve as temporal anchors, much as landmarks serve as spatial anchors."[13] A survey description helps us to locate where we are, but a route description leads us out and back. Chesley Flowers warns Creates, "The land looks different coming back, if you only look straight ahead, if you don't look behind when you're going up."

The maps and transcriptions are part of an assemblage that forms an analogy for the constructed nature of spatial memory. The subjects have not been encouraged to draw territorial, racial, or social boundaries, but to fulfill their responsibilities as elders by giving a younger person directions to a remote place that represents a disappearing way of life. As elders, they are also concerned for her safe return. Memory is thus used to fill the gaps between then and now, old age and youth, immobility and mobility, indoors and outdoors, insider and outsider, these things encapsulated in the differences between *here* and *there* — these are the "points" that Creates is measuring as she attempts to reconnect culture with nature, to move the spectator from

the culture-bounded present into a freer, more natural past. Creates provides the impetus; the elders provide the data. "It is their memory that she places at the centre of an experience of the environment," writes Fry — their map and their words.[14] The portrait records the rememberer for posterity, while the landscape is a partial view of a place described from memory.

The key word here is "partial." Photography's single-point perspective on the landscape is no substitute for memory; indeed, by Chesley Flowers's rule, a photograph which by definition only looks straight ahead is a mis-memory or, at least, a very bad map. Creates is an honest explorer. She is not intent on proving that she reached and photographed the precise area described; she claims only to have captured partial views. The memory that is encoded by the landscape photograph is plainly her view; so, in fact, is the portrait. Fry is correct in binding the images to the memory of the elders; their crude memory-maps and halting reminiscences are the pretexts for the piece. And the

place that each has been asked to describe is not just any place, but the place to which they return for their narratives of origin. But this evidence would not exist without Creates's intervention; it is not part of the host culture, but a form of culture that she imports. Her process brings out the gendered similarities that remove racial boundaries, as well as the words that put them back. What the elders manifest in her encouraging presence binds them together – a community is thus mapped for this visitor and this experience is memorialized by photography.[15]

RÉPERTOIRE

Another kind of community – another aggregate of interests – is the underpinning of an eccentric and strangely sensual photographic work by Arnaud Maggs. His *Répertoire* (1997) makes a subject of the annotated address book that contains some of French photographer Eugène Atget's commercial records, an object now held by the Museum of Modern Art in New York (fig. 17.2). From cover to cover, this photographic relic is documented in forty-eight colour views that are framed simply and arranged in the form of a large grid at mural proportions. I say "relic" risking accusations of blasphemy, for Maggs's subject is the very antithesis of a religious or fetish object. Atget's *Répertoire* was a practical instrument used to conduct his business which was, as he always insisted, as his trademan's sign proclaimed, to furnish *documents*. According to Molly Nesbit, the late nineteenth-century appetite for visual documents, or "study sheets," drove Atget's productivity and shaped his unique photographic style:

Whether drawn or photographed, the document was playing an increasingly important role in the elaboration of scientific and historical proof. It became a standard way of expressing knowledge; it became a means to knowledge; and it put together pictorial forms of knowledge, though they were not yet taken up as aesthetic forms and exploited for their own sake. That would come later.[16]

In the meantime, Atget's clients were painters, sculptors, architects, decorators, craftspeople, industrial designers, set designers, urban planners, publishers, and librarians, whom he visited in their places of business.

Atget's *Répertoire* is thus not a guide to pictures taken, but to pictures wanted. Clients are listed, as well as their addresses and Métro stops. Other notations, less systematic, include the best time to call, purchasing history, type of requirements, and connections to other purchasers.[17] This book – there were apparently others – was in use from about 1900 until he gave up business (he died in 1927).[18] Atget, as Nesbit says, was encouraged "to map out his documents according to their functions,"[19] and also to map out his life, in order to move through the city efficiently as he served and expanded his clientele. Nesbit, whose rigorous analysis of the *Répertoire* strikes a chord in Maggs, helps us to understand the practical function of Atget's photographs as an explanation for their extended life in the collective imagination:

The photographs in their capacity as documents asked for a narrative, dramatic action, a relation to a larger whole; they anticipated a look that would pirate; they also expected a look that would supplement. Each kind of document however worked off a different profile of possibilities; the nature of the supplement varied with the genre. This much can be said of all documents for artists: they anticipated a look that would see ahead to fully brushed and well-populated landscapes, characters, narrative action, and punch

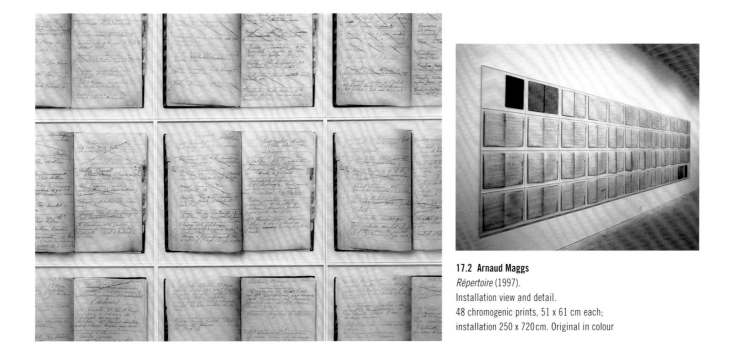

17.2 Arnaud Maggs
Répertoire (1997).
Installation view and detail.
48 chromogenic prints, 51 x 61 cm each;
installation 250 x 720 cm. Original in colour

lines, the horizon of expectations in the artists' practical vision. Space in those documents left room for a look; more than that, it signified absence.[20]

The infinite possibilities of Atget's pictorial spaces have been analysed by scholars from every angle, though there is apparently still room for discoveries. Atget's address book, as a document of the documents, can now also be said to have "anticipated a look" that would "pirate," "supplement," and signify "absence," for this is in effect what Maggs has done with his photographic work of art, *Répertoire*.

The notion of *pirating* needs, however, to be qualified. Maggs sought permission to photograph the original object and did so in the precincts of the museum. This act is nei-

ther modern piracy, the stealing of intellectual property, nor Postmodern appropriation, the reconstruction of intellectual property, but straightforward documentation. Maggs made a photographic document of the *Répertoire*, in the same spirit that Atget photographed Paris and its environs: to make the subject available for study in detail; to look at the object whole as it had never been seen before. Like Atget's highly detailed, and equally selective, documentation of Paris, Maggs's *Répertoire* is only an impression of wholeness. Not every page is represented; some of the blank pages have been omitted, to the consternation of at least one photographic historian.[21] The artist has taken licence with the document in order to present it in a grid structure of forty-eight views, which, by no coincidence,

conforms to a system of portraiture that he developed in the 1980s. Under this system, people who agreed, or asked, to pose were photographed forty-eight times, half of these facing the camera and half in profile. The effect of Maggs's method was to neutralize the usual underpinnings of a portrait – psychological, social, environmental, and so forth – to the advantage of documenting and comparing specimens of human physiognomy. The project was pursued assiduously, creating an enormous archive that represents Maggs's network of artists, performers, curators, chefs, theorists, family, friends, and public intellectuals. Maggs's address book, if it exists, remains hidden; he could be said, by his look, to have pirated Atget's, building a photographic monument to their shared sensibilities.

Bringing a facsimile of the *Répertoire* into the light allows its partial, encrypted entries to be *supplemented* with memories and narratives. This is another form of pirating, "a somewhat romantic practice" that Irit Rogoff finds erupting even in the taxonomic geographies of Foucault and Dennis Wood: "What is so interesting to me here is that the slightest breach of the agreed-upon system of represented knowledge allows for everyone's flights of fancy to enter the argument, and that is as it should be but so rarely is."[22] The mapping and indexing that are the function of Atget's personal atlas contribute to many histories of Paris; they stretch beyond the biographical frame of the photographer; they form a crowd. Seeing Atget as the servant of so many masters complicates the understanding of his photography as a form of place deixis – reference to a location in relation to the speaker, in this case, the photographer. One begins to wonder which of these clients is sitting on Atget's shoulder as he aims his camera at a Parisian facade.

Each handwritten entry, even the simplest name and street address, pushes this inquiry along, summoning the powers of memory and imagination. Remembering Atget's photographs in the context of the *Répertoire* is looking back in order to "see ahead." These meetings over pictures, did they lead to ideas for pictures? For such is the nature of photography done on spec, or so one might speculate.[23] And how are these documents used? This figure moving between studios and workshops, supplying the history painters, but also feeding the designers, is he ensuring the preservation of old Paris, or cross-pollinating the old with the new? Both, and this is not the only duality to be considered.

Photography's connection with death – the trope of *absence* in presence – seems to be expressed in the *Répertoire*'s well-thumbed condition and the lines drawn diagonally across so many names and addresses. But Atget's marks are not so easily decoded. To dwell morbidly on Maggs's *Répertoire* is fatal to its understanding, for when the address book was in use, Atget's cancellations might have meant "moved," or "out of business," or "waste of time." Cancellation, in these cases, is not giving up, but turning one's attention elsewhere, replacing blind alleys with open prospects. The multiple appearances of some names also suggests that Atget was wont to reclassify his entries, reorienting his approach path to his clients.[24] For whatever reason, these cancellations and relocations are about life, because life keeps going, and with ruthless regularity, sloughs off memories that have lost their utility. Maggs's *Répertoire* is a portrait of that process, in "48 Views."

NESTED MEMORIES

Place memory makes a link between location and event: something happened here. The trigger may be elusive, as with Denniston's *Reminders*, but the feeling of recognition is no less persuasive, and especially so if mixed with a certain degree of excitement. Landscape photographs discussed in

this book – Brenda Pelkey's, Thaddeus Holownia's, Sylvie Readman's, and to some degree, Jin-me Yoon's – suggest that the spatial configuration of memory lends itself to generic reproduction, to typological landscapes which are both retrodictive and predictive. Cultural memory, then, as much as territorial history, shapes our apprehension of space and our sense of possession. It designates and demarcates zones of contestation, the borderlands between inclusion and exclusion.

These liminal spaces are Rogoff's "unhomed geographies," whose territories are defined according to "an alternative set of relations … linked sets of political insights, memories, subjectivities, projections of fantasmatic desires and great long chains of sliding signifiers." Rogoff is interested in how these spaces are recognized and claimed in a process that informs "identity politics" but is not restricted to it. Following Foucault, she conceptualizes geography as "a system of classification, a mode of location, a site of collective national, cultural, linguistic and topographic histories. All of these are countered by the zones which provide resistance through processes of disidentification; international free cities, no man's land, demilitarized zones, ghettos, red light districts, border areas etc."[25] Gay cruising grounds could certainly be added to Rogoff's list, and especially as they have been surveyed by the photographic artist, Evergon.

Since the early 1970s, Evergon has been making photographs whose exploration of gay sexuality and male community sustains readings of sexual politics. His *Manscapes* are part of this production (fig 17.3). Evergon does not, however, see himself as an activist, but rather as an artist who translates his states of being and erotic fantasies into visual form. His desire for experimentation is expressed in material and form, as much as content: he is drawn to alternative photographic processes, such as cyanotype,

17.3 Evergon
Shipshaw: aubergine. Passage entre les deux plages, from the series, *Manscapes* (2003). Inkjet print from Polaroid negative on watercolour paper, 117 x 91.5 cm

xerography, and Polaroid; his photographic images are compositions in collage, still life, or tableau vivant; his straight photography is often manipulated; the results are fiction, rather than fact. In homophobic, or politically correct, environments, controversy may flare up around the work, but an objective observer sees its lush beauty and Pandean playfulness. This is especially true of the impressive tableaux vivants that the artist, assisted by a team of models, costume designers, decorators, and prop persons,

and inspired by the history of painting, created in large-scale Polaroid during the 1980s.[26]

Evergon's work revolved around the figure until 1992. It was then, while living for the summer near his childhood home, Niagara Falls, Ontario, that he made his first landscapes. He photographed the places where he, as a young teenager, had gone to evade parental and social surveillance, to pleasure himself in the "wilderness."

These "boy nests," as Evergon calls them, were all within biking distance of his home. By 1992, urban sprawl had reached out and destroyed many of the spots he remembered. Worse still, his adult perspective stripped much of the personal magic from the sites he found, for he suddenly understood that they were not his, but everybody's secret places – the lovers' lanes and cruising grounds of a community. His first landscapes honoured a boy's possessive memories by framing the nests from a very low angle, and from within. Then moving from "boy nests" to *Manscapes*, Evergon began to photograph cruising grounds wherever he went. A tireless traveller, he built up an enormous archive, now numbering in the high thousands. Evergon explained his project in the following terms:

I have chosen to photograph these cruising grounds devoid of their inhabitants. These places are enchanted forests of homo-folklore – transient locales identified through word-of-mouth or maps drawn on scraps of paper. These are not badlands, but they are territories with behavioural codes which survive as long as there is relative security and guaranteed anonymity. Government and police are constantly trying to close down these areas through intimidation, limitation of access, and more recently, by gentrification. In this sense, they are landscapes under siege – cultural battlegrounds. They are gay. They are present. They are history. Life inside the enchanted forest is a norm; it is only upon leaving the forest that you step into a memory of perversion. It is a memory that makes the work both document and fiction.[27]

Evergon's documents show that these trysting places exist everywhere, at the edges and in the folds of every settlement; it is simply a matter of recognizing the signs. As Evergon notes, "Manscape = Landscape, Landmark and Marked Landscape. Almost all the scapes are to be located by a constructed landmark, i.e., a stone ski lift, a bridge, a water tower, the end of the number four trolley line, etc."[28] At close range, makeshift shelters, sexual graffiti, the litter of food wrappers and used condoms, even a rain-soaked teddy bear confirm that the hunter has left civilization and crossed into the "wild garden." Such proofs are sometimes included in Evergon's landscapes, though generally the descriptions are more subtle; like Creates's partial memories, the pictures preserve the verbal directions and simple maps that the photographer has followed. The novel thus begins, a kind of detective story. As Benjamin took from Roger Caillois: "this metamorphosis of the city is due to a transposition of the setting – namely, from the *savannah* and *forest* of Fenimore Cooper, where every broken branch signifies a worry or a hope, where every tree trunk hides an enemy rifle or the bow of an invisible and silent avenger."[29] Markers are also counter-markers. Dappled paths, bent branches, and soft impressions in the grass gently mock the boundary stones and postings that read "Keep out." The old photographic games of truth and fiction, fact and fantasy, lead us in. Are these really cruising grounds or do they simply remind us of such forbidden places? Therein lies the mystery, heightened by the photographer's objective stance. He is no longer a child, looking out, but an adult looking in, coolly appraising the traces of his community. The project is cast as a form of militant archaeology, for the

empty cruising grounds are also reminders of lives and communities devastated by AIDS.

Foucault has famously characterized the legacy of sexual repression as "perpetual spirals of power and pleasure." This is the mechanism created by modern industrial society's classification and persecution of "peripheral sexualities … The pleasure that comes of exercising a power that questions, monitors, watches, spies, searches out, palpates, brings to light; and on the other hand, the pleasure that kindles at having to evade this power, flee from it, fool it, or travesty it."[30] Evergon's photographs of these power/pleasure grounds are made without a hint of romance. The images are taken in black and white and, as the artist says, they are emphatically *not* feminine, which to him means "no rolling hills, no valleys, no expanse of water, no horizon, no illusions." With a legalistic flourish, he adds, "I photograph the landscape like it is a man and I am loitering with intent."[31]

Formally, the landscapes are organized around axes of penetration into a natural, that is overgrown, or man-made shelter. The instantaneity of Polaroid is well suited to the atmosphere of the sites, and Evergon uses the material expressively, as Jonathan Turner explains about pictures made in the summer of 1998, around Sydney, Australia: " a deep mystical darkness … with areas lost in blackness. By purposely interrupting the normal development of his Polaroid film, Evergon further enhances the sense of alienation through a process known as Sabattier. Fern fronds exist as silhouettes in silver. The torso-trunk of a banksia tree becomes frozen like an x-ray."[32]

In 2001, Evergon began to experiment with monochromatic toning, giving each landscape a colour coded to gay male culture: charcoal, evergreen, night blue, cerise, aubergine, and so on. This colour cast strengthens the sense of boundedness expressed around the edges by the photographic frame; a colour whose gradations lead us into the picture's spatial depths heightens the difference between what is out here and in there. At the same time, the strict documentary gaze is being teased out of its seriousness. Works of this nature were made during an artist's residency at Chicoutimi, Quebec, and the prints were then exhibited in the community.

Chicoutimi, as a once lively port, now touristic, and a former industrial site of Anglophone-controlled, Francophone-sweated labour, is an old meeting place for power and pleasure. In a photographic reading that Foucault, I think, would have enjoyed, I learned from a university student that one of Evergon's views showing the blocked path to a cruising ground was (also?) the way that local kids snuck into a private company's fenced grounds to swim; as a child, the young man had learned to trespass by evading, tricking, and fooling the company's guards, and he was delighted to realize that the game was still going on. Prohibitions build coalitions of resistance wherever they are imposed, as Foucault insists: "never have there existed more centers of power; never more attention manifested and verbalized; never more circular contacts and linkages; never more sites where the intensity of pleasures and the persistency of power catch hold, only to spread elsewhere."[33] Boys will be builders of boy-nests.

IMPLACEMENTS

In the introduction to *Stone*, I presented the photographic work of Jeff Thomas as a form of urban archaeology, excavating memories and histories of place, and asking questions about rights and representations. Marian Penner Bancroft's work tries to answer questions of that nature from where she stands, in terms of the personal, the familial, and

the local. Her photographic oeuvre engages with history and memory, feminism and postcolonialism, romanticism and environmentalism, cartography and chorography,[34] body and place. I refer here selectively to works spanning fifteen years of production – 1984 to 2001 – during which Bancroft never ceased to experiment, not for the sake of novelty, but to make correspondences between images and ideas. The boundaries of photographic convention are crossed in the process.

A central theme of her work, its engagement with place, is expressed in three dimensions. Bancroft moved her photographs off the wall in the early eighties. Her large black and white prints were displayed as tapestries that continued to live and breathe in the gallery as they curled out from the wall. *Transfigured Wood: Family Tree* (1984) consists of photographic prints that are laced together in strips that extend into the spectator's space. *Mnemonicon (the screen)* (1988) is a free-standing, three-dimensional collage that must be circled and committed to memory as it is read. *Shift* (1989) is a group of five lecterns with photographic portraits fixed to the reading surface. *Xá: ytem* (1991) is designed to be displayed on four walls of a room, referring obliquely to the canonical axes. The spectator's movements are thus mapped through the space. *By Land and Sea (prospect and refuge)* (1999) and *Visit* (2001) are photographic prints supplemented with text. Their different photographic styles and modes of presentation – *By Land and Sea* copious, *Visit* minimal – are organized to embed the spectator in a Jamesian "sensible present," a thick autobiographical fragment, presented with its head and tail, that is, *not* artificially condensed into a decisive moment. So to experience Bancroft's work, one moves in real time though chronicled time – stages of the artist's thinking – and also through space, literally and figuratively, covering ground. Bancroft's move off the wall and into the spectator's space was not her first

attack on Modernism – that was text – but she was quick in the early 1980s to understand the insufficiency of the framed photographic image.

Many of her early works were landscapes – one could argue that they all depended on an understanding of place. But here again, what they were *not* is equally important. As Claudia Beck has observed, they were *not* conventionally beautiful: at this stage, Bancroft's recourse to the landscape refused its colour and delimited its light, opting for the greys of a gestural blur as an expression of her politics and her disquietude. She was often away from her birthplace and extended family at that time – the journey was a recurrent theme. In the work that followed her return to British Columbia, Beck justly notes that the interiority of Bancroft's landscapes ("mindscapes") was transformed by the presence of loved ones and social rituals.[35] The objecthood of intimacy entered the picture as well.

Transfigured Wood: Family Tree brings forward a very influential object: the family album (fig. 17.4). Bancroft had referred to this kind of picture-making in the past, by featuring members of her family, their experiences of grief and healing that she amplified with hand-written texts. *Transfigured Wood: Family Tree* pulls pictures from the Penner family archives and presents them in totemic arrangements in relation to photographs of the forest and its exploitation. In the context of British Columbia, these combinations are personal and political, but rather than the simple formula of the personal *being* the political, the spectator is asked to consider the complexity of adjacent life cycles and political forces that must try to co-exist. The challenge is to embrace the co-habitants of the British Columbian landscape: the descendants of different cultures and the success stories of nature, each jostling for space. Bancroft sews these paper memories together and reminds us of their single source in nature, but she is not

nostalgic. The work is a present-tense ecology of history and memory, nature and culture, individuality and universality; the effect is both elegiac and premonitory; we are urged to make coevalness work.

Conceived as an *aide-mémoire*, *Mnemonicon (the screen)* combines appropriated imagery with photographs of Bancroft's daughter, as well as pictures and texts that play on the various associations that we make with the word "screen." Freud's concept of screen memory is not among them — there is no process of psychological concealment taking place, but rather an assemblage of visual and textual fragments that Bancroft acknowledges as part of her cultural construction. The screen is therefore of Lacanian extraction, though Bancroft's version fits better with Kaja Silverman's multi-stage development of the "image/screen" than with Lacan's rather restrictive model. Silverman attributes to the screen an "ideological status ... that culturally generated image or repertoire of images through which subjects are not only constituted, but differentiated in relation to class, race, sexuality, age, and nationality." Predestination and concomitant passivity still cling to this model, which Silverman is at pains to revise. Holbein's *The Ambassadors* becomes a site of reconsideration, a painting that marvellously (and mysteriously) "provides a model both for understanding normative vision, and for imagining how it might be possible to see in a way which is not entirely given in advance." Spectatorial experience based on movement in front of the painting proves that "the same image can look very different depending upon the vantage-point from which it is observed." This complication, which is also an identity, encourages Silverman to step away from the gaze, or "dominant fiction," through the portal of the look, which is imbricated in memory.[36]

In Bancroft's work, the screens depicted are both actual and symbolic: a line of poplars, a television, a mesh fence, a wind-

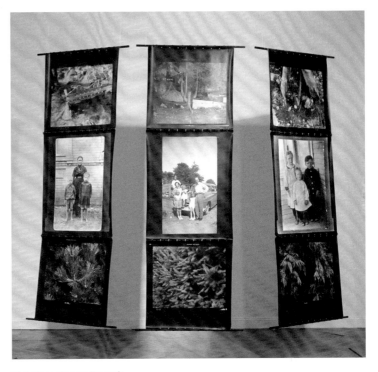

17.4 Marian Penner Bancroft
Transfigured Wood (Part Three): Family Tree (1984).
View of installation by the artist, Centre culturel canadien, Paris.
Black and white photographs, fir, cotton lacing, 244 x 244 cm overall

shield and, of course, the object itself whose practical use is the division of space into more private enclosures, protected from drafts or improper gazes. The images that Bancroft brings together are of different types and the juxtaposition of media prompts questions on the relative mnemonic values of pictures. Our culture – this book – sets great store by photography. Casey's study of landscape painting and maps also emphasizes the memorability of engravings:

17.5 Marian Penner Bancroft
Mnemonicon (the screen) (1988).
Detail: view of installation by the artist, Presentation House Gallery, North Vancouver. Black and white photographs, fir, metal hinges, 203 x 317 x 7.62 cm

the discrete exactitude of etched lines provides a precise and easily rememberable representation of a given scene. An engraving fixes this scene in its literal traces. Like human memory itself, such a representation exists between perception and reflection; it both depicts and guides – and, again like memory, it does so by means of a network of traces."[37]

The line drawings of children that Bancroft copies and enlarges onto the panels function in this way: one can feel the pudgy finger of a child tracing the figures as her mother reads the story. Our eyes perform this retracing in the gallery.

Bancroft's practice admits complete strangers to her identity-work-in-progress. Here the role is motherhood. Bancroft's assumption of this role is cast in light of her childhood memories, and specifically – poignantly – paralleled with the advice books used by her own mother (fig. 17.5). Rediscovering these texts as an adult-become-a-mother, Bancroft realized that the operant pronoun for the child was consistently "he" while almost all the illustrations showed a "she," and one who looked uncannily like Bancroft herself. How *normative* is this, yet there is also comfort in the belief that your mother has a book in which all phases of your development, even your encounter with measles, are mapped out in advance, and these are the mixed feelings that Bancroft is addressing. She is particularly concerned with the prescribed complacency of her "white Canadian female identity"; hence the references to Queen and country.[38] Bancroft's daughter is pictured from behind looking through a screen – a chain-link fence – at lawn-bowlers in their spotless whites. The suggestion is that Bancroft's place-memories are all around her – at her very fingertips – making the contrast with Jeff Thomas's search through the city for an adequate representations of urban "Indian-ness" very sharp. No "white Canadian female" could be more aware of this injustice, as Bancroft's production continues to show, though never simplistically, but from different vantage points. While Bancroft descends from European colonists, her whiteness screens an ancestry of German-speaking Mennonites who came to Canada via Ukraine, booted out by the Bolsheviks, and a mixture of English and Scottish farmers, forced by the clearances to seek new homes. This story – these stories – will later inspire a pilgrimage to the memory places of her ancestors in Europe, but Bancroft's roots are no less important in shaping her *Mnemonicon*. Her autobiographical sense is microcosmic, and she plays with notions of typicality and particularity, treating *herstory* – an instance of hybridity – as a metonymic puzzle. The art of memory, in this case, is reconstructing and thus reactivating an identity whose

parts have been secreted in media. The paradigmatic child who was Marian and is now her daughter, Susanna, shows us where to look. That is, we look over her shoulder, and try to see what she is seeing *through* the screen.

Shift is another chapter in this relation, one in which Bancroft's role as a teacher comes to the fore (fig. 17.6). There is one source image for this five-part work, a tiny snapshot of the Penner family (the four sisters and their mother), taken in 1953. Each face, enlarged one hundred times, yet still legible, is printed with a block of twenty-five five-letter words, and the print forms the top of a lectern. The five lecterns are arranged in a V-shape, reminiscent of

the formation of migrating geese. The mother-leader-lectern forms the apex of the triangle. The force of the gaze can be felt in Denise Oleksijczuk's interpretation of *Shift*, in which she underscores the assumed identity of the original photographer, Bancroft's father: he is "'placing' the females in his family, both literally and symbolically."[39] Bancroft's performative re-enactment is therefore a significant first shift. The camera is now in her hands as she appropriates and transforms the group portrait. Each woman is accorded a new place and a new text from which her identity can be articulated, but at considerable cost, only by dint of separation. The father's image has been

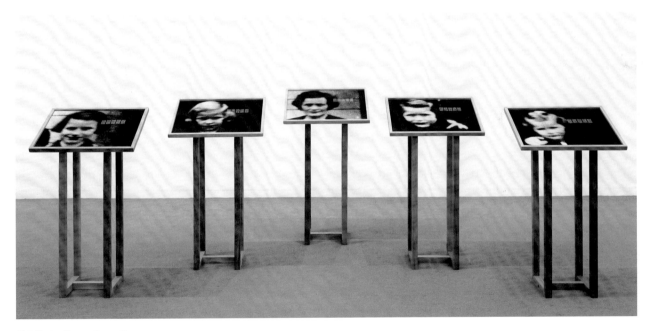

17.6 Marian Penner Bancroft
Shift (1989). View of installation by Trevor Mills, Vancouver Art Gallery.
Five black and white photographs with cedar stands, each 45.72 x 61 x 102 cm

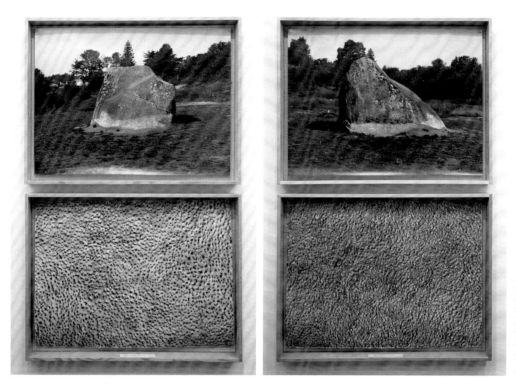

17.7 Marian Penner Bancroft
Details from *X̱á:ytem* (1991),
formerly entitled *Holding (property)*.
Four diptychs. Mixed media (graphite,
black and white photographs,
fir frames, hardware, cloth), each
diptych 184 x 122 x 10.16 cm

fragmented, spread throughout the space. We must look at these faces and read from these texts one by one. Still, the women's affiliation is secure. Five remains the magic number; the four sisters and their mother are a biological constellation, five women radiant in the remembrance of who they are.

A central motif of Bancroft's work is the family tree. In *Transfigured Wood: Family Tree* and in *Shift*, the genealogical model is her own. *Mnemonicon (the screen)* expresses the interconnectedness of individual and collective memories. In *X̱á:ytem*, Bancroft expands her field; she confronts her culture's insularity and blindness to the other by taking it

on as part of her heritage. There are four parts to this work; each is made up of a photograph and a graphite rubbing (fig. 17.7). The photographic subject is consistent: a glacial erratic boulder that rests in a field near Mission, British Columbia, a landmark locally known as Hatzic Rock. In 1990, the rock was slated to be dynamited to make way for development. Gordon Mohs, an archaeologist for the Stó:lo Nation, recognized the erratic as a source of spiritual power and a likely attractor of human habitation. He convinced the developer to suspend activity on the site until excavations could be conducted. Evidence of habitation – some 16,000 artifacts – was indeed found; the site includes two

subterranean houses, the oldest discovered to that point in British Columbia, with deposits related to their occupation dated between 3,300 and 3,650 BCE. The property has since been acquired by the provincial government as an archaeological site and educational centre where visitors learn about the ancestors of the Stó:lo Nation and the symbolism of the rock, a Transformer Stone. Stó:lo oral tradition holds that the erratic boulder is the life force of three Si:ya:m, respected leaders, who were turned to stone by the Creator for fighting and not sharing the knowledge of writing. For the Stó:lo people of the Fraser Valley, the Transformer Stone is a site of prayer and meditation.

When Bancroft visited the site in 1991, its fate was still in the balance. She was moved by the myth and shamed by her prior ignorance. Her response was a subtle and very moving combination of these forces. She photographed the stone from four mid-points of the compass: northwest, northeast, southwest, and southeast. Returning to her home in Kitsilano, she made rubbings of surfaces on points north/south/east/west of the building, "a place I could know only a little better, given the short duration of non-native settlement in this part of the world." The language of her place is taken from a pebble aggregate walkway, an asphalt pathway, a concrete sidewalk, and a cement and concrete walkway – thin crusts – each to varying degrees identified as "private" or "public." It adds something to the reading of these composite works to picture the artist doing the rubbings, kneeling on the ground. The indexical nature of photography is frequently compared to footprints in the sand. In Bancroft's combinatory process, the impress was reciprocal, that is, it left a mark on her body. At the same time, the photographs of the Transformer Stone have great sculptural presence and authority. Their form, not their function, sets up a dialogue with the Western histories of photography and land art. Bancroft's images engage with Minimalism and its guilty

conscience, a performative spectatorship that is awestruck and critical at the same time. The rubbings are of course about touch and about the raising of one's eyes from the ground on which one stands, to grapple with the paradox of possession.

The strands of Bancroft's family history, as well as the connection between landscape and memory, continue to interweave in *By Land and Sea (prospect and refuge)*[40] (fig. 17.8). The work is made up of large and rather luscious colour photographs taken by Bancroft in Scotland and Ukraine as she retraced her European roots. These images are contextualized by black and white portraits of Bancroft's ancestors, including an extraordinary document of family history found in the Canadian Pacific Railway archives: a picture of the first group of Mennonites in the 1923 migration to Canada as they boarded the SS Bruton at Libau, near Riga, Latvia. In this group are Bancroft's father, grandmother, aunt, and great-grandfather.

On first encounter, *By Land and Sea* appears to be following photographic convention; its multiple vantage points do not leap to the eye. The beauty of the landscapes is rather puzzling in an oeuvre that long ago rejected such visual seductions. For Bancroft, the revival of pictorial beauty in this body of work functions as a form of quotation. The pictures, taken on the move, mark her as a tourist: they are tremulous, instantaneous memories and romantic expressions of longing. Accompanying the photographs are six lists of words, signs harvested from her memories, that poet Fred Wah used as prompts for a poetic text, "Lullabye and Sea."[41] Wah's free associations make space for the inner voice and personal memories of the spectator. These imaginary geographies – pictures, words, poems, and maps – re-place the reality. They make cultural memories of place transportable, *re-placeable*, not possessive, then, but mobile – they are fluid.

18 | CONCLUSION:
IS PHOTOGRAPHY AN ART OR MEMORY?

An art of memory is a system for encoding knowledge in signs that make it retrievable. Can that concept be translated to photography, or to put the question more honestly, have I done so in this book? I'll rehearse my assumptions and arguments, and let you decide for yourself.

Scissors, Paper, Stone is a composite of stated and unstated assumptions. I'll start with one from the latter category: photography is an art form. This simple statement unleashes a myriad of images and theories about the way art should look and how it should function. Since photography was invented in the early nineteenth-century, those ideas have changed dramatically. From our perspective – humans like to think that they are developing – definitions of art have expanded, some would say to accommodate the mechanical media, some would say to remake them in a form that accords with cultural values and keeps the power structures intact. The art works visited in this book are shot through

with assumptions and arguments about the nature of art. Their creation is an attempt to enter the discourse and to add something to it. That is in effect what we have retained from Romanticism's exaltation of originality.

With that in mind, I'll return to one of my stated assumptions, the basic idea that photography is not an equivalent for memory, or even its faithful servant. Service is rendered, without a doubt, but to many masters and mistresses, as I have shown. Photography serves forgetting as readily as it operates as an *aide-mémoire*. It also conspires with the imagination to trick memory. It smiles on history while slyly proposing that alternative accounts are being overlooked.

Earlier I spoke about memory in terms of religious experience. Memory is a system of belief. Operate within a system that says, Trust your eyes, and accept the line of guff that a photographer is an impartial witness, and, Bob's your uncle. You have just joined the stalwart, hopefully shrinking, band whose photographic credo is "mirror with a memory." The problem is that no two people in the band, with their feet to the fire, would likely come up with the same definition of memory, much less extract the same memories from an image.

To say that any two things are the same sets those elements on a balance. To remain in balance, nothing can be added to either tray. Let us assume, just for the sake of argument, that the essential nature of photography has not changed since the invention. "Mirror with a memory" is just a catch-phrase, a likeness that accommodates all kinds of opinion, from Delacroix to Derrida – oh, that's not very far – from Talbot to Foucault. The mirror part is indeed very accommodating; virtually anything can be placed in front of it, except a mental image, which is what a memory is. And then, to paraphrase Michael Snow, and to set your mind a-wandering over all the examples in this book, you need to get down to the problem of recognizing memory, that is,

knowing it when you see it, and seeing it plain. Over the course of photography's short life on this planet, our beliefs about memory have changed radically. We have a great long list of terms that correspond to evolving ideas and intellectual fiefdoms: autobiographical memory, collective memory, personal memory, cultural memory, flashbulb memory, screen memory, false memory, post-memory ... Set all those on the balance, and watch the transparent photographic image be catapulted into the air. There are no transparent images in this book.

Under *Scissors*, I started with a collection of images that ressemble photographic albums. That was a pretty obvious trick, since *Suspended Conversations* had already persuaded you that an album, or album-work, needed re-activation through spectatorial performance, that the prompts were all visible in the album, in the form of content and structure. At that point, the message was clear: disinterested spectatorship, if such a thing can be imagined, would get you know-where. The album needed sounding out – speaking – to release its meaning. The album-work is likewise cast in a performative tradition. That pair of statements suggests that we have to grapple with authorship, and in an autobiographical work, we do, with the caveat that this is not a restriction, but an invitation to become a character. "Take your own picture," says Michel Lambeth. Inscribe your own subjecthood on the surface, I've left you plenty of room. Room to go crazy as you oscillate between systems of belief about observation and knowledge; room to re-create yourself, to re-remember your past through a process of forgetting.

Under *Paper*, the currency of ideas that we call modern culture is exchanged along an echoing corridor. Like Alice, we try the doors of perception and memory sometimes pops out, in the form of images that haunt us, images that we love, images that have stuck with us for one reason or

another. The artists that I gathered under *Paper* express their affinities with the past in part-images, supplemented with a presentness that irrevocably changes my ideas about past, present, and future. When the context of this reworking is social or political – and many people feel that this is ever so – art's capacity for transformation raises my consciousness, which is another way of saying that my notions of past and present are reshaped into other possibilities. I remember the past as having contained those possibilities – memory functions as a platform of plausibility on which I can imagine moving foward.

Under *Stone*, the intersections between remembering and forgetting, or remembering and imagining, shift into the public sphere as pictures are taxed with the function of monuments. The hortatory function of these works is patently clear. To look at the re-enactment of labour history through the optic of workers' memory is a two-stage correction to history – a deep excavation of the social actors' memories. To look at the self-representation of the First Nations through the optic of photographic history summons both memory and imagination to try to put justice in place. This section of the book is full of stories, and stories always have a point. Time is traversed and place is signposted along the way. History is part of the commonwealth; it is also something we individually possess, selectively remembering the parts of our story that knit us into community, and also set us apart. I believe that Bill Dutoff told Robert Minden that "We are given instruments to find out where we stand" whether Dutoff said it, in so many words, or whether the encounter generated it in Minden's mind. No instrument recorded this statement, but it is now history, that is, accepted into the history of photography by this photographic historian.

Scissors, Paper, Stone announces a mental game of intuition and power, serious play between three orders of rep-resentation. The game's Latin name is a photographic delight: *Hic, Haec, Hoc*, three declensions of *this*. When I fixed on *this* idea, I felt that I had stumbled onto a playground of deconstruction, a place of productive instability, shaped by co-operative opposition, experienced anticipation, and an insatiable desire for the supplement. The framework felt fresh, though hardly original; indeed, as a cliché, or entry to shared experience, its lack of originality recommended it. Good thing too, because when I returned to my notes, I found that cultural theorist Marianne Hirsch had pulled a game of "Rock-Scissors-Paper" from Sue Miller's novel, *Family Pictures*.[1] In this fictional family's playing of the game, scissors always wins; the arena of memory is a collage that the main protagonist, a photographer, eventually sees through as a power struggle over her identity.[2] I also remembered that A.S. Byatt had conceived her novel *Babel Tower* in a structure of "scissors, paper, stone." Byatt's autobiographical character, Frederica, conceptualizes human growth as the *lamination* of different pieces of knowledge, identifying one type of memory as experience that presents itself in the moment to be "*recognized* as a memory."[3] Frederica is not a photographer, but this *recognition* is a very photographic concept; it is not retrospective, but prospective, as well as immediate, as though the image had been snapped, printed, and archived for future use.

I have saved these precedents for the end to reinforce my point that the game that I have methodically presented as *photographic*, both in form and effect, is a mirror-image of contemporary thought and theory about memory. Giving these thoughts photographic form is a brilliant stroke, of course, because so much photographic imagery – the print, the transparency, the slide reproduction of the work of art, the news photograph, the family photo, what have you – is already internalized as memorable. I am not going back and saying that photographs are memories, I am saying that we

have powerful memories of photographs that circulate with our mental images of the visible world. An artist who can express this fluid condition can be said to be expressing memory. The construct is cultural.

And on that note, what about this problem of Canadian photographic history? Shall we abandon the project of photographic historiography, and simply add one more item to Jacques Le Goff's "history of mentalities?"[4] *Memoriography:* what sort of methodology is this?

I see *memoriography* as the history of our photographic habits of attention. Call it cultural history, if you will, but an important distinction will be lost. The artists who do the memory-work for us have attended, consciously or unconsciously, to the *ecology* of mental images. Their work makes a place for psychological participation; I have to respond in kind. As a *memoriographer* I must include my *being* with the image, the factors of co-presence that have mattered to me, and therefore shaped what I have retained as an image. The work before me is the materialization of a thought that is now *partially* mine. A part-aspect is all I can hope to retain because my own memories have been brought to bear to make sense of what I see.

Does *memoriography* only apply to photographic works of art? Again, it all returns to mental states, to modes of reception. The photographic witness says, "This is what I saw," while the photographic memory-worker says, "This is how I remember it." In a world grown skeptical of journalistic claims, the former will be cross-examined, while the latter will be engaged in polite conversation. But we don't live in such a world. Pictures still matter, and we accept them from all comers. In the wake of 9/11, Albert Boime suggests that copious representation has replaced the decisive moment as the medium of photographic history. He refers to Joel Meyerowitz's generation of over 8,000 pictures whose exhibition made visitors feel like "participants in the event,

vicarious sufferers of the devastation."[5] Photographic history may see this work as a turning-point. I see copiousness of display and formulaic repetition as part of an unbroken line, stretching back through the photographic album to the itinerant storyteller. Consciously, or unconsciously, Meyerowitz was affected by the vast displays of family photographs prospecting for recognition – for life to continue – which were all around the site. How do we remember the date of a loved one's death? We remember what we were doing at the time; death intersects with life's stubborn continuance. Will Canadian photographic history take note that Raymonde April's copious recollection of daily life, *Tout embrasser*, opened to the public on 11 September 2001? A *memoriographer* remembers and, tutored by the example of Stan Denniston, anticipates the issue of flashbulb memory and album-work when the next generation of photographic memory comes.

ACKNOWLEDGMENTS

Scissors, Paper, Stone has been over a decade in the writing, its raw beginnings running parallel to its supposed progenitor, *Suspended Conversations*. Casting back over the inception and development of *Scissors, Paper, Stone*, I am tempted to play the game to bring my memories of this project to order.

First, *Scissors:* this is a book of many parts, with as many starts. Without reprising the acknowledgments that accompanied *Suspended Conversations*, I will practice the art of memory by revisiting the locations that I associate with the first glimmerings of this book: McGill University, the McCord Museum, the Canadian Museum of Contemporary Photography, the National Gallery of Canada, and the Canadian Centre for Architecture. Some of the essays that would grow into this book were curatorial projects, going back to exhibitions organized at the invitation of Marcel Blouin, Marie-Josée Jean, and Pierre Blache, for what was then Vox Populi, and is now Le Mois de la Photo à Montréal; of Catherine Bédard, for the Centre culturel canadien in Paris; of David Liss, Sylvie Gilbert, and Katia Meir for the Saydie Bronfman Centre. Other chapters of the book have their roots in articles commissioned by Meeka Walsh, for *Border Crossings*; Monte Greenshields, for *Black Flash*; and Jacques Doyon, for *CV Photo*. Essays in books or catalogues, edited by Marie-Lucie Crépeau, Liz Wells, and Serena Keshavjee, were also important milestones, while editorial collaborations with M.A. Greenstein, for *exposure*, and with Jerry Zaslove, for *West Coast Line*, clarified my ideas on photography, memory, and community. Rehearsing some of the chapters as conference papers and public lectures was also extremely helpful, and here I would underscore my teaching at Bishop's, McGill, and my academic home, Concordia University, where students' responses and papers have taught me a great deal about the workings of memory and its cultural expression.

Paper in this conceptual game refers to the image-object as it is remembered and extended into a new work of art. My warmest thanks to the artists who have produced these photographic works and talked to me about them. I feel especially fortunate to have had conversations with Carl Beam and Robin Mackenzie, their youthful voices and creative spirits "flying" above their illnesses: they are much missed. More than an endnote or bibliographical entry is due the critics, curators, and historians whose writings and lectures have nourished my research and enriched my text: hoping to have done their work justice, I thank them one and all. I am also very grateful for permission to reproduce images from public and private collections, and for the precious information that came with them. 'Paper' in the life of this book is also the folding money that allowed me time for research and writing, that paid the artists, and contributed to the book's production. Time came from the Social Sciences and Humanities Research Council in the form of a postdoctoral fellowship at the Institute for the Humanities of Simon Fraser University and later, from the Visual Arts section of the Canada Council for the Arts. The Faculty of Fine Arts of Concordia University subsidized the permission fees for the reproduction of images through its program of aid to scholarly publications. Here I want particularly to thank Dean Catherine Wild and Associate Dean, Research Graduate Studies and International Relations, Ana Cappelluto. The Humanities and Social Sciences Federation of Canada has assisted McGill-Queen's with the production of this book, as has the Canada Council, through its program to encourage high-quality reproduction. Canadian scholarship is much indebted to these programs, which in turn need our vigilance and support, lest they be relegated to memory.

Stone blunts scissors because it turns the fragments of memory into an object that you can hold in your hand: this book. Stone, you may object, also sharpens scissors. True enough: both forming and sharpening are performed by the extraordinary team at McGill-Queen's University Press. First thanks are due to the former acquisitions editor of MQUP, Aurèle Parisien, who welcomed *Scissors, Paper, Stone* with critical input and boundless enthusiasm. His particular contribution to this book was the engagement of two anonymous readers whose generous and detailed responses to the book have been received and, hopefully, incorporated in a state of admiration and gratitude. With energy and good humour, editorial assistant Jonathan Crago guided the manuscript into production, where its transformation into a book really began. The experience, wisdom, and artistry brought to MQUP publications by coordinating editor Joan McGilvray and the production and design manager, Susanne McAdam, are unsurpassed. As a lover of books, especially my own, I feel very privileged to have worked with these talented (and quick-witted) women, as well as their collaborators: Kate Merriman, who copy-edited *Scissors, Paper, Stone* with grace and attention; David Leblanc, who responded to the images and ideas with an elegant book design. Still at the Press, I want to signal my gratitude to business manager Arden Ford. Finally, for her work in finalizing the manuscript and careful preparation of the Index, I want warmly to thank Erin Silver.

No framework is all-encompassing, not even mine. Some contributions are indirect, yet enormously important in terms of inspiration, encouragement, and affection. For these intangible daily gifts, I thank my colleagues in Concordia's Department of Art History, my lodge mates and friends, my family, and one very special person: teacher, writer, activist, founding director of the Institute for the Humanities of Simon Fraser University, and friend, Jerry Zaslove. With the reluctant permission of this remarkable and modest man, I dedicate my book on photography and memory to Jerry, without whom I can't imagine its existence.

NOTES

INTRODUCTION

1 Walton, *Mimesis as Make-Believe*, 348.
2 James, *The Varieties of Religious Experience*, 72.
3 See Berger, "Uses of Photography," in Berger and Mohr *About Looking*, and "Stories," in *Another Way of Telling*. "The Idea of Album" is the first chapter of my *Suspended Conversations*, 22–39.
4 Halbwachs, *The Collective Memory*, 41.
5 Author's notes on a conference organized by the Musée d'art contemporain de Montréal, *Memory and Archive*, 23–25 March 2000.
6 Nora, *Realms of Memory*.
7 Casey, *Remembering*, xi. In *Remembering Postmodernism*, Cheetham calls forgetting "memory's essential correlate" (8). We can also turn to William James: "Selection is the very keel on which our mental ship is built," in *The Principles of Psychology*, Vol. 1, 680.
8 Russell, *Experimental Ethnography*, 58–62.
9 Said, "Invention, Memory, and Place," 179.
10 Le Goff, *History and Memory*, xi, 215.
11 Frizot, *The New History of Photography*, 9–13; see also Wells *Photography*, 48–63.
12 Marien, *Photography*, xiv.

CHAPTER TWO

1 Benjamin, *The Arcades Project*, 864.
2 Ian Walker's analysis of a poem entitled "Instantané" ("Snapshot") by Belgian Surrealist Paul Nougé draws out the photographic act of slicing into reality, beginning with the first line: "The fine straight blade." See Walker, *City Gorged with Dreams*, 13–14.
3 Dubois' *L'Acte photographique et autres essais*, 151–202.
4 Dean's strategies are discussed by Mark in "Button Pusher."
5 Benjamin, *The Arcades Project*, 204–5.
6 Ibid., 205.
7 Keenan, "On the Relationship between Personal Photographs and Individual Memory," 17.
8 Warnock, *Memory*, 12.
9 For insights on the condition of exile, I am indebted to David Kettler, Peyman Vahabzadeh, and Jerry Zaslove.
10 Keenan cites Henry Heim's translation of Kundera's novel, *The Book of Laughter and Forgetting* (London, 1983). Though there are controversies surrounding the translation of Kundera's novels, the plot point about the journals is the same in Heim's and Aaron Asher's translation from the French (New York, 1996).
11 Keenan, "On the Relationship between Personal Photographs and Individual Memory," 18–19.

12 Margalit, *The Ethics of Memory*, 25–6. He refers to Anderson, *Imagined Communities*.

13 See Abramson, "Make History, Not Memory.".

14 Olney, *Memory and Narrative*, 3.

15 Olney, *Memory and Narrative*, 5, 11–12. He cites Beckett from Tom Driver, "Beckett by the Madeleine," *Columbia University Forum* 4 (summer 1961): 23.

16 Owens, "Photography *en abyme*," 80–4. He refers to Barthes, "The Photographic Message," in his *Image, Music, Text*.

17 Cheetham, *Remembering Postmodernism*, 7.

18 Ibid., 10.

19 Hardt, "Pierced Memories," 160–1.

20 Fraser, in Gallery/Stratford, *Artifact*, 5.

21 See Yates, *The Art of Memory*.

22 Benjamin, "The Image of Proust," in his *Illuminations*, 202.

23 Schacter, *Searching for Memory*, 21.

24 Neisser, "Nested Structure in Autobiographical Memory," 71.

25 Neisser, "Nested Structure in Autobiographical Memory," citing Marigold Linton, 74.

26. Schacter, *The Seven Sins of Memory*, 84.

CHAPTER THREE

1 Kosta, *Recasting Autobiography*, 1; also see Bal and Bryson, "Semiotics and Art History," 184.

2 Calvino, "The Adventures of a Photographer," 185.

3 Mark Twain, 1897. There are many variations on Twain's note to an English reporter, including the writer's own revision, "The reports of my death are greatly exaggerated," anecdotally traced to a cable sent from London to the Associated Press.

4 In *Suspended Conversations*, considerable discussion was devoted to this "idea of album" as a way of unpacking the history and criticism of amateur compilation. Artists' album-works, or meta-albums, were treated as texts: a sampling of European, American, and Canadian works was drawn into a hermeneutic circle of philosophical, social, political, psychoanalytic, feminist, postcolonial, and cultural theory. My aim was to illustrate the great variety of perspectives on the album, while underscoring the hardiness of certain paradigms, their influence on artists and critics alike. See Langford, *Suspended Conversations*, 22–39.

5 The phrase is borrowed from Kaufmann, "Photographs & History: Flexible Illustrations."

6 Cheetham, *Remembering Postmodernism*, 42.

7 For a comparative analysis of diachronic and episodic modes, in praise of the latter, see Strawson, "Against Narrativity."

8 Brewer, "What is Autobiographical Memory?" 25–49.

9 Barclay, "Schematization of Autobiographical Memory," in Rubin, ed., *Autobiographical Memory*, 84–5.

10 Foucault, *Language, Counter-Memory, Practice: Selected Essays and Interviews*, 113–38.

11 Kosta, *Recasting Autobiography*, 17; also see Nelson, "Self and Social Functions."

12 For Warburg's *Mnemosyne Atlas* as a precedent for the contemporary artist-archivist, see Bénichou, "Temporal Montage in the Artistic Practices of the Archive"; for comparison, see Erving Goffman, *Gender Advertisements*.

13 Mark, "The Pressing of Flesh," 57.

14 Vroege, "Hamish Buchanan," in Foto Biennale Enschede 1995, *Obsessions*, 18.

15 Watney, "Ordinary Boys," 26–34.

16 See Sturken, "The Image as Memorial."

17 Stewart, *On Longing*, 145.

18 In *Suspended Conversations*, 61.

19 Dessureault, "Between Identity and Recognition," in Canadian Museum of Contemporary Photography, *Sandra Semchuk*, 24–5.

20 Cousineau, "Notes on *Excerpts from a Diary*," in Mendel Art Gallery, *Excerpts from a Diary*, 1.

21 Ibid.

22 See Langford, "When is a Photographic Self-portrait Not?"

23 Ong's concept of "secondary orality" covers work in which the features of orality are "supercharged" with self-consciousness. In *Suspended Conversations*, I cited Robert Frank's annotations of his photographic collages and off-camera narration in video works, such as *Home Improvements*. One should now add *Paper Route* (2003) as a work replete with references to earlier photographic and video works. For Ong, see *Rhetoric, Romance and Technology*, 298.

24 Ninacs, "For a Piece of Eternity," in Musée national des beaux-arts du Québec, *L'emploi du temps*, 62.

25 Durand, in Galerie d'art Leonard & Bina Ellen/Leonard & Bina Ellen Art Gallery, *Raymonde April: Tout embrasser*, unpaginated.

26 For guidance, see Scott, *The Sculpted Word*.

27 Morose, "Big Story Blues," 24–5.

28 Napier, *Foreign Bodies*, 154, 153, 150, 155–6, 163–4, 167–8.

29 Cousineau-Levine, *Faking Death*, 199.

30 Napier, *Foreign Bodies*, xxv.

31 Jim, "An Analysis and Documentation of the 1989 Exhibition *Black Wimmin: When and Where We Enter*," 72.

32 As Nkiru Nzegwu explains, Pan-Africanity "refers to critical moments of encounter with Africa's past and present histories, the global dispersal of Africans and African cultures through the slave trade and by voluntary emigration, knowledge of these histories of dispersal and emigration, interrogations of self-defined and externally imposed identities, knowledge of the histories of domination, and an understanding of the kinds of relationships that exist between peoples of Africa, and with those in Diaspora, as well as with peoples of other ethnicities." See Nzegwu, "Memory Lines," 5.

33 Jim cites bell hooks's *Yearning: Race, Gender and Cultural Politics* in "An Analysis and Documentation of the 1989 Exhibition *Black Wimmin: When and Where We Enter*," 72–3.

34 Nzegwu, "Memory Lines," 11.

35 Jim cites an interview with the artist, conducted by Susan Douglas, "When I Breathe There is a Space: An Interview with Buseje Bailey," *Canadian Woman Studies* 11, 1 (1989): 40–2; see Jim, "An Analysis and Documentation of the 1989 Exhibition *Black Wimmin: When and Where We Enter*," 78.

36 Farrell, "At the Still Point," in Koffler Gallery, *June Clark-Greenberg*, 5.

37 Nzegwu, "Memory Lines," 28. Homeostasis is not universally accepted as a feature of oral tradition. I review this point in *Suspended Conversations*, 151.

CHAPTER FOUR

1 Freud, "The Uncanny," 248, note 1.

2 Barthes, *Camera Lucida*, 6.

3 Ibid., 106–19.

4 Krauss, *L'Amour Fou*, 28.

5 Ibid., 28–31.

6 The expression was coined by the American writer and physician Oliver Wendell Holmes, and refers specifically to the daguerreotype whose emulsion is laid on a polished metal support. The image has been extended to all forms of photography.

7 Cirlot, *A Dictionary of Symbols*, 211.

8 Wimsatt, *Allegory and Mirror*, 1–35.

9 Leonardo da Vinci, *Leonardo on Painting*, 202–3, 205.

10 Abrams, *The Mirror and the Lamp*. Abrams, Jacques Derrida, and W.J.T. Mitchell ground Michael Newman's magisterial essay for the Fruitmarket Gallery exhibition catalogue, *The Mirror + the Lamp*. The proto-photographic period has been analysed by Geoffrey Batchen, Peter Galassi, and Heinrich Schwarz.

11 Grabes, *The Mutable Glass*, 86.

12 Gasché, *The Tain of the Mirror*, 16–34.

13 Grabes, 96.

14 Silverman, *The Threshold of the Visible World*, 126. The point is made in relation to cinematic theories of the gaze, and specifically, spectatorial identification, as Silverman expands the psychoanalytic "mirror stage."

15 Dällenbach, *The Mirror in the Text*.

16 Gide, *The Journals of André Gide*, 29–30.

17 Dällenbach cites J. Ricardou, *Le Nouveau Roman* (Paris: Seuil, 1973), 49. Victor Hugo: "Le moyen-âge a deux clefs: l'architecture et le blason," in *Oeuvres dramatiques complètes / Oeuvres critiques complètes*, 1232. Hugo is cited under "blason" in *Le Nouveau Petit Robert*, 1994: "Le blason est une langue. Ce sont les hiéroglyphes de la féodalité."

18 According to heraldic rule, the inescutcheon must be the same shape as the escutcheon (the shield) – this is the formal aspect that attracted Gide – but the smaller element is otherwise different because it symbolizes different entitlements or lineal claims. It is therefore not the mirror-image of the larger field, though the signifying systems are the same.

19 This range of symbols – factual, exemplary, prognostic, and fantastic – parallels the four basic types of mirror-titles outlined by Grabes in *The Mutable Mirror*, 38–63.

20 Dällenbach, 16–17.

21 Ibid., 56.

22 Ricardou, "L'Histoire dans l'histoire," *Problèmes du nouveau roman*, 171–90. Author's translation of passage on page 189.

23 I am referring here to Michael Snow's bookwork *Cover to Cover* (1975) in which the recto-verso relationship of a page layout is actually realized in a sequence of images of the artist taken simultaneously from the front and the back (one photographer mirroring the action of the other). An earlier, more frequently cited example is Snow's photographic collage, *Authorization* (1969). See Dubois, *L'Acte photographique et autres essais*, 7–15.

24 Breton, *Manifestoes of Surrealism*, 26.

25 Walker, *City Gorged with Dreams*, 17. See also Roegiers, "The

Self-Resistant René Magritte," 40.

26 Arden, "After Photography," 53.

27 A history of the mind as mirror and the dismantling of this image by Dewey, Heidegger, and Wittgenstein is given by Rorty, *Philosophy and the Mirror of Nature*.

28 Baillargeon's print measures 70 x 101 cm. The black edge is made by slightly expanding the negative holder in the enlarger. Photographers used to file the edges of their negative holders, giving the black borders of their prints an uneven, hand-crafted look. The black border also strengthens the photographic composition and signals that the image has been framed in the camera, with no further cropping in the darkroom.

29 For an artist's perspective on these unavoidable reflections, see Horowitz, "Before the Mirror. Again." The article, which considers my exhibition "The Power of Reflection," is illustrated with Horowitz's self-portraits created by reflection in the other artists' works.

30 Cirlot, 212.

31 Tierney, *The Monkey as Mirror*, 6–7.

32 Author's translation of Lisanne Nadeau, "Les rivages invisibles / à propos de *Comme des îles*," in Richard Baillargeon, *Comme des îles*, unpaginated.

33 Roger Shattuck, *Proust's Binoculars: A Study of Memory, Time, and Recognition in* A La Recherche du Temps Perdu, Princeton: Princeton University Press, 1983, 46–7, as cited by Schacter, *Searching for Memory*, 28.

34 For the autobiographical nature of Steeves's work, see Canadian Museum of Contemporary Photography, *George Steeves: 1979–1993*.

35 Bollas, *Cracking Up*, 34.

36 Ibid., 37.

37 Breton, *Mad Love*, 93. I cite the same passage at greater length to express Steeves's love of photography in *Image & Imagination*, 250.

38 Zolla, *The Androgyne*, 31, citing William Blake, *The Gates of Paradise*, in G. Keynes, ed., *The Poetry and Prose of William Blake*, London, 1948.

CHAPTER FIVE

1 Locke, *An Essay Concerning Human Understanding*. Book II, chapter 11, part 17.

2 Marcel Proust, *Remembrance of Things Past: Swann's Way*, 5.

3 Ibid., 5, 6, 33, 143.

4 Locke, *An Essay Concerning Human Understanding*. Book II, chapter 10, part 7.

5 See Crary, "Attention and Modernity in the Nineteenth Century," 479–81.

6 Locke, *An Essay Concerning Human Understanding*. Book II, chapter 10, part 9.

7 Pomian, "Vision and Cognition," 218–19.

8 Locke, *An Essay Concerning Human Understanding*. Book II, Chapter 27, part 23.

9 Chappell, "Locke's Theory of Ideas," in Chappell, ed., *The Cambridge Companion to Locke*, 44–9.

10 Kerouac, *On the Road*, 254.

11 Silverman, *The Threshold of the Visible World*, 26, 170, 84–7, 181, 189.

12 Hirsch, "Projected Memory," 9–10; see also Hirsch, "I Took Pictures."

13 Langford, "Donigan Cumming: Crossing Photography's Chalk Lines," in Canadian Museum of Contemporary Photography, *Donigan Cumming*, 14–33.

14 For an instructive application of Émile Benveniste's *Problems in General Linguistics* to Beckett, and other writers, see Olney, *Memory & Narrative*, 243–70.

15 Bourdieu, "Ce terrible repos qui est celui de la mort sociale," 5. Author's translation.

16 See Olney, *Memory & Narrative*, and especially his chapter, "Not I," on the "impossibility of the I" for autobiographers and disguised autobiographers, including Gertrude Stein, Ronald Fraser, Christa Wolf, and Olney's paradigmatic case, Samuel Beckett.

17 Olney, *Memory & Narrative*, 352.

18 There are parallels with the methodology of American photographers Diane Arbus and Chauncey Hare, both of whom Cumming admires and occasionally quotes in his work. Hare drew disturbing conclusions about American society from his observation that, after supper, most working men could be found drowsing half-drunk in front of the television; his extraordinary body of work, *Interior America*, drank deep of these findings. But Hare, a chemical engineer, was a nine-to-fiver himself, and not a happy one. A somnolent figure in a lazy boy represented his worst nightmares and confirmed his belief that America was in the grip of mind-destroying corporations. These were the figures he found when he got off work and went

trolling with his camera in the early evening.

19 Cited by Cumming in "The Subject of the Artist," from LaCapra, *Representing the Holocaust*, 70–1.

20 See Adams, "Passing By on the Other Side."

21 Gale, "Touching on Donigan Cumming," 12.

22 The photographs were part of a series entitled *Portraits of Men* that Cumming exhibited in 1978 under the name C.D. Battey, one of three pseudonyms under which Cumming presented work before *Reality and Motive in Documentary Photography*. In *My Dinner with Weegee*, the portraits are intermingled with urban landscapes that Cumming showed under the name Georgia Freeman. The Battey and Marlowe exhibitions are listed by Gingras in the Art Gallery of Windsor catalogue, *Diverting the Image*.

23 Gale, "Touching on Donigan Cumming," 12.

24 Silverman, *The Threshold of the Visible World*, 181.

25 Damasio's projective memories are part of the weave of life-writing which Olney sees exemplified by Beckett. See Olney, *Memory & Narrative*, 344; also see Damasio, *Descartes' Error*, 238–9.

26 Gale, "Touching on Donigan Cumming," 13.

27 Crary, "Attention and Modernity in the Nineteenth Century," in Jones and Galison, eds, *Picturing Science, Producing Art*, 487–90.

28 Nietzsche, "On the Uses and Disadvantages of History for Life," in his *Untimely Meditations*, 76.

29 Bishai, "Forgetting Ourselves," 10–13; she cites William Connolly, *Why I Am Not a Secularist* (Minneapolis: Univeristy of Minnesota Press, 1999).

30 Ibid., 15.

31 Silverman, *The Threshold of the Visible World*, 206.

32 Nietzsche, *Untimely Meditations*, 76.

33 Cumming, "The Subject of the Artist."

34 Beckett, "The End," in his *Stories and Texts for Nothing*, 72.

CHAPTER SIX

1 Robert Enright, "Memory Feeder: An Interview in Two Parts," in Meeka Walsh, ed., *Diana Thorneycroft: The body, its lesson and camouflage*, 27. Thorneycroft's statement is from the first part, a slightly revised version of Enright's "Memory Feeder: Subjects and Objects in the Art of Diana Thorneycroft."

2 Thorneycroft, artist's talk, Concordia University, 3 October, 2002.

3 Hacking, *Rewriting the Soul: Multiple Personality and the Sciences of Memory*, 210–20. Hacking patterns his term on Michel Foucault's "anatomo-politics and bio-politics," redressing his omission of "the mind, the psyche, the soul."

4 Ibid., 211–12.

5 Caruth, *Trauma*, 5, 7, 8.

6 Ibid., 10.

7 To Hacking's bibliography one might add cognitive psychologist Daniel L. Schacter's in *The Seven Sins of Memory (How the Mind Forgets and Remembers)*, as well as Judith Herman's references in *Trauma and Recovery*.

8 "Family Secrets/Social Tales," prepared and presented by Gail Fisher-Taylor, writer and incest survivor, for the CBC series, *Ideas*, aired nationally on 1 and 2 November 1988. "Part 1 is about the experience of incest, buried memories, and excavation. Part 2: Now that people are telling the family secrets, new social tales are emerging in recent studies and revised histories, arousing old controversies and posing new questions."

9 What is on trial is the belief that autobiographical memories are retrieved from secure storage, rather than reconstructed. Jean-Roch Laurence, Duncan Day, and Louise Gaston stress the point that reconstruction is normal: "Everything we can recall about our own past is the result of some accurate information about events gone by and a healthy dose of filling in the details." Their emphasis is on "healthy," meaning that they reject the idea that imperfect memory is a pathological sign, preferring the term "pseudo-memories" to the more alarming and loaded "false memories." See Laurence, Day, and Gaston, "From memories of abuse to the abuse of memories," 326.

10 Thorneycroft's work can be seen as a paradigm of the photographic grotesque, a condition defined as the expression of something unnatural and ineffable gnawing at the edges of the real. This definition is predicated on the idea that there are no grotesques in nature; there is no possible indexical relationship to the grotesque. Rather, the grotesque presents photographically by allusion. As the document of a real body's performance in front of a camera, Thorneycroft's imagery only alludes to the unnatural; in psychoanalytical terms, her imagery condenses or displaces the repressed; in photographic terms, the repressed is held outside the frame because it is grotesque, therefore unrepresentable. For an elaboration and other examples of the photographic grotesque, see Langford, "The Machine in the Grotto" and "In the Playground of Allusion."

11 These works are accessible in reproduction, notably in Walsh, ed., *Diana Thorneycroft*, and in exhibition catalogues cited here.

12 Maranda, "The Reluctant Critic," 17.

13 Breton, *Manifestoes of Surrealism*, 11.

14 Benjamin, "The Image of Proust," in his *Illuminations*, 202.

15 Breton, *Manifestoes of Surrealism*, 39–40.

16 Caws, "Diana Thorneycroft: Surrealism's Body Now," in Walsh, ed., *Diana Thorneycroft*, 17–25.

17 In 1996, Thorneycroft noted that her exposures took between ten to twenty seconds, and sometimes longer, depending on the complexity of the set, and that each image would be performed many times, so that a typical working session might go on for hours.

18 Enright, "Memory Feeder" (1996), in Walsh, ed., *Diana Thorneycroft*, 35.

19 Price, *The Photograph: A Strange, Confined Space*, 120–1.

20 Krauss, *L'Amour fou: Photography and Surrealism*, 24.

21 Ibid., 25–31.

22 Walker, *City Gorged with Dreams*.

23 Caws, "Diana Thorneycroft," in Walsh, ed., *Diana Thorneycroft*, 17.

24 Townsend, "Flashes of Light: Diana Thorneycroft's 'impossible' photographs and the possibility of history," in Keshavjee, ed., *slytod: Diana Thorneycroft*, 37.

25 Ibid., 38–40.

26 Kracauer, "Photography," in his *The Mass Ornament*, 51.

27 Caws, "Diana Thorneycroft," in Walsh, ed., *Diana Thorneycroft*, 24.

28 Within a framework of psychoanalysis and feminism, film studies include Mary Ann Doane, "Film and the Masquerade: Theorizing the Female Spectator," "Masquerade Reconsidered: Further Thoughts on the Female Spectator," and "Veiling Over Desire: Close-ups of the Woman," collected in *Femmes Fatales: Feminism, Film, Theory, Psychoanalysis*; Laura Mulvey, "Pandora: Topographies of the Mask and Curiosity," in Beatriz Colomina, ed., *Sexuality and Space*, 53–71.

29 Russo, *The Female Grotesque*, 53–73.

30 Isaak, *Feminism & Contemporary Art*, 11–46. For more laughter and other transformative processes, see Hélène Cixous, "Castration or Decapitation?" (1981) in Ferguson et al., eds, *Out There*, 345–56.

31 Cirlot, *A Dictionary of Symbols*, 205–6.

32 For the distinction between the intimate and contingent "family look" and the ideological framing of the "familial gaze" see Hirsch, *Family Frames*.

33 Lury, *Prosthetic Culture*.

34 Ibid., 84–5.

35 The notion of cannibalization comes from Donna Haraway via C.A. Lutz and J.L. Collins, *Reading National Geographic* (1993), cited by Lury, *Prosthetic Culture*, 86, note 9. Haraway's direct and substantial contributions to Lury's scholarship are documented in her bibliography. Her concept of "retrodictive prophecy" is elaborated on pages 85–8.

36 Enright, "Memory Feeder" (1996), in Walsh, ed., *Diana Thorneycroft*, 33.

37 Petr Wittlich, "Closed Eyes, Symbolism and the New Shapes of Suffering," 239.

38 Walker, *City Gorged with Dreams*, 17.

39 Kroker, *Technology and the Canadian Mind*, 89.

40 Freud, *The Interpretation of Dreams*, Standard Edition, Vol. V, 356–7.

41 Weiss, *Perverse Desire and the Ambiguous Icon*, 23.

42 Barasch, *Gestures of Despair in Medieval and Early Renaissance Art*, 64–7.

43 The drawing is held by Staatliche Museen Preussischer Kulturbesitz and reproduced in Anzelewsky, *Dürer*, 223.

44 Fraser, *My Father's House*, 21.

45 Ibid., 214–15.

46 Ibid., 220–1.

47 Herman, *Trauma and Recovery*, 115–29.

48 Hopper and van der Kolk, "Retrieving, Assessing, and Classifying Traumatic Memories."

49 Caruth, *Trauma*, 10.

50 Hopper and van der Kolk, 60.

51 Enright, "Memory Feeder" (1996), in Walsh, ed., *Diana Thorneycroft*, 35.

52 Weiss, *Perverse Desire and the Ambiguous Icon*, 15.

CHAPTER SEVEN

1 Ryle, *The Concept of Mind*, 240.

2 Laurence Louppe, "Entre-corps," in The Morris and Helen Belkin Art Gallery, Vancouver, and The Montreal Museum of Fine Arts, *Geneviève Cadieux*, 42.

3 Otis, *Organic Memory: History and the Body in the Late Nineteenth & Early Twentieth Centuries*, 1–40; quotation, 138. Theorists of organic memory included Ewald Hering, Valentin Magnan, Théodule Ribot, Richard Semon, Herbert Spencer, Samuel

Butler, Emilia Pardo Bazán, Thomas Hardy, Thomas Mann, and Émile Zola.

4 Casey, "Comparative Phenomenology of Mental Activity," 2–10.

5 Ryle, *The Concept of Mind*, 240. Walton's theory of "Transparent Pictures" has excited considerable debate. Some of the objections are addressed in "On Pictures and Photographs" in which he stresses the point about combinatory (actual and imagined) seeing on page 68.

6 Carruthers, *The Book of Memory*, 53.

7 Mary Pardo, "Memory, Imagination, Figuration," in Küchler and Melion, eds., *Images of Memory*, 61.

8 Barthes, *Camera Lucida*, 77; Silverman, translating Lacan, *The Threshold of the Visible World*, 174.

9 The literature that supports this assertion is reviewed by contributors to *Image & Imagination*, including my own essay, "Lost Horizons, or The Gates Close at Sunset." See entries under Langford.

10 Casey, "Comparative Phenomenology of Mental Activity," 4–10.

11 Benjamin, "The Work of Art in the Age of Mechanical Reproduction," *Illuminations*, 226.

12 See, for example, Sebald's *The Emigrants*, in which snapshots, postcards, aerial photographs, architectural details, and crude maps strangely supplement the narrator's close description.

13 Walton, *Mimesis as Make-Believe*, 17.

14 *Time* cover, special issue, Fall 1993; reproduced in Marien, *Photography: A Cultural History*, 408.

15 Oliver Wendell Holmes, "The Stereoscope and the Stereograph" (1859), in Newhall, ed., *Photography*, 54; Walton, "Transparent Pictures," "Looking Again Through Photographs," "On Pictures and Photographs," and "Experiencing Still Photographs."

16 Walton, "Transparent Pictures," 252.

17 Ibid., 273, 330.

18 Ibid., 254.

19 Logie, *Visuo-Spatial Working Memory*, 37–9; Logie cites D. Chambers and D. Reisberg, "Can mental images be ambiguous?" (1985). Wittgenstein's analysis of "aspect seeing" or "seeing as" includes the famous duck-rabbit.

20 Walton's exclusion of photography from *Mimesis as Make-Believe* seems almost unconscious. For example, when he turns to "suspense and surprise in the static arts," he tells us that he is going to include photographs, but he does not. Closest in kind is a reference to a "picture" in which a suspense-provoking detail (a gun hidden in the shrubbery) is revealed only on careful examination. This picture might be a painting, a drawing, or a photographic print; Walton is here silent on medium, though he refers in a footnote to Michael Fried's emphasis on close study of paintings (267–70). Perhaps the distinction between painting and photography, made in "Transparent Pictures," is breaking down. It is startling to stumble over his description of "a person viewing Cézanne's *Montagne Sainte-Victoire* for the second or seventeeth time as fictionally looking again at a mountain he has seen before." (264) Walton's understanding of photography is overdetermined by his belief in its perceptual connection to the *here and now*. He shrinks photographic reception, however fictional, to "our actual mental lives" by depriving it of repetition and extendure.

21 Walton, *Mimesis as Make-Believe*, 240–89.

22 These are two characteristics of psychological participation described by Walton, *Mimesis as Make-Believe*, 252–4.

23 Ibid., 292.

24 Benjamin, "The Task of the Translator," in *Illuminations*, 73.

25 See Nikos Papastergiadis, "From the Edges of Exile to the Limits of Translation," in Nemiroff, ed., *Crossings*, 43–69.

26 As Casey explains, Freud's concept of the dream is a "*doubly doubly articulated* set of signifiers or symbolic signs … *dreams parse into words*." (141) Thus dream-work, conceived as picture-work and word-work, is productive along two double lines. Casey, "The Image/Sign Relationship in Husserl and Freud," in Bruzina and Wilshire, eds., *Crosscurrents in Phenomenology*, 120–43; citations, 128, 130, 134–6.

27 Cousineau-Levine, *Faking Death*.

28 Ryle, *The Concept of the Mind*, 263.

CHAPTER EIGHT

1 Bollas, *Cracking Up*, 66.

2 Ibid., 4.

3 Bollas, *The Mystery of Things*, 28.

4 Bollas, *Cracking Up*, 30–1.

5 Barthes, *Camera Lucida*, 70.

6 The notion is carried over from psychoanalysis: "Toute photographie, indépendamment de ses contenus, fournit une image de la façon dont le système psychique contient les

représentations du monde constituées sous le regard du sujet et le sujet lui-même sur le mode de l'exclusion." Tisseron, "L'inconscient de la photographie," 84.

7 Nabokov, *Speak, Memory*, 5.

8 Dubois returns to sculptor Adolf Hildebrand's concept of haptics which is essentially tactile, that is, touching with one's eyes, also referring to seminal texts by Denis Diderot, Erwin Panofsky, Maurice Merleau-Ponty, Gilles Deleuze, and Georges Didi-Huberman. See Dubois, "Des Images pour que notre main s'émeuve."

9 This allusion to blindness can be contrasted with Henri Bergson's image of shutting his eyes to the blinding flash, an act that creates an afterimage. The concept is developed by Cadava in *Words of Light* (87–92), with reference to an article by Elissa Marder, "Flat Death: Snapshots of History," *diacritics* 22 (1992).

10 Brewer, "What Is Autobiographical Memory?"

11 Batchen, *Burning with Desire*, 202. Batchen goes to Raymond Williams to understand better the cultural histories of "nature" and "realism." I go to the same well for "mediation." Williams surveys its pre-modern senses, "from reconciling to intermediate to indirect," leading to its current and conflicting uses in political, psychoanalytical, and aesthetic systems of thought. The use of the word in this context is probably quite clear, though I should stress that my intention is combinative, including most obviously *process*, but also the contrast between *mediate* and *immediate* which found currency in the philosophy of the early nineteenth century. Williams cites Coleridge, 1817: "all truth is either mediate … derived from some other truth … or immediate and original." See Williams, *Keywords*, 204–7.

12 Bazin, "The Ontology of the Photographic Image," 14.

13 Barthes, *Camera Lucida*, 55.

14 *The Journal of Eugène Delacroix*, Strasbourg, 1 September 1859, cited by Jammes and Janis, *The Art of French Calotype*, 98.

15 Jammes and Janis, *The Art of French Calotype*, 96–101.

16 Peter Henry Emerson, "Naturalistic Photography," (1889), cited by Beaumont Newhall, *The History of Photography*, 98.

17 Bollas, *Cracking Up*, 30–2.

18 Freud, "The 'Uncanny,'" 219, 220, 224, 225.

19 Dion, "Greg Staats, ou la persistance motivée," in Staats, *Animose*, 41.

20 Clark, "Greg Staats: Memories of a Collective Reality – Sour Springs," Thunder Bay Art Gallery, *Greg Staats: Memories of a Collective Reality – Sour Springs, 1995*, unpaginated.

21 Staats, cited by Clark, in Thunder Bay Art Gallery, *Greg Staats*, unpaginated.

22 Dion, "Greg Staats, ou la persistance motivée," in Staats, *Animose*, 42.

23 Casey, *Getting Back into Place*, 52.

24 Nathan Lyons, who coined the term "social landscape," is also discussed in relation to the "snapshot aesthetic," a term I have seen mistakenly applied to Staats's work. There is nothing of the street photographer, or flâneur, in Staats's approach.

25 Staats, "Artist Statement: Animose," in Mercer Union, Toronto, brochure/invitation, 13 April–20 May 2000.

26 Staats, personal communication with the author, 14 June 2006.

27 Williams, *The Country and the City*, 1–8; Schama, *Landscape and Memory*, 23–36.

28 Williams, *The Country and the City*, 138.

29 Lippard, *The Lure of the Local*.

30 Staats, 17 May 1991, cited by Mastai, "The Post-Colonial Landscape," 12.

31 Staats, personal communication with the author, 14 June 2006.

32 Pelkey, in The Photographers Gallery, *Search, Image and Identity*, 53.

33 Richmond, "Picturing Home."

34 Bernstein, *Foregone Conclusions*, 7.

35 Derrida, *Memoirs of the Blind*; citation, 45.

36 Broadfoot interweaves the theories of Jacques Derrida, Jacques Lacan, and Michael Fried with Jackson Pollock's abstract paintings in "Before and After Pollock"; citation, 131.

CHAPTER NINE

1 Merleau-Ponty, *Phenomenology of Perception*, 22.

2 Ibid., viii.

3 Snow in interview, 24 October 2000.

4 Pontbriand, "*Plus Tard*, plus tard … Michael Snow," 54 (author's translation).

5 Snow in interview, 24 October 2000.

6 Bruce Elder says something similar about Snow's film, *One Second in Montreal* – "instantaneous events become durative" – seeing in its temporal expansion something of the eternal, a characteristic that he also finds in the dialectic between past

and present in a representational image, the perennial presentness of its reception. See "Michael Snow and Bruce Elder in Conversation, 1982," reprinted in Snow's *Collected Writings*, 224.

7 Snow, "Notes on the Whys and Hows of My Photographic Works," in Société des Expositions du Palais des Beaux-Arts, *Michael Snow: Panoramique*, 113.

8 Snow, from Roberts and Snow, "An Intercontinental Collage," in Roberts, ed., *Michael Snow, almost Cover to Cover*, 20.

9 Snow, from "Pierre Théberge: Conversation with Michael Snow, 1978," in his *Collected Writings*, 195.

10 Dompierre, "Embodied Vision," in Art Gallery of Ontario and Powerplant, *The Michael Snow Project*, 423–6.

11 In Snow's film, *La Région Centrale* (1971), a recurrent X acts as a break in the film, reminds the spectator of the importance of place, and reasserts the presence of the projection screen. See Snow and Du Cane, "The Camera and the Spectator: Michael Snow in Discussion with John Du Cane, 1973," in Snow's *Collected Writings*, 90.

12 This recurrent motif was the basis of *Michael Snow: Windows*, an exhibition that I organized for the Galerie de l'UQAM and Le Mois de la Photo à Montréal in 2005. See Langford, *Image & Imagination*, 26–9.

13 Snow, "Pierre Théberge: Conversation with Michael Snow, 1978," in his *Collected Writings*, 196–7.

14 Ibid., 197.

15 Ebert-Schifferer, *Still Life*, 122.

16 Fuchs, *Dutch Painting*, 115.

17 Cirlot, *A Dictionary of Symbols*, 38.

18 Fuchs, *Dutch Painting*, 114–15.

19 The careful planning that went into *Midnight Blue* is preserved in four annotated sketches. Snow initially intended to set the candle against a grid; nine photographs were to form the backdrop. The final drawing replaces the grid with diagonal lines. Colours are specified: yellow flame; orange behind flame; red; dark red; yellow wood; for memory's sake, the drawing includes a daub of blue paint. There is also the suggestion of a camera. The drawings are held by the Art Gallery of Ontario, Michael Snow Fonds, Box 89.

20 This observation comes from Peggy Gale, who relates the shape to Snow's sculpture, *Monocular Abyss* (1982). Personal correspondence with the author, 10 March 2002.

21 Sartre, *The Psychology of Imagination*, 24.

22 Snow, "Notes on the Whys and Hows of My Photographic Works," 117.

23 Read, *Icon and Idea*, 24.

24 Snow in interview, 24 October 2000.

25 Read, *The Art of Sculpture*, 102–3. Both these works are in the permanent collection of the Museum of Modern Art in New York.

26 Krauss, *Passages in Modern Sculpture*, 114.

27 Snow in interview, 24 October 2000.

28 Lord, *Giacometti: A Biography*, 143–4.

29 Snow, "Pierre Théberge: Conversation with Michael Snow, 1978," in his *Collected Writings*, 196.

30 Here again, the preparatory work exists, in the form of sketches and photographic images. The parrot was a trained actor who flew up and over to its handler, unseen in the photograph.

31 From an interview by Andree Hayum, first published in *Review* 72, 7 (Winter 1972); reprinted in Snow, *Collected Writings*, 85.

32 Bergson, "Memory of the Present and False Recognition," in his *Mind-Energy*, 134–85. I draw freely on this essay; citations 136, 137, 139, 157–8, 167, 174, 184.

33 Regina Cornwell, "Two Sides to Every Story" (1974), reprinted in Roberts, ed., *Michael Snow, almost Cover to Cover*, 126.

34 Warnock, *Imagination*, 173.

35 Sartre, *The Psychology of Imagination*, 201–5.

36 Warnock's discussion of Sartre and Wittgenstein is part of her chapter "The Nature of the Mental Image," *Imagination*, 131–95; quotations on 182, 183 (Warnock) and 191–2 (Wittgenstein).

37 Snow, quoted by Kay Kritzwiser, "Snow's Walking Woman walks again," *Globe and Mail*, 16 April 1966; cited by Reid, "Exploring Plane and Contour: The Drawing, Painting, Collage, Foldage, Photo-Work, Sculpture and Film of Michael Snow from 1951 to 1967," in Art Gallery of Ontario and Power Plant, *The Michael Snow Project*, 32.

38 Read, *The Art of Sculpture*, 116.

39 The essay is "Repetition/La Répétition: Michael Snow and the Art of Memory," in Roberts, ed., *Michael Snow, almost Cover to Cover*, 34–75.

40 Snow, "Passage (Dairy), 1971," in his *Collected Writings*, 66.

41 Snow, "Notes on the Whys and Hows of My Photographic Works," 113.

botte's Changing Roles in the History of Art," in La Réunion
des Musées Nationaux, Musée d'Orsay, Paris, et al., *Gustave
Caillebotte*, 13.

34 Scharf, *Art and Photography*, 176.

35 Norma Broude, "Outing Impressionism: Homosexuality and
Homosocial Bonding in the Work of Caillebotte and Bazille," in
Broude, ed., *Gustave Caillebotte and the Fashioning of Identity in
Impressionist Paris*, 117–74.

36 Wall and Jean François Chevrier, "The Interiorized Academy,"
in de Duve et al., *Jeff Wall*, 109–10.

37 Zaslove, "Faking Nature and Reading History," 77, 98.

38 Arnheim, "Outer Space and Inner Space" (1991), reprinted
in *The Split and the Structure*, 44.

39 Arnheim, *The Split and the Structure*, 44.

40 Monika Kin Gagnon and Yoon, "Other Conundrums," in West-
ern Front Exhibitions Program, *Jin-me Yoon: Between Departure
and Arrival*, 68.

41 Kang, "The Autobiographical Stagings of Jin-me Yoon," in
Western Front, *Jin-me Yoon*, 24.

42 Gagnon and Yoon, "Other Conundrums," in Western Front,
Jin-me Yoon, 49–51.

43 Rob Shields, "Imaginary Sites," in Walter Philips Gallery,
Between Views, 25–6.

44 Jody Berland, "Fire and Flame, Lighting and Landscape:
Tourism and Nature in Banff, Alberta," in Walter Philips
Gallery, *Between Views*, 14–15.

45 Augaitis and Gilbert, "Between Views and Points of View,"
in Walter Philips Gallery, *Between Views*, 6.

46 The photographs were taken by Cheryl Bellows.

47 Silverman, *The Threshold of the Visible World*, 201.

48 Kang, "The Autobiographical Stagings of Jin-me-Yoon,"
Western Front, *Jin-me Yoon*, 34.

49 Kang, "The Autobiographical Stagings of Jin-me-Yoon,"
30–6.

50 Marien cites John W. Dower, *Embracing Defeat: Japan in the
Wake of World War II* (1999) in *Photography*, 330–1.

51 Knights, "Chronology," in Lateral Gallery, *(Inter)reference*,
Part II, unpaginated.

52 VAG staff photographer Trevor Mills took the pictures, while
Yoon functioned as an art director and also posed. See Gagnon
and Yoon, "Other Conundrums," in Western Front, *Jin-me
Yoon*, 56–8.

53 Arnold, "Purism, Heterogeneity and *A Group of Sixty-Seven*," 150–1.

54 Ibid., 150.

55 Yoon, in Gagnon and Yoon, "Other Conundrums," in Western
Front, *Jin-me Yoon*, 69.

56 Roberts, *The Art of Interruption*, 192–3.

57 de Duve, "The Mainstream and the Crooked Path," in de Duve
et al., *Jeff Wall*, 28.

58 Roberts, *The Art of Interruption*, 193.

59 Ibid.

60 Yoon, in Gagnon and Yoon, "Other Conundrums," in Western
Front, *Jin-me Yoon*, 70.

61 Wall, interviewed by Pelenc, in de Duve et al., *Jeff Wall*, 21–2.

62 Watson, "The Giant." Wall refers to the interpretation, without
identifying Watson, in the interview with Pelenc just cited, 22.

63 Wall was part of a group exhibition in Cologne in 1981 and has
had numerous solo exhibitions there.

64 Jean Roudaut, "A Grand Illusion," in Abadie, *Magritte*, 25–6.

65 Wall, "Unity and Fragmentation in Manet (1984)" in de Duve
et al., *Jeff Wall*, 79.

66 Bhabha, *The Location of Culture*, 254.

CHAPTER TWELVE

1 Le Goff, *History and Memory*, xi–xii.

2 Kogawa, *Obasan*, epilogue.

3 Claude Lefort, "Editor's Foreword" to Merleau-Ponty, *The Visi-
ble and the Invisible*, xxvi.

4 Cirlot, *A Dictionary of Symbols*, 313.

5 Nora, "Between Memory and History: *Les Lieux de Mémoire*," 12.

6 Huyssen, *Twilight Memories*, 250.

7 Young, "Memory and Counter-Memory," 8.

8 Harbison, "Half-Truths and Misquotations," 22.

9 Abramson, "Make History, Not Memory."

10 Phillips, "Settler Monuments, Indigenous Memory," 282. This
important essay deals with the work of Robert Houle in the
same terms.

11 Hill, "Jeff Thomas: Working Histories," in Gallery 44, *Jeff
Thomas: A Study of Indian-ness*," 13–14.

12 Thomas, "Scouting for Indians," in Gallery 101, Ottawa, *Bear-
ings*, 47–59. This feature had long been recognized by the gay
community: meetings "by the Scout" were common before the
statue was moved. Perhaps its navigational function continues:
in the collective memory of Ottawa, "Major's Hill Park" con-
notes cruising grounds.

13 Phillips, "Settler Monuments, Indigenous Memory," 300.

14 Solnit, "The Struggle of Dawning Intelligence: On Monuments and Native Americans," 52–7.

15 Nora, "Between Memory and History," 7. In this article, published in *Representations* 26 (Spring 1989), Nora thanked his translator for conserving the French *lieu de mémoire* in all its "profound connotations." The English word "site" was occasionally substituted. *Realms of Memory* was ultimately chosen as the title of the three-volume work in translation, with *lieux de mémoire* retained in the text.

16 Nora, "The Era of Commemoration," *Realms of Memory*, Vol. 3, 609.

17 Nora, "Between Memory and History," 18.

18 Ibid.

19 Ibid., 10.

20 Ibid., 19.

21 Le Goff, *History and Memory*, xiv.

22 Ibid., xvi.

23 Van Alphen, *Caught by History*, 99–100.

24 Le Goff, *History and Memory*, 97.

25 Ibid., 95–6.

26 Ibid., xviii–xxiii.

27 Ibid., xiv.

28 Edward Said, "Invention, Memory, and Place," 179.

29 Anderson, *Imagined Communities*, 204.

30 Ibid., 187–206.

31 Merridale, *Night of Stone: Death and Memory in Russia*, 20.

32 Dostoyevsky, *The House of the Dead*, thanks to Jerry Zaslove.

33 Merridale, *Night of Stone*, 412–41.

34 Berger, *The Writing of Canadian History*, 259–60.

35 See Lavoie, *L'instant-monument*.

36 Much testing has been done on children, but adults as well exhibit a tendency to change their stories – to remember differently – depending on the consequences of their statement. See Stein, Ornstein, et al., *Memory for Everyday and Emotional Events*.

37 Margalit, *The Ethics of Memory*, 147–82.

38 Sturken, *Tangled Memories*, 15.

CHAPTER THIRTEEN

1 Nora, "Between Memory and History," 22.

2 Debouzy, "In Search of Working-Class Memory," 62.

3 Willett, *Art & Politics in the Weimar Period*, 157.

4 The categories are the artists' as presented on their website http://www.workingimage.ca. Site visited 12 February 2007.

5 Rose, "The Politics of Art, Part II."

6 Fleming, "The Production of Meaning," 10.

7 Tuer, "Is It Still Privileged Art?," 198–201.

8 From a nationalist political and postcolonial perspective, complicated by sympathies for Quebec nationalism, Barry Lord explains the components of the art market in "Painting in the Age of U.S. Imperialism," *The History of Painting in Canada*, 139–241. Lord's history predates the emergence of Condé and Beveridge's collaboration.

9 For a concise history of the period in which Condé and Beveridge were developing their political views and their artistic collaboration, see Clark, "The Art of Protest: From Vietnam to AIDS," *Art and Propaganda in the Twentieth Century*, 125–61.

10 Samuel, *Theatres of Memory*. Vol. I, 6.

11 Guest, "Maybe Wendy's Right," 278.

12 Clive Robertson, "Carole Condé and Karl Beveridge's Political Landscapes: Making art about the struggles for social justice and the limits of the political order," in Gallery TPW, *Carole Condé and Karl Beveridge*, 21.

13 In the same period, American and British artists dealing critically with themes of labour and community include Chauncey Hare, Fred Lonidier, Allan Sekula, the Hackney Flashers Collective, Jo Spence, and Rosy Martin.

14 Debouzy, "In Search of Working-Class Memory," 55.

15 Ibid., 57.

16 Ibid., 58.

17 Ibid.

18 Ibid.

19 Ibid., 61.

20 Ibid., 62.

21 Ibid.

22 Ibid., 64.

23 Debouzy reviews a study of retired metal workers in the industrial town of Givors, near Lyon, conducted by Yves Lequin and Jean Métral whose findings were published in *Annales* (January-February, 1980); The study is cited in Debouzy, 64–5.

24 Debouzy, "In Search of Working-Class Memory," 66.

25 Ibid., 72.

26 Ibid.

27 In January 2004, I submitted a list of questions to Carole

Condé and Karl Beveridge to which they responded on 4 February 2004. A few clarifications were then sought, and their response is dated 2 April 2004. I draw freely on this exchange in the "Adaptive Methodologies" section, citing by date only as required to separate these comments from other published texts.

28 Condé and Beveridge, *Oshawa*, introduction, unpaginated.

29 Condé and Beveridge, electronic interview, 4 February 2004.

30 Ibid.

31 Condé and Beveridge have reopened or reworked some of their series. When *Work in Progress* was first released in 1980, the series consisted of eight images, plus a title panel, covering the years 1908 to 1979. The series was updated in 2006, and the timeline lengthened from 1895 to 2006. See Langford, "Workers in Progress." *Standing Up* is reproduced in *First Contract: Women and the Fight to Unionize*.

32 Condé and Beveridge, electronic interview, 2 April 2004.

33 Condé and Beveridge, *First Contract*, 4.

34 Ibid., 18–9.

35 Samuel, *Theatres of Memory*, 317.

36 Ibid., 328.

37 Condé and Beveridge have conducted extensive research to get their sets and costumes right. For editorial images, "The best Canadian source we found was a magazine called *New World Illustrated* (it published both an English and a French edition) which ran from 1936–38 to about 1948–50. No one has ever heard of it." Mindful of dates and economics, they designed their sets "four to six years back from what appeared in magazine ads." Condé and Beveridge, electronic interview, 4 February 2004.

38 For a case study and Marxist analysis of a photographic studio engaged in all facets of corporate promotion, see Leslie Shedden, *Mining Photographs and Other Pictures 1948–1968*, edited by Benjamin H.D. Buchloh and Robert Wilkie.

39 Terry Dennett, "Popular Photography and Labour Albums," in Spence and Holland, eds, *Family Snaps*, 72–83.

40 Roberts, *The Art of Interruption*, 62–5.

41 Ibid., 64.

42 Payne, "A Canadian Document: The National Film Board's Still Photography Division," in Canadian Museum of Contemporary Photography, *A Canadian Document*, 33.

43 Glass, "Class Pictures," 39.

44 Donegan, in Art Gallery of Hamilton, *Industrial Images*, x.

Donegan's curatorial work in this area, informed by her involvement with the Canadian Labour Congress–Labour Education and Studies Centre, is exemplary.

45 Huneault, *Difficult Subjects*, 160.

46 Ibid., 157–205.

47 Always, to some degree, present in their work, the history of art is the mainspring of their series on the erosion of Canadian socialized medicine, *Not a Care: A Short History of Health Care* (1999–2001).

48 Hutcheon, *A Theory of Parody*, 11.

49 Hareven, *Family Time and Industrial Time*, xii, 7.

50 Wajcman, *Women in Control*, 13.

51 Steele and Tomczak, interviewing Condé and Beveridge, "Oshawa 1938–45."

52 Wajcman, *Women in Control*, 12.

53 Condé and Beveridge, *First Contract*, 22–33.

54 Fleming, open letter to Carole Condé and Karl Beveridge, appended to "The Production of Meaning: An Interview with Carol Condé and Karl Beveridge," 13–14.

55 Condé and Beveridge, open letter to Martha Fleming, appended to Fleming, "The Production of Meaning," 12.

56 Condé in conversation with M.M. (Michael Mitchell) for *Photo Communiqué*, "Karl Beveridge and Carole Condé," 38.

57 Steele and Tomczak, interviewing Condé and Beveridge, "Oshawa 1938–45."

58 Nora, "Between Memory and History," 14.

59 Williams, "A Defence of Realism," *What I Came to Say*, 238.

CHAPTER FOURTEEN

1 Barthes, *Camera Lucida*, 27.

2 Gale, "*Kanehsatake X*," Centre international d'art contemporain de Montréal, *Tout le temps/Every Time*, 80.

3 Robert Houle as cited by Gale in her catalogue entry.

4 Walton, "Transparent Pictures."

5 Hill, "Historical Confluence," in McMichael Canadian Art Collection, Alter*Native: Contemporary Photo Compositions*, 8.

6 Ibid., 9.

7 McMaster, "Desperately Seeking Identity in the Space of the Other," in Canadian Museum of Civilization, *Edward Poitras*, 22.

8 See, for example, Renisa Mawani, "Legal Geographies of Aboriginal Segregation in British Columbia: The Making and Unmaking of the Songhees Reserve, 1850–1911," in Strange

and Bashford, eds, *Isolation*, 173–90.

9 Hill, "Historical Confluence," 10.

10 Nelson H.H. Graburn, "The Fourth World and Fourth World Art," in Canadian Museum of Civilization, *In the Shadow of the Sun: Perspectives on Contemporary Native Art*, 3–11; quotation, 7.

11 For a correlation of this history with Houle's life and production, see Winnipeg Art Gallery, *Robert Houle: Sovereignty over Subjectivity*, and especially Bonnie Devine, "Ways of Telling: Sandy Bay."

12 Hill, "Historical Confluence," 10.

13 The view that the First Nations, and especially the Haida carvers, experienced a visual arts "Renaissance" in the 1960s is a commonplace of the literature, now vigorously contested. Anthropologist Martine Reid sees the metaphor as a Euro-American myth founded on the interests of that "immigrant community," motivated by "genuine appreciation, a fascination for the exotic, boredom with the lack of richness in 'Western' art, even feelings of guilt about the destruction of the once-flourishing cultures and conditions of their survivors." For Reid, the metaphor has run its course, its emphasis on form and technique obscuring the importance of reinvention and reinterpretation within the contemporary cultural context. See Martine Reid, In "Search of Things Past, Remembered, Retraced, and Reinvented," in Canadian Museum of Civilization, *In the Shadow of the Sun*, 71–92; quotations, 74–5.

14 Goldie, *Fear and Temptation*, 17.

15 Curtis, cited by T.C. McLuhan, "Curtis: His Life," in Edward S. Curtis, *Portraits from North American Indian Life*, x.

16 A.D. Coleman, "Curtis: His Work," in Curtis, *Portraits from North American Indian Life*, vi–vii.

17 Diana Nemiroff writes, "Apart from a small group of Inuit prints and sculptures 'of very little historic importance as a collection' assembled in the fifties and sixties, Beam's painting [*The North American Iceberg* (1985)] was the first work by a native artist acquired by the National Gallery since the acquisition of a small Northwest Coast argillite pole in 1927." See Nemiroff, "Modernism, Nationalism, and Beyond: A Critical History of Exhibitions of First Nations Art," in National Gallery of Canada, *Land, Spirit, Power*, 18. McMaster calls the acquisition a "Trojan horse" and wonders whether the work's symbolization of "the mainstream's avoidance of a 500-year historical relation with the aboriginal people of North America" also marks "the end of an aboriginal art history?" See Ger-

ald McMaster, "Towards an Aboriginal Art History," in Rushing, *Native American Art in the Twentieth Century*, 92–3. See also John K. Grande, "Carl Beam: Dissolving Time," for Beam's and Grande's critical views of the National Gallery's and other museums' policies.

18 Hill, "Historical Confluence," 10.

19 Ruth B. Phillips, "Art History and the Native-Made Object," in W. Jackson Rushing III, *Native American Art in the Twentieth Century*, 98–9.

20 Hill, "Historical Confluence," 11–12.

21 Vervoort, "A Visual Autobiography: The Self-Portraits of Carl Beam."

22 Eichhorn, "Carl and Ann Beam," 44.

23 Charlotte Townsend-Gault, "Hot Dogs, a Ball Gown, Adobe and Words: The Modes and Materials of Identity," in Rushing, *Native American Art in the Twentieth Century*, 128–9.

24 Gale recounts that Houle blocked the windows of his Toronto studio with banners to proclaim his solidarity during Oka, a gesture that deprived him of natural light, forcing him to stop painting for the duration.

25 Houle, "The Spiritual Legacy of the Ancient Ones," in National Gallery of Canada, *Land, Spirit, Power*, 73.

26 Robert S. Nelson, "Appropriation," in Nelson and Shiff, *Critical Terms for Art History*, 119.

27 Grande, "Carl Beam," quotation, 21–2; also, see Grande's conclusion, 23.

28 Carl Beam, from a series of talks broadcast on Trent Radio, in Artspace and Art Gallery of Peterborough, *Carl Beam: The Columbus Project. Phase 1*, 13.

29 The textual intervention followed Baumgarten's earlier work, *Monument to the Indian Nations of South America* (1978–82), installed at Documenta 7, Museum Fridericianum, Kassel, June 1982. See Art Gallery of Ontario, *The European Iceberg*.

30 Houle, "The Spiritual Legacy of the Ancient Ones," in National Gallery of Canada, *Land, Spirit, Power*, 49–50; quotation, 51.

31 Gachnang, "German Paintings: Manifestos of a New Self-Confidence," in Art Gallery of Ontario, *The European Iceberg*, 63.

32 Berlo and Phillips, *Native North American Art*, 9. The authors discuss the criteria for "art," as well as the ethical problems that arise from the collection and display of sacred objects.

33 Beam referred to this notion during a telephone conversation (3 February 2004) about the sources of his images. It is also the title of a book by Daniel Francis, *The Imaginary Indian: The*

Image of the Indian in Canadian Culture, 1992.

34 McLuhan, "Curtis: His Life," in Edward S. Curtis, *Portraits from North American Indian Life*, xi.

35 Robert A. Weinstein, "The American Indian: The Image Fixed," in Belous and Weinstein, *Will Soule: Indian Photographer at Fort Sill, Oklahoma 1869–74*, 20. Published in 1969, Belous's introduction addresses the ongoing mythologizing of Native people. His essay begins: "It may not be an exaggeration to suppose that if there had never been an American Indian, then he would have had to have been invented."

36 Williams, *Framing the West*.

37 Skidmore, "Touring an Other's Reality."

38 Elizabeth Edwards, *Raw Histories*, cited by Peers and Brown, "Colonial Photographs and Post-Colonial Histories," 5.

39 Belous and Weinstein, *Will Soule*, 32.

40 Carl Beam, cited by Elizabeth McLuhan from an interview conducted in December 1983. See Thunder Bay National Exhibition Centre and Centre for Indian Art, *Altered Egos: The Multimedia Work of Carl Beam*, 5. Gerhard Hoffmann draws attention to a similar statement by Robert Rauschenberg, published in *Art News*, February 1983. See Hoffmann, "Postmodern Culture and Indian Art," in Canadian Museum of Civilization, *In the Shadow of the Sun*, 295 (note 41).

41 Berlo and Phillips emphasize the dialectical aspects of Beam's collage, thus privileging the rational over the irrational. See *Native North American Art*, 232–3.

42 Jacqueline Fry, introduction to The Winnipeg Art Gallery, *Treaty Numbers 23, 287, 1171*, unpaginated.

43 Hoffmann, "Postmodern Culture and Indian Art," in Canadian Museum of Civilization, *In the Shadow of the Sun*, 276–7, 283.

44 See McMaster, "Towards an Aboriginal Art History," in Rushing, *Native American Art in the Twentieth Century*, 89; see also Phillips, "Settler Monuments, Indigenous Memory," 289–94.

45 W. Jackson Rushing III, "Beautiful Object = Paradigm of Power: Robert Houle from A to Z," in Winnipeg Art Gallery, *Robert Houle: Sovereignty over Subjectivity*, 27.

46 Peggy Gale, "Robert Houle: Recording," in Winnipeg Art Gallery, *Robert Houle: Sovereignty over Subjectivity*, 22.

47 Payne, introduction to Canadian Museum of Contemporary Photography, *Displaced Histories*, unpaginated.

48 Houle's admiration for these artists is confirmed throughout the literature. See Winnipeg Art Gallery, *Robert Houle: Indians from A to Z*.

49 Houle, "The Spiritual Legacy of the Ancient Ones," in National Gallery of Canada, *Land, Spirit, Power*, 72.

50 Douglas, "In the Field of Visibility," 760–1.

51 Chamberlin, *If This Is Your Land, Where Are Your Stories? Finding Common Ground*, 63.

52 Peggy Gale, "Robert Houle: Recording," in Winnipeg Art Gallery, *Robert Houle: Sovereignty over Subjectivity*, 22.

53 McLuhan, "Altered Egos," in Thunder Bay National Exhibition Centre and Centre for Indian Art, *Altered Egos*, 6.

54 Richard Rhodes, "Carl Beam: The Columbus Boat," in The Power Plant – Contemporary Art at Harbourfront, *Carl Beam: The Columbus Boat*, 43.

55 Bonnie Devine, "Ways of Telling: Sandy Bay," in Winnipeg Art Gallery, *Robert Houle: Sovereignty over Subjectivity*, 40–7.

CHAPTER FIFTEEN

1 Minden, cited by Rosenberg, "Robert Minden," 16.

2 To cite but one individual example, Gabor Szilasi's work in rural Quebec, identified by place names such as Charlevoix, Beauce, Lotbinière, and Abitibi, demonstrates a shift from collective portraiture as a series of individual portraits in private settings to a detailed recording of the imprint of place, as expressed in the topography and the built environment. See David Harris, "The Photographs of Gabor Szilasi," in Szilasi, *Gabor Szilasi*, 31–3.

3 Participants in the Disraëli project were Claire Beaugrand-Champagne, Michel Campeau, and Roger Charbonneau (G.A.P.), along with Cedric Pearson, Maryse Pellerin, and Ginette Laurin.

4 For succinct histories of three of these collections (National Archives of Canada, National Film Board of Canada/Canadian Museum of Contemporary Photography, and National Gallery of Canada), see "Some Canadian Collections," in *History of Photography* 20, 2 (Summer 1996): 166–85. For a more detailed history of the National Film Board collection, see National Film Board of Canada, *Contemporary Canadian Photography* and Canadian Museum of Contemporary Photography, *A Canadian Document*. The Art Bank of the Canada Council, though a significant source of support to artists and a resource for exhibitions, acquired work by peer-review.

5 A heartening example of photographic archives as electronic hosts of intergenerational communication is Project Naming,

in which social documentary photographs of Inuit people are returned to their communities for identification and amplification by the elders. See http://www.collectionscanada.ca /inuit/054301-e.html. Site visited on 9 April 2006. I discuss this project in light of Benjamin, Berger, Margalit, Marshall McLuhan, and others in "What Use is Photography?"

6 Berger, *About Looking*, 61.

7 Ibid., 48–63; quotation, 63.

8 Berger, *Another Way of Telling*, 131-289.

9 Walter Ong, "Text as Interpretation: Mark and After," in Foley, *Oral Tradition in Literature*, 148.

10 Benjamin, "The Storyteller," in *Illuminations*, 91-2.

11 Minden, *Separate from the World*, unpaginated.

12 Minden, "'Strangers on the Earth,'" 34.

13 Minden, *Separate from the World*.

14 Benjamin, "The Storyteller," in *Illuminations*, 91.

15 Caponigro, introduction to *Megalyths*, unpaginated.

16 Minden in interview, Vancouver, 14–15 December 2000. All quotations, unless otherwise noted, are from this interview.

17 Hoy, *Fabrications*, 6.

18 Goffman, *The Presentation of Self*, 1–16.

19 Schegloff, "Goffman and the Analysis of Conversation," 90–1.

20 Goffman, *Interaction Ritual*, 1. First published in 1967, this collection includes essays from the mid-1950s, such as "The Nature of Deference and Demeanor" (1956), here cited below.

21 Giddens, "Goffman as a Systematic Social Theorist," 254.

22 Goffman, "The Nature of Deference and Demeanor," *Interaction Ritual*, 48.

23 Goffman, *Stigma*, 1–19.

24 Goffman, *Interaction Ritual*, 3.

25 Schegloff, "Goffman and the Analysis of Conversation," 99.

26 Ibid., 90.

27 Minden, letter to the author, 17 August, 2001.

28 Rawls, "Orders of Interaction and Intelligibility," 231, 246.

29 Giddens, "Goffman as a Systematic Social Theorist," 251.

30 A curious, and disturbing, example is Gary Michael Dault's exhibition review, "Photos' warring truths kill esthetic excitement," *The Globe and Mail*, 2 April 1982. Reviewing the history of this pacifist community, Dault cleverly declares a war between art and sociology, defining the latter as "academic rigor and methodological airtightness." Showing eighty-five portraits of Doukhobors is deemed excessive: "Too much dignity and pathos is just as trivializing as too little. There's no guilt so annoying as the guilt you feel when you know you can't look at one more wrinkled peasant without your brains turning to borscht."

31 Greenough, "An American Vision," *Paul Strand*, 32-3. See also Greenough, "Alfred Stieglitz and 'The Idea Photography,'" in National Gallery of Art, Washington, *Alfred Stieglitz: Photographs and Writings*, 11–32.

32 Giddens, "Goffman as a Systematic Social Theorist," 255–6.

33 During his graduate studies at Berkeley, Minden was involved in both traditional sociological research projects which assumed the objectivity of the researchers and the methodology of participant observation. These competing research methodologies sparked his growing critique of behaviourism and naive objectivity.

34 Missing the point by misreading *Steveston*'s epigraph can be fatal to understanding. In *PhotoGraphic Encounters*, Garrett-Petts and Lawrence transcribe the Agee quotation as "seeing to perceive it as it stands," a misreading that fits nicely into their study's framework of binary opposition, "cultural flow" represented by Marlatt's words and "frozen moments" by Minden's pictures (262). Further misunderstandings of Marlatt's and Minden's collaboration flow freely from that point. They are reviewed in an earlier version of this chapter, "Robert Minden, Photographer and Storyteller," note 28, 75–6.

35 Giddens, "Goffman as a Systematic Social Theorist," 255–6.

36 "Moral witness" is a concept developed by Margalit, and discussed in the introduction to *Stone*; Barthes's opening paragraph of *Camera Lucida* expresses his amazement over a photograph of Napoleon's youngest brother Jerome: "I am looking at eyes that looked at the Emperor."

37 Georg Simmel, "The Stranger" (1908), 143, 145.

38 Minden, *Separate from the World*. Minden's recordings of Doukhobor singers accompanied his photographic exhibition.

39 The *mise en abyme* and "autograft" are discussed in chapter 4.

40 Batchen, *Forget Me Not*, 14.

41 Benjamin, "Little History of Photography," in his *Selected Writings*, 514.

42 The first comment is extracted from a taped discussion with members of the Union of Spiritual Communities of Christ, Youth Commission on the Future. The second and third were recorded in people's homes. See Minden, *Separate from the World*.

43 Brilliant, *Portraiture*, 8.

44 A sampling of the official photographic record of Steveston is found among historic photographs by Philip Timms and F. Dundas Todd, and contemporary photographs by Minden and Rex Weyler in the oral history collected by Maya Koizumi and edited by Marlatt, *Steveston Recollected*. McAllister gives a very moving account of the afterlife of images produced by the Japanese-Canadian internees in "Held Captive."

45 See, for example, Marlatt's poem "'Slave of the canneries,'" which begins: "dipping into his album, fisherman's oldest son," and continues as though the pages of the album were being turned and the pictures explained to a stranger. In Marlatt and Minden, *Steveston* (2001), 35–6.

46 Dening, *Performances*, 37–8.

47 For the third edition of *Steveston*, Minden looked at all the negatives from 1973–75, deciding to add a number of photographs and also open up to their full negative some of the images that had been cropped in previous editions.

48 Returning to the archives of his photographic projects, including *Portraits of my Daughters*, Minden has created a body of work entitled *Double Portraits*.

49 Benjamin, "The Storyteller," 98.

50 The manuscript was illustrated by Nancy Walker. It remains unpublished.

51 The Robert Minden Ensemble consisted of Carla Hallett, Andrea Minden, Dewi Minden, and Robert Minden. Minden now composes and performs with Hallett.

52 Barthes opposes the notion of *studium*, defined as learned interest in an image, to *punctum*, a detail that pricks the spectator's interest in some unexpected way. See *Camera Lucida*, 25–59.

53 Minden, letter to the author, 17 July 2000.

54 Recorded in Minden, *Separate from the World*.

CHAPTER SIXTEEN

1 Bradley and Nemiroff, "Songs of Experience," in National Gallery of Canada, *Songs of Experience*, 24–7.

2 Ibid., 24.

3 Ibid.

4 It seem important to reiterate that this is not a psychobiography, nor am I entering the debate between cognitive psychologists on the distinctness and stability of flashbulb memories. I use these categories because there is sufficient evidence that they are useful mnemonic frames and because they illuminate Denniston's work. In the case of flashbulb memories, enough people believe that they have stable memories of the day that Kennedy was assassinated to fill many volumes of oral history. Denniston's awareness of the event as a generational meeting-point is on the record. Inasmuch as screen memories have infiltrated popular culture, Denniston can be expected to have absorbed them into his definition of memory. And, as I've said before, artists' beliefs about memory are the foundation of its photographic expression, which is the subject of this book.

5 As previously noted, there are two key articles by Freud: "Screen Memories" (1899) and "Childhood Memories and Screen Memories" (1901/1907/1920).

6 Conway, *Flashbulb Memories*, 1995.

7 Gail Fisher-Taylor, a psychotherapist who works with trauma survivors, was the founding editor of the magazine *Photo Communiqué*. Her definition of "flashbulb memory," taken from a lecture by Bessel van der Kolk, a Harvard-based specialist in tramautic disorders, is "a very vivid memory, an enhanced memory for the rest of our lives for that event occurring." She connects that vivacity to the adrenalin level of the rememberer. Fisher-Taylor was interviewed as part of a 1997 radio series on mind control produced by Wayne Morris of CKLN-FM, Ryerson Polytechnical University, Toronto.

8 Conway (5) cites S.F. Larsen, "Potential Flashbulbs: Memories of Ordinary News as the Baseline," in E. Winograd and U. Neisser, eds, *Affect and Accuracy in Recall: Studies of "Flashbulb Memories"* (New York: Cambridge University Press, 1992), 32–64. Conway dedicates a chapter to Neisser's (1982) and subsequent critiques of the "flashbulb memory hypothesis."

9 See, for example, Eric L. Santner's "Screen Memories Made in Germany: Edgar Reitz's *Heimat* and the Question of Mourning," in his *Stranded Objects*. On the lighter side, a quick search on the Web turns up myriad examples of popular appropriations, including two beautifully symmetrical theories: one, that aliens impose Operational Screen Memories to cover up abductions; two, that government researchers introduce screen memories of alien abductions into the minds of citizens illegally used for military or espionage experiments.

10 Important sources include Randolph, "Stan Denniston, Mercer Union Gallery"; Sherrin, "The Resistance of Remembrance"; National Gallery of Canada, *Songs of Experience*, 1985, 87–92; Cheetham, *Remembering Postmodernism*, 73–101.

11 Denniston and Shaw, *Hard to Read*.

12 Denniston, edited excerpt from an interview with Diana Nemiroff, 7 September 1995; see National Gallery of Canada, *Songs of Experience*, 87; Sherrin's article is based on earlier interviews conducted on 7 October and 1 November 1983.

13 Randolph, "Stan Denniston: Reminders," in Art Gallery of Greater Victoria, *Stan Denniston*; text reprinted with a brief introduction under "Ficto-criticism" in Randolph, *Psychoanalysis & Synchronized Swimming*, 88–97. I will refer to the more widely available reprint.

14 Keziere, essay on *Fictions*, unpaginated; expanded version in *Stan Denniston: Fictions* (Paris: Esplanade/Services culturels de l'Ambassade du Canada, 1997).

15 The figures are identified by Keziere.

16 Langford, *On Space, Memory and Metaphor*, 8–9.

17 National Gallery of Canada, *Songs of Experience*, 87.

18 Barbara Fischer in Art Gallery of Ontario: Contact 1986–87 (touring exhibition) brochure, *Stan Denniston: Reminders*.

19 Cheetham, "Ironies of Memory: Postmodern Reflections on Recent Canadian Art," in Hutcheon, ed., *Essays in Canadian Irony*, Vol. 1, 92; Fischer, ibid.

20 Randolph, *Psychoanalysis & Synchronized Swimming*, 96.

21 Sherrin, "The Resistance of Remembrance," 17–18.

22 Cheetham, *Remembering Postmodernism*, 96–7.

23 Randolph, "Stan Denniston, Mercer Union Gallery," 82.

24 Denniston, detail from *Dealey Plaza/Recognition & Mnemonic*.

25 In the exhibition catalogue for *Songs of Experience*, the illustrated version is the YYZ installation of 1983 which was 9.8 metres long.

26 Sherrin, "The Resistance of Remembrance," 18, 20, 19.

27 Cheetham, *Remembering Postmodernism*, x.

28 Sherrin, "The Resistance of Remembrance," 20.

29 Cheetham, *Remembering Postmodernism*, 100.

30 See note 10.

31 Conway, *Flashbulb Memories*, 121–7.

32 Randolph, "The Amenable Object" (1983), *Psychoanalysis & Synchronized Swimming*, 21–35.

CHAPTER SEVENTEEN

1 Macfarlane, *The Danger Tree*, 130.

2 Baer, *Spectral Evidence*, 65–6.

3 The perpetuation of the myths that carried Canadians and the British colonials of Newfoundland through the First World War and its bitter aftermath are brilliantly analysed by Vance in *Death So Noble*.

4 Sturken, *Tangled Memories*, 5.

5 Ibid., 10.

6 Sturken summarizes Foucault's "popular memory" as "a form of collective knowledge for those who don't have access to publishing houses or movie studios." Set in opposition to dissemination technologies, it is therefore construed as an alternative technology, productive, rather than passive. See Sturken, *Tangled Memories*, 6.

7 Ibid., 7.

8 Ibid., 12.

9 Casey, *Getting Back into Place*, 31.

10 Jacqueline Fry, in Marlene Creates, *The Distance Between Two Points is Measured in Memories. Labrador 1988*, 55. Fry's essay considers Creates's transition from solitary Land Art to this more communal way of working.

11 All citations of the subjects are from Creates, *The Distance Between Two Points is Measured in Memories. Labrador 1988* in which the entire series is reproduced.

12 Barbara Tversky, "Spatial Constructions," in Nancy Stein et al., *Memory for Everyday and Emotional Events*, 183.

13 Ibid., 197–201.

14 Fry, in Creates, *The Distance Between Two Points is Measured in Memories. Labrador 1988*, 58.

15 A closely related project, Creates's *Places of Presence: Newfoundland Kin and Ancestral Land, Newfoundland 1989–1991*, deals with a more populated landscape, and as the artist herself says, with the history of land use on the island. The memory-maps more powerfully articulate possession; most of them survey perspectives drawn with straight edges and inscribed titles.

16 Nesbit, *Atget's Seven Albums*, 16.

17 Hamburg, "A Biography of Eugène Atget," in Szarkowski and Hamburg, *The Work of Atget*. Vol. 2, 18.

18 Nesbit, *Atget's Seven Albums*, 23–6.

19 Ibid., 26.

20 Ibid., 35.

21 Proving that any work can stir up controversy, Maggs mentioned to me in conversation that he had been taxed by one Atget scholar for omitting *some* of the blank spreads and for failing to mention Atget in the title of the work.

22 Rogoff, *Terra Infirma: Geography's Visual Culture*, 91–2.

23 Nesbit, *Atget's Seven Albums*, 26.
24 Ibid., 20–7.
25 Rogoff, *Terra Infirma*, 4, 7, 8.
26 For an overview of Evergon's production to 1987, see Canadian Museum of Contemporary Photography, *Evergon 1971–1987*.
27 Evergon, "Introduction," in Australian Centre for Photography, *Evergon*, 5.
28 Evergon, "The Ramboys: A Bookless Novel & Manscapes – Truckstops and Lovers Lanes," in National Museum of Photography, Film and Television, Bradford, England, *Evergon 1987–1997*, 54.
29 Benjamin, "The Flâneur," [M11a,5; M11a,6] *The Arcades Project*, 439.
30 Foucault, "The Repressive Hypothesis," from *The History of Sexuality*, Vol. I, reprinted in *The Foucault Reader*, 322–4.
31 Evergon, "Introduction," in Australian Centre for Photography, *Evergon*, 5.
32 Jonathan Turner, "Evergon: The Final Frontier," in Australian Centre for Photography, *Evergon*, 8.
33 Foucault, *The Foucault Reader*, 328.
34 I refer to Casey's distinction between cartography and chorography: "the exact mapping of sites versus the qualitative mapping of regions." Landscape painting, according to Casey, "gives us the images of particular places that constitute particular regions ... we lose the region as geographic entity, but we grasp its material essence in terms of the discrete localities that are its integral parts." See *Representing Place*, xvii, 166–70.
35 Beck, "Two Places at Once," 24–9.
36 Silverman, *The Threshold of the Visible World*, 125–93; citations, 135, 177, 178.
37 Casey, *Representing Place*, 9.
38 Marian Penner Bancroft, Lorna Brown, Kati Campbell, and Sandra Semchuk, "Installation and Photography," 6.
39 Denise Oleksijczuk, essay in a brochure published by the Vancouver Art Gallery in 1990 to accompany Bancroft's solo exhibition.
40 See Presentation House, *By Land and Sea (prospect and refuge)*.
41 Fred Wah, a writer and teacher at the University of Calgary, contributed to the exhibition *By Land and Sea (prospect and refuge)*. His allusive text is reproduced in full in the Presentation House catalogue.
42 Kelly, "Re-Viewing Modernist Criticism," 54–6.
43 The first list of roles is Bancroft's from her 1990 dialogue with Lorna Brown; the second is Karen Henry's from her catalogue essay, "The View from Here," in *By Land and Sea (prospect and refuge)*, unpaginated.

CONCLUSION

1 Hirsch, *Family Frames*, 122.
2 Miller, *Family Pictures*, 376, 383.
3 A.S. Byatt, "Memory and the Making of Fiction," in Fara and Patterson, eds, *Memory*, 47–9.
4 Le Goff, *History and Memory*, xviii.
5 Albert Boime, "The Fate of the Image-Monument in the Wake of 9/11," in Lavoie, ed., *Maintenant/Now*, 199–201.

BIBLIOGRAPHY

Abadie, Daniel, ed. *Magritte*. New York: Distributed Art Publishers, 2003.

Abrams, M.H. *The Mirror and the Lamp: Romantic Theory and the Critical Tradition*. New York: W.W. Norton & Company, 1958.

Abramson, Daniel. "Make History, Not Memory: History's Critique of Memory." *Harvard Design Magazine* (Fall 1999): 78–83.

Adams, Hugh. "Passing by on the Other Side: Theatre of the Forgotten & Art of the Scars of the People—The Work of Donigan Cumming," in Chapter and Ffotogallery, *Donigan Cumming*, 9–29.

Alpers, Svetlana. *The Art of Describing: Dutch Art in the Seventeenth Century*. Chicago: University of Chicago Press, 1983.

Ambassade du Canada. *Richard Baillargeon & Thomas Corriveau: Cadrages nomades*. Essay by Chantal Boulanger. Paris, 1994–95.

Amelunxen, Hubertus v., Stefan Iglhaut, Florian Rötzer, et al. *Photography after Photography: Memory and Representation in the Digital Age*. Munich: G+B Arts, 1996.

Anderson, Benedict. *Imagined Communities: Reflections on the Origin and Spread of Nationalism*. Rev. ed. London and New York: Verso, 2002.

Anderson, Heather. "Beyond Vision: Brenda Pelkey's 'Haunts.'" *Blackflash*, 19, 3 (2002): 22–30.

– "Brenda Pelkey: Haunts," *Arts Atlantic*, 19, 2 (Spring 2002): 32.

Anderson, Perry. "Union Sucrée." *London Review of Books*, 26, 18 (23 September 2004): 10–16.

Andrews, Malcolm. *Landscape and Western Art*. Oxford: Oxford University Press, 1999.

Anzelewsky, Fedja. *Dürer: His Art and Life*. New York: Konecky & Konecky, 1980.

April, Raymonde. *Réservoirs soupirs*. Québec: VU, Centre d'animation et de diffusion de la photographie, 1992.

Arden, Roy. "After Photography." *Canadian Art* 17, 4 (March 2000): 48–56.

Armstrong, Carol. *Scenes in a Library. Reading the Photograph in the Book, 1843–1875*. Cambridge, MA and London: MIT Press, 1998.

Arn, Robert. "The uses and transformation of history in the work of Bloore and Snow." *artscanada*, no. 198/199 (June 1975): 38–51.

Arnheim, Rudolf. *The Split and the Structure*. Berkeley: University of California Press, 1996.

Arnold, Grant. "Purism, Heterogeneity and *A Group of Sixty-Seven*," *Collapse* #3 (December 1997): 147–53.

Art Gallery of Greater Victoria, Victoria. *Stan Denniston*. Exhibition catalogue by Greg Bellerby, essay by Jeanne Randolph, 1983.

– *Memoirs: Transcribing Loss*. Exhibition catalogue by Lisa Baldissera, 2000.

Art Gallery of Hamilton, Hamilton. *Industrial Images*. Exhibition catalogue by Rosemary Donegan, 1987.

Art Gallery of Ontario, Toronto. *The European Iceberg*. Exhibition catalogue by Roald Nasgaard and Germano Celant, 1985.

– and Power Plant, Toronto. *The Michael Snow Project: Visual Art 1951–1993*. Exhibition catalogue by Dennis Reid, Philip Monk, and Louise Dompierre.

– *Stan Denniston: Reminders*. "Contact" exhibition catalogue by Barbara Fischer, 1986.

Art Gallery of Peterborough, Peterborough. *Photographic Sequences*. Exhibition catalogue by Jann Bailey, 1983.

Art Gallery of Windsor, Windsor. *Donigan Cumming: Diverting the Image*. Exhibition catalogue by Nicole Gingras, 1993.

Arts Council of Great Britain. *The British Worker: Photographs of Working Life 1839–1939*. Exhibition catalogue by Nicola Bennett and Michael Harrison, 1981.

Artspace and the Art Gallery of Peterborough, Peterborough. *Carl Beam: The Columbus Project*. Exhibition catalogue by Illi-Maria Tamplin and Shelagh Young, 1989.

Atkinson, Terry. "History Painting: Painting and Recapitulation." In Green and Seddon, eds, *History Painting Reassessed*, 149–62.

Australian Centre for Photography, Sydney. *Evergon: Loitering with Intent*. Essay by Jonathan Turner, 1999.

Baer, Ulrich. *Spectral Evidence: The Photography of Trauma*. Cambridge and London: MIT Press, 2002.

Baillargeon, Richard. *Comme des îles*. Essay by Lisanne Nadeau. Québec: VU, Centre d'animation et de diffusion de la photographie, 1991.

– "Le fait du temps." In Michel Campeau, *Les Tremblements du Coeur*. Quebec: VU, Centre d'animation et de diffusion de la photographie, 1998: 13–18.

Baker, Alan R.H. and Gideon Biger, eds. *Ideology and Landscape in Historical Perspective. Essays on the Meanings of Some Places in the Past*. Cambridge: Cambridge University Press, 1992.

Bakhtin, Mikhaïl. *L'oeuvre de François Rabelais et la culture populaire au Moyen Age et sous la Renaissance*. Trans. Andrée Robel. Paris: Gallimard, 1970.

Bal, Mieke. *Looking In: The Art of Viewing*. Introduction by Norman Bryson. Amsterdam: G+B Arts International, 2001.

Bal, Mieke, and Norman Bryson. "Semiotics and Art History," *The Art Bulletin* 73, 2 (June 1991), 174–208.

Bal, Mieke, Jonathan Crewe, and Leo Spitzer, eds. *Acts of Memory: Cultural Recall in the Present*. Hanover and London: University Press of New England, 1999.

Bancroft, Marian Penner, Lorna Brown, Kati Campbell, and Sandra Semchuk. "Installation and Photography." *Blackflash* 8, 2 (Summer 1990): 5–15.

Baqué, Dominique. "Savoir, retenir et fixer ce qui est sublime …" *Art Press* (May 1995): 74.

Barasch, Frances K. *The Grotesque: A Study in Meanings*. The Hague and Paris: Mouton & Co. N.V., Publishers, 1971.

Barasch, Moshe. *Gestures of Despair in Medieval and Early Renaissance Art*. New York: New York University Press, 1976.

Barbican Art Gallery, London. *True North: Canadian Landscape Painting 1896–1939*. Exhibition catalogue by Michael Tooby, 1991.

Barclay, Craig R. "Schematization of Autobiographical Memory." In Rubin, ed., *Autobiographical Memory*, 82–99.

Barnouw, Dagmar. *Critical Realism: History, Photography, and the Work of Siegfried Kracauer*. Baltimore and London: Johns Hopkins University Press, 1994.

Barreca, Regina. *Sex and Death in Victorian Literature*. Bloomington and Indianapolis: Indiana University Press, 1990.

Barrell, John. *The Dark Side of the Landscape: The Rural Poor in English Painting 1730–1840*. Cambridge: Cambridge University Press, 1980.

Barthes Roland. *Camera Lucida: Reflections on Photography*. Trans. Richard Howard. New York: The Noonday Press, 1981.

– *Image, Music, Text*, trans. Stephen Heath. New York: Hill and Wang, 1977.

– *A Barthes Reader*. Ed. Susan Sontag. New York: Farrar, Strauss & Giroux, 1983.

Batchen, Geoffrey. "Photogenics." *History of Photography* 22, 1 (Spring 1998): 18–26 .

– *Burning with Desire: The Conception of Photography*. Cambridge, MA and London: MIT Press, 1999.

– *Each Wild Idea: Writing, Photography, History*. Cambridge, MA and London: MIT Press, 2001.

– *Forget Me Not: Photography & Remembrance*. New York: Princeton Architectural Press, 2004.

Bazin, André. "The Ontology of the Photographic Image." In *What is Cinema?* Trans. Hugh Gray. Berkeley and Los Angeles: University of California Press, 1967, 9–16.

Beck, Claudia. "Two Places at Once," *Vanguard* 17, 6 (December–January, 1988/89): 24–9.

Becker, Howard S. and Michael M. McCall, eds. *Symbolic Interaction*

and Cultural Studies. Chicago & London: Chicago University Press, 1990.

Beckett, Samuel. *Stories and Texts for Nothing*. New York: Grove Press, 1967.

Bédard, Catherine. "L'Image réticente." In *Tombeau de René Payant*. Montréal: Édition du centre d'exposition et de théorie de l'art contemporain et Éditions trois, 1991, 47–57.

Beer, Gillian. *Arguing with the Past. Essays in Narrative from Woolf to Sidney*. London: Routledge, 1989.

Beevor, Anthony. *Stalingrad. The Fateful Siege: 1942–1943*. New York: Viking Penguin, 1998.

Belous, Russell E. and Robert A. Weinstein. *Will Soule: Indian Photographer at Fort Sill, Oklahoma 1869–74*. Los Angeles: The Ward Ritchie Press, 1969.

Bender, John and David E. Wellbery, eds. *Chronotypes: The Construction of Time*. Stanford: Stanford University Press, 1991.

Bénichou, Anne. "Temporal Montage in the Artistic Practices of the Archive." Trans. Timothy Barnard. In Lavoie, ed., *Maintenant/Now*, 166–87.

Benjamin, Walter. *Illuminations*. Ed. Hannah Arendt. New York: Schocken Books, 1978.

– *The Arcades Project*. Ed. Rolf Tiedemann. Trans. Howard Eiland and Kevin McLaughlin. Cambridge, MA, and London: The Belknap Press of Harvard University Press, 1999.

– *Selected Writings*, Vols. 1 and 2. Ed. Michael W. Jennings, Marcus Bullock, Howard Eiland, and Gary Smith. Cambridge, MA, and London: The Belknap Press of Harvard University Press, 2004–5.

Bennekom, Josephine van. "Carole Condé and Karl Beveridge: Staged Political Photography." *Perspektief* 35 (April 1989): 20–6.

Berger, Carl. *The Writing of Canadian History: Aspects of English-Canadian Historical Writing since 1900*. 2nd ed. Toronto, Buffalo and London: University of Toronto Press, 1988.

Berger, John. *About Looking*. New York: Pantheon Books, 1980.

Berger, John and Jean Mohr. *Another Way of Telling*. London: Writers and Readers Publishing Cooperative Society Ltd., 1982.

Bergman-Carton, Janis. "Christian Boltanski's *Dernières Années*: The History of Violence and the Violence of History." *History and Memory* 13, 1 (Spring/Summer 2001): 3–18.

Bergmann, Bettina. "The Roman House as Memory Theatre: The House of the Tragic Poet in Pompeii." *Art Bulletin* (June 1994).

Bergson, Henri. *Matter and Memory*. Trans. Anacy Margaret Paul and W. Scott Palmer. London: George Allen & Unwin Ltd., 1911, 1978.

– *Mind-Energy*. Trans. H. Wildon Carr. New York: Henry Holt and Company, 1920.

Berlo, Janet C. and Ruth B. Phillips. *Native North American Art*. Oxford and New York: Oxford University Press, 1998.

Bernstein, Michael André. *Foregone Conclusions: Against Apocalyptic History*. Berkeley and Los Angeles; London: University of California Press, 1994.

– "The Sorrow Reflex." *The New Republic* (25 July 2005): 32–37.

Beveridge, Karl. "A Fair Day's Work." *Fuse*, no. 51 (September 1988): 32–33.

Beveridge, Karl, and Carole Condé. "Canadian Farmworkers Union: The Effects of an Automated Agribusiness on Workers' Lives are often Hidden." *FUSE* (February/March 1982): 317–23.

– "So What's so Important about Culture?" *Our Times* (March 1984): 12–13.

Bhabha, Homi. *The Location of Culture*. London: Routledge, 1994.

– "Of Mimicry and Man: The Ambivalence of Colonial Discourse." In *October: The First Decade, 1976–1986*, Annette Michelson et al., eds. Cambridge and London: MIT Press, 1987, 317–25.

Bishai, Linda, "Forgetting Ourselves: Nietzsche, Critical History and the Politics of Collective Memory." Paper for the Political Studies Association – UK 50th Annual Conference, London, 10–13 April 2000. http://www.psa.ac.uk/cps/2000/Bishai%20 Linda.pdf. Site visited 22 August 2003.

Bollas, Christopher. *Cracking Up. The Work of Unconscious Experience*. New York: Hill and Wang, 1995 .

– *The Mystery of Things*. London and New York: Routledge, 1999.

Bordo, Jonathan. "Picture and Witness at the Site of the Wilderness." *Critical Inquiry* 26, 2 (Winter 2000): 225–47.

Boulanger, Luc. "L'envers du décor," *Voir* (13 to 19 February 1992).

Bourdieu, Pierre. "Ce terrible repos qui est celui de la mort sociale." Preface to Paul Lazarsfeld, Marie Jaboda and Hans Zeisel, *Les Chômeurs de Marienthal*. Éditions de Minuit, 1981. Reprinted in *Le Monde diplomatique* 591 (June 2003): 5.

Bourget, Marie-Noëlle, Lucette Valensi and Nathan Wachtel, eds. *Between Memory and History*. London: Harwood Academic Publishers, 1990.

Boyer, M. Christine. *The City of Collective Memory: Its Collective Imagery and Architectural Entertainments*. Cambridge; London: MIT Press, 1994, 1996.

Bredekamp, Horst. "A Neglected Tradition? Art History as *Bildwissenschaft*." *Critical Inquiry* 29, 3 (Spring 2003).

Brennen, Bonnie and Hanno Hardt. *Picturing the Past: Media,*

History, and Photography. Urbana: University of Illinois Press, 1999.

Breton, André. *Mad Love*, trans. Marianne Caws. Lincoln and London: University of Nebraska Press, 1987.

– *Manifestoes of Surrealism*. Trans. R. Seavor and H.R. Lane. Michigan, 1969.

Brewer, William F. "What is Autobiographical Memory?" In Rubin, ed., *Autobiographical Memory*, 25–49.

Brilliant, Richard. *Portraiture*. Cambridge, MA: Harvard University Press, 1991.

Broadfoot, Keith. "Before and After Pollock." In *Refracting Vision: Essays on the Writing of Michael Fried*. Ed. Jill Beaulieu, Mary Roberts, and Toni Ross. Sydney: Power Publications, 2000, 129–53.

Broude, Norma. *Gustave Caillebotte and the Fashioning of Identity in Impressionist Paris*. New Brunswick, New Jersey, and London: Rutgers University Press, 2002.

Bruzina, Ronald and Bruce Wilshire, eds. *Crosscurrents in Phenomenology*. The Hague/Boston: Martinus Nijhoff, 1978.

Buchloh, Benjamin H.D. "Warburg's Model: The Photographic Structure of Memory in Broodthaers and Richter." Paper presented at *Modernist Utopias. Postformalism and Pure Visuality*, conference organized by the Musée d'art contemporain, Montréal, 9–10 December 1995.

Burgin, Victor. "'Something About Photography Theory,'" *The New Art History*. Ed. A.L. Rees and Frances Borzello. Atlantic Highlands: Humanities Press International, 1988, 41–54.

– "Jenni's Room: Exhibitionism and Solitude." *Critical Inquiry* 27, 1 (Autumn 2000): 77–89.

Burke, Peter. *Eyewitnessing: The Uses of Images as Historical Evidence*. Ithaca, NY: Cornell University Press, 2001.

Burton, Randy, "'What's the Difference?' Carole Condé and Karl Beveridge in Conversation." *Blackflash* (Fall 1987): 8–12.

Cadava, Eduardo. *Words of Light: Theses on the Photography of History*. Princeton: Princeton University Press, 1997.

Calvino, Italo. "The Adventures of a Photographer," ("La Follia del mirino," 1955). Trans. William Weaver, Archibald Colquhoun, and Peggy Wright. In Rabb, ed., *The Short Story and Photography: 1880's–1980's*, 176–86.

Cameron, Heather. "Memento Mori: Mourning, Monuments and Memory." *Prefix Photo* 3, 5 (May 2002): 48–57.

Campbell, David. "Atrocity, memory, photography: imaging the concentration camps of Bosnia – the case of ITN versus *Living Marxism*, Part I." *Journal of Human Rights* 1, 1 (March 2002): 1–33.

– "Atrocity, memory, photography: imaging the concentration camps of Bosnia – the case of ITN versus *Living Marxism*, Part II." *Journal of Human Rights* 1, 2 (June 2002): 143–72.

Campeau, Michel. Artist Statement, 2000.

– "Bertrand Carrière. La brèche aiguë de l'oeil dessous la porte." *CV Photo*, no. 22 (1993).

– *Eloquent Images/Les Images Volubiles*. Essay by Pierre Dessureault. Ottawa: Canadian Museum of Contemporary Photography, 1996.

– *Les Tremblements du coeur*. Québec: VU, Centre d'animation et de diffusion de la photographie, 1988.

– "Richard Baillargeon." *Parachute*, no. 87 (July–September 1997): 46–7.

Campeau, Sylvain. "L'éden redécouvert." *Vie des arts* 45, 184 (Autumn 2001): 26–9.

Canadian Museum of Civilization. *In the Shadow of the Sun: Perspectives on Contemporary Native Art*. Hull: Canadian Museum of Civilization, 1993.

Canadian Museum of Civilization, Hull. *Edward Poitras: Canada XLVI Biennale di Venezia*. Exhibition catalogue by Gerald McMaster, 1995.

Canadian Museum of Contemporary Photography, Ottawa. *BEAU: A Reflection on the Nature of Beauty in Photography*. Exhibition catalogue by Martha Langford, 1992.

– *A Canadian Document*. Exhibition catalogue by Carol Payne, 1999.

– *Confluence: Contemporary Canadian Photography/La photographie canadienne contemporaine*. Exhibition catalogue by Martha Hanna, 2003.

– *Displaced Histories*. Exhibition brochure by Carol Payne, Ottawa, 1995.

– *Donigan Cumming: Reality and Motive in Documentary Photography*. Exhibition catalogue by Martha Langford, 1986.

– *Evergon 1971–1987*. Exhibition catalogue by Martha Hanna, 1988 .

– *Extended Vision: The Photography of Thaddeus Holownia*. Exhibition catalogue by Carol Payne (1998).

– *George Steeves: 1979–1993*. Exhibition catalogue by Martha Langford, 1993 .

– *Michel Campeau: Les Images volubiles/Eloquent images*. Exhibition catalogue by Pierre Dessureault, 1996.

– *Sandra Semchuk: How Far Back is Home?* Exhibition catalogue by Pierre Dessureault, 1995.

Caponigro, Paul. *Megalyths*. Boston: New York Graphic Society Books; Little, Brown and Company, 1986.

Carr, David. *Time, Narrative, and History*. Bloomington: Indiana University Press, 1986.

Carrière, Bertrand. Artist's statement, *Signes de Jour*.

– *Signes de jour. Photographies 1996–1999*.

Carroll, Lewis. *Alice's Adventures in Wonderland* (1865), *The Annotated Alice*, Martin Gardner, ed. Middlesex: Penguin Books, 1975.

Carruthers, Mary J. *The Book of Memory: A Study of Memory in Medieval Culture*. Cambridge: Cambridge University Press, 1993.

Caruth, Cathy, ed. *Trauma: Explorations in Memory*. Baltimore and London: The Johns Hopkins University Press, 1995.

Casey, Edward S. "Comparative Phenomenology of Mental Activity: Memory, Hallucination, and Fantasy Contrasted with Imagination." *Research in Phenomenology* 6 (1976): 1–25.

– *Earth-Mapping: Artists Reshaping Landscape*. Minneapolis and London: University of Minnesota Press, 2005.

– "The Image/Sign Relation in Husserl and Freud." In Ronald Bruzina and Bruce Wilshire, eds, *Crosscurrents in Phenomenology*. The Hague/Boston: Martinus Nijhoff, 1978, 120–43.

– *Getting Back into Place: Toward a Renewed Understanding of the Place-World*. Bloomington and Indianapolis: Indiana University Press, 1993.

– *Imagining: A Phenomenological Study*. 2nd ed. Bloomington and Indianapolis: Indiana University Press, 2000.

– *Remembering. A Phenomenological Study*. 2nd ed. Bloomington and Indianapolis: Indiana University Press, 2000.

– *Representing Place: Landscape Painting and Maps*. Minneapolis and London: University of Minnesota Press, 2002.

Cassiman, Bart, Greet Ramael and Frank Vande Veire, eds. *The Supreme Void. On the Memory of the Imagination*. Ghent: Ludion, 1993.

Catchlove, Lucinda. "Swamp thing: Richard Baillargeon: Landscape artist of the mind." *Hour* (6–12 February 1997) .

Catriona Jeffries Gallery. *Fugitive Spaces*. Essay by Jeff Derksen. Vancouver, 2004.

– *Jin-me Yoon: Intersection*, 2001.

Caws, Mary Ann. "Diana Thorneycroft: Surrealism's Body Now," in Walsh, ed. *Diana Thorneycroft*, 17–25.

– *The Surrealist Look: The Erotics of Encounter*. Cambridge, MA: MIT Press, 1999.

Centre culturel canadien/Canadian Cultural Centre, Paris. *Stan Deniston: Fictions*. Exhibition catalogue by Catherine Bédard, 1997.

Centre culturel canadien, Paris. *Trouble en Vue/Trouble in View*.

Exhibition catalogue by Catherine Bédard and Martha Langford, 2002.

Centre culturel de la Communauté française Le Botanique, Bruxelles. *Magritte en Compagnie: Du bon usage de l'irrévérence*. Exhibition catalogue by Michel Baudson, 1997.

Centre d'Art Contemporain de Rueil-Malmaison. *Claude-Philippe Benoit – Alain Paiment – Sylvie Readman*. Exhibition catalogue by Pierre-Jean Sugier, 1997.

Centre international d'art contemporain de Montréal. *Tout le temps/Every Time*. Exhibition catalogue by Peggy Gale. La Biennale de Montréal 2000.

Chadwick, Whitney. *Women Artists and the Surrealist Movement*. Boston: Little, Brown and Company, 1985.

– *Women, Art, and Society*. 2nd ed. New York: Thames and Hudson, 1997.

Chamberlin, J. Edward. *If This Is Your Land, Where Are Your Stories? Finding Common Ground*. Toronto: Albert A. Knopf Canada, 2003.

Chandler, John Noel. "The Artist in the Landscape." *artscanada* 164/165 (Feb/Mar 1972): 35–40.

Chappell, Vere, ed. *The Cambridge Companion to Locke*. Cambridge: Cambridge University Press, 1994.

Cheetham, Mark A. with Linda Hutcheon. *Remembering Postmodernism: Trends in Recent Canadian Art*. Toronto, Oxford, New York: Oxford University Press, 1991.

Cheetham, Mark A., Michael Ann Holly and Keith Moxey, eds. *The Subjects of Art History: Historical Objects in Contemporary Perspectives*. Cambridge: Cambridge University Press, 1998.

Chéroux, Clément, ed. *Mémoire des camps. Photographies des camps de concentration et d'extermination nazis (1933–1999)*. Paris: Marval, 2001.

Christ, Carol T. and John O. Jordan, eds. *Victorian Literature and the Victorian Visual Imagination*. Berkeley: University of California Press, 1995.

Christopherson, Richard W. "From Folk Art to Fine Art: A Transformation in the Meaning of Photographic Work." *Urban Life and Culture* 3, 2 (July 1974): 123–57.

Cirlot, J.E. *A Dictionary of Symbols*. Trans. Jack Sage. London and Henley: Routledge and Kegan Paul, 1985.

Cixous, Hélène. "Castration or Decapitation?" In Ferguson et al., eds, *Out There*, 345–56.

Clark, Douglas. "D'Orient: Richard Baillargeon." *Blackflash* (Winter 1989): 18–22.

Clark, Kenneth. *Landscape into Art*. New York: Icon Editions, 1991.

Clark, Toby. *Art and Propaganda in the Twentieth Century: The Political Image in the Age of Mass Culture*. New York: Harry N. Abrams, 1977.

Clendinnen, Inga. *Reading the Holocaust*. Cambridge: Cambridge University Press, 1999.

Cohen, Jeffrey Jerome, ed. *Monster Theory: Reading Culture*. Minneapolis and London: University of Minnesota Press, 1996.

Collins, Lisa Gail. *The Art of History: African American Women Artists Engage the Past*. New Brunswick, New Jersey and London: Rutgers University Press, 2002.

Colomina, Beatriz, ed. *Sexuality and Space*. Princeton Papers on Architecture. New York: Princeton Architectural Press, 1992.

Condé, Carole, and Karl Beveridge. *First Contract: Women and the Fight to Unionize*. Toronto: Between the Lines, 1986.

– *It's Still Privileged Art*. Toronto: Art Gallery of Ontario, 1976.

– *Maybe Wendy's Right*. Toronto: Carmen Lamanna Gallery, 1979.

– *Oshawa: A History of Local 222. United Auto Workers of America, CLC*. Toronto: Canadian Fiction Magazine, 1984.

Connerton, Paul. *How Societies Remember*. Cambridge, England; New York: Cambridge University Press, 1989.

Conway, Martin A. *Autobiographical Memory. An Introduction*. Buckingham: Open University Press, 1990.

– *Flashbulb Memories*. Hove & Hillsdale: Lawrence Erlbaum Associates, Publishers, 1995.

Conway, Martin A., Susan E. Gathercole and Cesare Cornoldi. *Theories of Memory*. Vol. 2. East Sussex: Psychology Press, 1998.

Cosgrove, Denis and Mona Domosh. "Author and Authority: Writing the New Cultural Geography." In *Place/Culture/Representation*, J. Duncan & D. Ley, eds. London & New York: Routledge, 1997: 25–38.

Cousineau-Levine, Penny. *Faking Death: Canadian Art Photography and the Canadian Imagination*. Montreal & Kingston: McGill-Queen's University Press, 2003.

Crary, Jonathan. "Attention and Modernity in the Nineteenth Century." In Jones and Galison, *Picturing Science, Producing Art*, 475–99.

– *Suspensions of Perception: Attention, Spectacle, and Modern Culture*. Cambridge, MA, and London: MIT Press, 1999.

– *The Techniques of the Observer: On Vision and Modernity in the Nineteenth Century*. Cambridge, MA, and London: MIT Press, 1990, 1999.

Creates, Marlene. *The Distance Between Two Points is Measured in Memories. Labrador 1988*. Essay by Jacqueline Fry. Trans. Elizabeth Ritchie. North Vancouver: Presentation House Gallery, 1990.

– *Language and Land Use, Alberta 1993*. Medicine Hat: Medicine Hat Museum and Art Gallery, 2000.

– *Places of Presence: Newfoundland Kin and Ancestral Land, Newfoundland 1989–1991*. Essay by Joan M. Schwartz. St John's: Killick Press, 1997.

CREDAC, Ivry-sur-Seine. *Montréal 89: Aspects de la photographie québécoise contemporaine*. Exhibition catalogue by Philippe Cyroulnik, 1989.

Cron, Marie-Michèle. "Carnets de voyage: Musée canadien de la photographie contemporaine." *Le Devoir* (13 and 14 August 1994): C9.

Crow, Thomas. *Modern Art in the Common Culture*. New Haven and London: Yale University Press, 1996.

Cumming, Donigan. "The Subject of the Artist: Created Communities/Fault Lines." Paper given at The Third Cardiff Symposium, *The Subject of the Artist*, Centre for Research in Fine Art, University of Wales Institute, Cardiff, 1 November 2000.

Cumming, Donigan, and Peggy Gale. *Lying Quiet*. Toronto: Museum of Contemporary Canadian Art, 2004.

Currie, Gregory. "Unreliability Refigured: Narrative in Literature and Film." *The Journal of Aesthetics and Art Criticism* 53, 1 (Winter 1995): 19–29.

Curtis, Edward S. *Portraits from North American Indian Life*. Reprint of Outerbridge & Lazard, Inc., 1972. Toronto: McClelland & Stewart, 1990.

Dalhousie Art Gallery, Halifax. *An Invested Nature: Contemporary Photography in the Permanent Collection*. Exhibition catalogue by Susan Gibson Garvey; essay by Ian McKinnon, 2002.

Dällenbach, Lucien. *The Mirror in the Text*. Trans. Jeremy Whiteley, with Emma Hughes. Chicago: University of Chicago Press, 1989.

Damasio, Antonio R. *Descartes' Error: Emotion, Reason, and the Human Brain*. New York: Grosset/Putman, 1994.

Damisch, Hubert. "Cinq notes pour une phénoménologie de l'image photographique." *L'arc* (March 1990): 34–7.

Danow, David K. *The Thought of Mikhail Bakhtin: From Word to Culture*. New York: St. Martin's Press, 1991.

Dault, Gary Michael. "Arnaud Maggs: The Narrative and its Double." *C Magazine*, no. 22 (June 1989).

– "in the galleries: *Toronto*." *artscanada* 28, 6 (December 1971): 54–6.

— "Photos' warring truths kill esthetic excitement." *The Globe and Mail*, 2 April 1982.

— "When art imitates a postcard." *The Globe and Mail*, (19 January 2002): R6.

David, Catherine. "Les clefs de la mémoire." *Le Nouvel Observateur* (17–23 May 2001): 4–9.

Davis, Natalie Zemon and Randolph Starn, eds. "Memory and Counter-Memory." Special Issue, *Representations*. University of California Press, no. 26 (Spring 1989).

Dazibao: Centre de photographies actuelles. *Anamnèse*. Exhibition catalogue by Michel Gaboury. Montreal, 1989.

— *Picture This! Documenting the Future*. Essay by Robert Graham. Montreal, 2001.

— *Richard Baillargeon: Le paysage et les choses*. Essay by Chantal Boulanger. Montreal, 1997.

Dean, Tacita. "W.G. Sebald." *October* 106 (Fall 2003): 122–36.

Debouzy, Marianne. "In Search of Working-Class Memory: Some Questions and a Tentative Assessment." In M.-N. Bourget, L. Valensi and N. Wachtel, eds. *Between Memory and History*, 55–76.

Dening, Greg. *Performances*. Chicago: University of Chicago Press, 1996.

Denniston, Stan, and Nancy Shaw. *Hard to Read*. North Vancouver: Presentation House, 1988.

Derrida, Jacques. "Plato's Pharmacy." In *Disseminations*, Barbara Johnson, trans. Chicago: University of Chicago Press, 1981.

— *Memoirs of the Blind: The Self-Portrait and Other Ruins*. Trans. Pascale-Anne Brault and Michael Naas. Chicago and London: University of Chicago Press, 1993.

— *The Gift of Death*. Chicago and London: University of Chicago Press, 1995.

— *Monolingualism of the Other; or, The Prosthesis of Origin*. Trans. Patrick Mensah. Stanford: Stanford University Press, 1998.

Didi-Huberman, Georges. *Ce que nous voyons, ce qui nous regarde*. Paris: Les Éditions de Minuit, 1992.

Dion, François. "*Mouvance et mutation*: Musée canadien de la photographie contemporaine, Ottawa." *CV* Photo (2000).

Doane, Mary Ann. *Femmes Fatales: Feminism, Film, Theory, Psychoanalysis*. New York: Routledge, 1991.

Docherty, Thomas. *After Theory: Postmodernism/postmarxism*. London and New York: Routledge, 1990.

Dostoyevsky, Fyodor. *The House of the Dead* (1860). London: Penguin Books, 1985.

Douglas, Susan. "In the Field of Visibility: Cadieux, Houle, Lukacs." *University of Toronto Quarterly* 71, 3 (Summer 2002): 755–64.

Drew, Paul, and Anthony Wootton, eds. *Erving Goffman: Exploring the Interaction Order*. Boston: Northeastern University Press, 1988.

Dubois, Philippe. *L'Acte photographique et autres essais*. Paris: Nathan, 1990.

— "Des Images pour que notre main s'émeuve: Michel Lamothe ou la photographie à fleur de peau." In Lamothe, *Michel Lamothe: Même les cigales dormaient*, 15–22.

Duve, Thierry de, Arielle Pelenc, and Boris Groys, *Jeff Wall*. London: Phaidon Press, 1996.

Eagleton, Terry. *Literary Theory: An Introduction*. Minneapolis: University of Minnesota Press, 1983.

Ebert-Schifferer, Sybille. *Still Life: A History*. Trans. Russell Stockman. New York: Harry N. Abrams, 1999.

Edensor, Tim. "Staging Tourism: Tourists as Performers." *Annals of Tourism Research*, no. 27 (2000): 322–44.

Edmonton Art Gallery, Edmonton. *Touring Home: Jin-me Yoon*. Exhibition catalogue by Kitty Scott, 1991.

Edwards, Elizabeth. *Raw Histories: Photographs, Anthropology and Museums*. Oxford and New York: Berg, 2001.

Edwards, Paul. "Against the Photograph as *Memento Mori*." *History of Photography* 22, 4 (winter 1998): 380–85.

Eichhorn, Virginia M. "Carl and Ann Beam: Painter's Pots." *Artichoke* 16, 2 (Summer 2004): 44–5.

Elcott, Noam M. "Tattered Snapshots and Castaway Tongues: An Essay at Layout and Translation with W.G. Sebald." *The German Review* (June 2004): 203–23.

Elkins, James. *The Object Stares Back: On the Nature of Seeing*. New York: Simon and Schuster, 1996.

Ender, Evelyne. *Sexing the Mind: Nineteenth-Century Fictions of Hysteria*. Ithaca and London: Cornell University Press, 1995.

Enos, Theresa, ed. *Encyclopedia of Rhetoric and Composition: Communication from Ancient Times to the Information Age*. New York and London: Garland Publishing, Inc., 1996.

Enright, Robert. "The Consolation of Plausibility: An Interview with Jeff Wall." *Border Crossings* 19, 1 (2002): 38–51.

— "Eyeing the Landscape: The Photography of Thaddeus Holownia." *Border Crossings*, 21, 4 (2002): 20–34.

— "Memory Feeder: Subjects and Objects in the Art of Diana Thorneycroft." *Border Crossings* 15, 3 (Summer 1996): 22–33.

False Memory Syndrome Foundation. "FMS Foundation Newsletter." 4, 5 (2 May 1995). http://www.fmsfonline.org . Site visited 12 February 2007.

Fara, Patricia and Karalyn Patterson, eds. *Memory*. Cambridge: Cambridge University Press, 1998.

Felshin, Nina, ed. *But is it Art?: The Spirit of Art as Activism*. Seattle: Bay Press, 1995.

Ferguson, Russell, Martha Gever, Trinh T. Minh-ha and Cornel West, eds. *Out There: Marginalization and Contemporary Cultures*. New York: The New Museum of Contemporary Art, 1990.

Ferrarotti, Franco. *Time, Memory, and Society*. New York, Westport CT, London: Greenwood Press, 1990.

Ffotogallery and Chapter, Cardiff. *Donigan Cumming: Gimlet Eye*. Essay by Hugh Adams, 2001 .

Fidelman, Charlie. "Photographs for the soul." *The Gazette* (30 January 1997): G9.

First Nations, First Thoughts. Conference, Centre for Canadian Studies, University of Edinburgh, 5 May 2005.

Fischer, Barbara. "Carole Condé and Karl Beveridge." *Art Gallery of Ontario*, 10, 4 (April 1988): 3.

Fisher-Taylor, Gail and CBC Radio. "Family Secrets/Social Tales." *Ideas*, 1, 2 November 1988. Produced by Marilyn Powell. Production assistant, Gail Brownell. Technical operations, Lorne Tulk and Philippe Lapointe.

Fleming, Martha. "The Production of Meaning: An Interview with Carole Condé and Karl Beveridge." *Afterimage* 10, 4 (November 1982): 10–15.

Foley, John Miles, ed. *Oral Tradition in Literature: Interpretation in Context*. Columbia: University of Missouri Press, 1986.

Foster, Hal. "Armor Fou." *October*, no. 56 (Spring 1991): 65–97.

– *Recodings: Art, Spectacle, Cultural Politics*. Port Townsend: Bat Press,1985.

Foto Biennale Enschede 1995. *Obsessions, from Wunderkammer to Cyberspace*. Exhibition catalogue by Bas Vroege, 1995.

Foucault, Michel. *The Foucault Reader*, Paul Rabinow, ed. Harmondsworth: Penguin, 1987.

– *Language, Counter-Memory, Practice: Selected Essays and Interviews*. Ed. Donald F. Bouchard. Trans. Donald F. Bouchard and Sherry Simon. Ithaca: Cornell University Press, 1977.

Fox-Davies, Arthur Charles. *A Complete Guide to Heraldry*. London: T.C. & E.C. Jack, 1909.

– *Heraldry Explained*. London: T.C. & E.C. Jack.

Francis, Margot. "Jeff Thomas: A Study of Indian-ness." *Fuse* 27, 3 (Sept. 2004): 40–4.

Franklin, David, ed. *Treasures of the National Gallery of Canada*. Ottawa: National Gallery of Canada in association with Yale University Press, 2003.

Fraser, Marie. "Le narrateur dans l'image. Analyse comparative d'une photographie de Jeff Wall et d'un texte de Walter Benjamin." *Revue d'art canadienne/Canadian Art Review* 29, 1–2 (2004): 65–74.

Fraser, Sylvia. *My Father's House: A Memoir of Incest and of Healing*. Toronto: Doubleday Canada Limited, 1987.

Freud, Sigmund. *Art and Literature*. The Penguin Freud Library 14. Harmondsworth: Penguin Books, 1985, 1987.

– "Leonardo da Vinci and a Memory of his Childhood," *The Standard Edition of the Complete Psychological Works*, Vol. 11, 1910. 1957, 1973, 63–137.

– *Psychopathology of Everyday Life*, 1901.

– "Screen Memories." In *The Standard Edition of the Complete Psychological Works*, Vol. 3, 1893–99, ed. James Strachey. London: The Hogarth Press, 1957, 1973, 301–22.

– *The Standard Edition of the Complete Psychological Works of Sigmund Freud*, Vol. 5, trans. James Strachey. London: The Hogarth Press and the Institute of Psycho–Analysis, 1953.

– "The 'Uncanny,'" *The Standard Edition of the Complete Psychological Works*, Vol. 27, 1917–1919. 1957, 1975.

Friedländer, Saul. *When Memory Comes*. Trans. Helen R. Lane. New York: The Noonday Press, Farrar Straus Giroux, 1979.

Frizot, Michel, ed. *The New History of Photography*. Köln: Könemann, 1998.

Fruitmarket Gallery, Edinburgh. *The Mirror + the Lamp*. Catalogue essay by Michael Newman, 1986.

Frye, Northrop. *Anatomy of Criticism: Four Essays*. Princeton: Princeton University Press, 1957.

Fuchs, R.H. *Dutch Painting*. London: Thames and Hudson, 1978.

Fussell, Paul. *The Great War and Modern Memory*. New York and London: Oxford University Press, 1985.

Gale, Peggy. "Touching on Donigan Cumming." In Cumming and Gale, *Lying Quiet*, 1–16.

Galerie Arena. *Richard Baillargeon. Champs/la mer*. Essay by Marie Eva Poggi and Clément Chéroux. Arles, 1994 .

Galerie Articule, Montréal. *Hochelaga: A Multi-Media Installation*

by Robert Houle. Exhibition catalogue by Curtis J. Collins, 1992.

Galerie d'art Leonard & Bina Ellen / Leonard & Bina Ellen . Gallery, Montreal. *Raymonde April: Tout embrasser*. Curatorial statement by Régis Durand. Trans. Janet Logan, 2001 .

Galerie Samuel Lallouz, Montreal. *Sylvie Readman*, 1992. Essay by Cheryl Simon.

Gallery 44, Toronto. *Jeff Thomas: A Study of Indian-ness*. Exhibition catalogue by Katy McCormick. Essay by Richard William Hill, 2004 .

— *Sylvie Readman: CONVERGENCES élémentaires*. Essay by Carol Payne, 2001.

— *Time and Again*. Exhibition catalogue by Sara Angelucci, 2003.

Gallery 101, Ottawa. *Bearings: Four Photographic essays/Quatre essais photographiques*. Exhibition catalogue by François Dion, 2001.

— *Greg Staats*. Essay by Deborah Mergo, 2002.

Gallery of Contemporary Art, Lewis & Clark College. *Encounters: Contemporary Native American Art*. Exhibition catalogue by Ronna and Eric Hoffman. Portland, 2004.

The Gallery/Stratford. *Artifact: Memory and Desire*. Exhibition catalogue by Ted Fraser, 1989.

Gallery TPW, Toronto. *Carole Condé and Karl Beveridge: Political Landscapes*. Exhibition catalogue for "Recent Histories." Essay by Clive Robertson, 1998.

— *Greg Staats: Animose*. Media Release, March 2002.

— *Stan Denniston & Johnnie Eisen: taking your time*. Essay by Jessica Wyman, 2005.

Garneau, David. "Bob Boyer and Jeff Thomas." *Border Crossings* 24, 2 (May 2005): 108.

— "River City," *Border Crossings* 18, 4 (Winter 2001): 82.

Garrett-Petts, W.F. and Donald Lawrence. *PhotoGraphic Encounters: The Edges and Edginess of Reading Prose Pictures and Visual Fictions*. Edmonton: University of Alberta Press, 2000.

Gasché, Rodolphe. *The Tain of the Mirror: Derrida and the Philosophy of Reflection*. Cambridge, MA and London: Harvard University Press, 1986.

Gebauer, Gunter, and Christoph Wulf. *Mimesis: Culture, Art, Society*. Berkeley; Los Angeles; London: University of California Press, 1995.

Geertz, Clifford. "Morality Tale," *The New York Review of Books* 51, 15 (7 October 2004). http://www.nybooks.com/articles/17450. Site visited 12 February 2007.

Giddens, Anthony. "Goffman as a Systematic Social Theorist," *Erving Goffman: Exploring the Interaction Order*, Paul Drew and Anthony Wooten, eds. Boston: Northeastern University Press, 1988: 251–79.

Gide, André. *The Journals of André Gide*. Trans. Justin O'Brien. New York: Alfred A. Knopf, 1947.

Gillmor, Alison. "Modern photos recall bygone era in photography." *Winnipeg Free Press* (Saturday, 25 July 1992).

Glass, Fred. "Class Pictures: Teaching about Photography to Labor Studies Students." *exposure* 28, 1/2 (1991): 35–42.

Glenbow Museum, Calgary. *Jin-me Yoon: Welcome Stranger Welcome Home*. Exhibition catalogue by Kirstin Evenden, 2002.

Glover, Edward. "The 'Screening' Function of Traumatic Memories." *International Journal of Psychoanalysis* 10 (1929): 90–3.

Goffman, Erving. *Behavior in Public Places: Notes on the Social Organization of Gatherings*. New York: The Free Press, 1963.

— *Gender Advertisements*. London and Basingstoke: The MacMillan Press, 1979.

— *Interaction Ritual*. New York: Pantheon Books, 1982 .

— *The Presentation of Self in Everyday Life*. Garden City, NY: Doubleday Anchor Books, 1959.

— *Relations in Public: Microstudies of the Public Order*. New York: Basic Books, Inc., Publishers, 1971.

— *Stigma: Notes on the Management of Spoiled Identity*. Englewood Cliffs, NJ: Prentice-Hall, Inc., 1963.

Goldie, Terry. *Fear and Temptation: The Image of the Indigene in Canadian, Australian, and New Zealand Literatures*. Kingston, Montreal, London: McGill-Queen's University Press, 1989.

Gombrich, E.H. *Aby Warburg: An Intellectual Biography*. Chicago: University of Chicago Press, 1986.

González, Jennifer A. "Autotopographies." In *Prosthetic Territories: Politics and Hypertechnologies*, Gabriel Brahm, Jr. and Mark Driscoll, eds. Boulder; San Francisco; Oxford: Westview Press, 1995.

Grabes, Herbert. *The Mutable Glass: Mirror-Imagery in Titles and Texts of the Middle Ages and English Renaissance*. Trans. Gordon Collier. Cambridge: Cambridge University Press, 1982.

Graham, Robert. "Under a Campeau Blue Sky." *CV Photo* 54 (Spring 2001): 15–22.

Grande, John K. "Carl Beam: Dissolving Time." *The Canadian Forum* 72, 820 (June 1993): 19–23.

Green, David and Peter Seddon, eds. *History Painting Reassessed*. Manchester and New York: Manchester University Press, 2000.

Green-Lewis, Jennifer. *Framing the Victorians. Photography and the*

Culture of Realism. Ithaca and London: Cornell University Press, 1996.

Greenhill, Pauline. "In Our Own Image." *Herizons*, 18, 4 (Spring 2005): 23–6, 45.

Greenough, Sarah. *Paul Strand*. New York: Aperture, 1990.

Grimm-Gobat, Genevieve. "Memoire: Que faisier-vous le 11 septembre? Vos souvenirs font avancer la science." *Latitudes* (4 November 2001).

Grout, Catherine. "Paysages." *CV Photo* 54 (Spring 2001): 23–30.

Guest, Tim. "Maybe Wendy's Right." *Centerfold* (June/July 1979): 277–8.

Gundle, Michael J. Review of *Truth in Memory*, Steven Jay Lynn and Kevin M. McConkey, eds. *Journal of Interpersonal Violence* 17, 7 (July 1999): 773–5.

Hacking, Ian. *Rewriting the Soul: Multiple Personality and the Sciences of Memory*. Princeton: Princeton University Press, 1995.

Hakim, Mona. "Expositions. Bertrand Carrière." *CV Photo*, no. 37 (Winter 1996).

Halbwachs, Maurice. *The Collective Memory*. Trans. Francis J. Ditter, Jr. and Vida Yazdi Ditter. New York: Harper & Row, Publishers, 1960.

Halkes, Petra. "Phantom Strings and Airless Breaths: The Puppet in Modern and Postmodern Art." *Parachute* 92 (Oct.–Nov.–Dec. 1998): 15–23.

Hall, Donald E. "On the making and unmaking of monsters: Christian Socialism, muscular Christianity, and the metaphorization of class conflict." In *Muscular Christianity: Embodying the Victorian Age*, ed. Donald E. Hall. Cambridge: Cambridge University Press, 1994.

Hall, Stuart. "Blue Election, Election Blues," *Marxism Today* (July 1987): 30–5.

Harbison, Robert. "Half-Truths and Misquotations." *Harvard Design Magazine* (Fall 1999): 20–2.

Hardt, Hanno. "Pierced Memories: On the Rhetoric of a Bayoneted Photograph," in his *In the Company of Media: Cultural Constructions of Communication 1920s–1930s*. Boulder: Westview Press, 2000, 151–62.

Hareven, Tamara K. "Cycles, Course and Cohorts: Reflections on Theoretical and Methodological Approaches to the Historical Study of Family Development." *Journal of Social History* 12 (1978–79): 97–109.

– "The Family as Process: The Historical Study of the Family Cycle." *Journal of Social History* 7, 3 (Spring 1974): 322–9.

– *Family Time and Industrial Time: The Relationship between the Family and Work in a New England Industrial Community*. Cambridge: Cambridge University Press, 1982.

Hareven, Tamara K. and Randolph Langenbach. *Amoskeag: Life and Work in an American Factory-City*. New York: Pantheon Books, 1978.

Hart, Susan. "Éclaireur Anishinabe tapi dans les buissons/Lurking in the Bushes: Ottawa's Anishinabe Scout." *Espaces* 72 (Summer 2005): 14–17.

Hartmann, Sadakichi. *The Valiant Knights of Daguerre: Selected Critical Essays on Photography and Profiles of Photographic Pioneers*. Ed. Harry W. Lawton and George Knox. Berkeley: University of California Press, 1978.

Haynes, Deborah. *Bakhtin and the Visual Arts*. Cambridge: Cambridge University Press, 1995.

Herman, Judith. *Trauma and Recovery*. Rev. ed. New York: Basic-Books, 1997.

Hiley, David R., James F. Bohman, and Richard Shusterman, eds. *The Interpretive Turn: Philosophy, Science, Culture*. Ithaca: Cornell University Press, 1991.

Hine, Lewis W. *Men at Work: Photographic Studies of Modern Men and Machines*. New York and Rochester: Dover Publications and George Eastman House, 1977.

Hirsch, Marianne. "Collected Memories: Lorie Novak's Virtual Family Album." In *Changing Focus: Family Photography & American Jewish Identity*. The Scholar and Feminist Online, http://www.barnard.edu/sfonline/cf/hirsch01.htm. Site visited 12 February 2007.

– ed., *The Familial Gaze*. Hanover and London: Dartmouth College/University Press of New England, 1999.

– *Family Frames: Photography, Narrative and Postmemory*. Cambridge, MA and London: Harvard University Press, 1997.

– "I Took Pictures: September 2001 and Beyond." *The Scholar and Feminist Online* 2, 1 (Summer 2003). http://www.barnard.columbia.edu/sfonline/ps/hirsch.htm. Site visited 12 February 2007.

– "Projected Memory: Holocaust Photographs in Personal and Public Fantasy." In Bal, Crewe and Spitzer, eds, *Acts of Memory*, 2–23.

Hobbs, Peter. "Arnaud Maggs. Susan Hobbs Gallery, Toronto." *C Magazine*, issue 43 (Fall 1994): 61.

Holownia, Thaddeus. "Walden Pond Revisited," *The Walrus*, 1, 6 (July–August 2004): 58–61.

Holownia, Thaddeus and Douglas Lochhead. *Dykelands*. Montreal: McGill-Queen's University Press, 1989.

Hopper, James W. and Bessel A. van der Kolk. "Retrieving, Assessing, and Classifying Traumatic Memories: A Preliminary Report on Three Case Studies of a New Standardized Method." *Journal of Aggression, Maltreatment & Trauma* 4, 2 #8 (2001): 33–71.

Horowitz, Risa. "Before the Mirror. Again." *Blackflash* 19, 3 (2002): 34–7.

Hoy, Anne H. *Fabrications: Staged, Altered, and Appropriated Photographs*. New York: Abbeville Press, 1987.

Hudson, Anna. "The Art of Inventing Canada." *The Beaver* 85, 3 (Jun/Jul 2005): 11.

Hugo, Victor. *Oeuvres dramatiques complètes / Oeuvres critiques complètes*. Paris: Jean-Jacques Pauvert, Éditeur, 1963.

Huneault, Kristina. *Difficult Subjects: Working Women and Visual Culture, Britain 1880–1914*. Hants: Ashgate, 2002.

Hutcheon, Linda, ed. *Essays in Canadian Irony*, Vol. 1. North York: York University/Robarts Centre for Canadian Studies, 1988.

– *A Theory of Parody*. New York: Methuen, 1985.

Hutton, Patrick H. "The Art of Memory Reconceived: From Rhetoric to Psychoanalysis." *Journal of the History of Ideas* 48, 3 (July–Sept 1987): 371–92 .

– "Foucault, Freud, and the Technologies of the Self." In *Technologies of the Self: A Seminar with Michel Foucault*. Ed. Luther H. Martin, Huck Gutman, and Patrick H. Hutton. Amherst: University of Massachusetts Press, 1988.

– *History as an Art of Memory*. Hanover and London: University of Vermont, 1993.

Huyssen, Andreas. *Twilight Memories: Marking Time in a Culture of Amnesia*. New York and London: Routledge, 1995.

Institute of Contemporary Arts, London. *Jeff Wall: Transparencies*. Exhibition catalogue by Declan McGonagle, 1984.

Isaak, Jo Anna. *Feminism & Contemporary Art: The Revolutionary Power of Woman's Laughter*. London and New York: Routledge, 1996.

Jackson, J.B. *The Necessity for Ruins and Other Topics*. Amherst: University of Massachusetts Press, 1980.

Jackson, William Henry. *Time Exposure: The Autobiography of William Henry Jackson*. Albuquerque: University of New Mexico Press, 1986.

Jacquet, Hugues. "Joseph Beuys et l'éternelle répétition." *Exporevue* (June 2004), www.exporevue.com/magazine/fr/beuys_joseph.html. Site visited 12 February 2007.

James, William. *The Principles of Psychology*, vols. 1 & 2. 1890. Reprint, New York: Dover Publications, Inc, 1950.

– *The Varieties of Religious Experience: A Study in Human Nature*. 1902. Reprint, edited and with an introduction by Martin E. Marty. Harmondsworth: Penguin Books, 1985.

Jameson, Frederic. "The End of Temporality." *Critical Inquiry* 29, 4 (Summer 2003).

Jammes, André and Eugenia Parry Janis. *The Art of the French Calotype*. Princeton: Princeton University Press, 1983.

Jean, Marie-Josée. "Petits écarts affectueux." *CV Photo* 47 (Summer 1999): 15–22.

Jeffrey, Ian. "Photography, History and Writing." In *The New Art History*, A.L. Rees and Frances Borzello, eds. Atlantic Highlands: Humanities Press International, Inc., 1988.

Jessup, Lynda, ed. *Antimodernism and Artistic Experience: Policing the Boundaries of Modernity*. Toronto: University of Toronto Press, 2001.

Jim, Alice Ming Wai. "An Analysis and Documentation of the 1989 Exhibition 'Black Wimmin: When and Where We Enter,'" *Revue d'art canadienne/Canadian Art Review* 23, 1–2 (1996): 71–83.

Jolly, Martin. "Faces of the Living Dead." *Photofile*, no. 66 (2001): 35–8.

Jones, Caroline A. and Peter Galison, eds. *Picturing Science, Producing Art*. New York; London: Routledge, 1998.

Jones, Jonathan. "André in Wonderland." *The Guardian*, 16 June 2004. http://arts.guardian.co.uk/print/0,,4948308-110428,00.html. Site visited 12 February 2007.

Jongué, Serge. "Le moi photographique." *Photo Sélection* 7, 1 (January–February 1987): 38–9.

Kamloops Art Gallery, Kamloops. *Lost Homelands*. Exhibition catalogue by Annette Hurtig, 1999.

– *Unbidden: Jin-me Yoon*. Exhibition catalogue by Susan Edelstein. Essays by Susan Edelstein and Susette Min, 2004.

Kammen, Michael. *Mystic Chords of Memory: The Transformation of Tradition in American Culture*. New York: Vintage Books, 1993.

Kang, Hyun Yi. "The Autobiographical Stagings of Jin-me Yoon." *Jin-me Yoon: Between Departure and Arrival*. Western Front, Vancouver, BC 1998.

Kaufmann, James C.A. "Photographs & History: Flexible Illustrations." In Thomas F. Barrow, Shelley Armitage, and William E.

Tydeman, eds, *Reading into Photography: Selected Essays,
1959–1980.* Albuquerque: University of New Mexico Press, 1982.

Kavanagh, Gaynor. *Dream Spaces: Memory and the Museum.* London
and New York: Leicester University Press, 2000.

Keenan, Catherine. "On the Relationship between Personal
Photographs and Individual Memory." *History of Photography* 22,
1 (Spring 1998): 60–4.

Kelly, Mary. "Re-Viewing Modernist Criticism." *Screen* 22, 3
(Autumn 1981): 41–62.

Kelly, Sean D. "Husserl and Phenomenology." In *Blackwell Guide to
Continental Philosophy*, Robert C. Solomon and David Sherman,
eds. London: Blackwell, 2002.

Kenderdine Art Gallery. *The Claustrophobic Forest.* Exhibition cata-
logue by Helen Marzolf. Saskatoon, 2002.

Kermode, Frank. *Forms of Attention.* Chicago: University of Chicago
Press, 1985.

Kerouac, Jack. *On The Road.* Harmondsworth: Penguin Books, 1991.

Keshavjee, Serena, ed. *slytod: Diana Thorneycroft.* Winnipeg:
Gallery I.I.I., School of Art and The University of Manitoba
Press, 1998.

Keyes, C.D. "Art and Temporality." *Research in Phenomenology* 1
(1971): 63–73.

Keziere, Russell. "Arnaud Maggs. Convergence sans coincidence."
CV Photo, no. 39 (Summer 1997).

– *Stan Denniston: Fictions.* Toronto: Olga Korper Gallery/Vancou-
ver: Or Gallery, 1995.

Kierkegaard, Soren. *Repetition: An Essay in Experimental Psychology.*
Princeton: Princeton University Press, 1941.

Koffler Gallery. *June Clark-Greenberg: Whispering City.* Essays by
Carolyn Bell Farrell and Alexandre Bohn, Toronto, 1994.

Kogawa, Joy. *Obasan* (1981). Toronto: Penguin Canada, 2003.

Kosta, Barbara. *Recasting Autobiography: Women's Counterfictions in
Contemporary German Literature and Film.* Ithaca and London:
Cornell University Press, 1994.

Kouvaros, George. "Images that remember us: photography and
memory in Austerlitz." *Textual Practice* 19, 1 (2005): 173–93.

Kracauer, Siegfried. *Theory of Film. The Redemption of Physical Reali-
ty.* New York: Oxford University Press, 1960.

– *The Mass Ornament: Weimar Essays.* Ed. & trans. Thomas Y. Levin.
Cambridge, MA, and London: Harvard University Press, 1995.

Krauss, Rosalind E. *Passages in Modern Sculpture.* Cambridge, MA,
and London: MIT Press, 1977, 1993.

– and Jane Livingston. *L'Amour fou. Photography and Surrealism.*

Washington, DC and New York: The Corcoran Gallery of Art and
Abbeville Press, 1985.

Kroker, Arthur. *Technology and the Canadian Mind: Innis/McLuhan/
Grant.* Montreal: New World Perspectives, 1984.

Küchler, Susanne and Walter Melion. *Images of Memory.* Washing-
ton and London: Smithsonian Institution Press, 1991.

Kuhn, Annette, and Kirsten McAllister, eds. *Locating Memory: Pho-
tographic Acts.* Oxford and New York: Berghahn Books, 2006.

Kundera, Milan. *The Book of Laughter and Forgetting.* Trans. from
the Czech, Michael Henry Hein. London and Boston: Faber and
Faber, 1983.

– *The Book of Laughter and Forgetting.* Trans. from the French, Aaron
Asher, 1996. New York: Perennial Classics, 1999.

Kuryluk, Ewa. *Salome and Judas in the Cave of Sex. The Grotesque:
Origins, Iconography, Techniques.* Evanston: Northwestern Univer-
sity Press, 1987.

LaCapra, Dominick. *Representing the Holocaust: History, Theory,
Trauma.* Ithaca and London: Cornell University Press, 1994.

– *History and Memory after Auschwitz.* Ithaca and London: Cornell
University Press, 1998.

– "Trauma, Absence, Loss." *Critical Inquiry*, no. 23 (Summer 1999):
696–727.

Lamarche, Bernard. "La douce brise du temps. Récits intimes d'un
voyage dans des contrées où le temps ralentit." *Le Devoir* (4 and 5
September 1999).

– "Nouvelle récolte." *Le Devoir* (12 and 13 April 1997).

– "Rétrospective sonore." *Le Devoir* (29 and 30 January 2000).

Lamothe, Michel. *Michel Lamothe: Même les cigales dormaient.*
Quebec: J'ai VU, 2000.

Langford, Martha. "The Canadian Museum of Contemporary Pho-
tography." *History of Photography* 20, 2 (Summer 1996): 174–80.

– ed. *Image & Imagination.* Montreal: McGill-Queen's University
Press, 2005.

– "The Machine in the Grotto: The Grotesque in Photography,"
*JAISA: The Journal of the Association for the Interdisciplinary Study
of the Arts,* 1, 2, (Spring 1996): 111–123.

– "In the Playground of Allusion." In M.A. Greenstein and Martha
Langford, eds. *exposure* 31, 3/4 [Essays on the Photographic
Grotesque] (1998): 13–24.

– *On Space, Memory and Metaphor: The Landscape in Photographic
Reprise.* Montreal: Vox Populi, 1997.

– *Suspended Conversations: The Afterlife of Memory in Photographic*

Albums. Montreal: McGill-Queen's University Press, 2001.

– "When is a Self-portrait Not?" In André Gilbert, ed., *Autoportraits dans la photographie canadienne contemporaine/Self-portraits in Contemporary Canadian Photography*. Quebec: J'ai VU, 2004.

– "What Use Is Photography?" In Christopher Coppock and Paul Seawright, eds, *So Now Then*. Cardiff: Ffotogallery, 2006: 164–7.

– "Workers in Progress: The Art of Carol Condé and Karl Beveridge," *Border Crossings*, 25, 3 (August 2006): 98–103.

Langley-Smith, Thomas. "Photographic Encounters: Prose Pictures and Visual Fictions," *Artichoke*, 13, 3 (Fall/Winter 2001): 17–19.

Lasch, Christopher. *The Culture of Narcissism: American Life in an Age of Diminishing Expectations*. New York: W.W. Norton & Company Inc., 1978.

Lateral Gallery at Women in Focus, Vancouver. *(Inter)reference, Part II: (In)authentic (Re)search. Jin-me Yoon*. Essay and chronology by Karen Knights, 1990.

Laurence, Jean-Roch, Duncan Day and Louise Gaston. "From Memories of Abuse to the Abuse of Memories." In *Truth in Memory*, S.J. Lynn and K.M McConkey, eds. New York: APA Press, 1998: 323–46.

Laurence, Robin. "Jin-me Yoon." *Canadian Art* 18, 3 (Fall 2001): 116.

Lavoie, Vincent. *L'instant-monument: du fait divers à l'humanitaire*. Montreal: Dazibao, 2001.

– ed. *Maintenant: Images du temps présent / Now: Images of Present Time*. Montreal: Le Mois de la Photo à Montréal, 2003.

Leggewie, Charles and Erik Meyer. "Shared Memory: Buchenwald and Beyond." *Transit online*, no. 22 (2002), http://www.iwm.at/index.php?option=com_content&task=view&id=317&Itemid=482. Site visited 12 February 2007.

Le Goff, Jacques. *History and Memory*. Trans. Steven Rendall and Elizabeth Claman. New York: Columbia University Press, 1992.

Le Grand, Jean-Pierre. "Raymonde April: célébrer la vie." *Vie des arts*, no. 200 (automne 2005): 64–6.

Leonard, Craig. "A Conversation with Carole Condé & Karl Beveridge." *Fuse* 28, 3 (July 2005): 33–40.

Leonardo da Vinci, *Leonardo on Painting*. Ed. Martin Kemp. New Haven and London: Yale University Press, 1989.

Levi, Primo. *The Drowned and the Saved*. New York: Random House, Inc., 1989.

Lippard, Lucy. *The Lure of the Local: Senses of Place in a Multicultured Society*. New York: The New Press, 1997.

Livingstone, David. "Making faces for history and art." *Maclean's* (30 August 1982): 53.

Locke, John. *An Essay Concerning Human Understanding*. Vols 1 and 2. Ed. Alexander Campbell Fraser. New York: Dover Publications, 1959 .

Logie, Robert H. *Visuo-Spatial Working Memory*. Hove and Hillsdale: Lawrence Erlbaum Associates, 1995.

Lord, Barry. *The History of Painting in Canada: Toward a People's Art*. Toronto: NC Press, 1974 .

Lord, James. *Giacometti: A Biography*. New York: Farrar, Straus, Giroux, 1985.

Luria, A.R. *The Mind of the Mnemonist*. Trans. Lynn Solotaroff. New York and London: Basic Books, Inc., 1968.

Lury, Celia. *Prosthetic Culture: Photography, Memory and Identity*. London and New York: Routledge, 1998.

Lynn, Steven Jay and Kevin M. McConkey, eds. *Truth in Memory*. New York: Guilford Press, 1998.

Lyotard, Jean-François. *La phénoménologie*. Paris: Presses Universitaires de France, 1954.

Macfarlane, David. *The Danger Tree: Memory, War, and the Search for a Family's Past*. Toronto: Random House of Canada, 2000.

Macdonald Stewart Art Centre, Guelph. *Site Memory: Contemporary Art From Canada*. Exhibition catalogue by Ingrid Jenkner, 1991.

Mackenzie, Robin. "No Reserves for the New Indians." *artscanada* 164/165 (Feb/Mar 1972): 75.

Magritte, René. *Écrits complets*. Ed. André Balvier. Paris: Flammarion, 1979.

Maier, Charles S. "Hot Memory … Cold Memory: On the Political Half-Life of Fascist and Communist Memory." *Transit online*, no. 22 (2002). http://www.iwm.at/index.php?option=com_content&task=view&id=316&Itemid=481. Site visited 12 February 2007.

Les Maisons de la Culture de la Ville de Montréal. *Bertrand Carrière. Voyage à domicile*, 1997.

Maranda, Michael. "The Reluctant Critic." *Blackflash* 20, 1 (2002): 14–23.

Margalit, Avishai. *The Ethics of Memory*. Cambridge: Harvard University Press, 2002.

Marien, Mary Warner. *Photography and Its Critics: A Cultural History*. Cambridge, UK and New York: Cambridge University Press, 1997.

– *Photography: A Cultural History*. 2nd ed. New York: Prentice Hall, Inc., and Harry N. Abrams, 2006.

Mark, Lisa Gabrielle. "Button Pusher." *Canadian Art* 18, 1 (Spring 2001): 54–9.

– "The Pressing of Flesh: Parallel Meditations on the Male Nude."

Border Crossings 30 (Summer 1992): 55–7.

Marlatt, Daphne, and Robert Minden. *Steveston*, 3rd ed. Vancouver: Ronsdale Press, 2001.

Martin, Edwin. "On Seeing Walton's Great-Grandfather." *Critical Inquiry* 12, 4 (Summer, 1986): 796–800.

Mastai, Judith. "Marian Penner Bancroft." *Canadian Art* (Spring 2000): 110–11.

– "The Post-Colonial Landscape." *Blackflash* 14, 2 (Summer 1996): 10–13.

Matsuda, Matt K. *The Memory of the Modern*. New York; Oxford: Oxford University Press, 1996.

Maynard, Patrick. *The Engine of Visualization: Thinking through Photography*. Ithaca and London: Cornell University Press, 1997.

McAllister, Kirsten Emiko. "Held Captive: The Postcard and the Internment Camp." *West Coast Line* 34/35/1 (Spring 2001): 20–40.

McCabe, Shauna. "Fissures," *CV Photo*, no. 55 (2001): 13–4.

McCance, Dawne. "Introduction." *Mosaic* 37, 4 (December 2004). http://www.umanitoba.ca/publications/mosaic/issues/_resources/intro_37_4.pdf. Site visited 12 February 2007.

McElroy, Gil. "Spatial Orientation." *Afterimage* 28, 6 (May/June 2001): 15.

McMichael Canadian Art Collection, Kleinburg. Alter*Native: Contemporary Photo Compositions*. Exhibition catalogue by Lynn A. Hill, 1995.

Medicine Hat Museum and Art Gallery. *Photo Roman*. Essay by Joanne Marion. Medicine Hat, AB, 2002, unpaginated.

Mehring, Christine. "Siegfried Kracauer's Theories of Photography: From Weimar to New York." *History of Photography* 21, 2 (Summer 1997): 129–36.

Melchior-Bonnet, Sabine. *The Mirror: A History*. Trans. Katherine H. Jewett. New York: Routledge, 2002.

Melion, Walter S. "Memory and the kinship of writing and picturing in the early seventeenth-century Netherlands." *Word & Image* 8, 1 (January–March 1992): 48–70.

Mendel Art Gallery, Saskatoon. *Sandra Semchuk: Excerpts from a Diary*. Essay by Penny Cousineau, 1982.

Mercer Union, Toronto. *Rethinking History*. Essay by Carol Podedworny. Media Release, 1992.

Merleau-Ponty, Maurice. *Phenomenology of Perception*. Trans. Colin Smith. London: Routledge, 1999.

– *The Visible and the Invisible*. Evanston: Northwestern University Press, 1968.

Merridale, Catherine. *Night of Stone: Death and Memory in Russia*. London: Granta Books, 2000.

Metz, Christian. *The Imaginary Signifier: Psychoanalysis and the Cinema*. Trans. Celia Britton et al. Bloomington: Indiana University Press, 1982.

– "Photography and Fetish." *October* 34 (1985): 81–90.

Miller, Nancy K. and Jason Tougaw, eds. *Extremities: Trauma, Testimony, and Community*. Urbana and Chicago: University of Illinois Press, 2002.

Miller, Sue. *Family Pictures*. New York: Harper & Row, 1990.

Milroy, Sarah. "We need artists to soldier on." *The Globe and Mail* (Tuesday, 2 October 2001): R1, R7.

Minden, Robert. "'Strangers on the Earth': Meetings with Doukhobor-Canadians in British Columbia." *Sound Heritage* 5, 2 (1976): 19–34.

– *Separate from the World: Meetings with Doukhobor-Canadians in British Columbia*. Ottawa: National Film Board of Canada, 1979.

Mitchell, Michael. "Karl Beveridge and Carole Condé." *Photo Communique* (Winter 1984/85): 35–8.

Mitchell, W.J.T., ed. *Landscape and Power*. Chicago & London: University of Chicago Press, 1994 .

– *Picture Theory*. Chicago & London: University of Chicago Press, 1994.

Mitchell, William J. *The Reconfigured Eye. Visual Truth in the Post-Photographic Era*. Cambridge, MA: MIT Press, 1994.

Morgan, Henry J. and Lawrence J. Burpee. *Canadian Life in Town and Country*. London: George Newnes, 1905.

Morin, Edgar. *The Cinema, or The Imaginary Man*. Trans. Lorraine Mortimer. Minneapolis and London: University of Minnesota Press, 1956 & 2005.

Morose, Edward. "Big Story Blues: The Photo Narratives of Henri Robideau." In Robideau, *Big Stories*, 5–28.

Morris and Helen Belkin Art Gallery, Vancouver, and Musée des beaux-arts de Montréal, Montreal. *Geneviève Cadieux*. Exhibition catalogue by Scott Watson, Guy Cogeval and Shirley Madill, 1999.

Morrison, Toni. "The Site of Memory." In Ferguson et al., eds, *Out There*, 299–305.

Morson, Gary Saul. *Bakhtin: Essays and Dialogues on His Work*. Chicago and London: University of Chicago Press, 1986.

– *Narrative and Freedom: The Shadows of Time*. New Haven and London: Yale University Press, 1994.

Mulvey, Laura. "A Phantasmagoria of the Female Body: The Work of Cindy Sherman." *New Left Review*, no. 188 (July/August 1991): 137–50.

Musée d'art de Joliette. *Raymonde April: Les Fleuves invisibles*. Exhibition catalogue by Nicole Gingras, 1997.

Musée national des beaux-arts du Québec. *L'emploi du temps: Acquisitions récentes en art actuel*. Exhibition catalogue by Anne-Marie Ninacs, 2003.

Musée régional de Rimouski. *Quatre histoires ou l'éthique du doute*. Essay by Lisanne Nadeau, 1993–94.

Museum of Contemporary Canadian Art, Toronto. *A History Lesson: Contemporary Aboriginal Art from the Collection of the MacKenzie Art Gallery*. Essay by Lee-Ann Martin, 2004.

Museum of Fine Arts, Houston. *Gustave Caillebotte: A Retrospective Exhibition*. Exhibition catalogue by J. Kirk, T. Varnedoe and Thomas P. Lee, 1976.

Myerhoff, Barbara and Deena Metzger. "The journal as activity and genre: Or listening to the Silent Laughter of Mozart." *Semiotica* 30, 1/2 (1980): 97–114.

Nabokov, Vladimir. *Speak, Memory: An Autobiography Revisited* [original title: *Conclusive Evidence*]. New York; Toronto: Alfred A. Knopf, 1999.

Napier, A. David. *Foreign Bodies. Performance, Art, and Symbolic Anthropology*. Berkeley, Los Angeles, and Oxford: University of California Press, 1992.

National Film Board of Canada. *Contemporary Canadian Photography from the Collection of the National Film Board*. Edited by Martha Langford, Pierre Dessureault, and Martha Hanna. Edmonton: Hurtig Publishers, 1984.

National Gallery of Art, Washington. *Alfred Stieglitz: Photographs and Writings*. Exhibition catalogue by Sarah Greenough and Juan Hamilton, 1983.

National Gallery of Canada, Ottawa. *Songs of Experience*. Exhibition catalogue by Jessica Bradley and Diana Nemiroff, 1986.

– *Land, Spirit, Power: First Nations at the National Gallery of Canada*. Exhibition catalogue by Diana Nemiroff, Robert Houle, and Charlotte Townsend-Gault, 1992.

– *Crossings*. Exhibition catalogue by Diana Nemiroff, 1998.

National Museum of Photography, Film and Television, Bradford, England. *Evergon: 1987–1997*. Exhibition catalogue by Will Stapp and Evergon, 1997.

Naughton, Leonie. "Germany Pale Mother: Screen Memories of Nazism." *Continuum: The Australian Journal of Media & Culture* 5, 2 (1990).

Neisser, Ulric. "Nested Structure in Autobiographical Memory." In Rubin, ed., *Autobiographical Memory*, 71–81.

Neisser, Ulric and Eugene Winogrand, eds. *Remembering Reconsidered: Ecological and Traditional Approaches to the Study of Memory*. Cambridge: Cambridge University Press, 1988.

Nelson, Katherine. "Self and social functions: Individual autobiographical memory and collective narrative," *Memory* 11, 2 (2003): 125–36.

Nelson, Robert S. and Margaret Olin, eds. *Monuments and Memory, Made and Unmade*. Chicago and London: University of Chicago Press, 2003.

Nelson, Robert S. and Richard Shiff. *Critical Terms for Art History*. Chicago and London: The University of Chicago Press, 1996.

Nemiroff, Diana. "Maybe it's only politics." *Vanguard* 11, 8/9 (November 1982): 8–11.

Nesbit, Molly. *Atget's Seven Albums*. New Haven and London: Yale University Press, 1992.

Newhall, Beaumont. *The History of Photography*. New York: The Museum of Modern Art, 1964.

– ed. *Photography: Essays and Images*. New York: The Museum of Modern Art, 1980.

Nickel, Douglas R. "History of Photography: The State of Research." *Art Bulletin* 83, 3 (September 2001): 548–58.

Nietzsche, Friedrich. *Untimely Meditations*. Ed. Daniel Breazeale. Cambridge: Cambridge University Press, 2003.

Nigro, Georgia and Ulric Neisser. "Point of View in Personal Memories." *Cognitive Psychology* 15 (1983): 467–82.

Nochlin, Linda. *The Politics of Vision: Essays on Nineteenth-Century Art and Society*. New York: Harper & Row, 1989.

Nora, Pierre. "Between Memory and History: Les Lieux de Mémoire." *Representations* 26, 7–25.

– ed. *Realms of Memory: The Reconstruction of the French Past*. Eng. ed. Lawrence D. Kritzman. Trans. Arthur Goldhammer. New York: Columbia University Press, 1996–98.

– "The Reasons for the Current Upsurge in Memory." *Transit online*, no. 22 (2002). http://www.iwm.at/index.php?option= com_content&task=view&id=285&Itemid=463. Site visited 12 February 2007.

Norman Mackenzie Art Gallery. *Bob Boyer/Edward Poitras: Horses Fly Too*. Essay by Norman Zepp and Michael Parke-Taylor. Regina, 1984.

Nzegwu, Nkiru. "Memory Lines: Art in the Pan-African World." *Ijele: Art ejournal of the African World* 1, 2 (2000). http://www.africaresource.com/ijele/vol1.2/nzegwu2.html. Site visited 12 February 2007.

Oakville Galleries. *Revealing the Subject*. Exhibition catalogue by Shannon Anderson, 2003.

Occurrence, Espace d'art et d'essai contemporains. *La Méthode et l'extase: Richard Baillargeon, Michel Campeau, Bertrand Carrière*. Exhibition catalogue by Martha Langford, 2001.

O'Donnell, Lorraine. "Towards Total Archives: The Form and Meaning of Photographic Records." *Archivaria*, no. 38 (Fall 1994): 105–18.

Ofshe, Richard and Ethan Watters. *Making Monsters: False Memories, Psychotherapy, and Sexual Hysteria*. Berkeley; Los Angeles: University of California Press, 1994, 1996.

Olivares, Rosa, ed. *Exit* 1, 1 (2000).

Olney, James. *Memory & Narrative: The Weave of Life-Writing*. Chicago & London: University of Chicago Press, 1998.

Ong, Walter. *Orality and Literacy: The Technologizing of the Word*. London and New York: Methuen, 1982.

– *Rhetoric, Romance and Technology: Studies in the Interaction of Expression and Culture*. Ithaca: Cornell University Press, 1971.

Or Gallery. *Marian Penner Bancroft: Holding*. Essay by Jeff Derksen, Vancouver, 1991.

Osborne, Catherine. "Arnaud Maggs: With Variations." *Canadian Art* 16, 2 (Summer 1999): 72.

Östlind, Niclas. "Voyage à domicile." *Brainstorm*, no. 60 (September 1997): 17–19.

Otis, Laura. *Organic Memory: History and the Body in the Late Nineteenth & Early Twentieth Centuries*. Lincoln & London: University of Nebraska Press, 1994.

Owens, Craig. "Photography *en abyme*." *October* 5 (Summer 1978): 73–88.

Ozick, Cynthia. "The Posthumous Sublime." *The New Republic* (16 December 1996): 33–8.

Papastergiadis, Nikos. "From the Edges of Exile to the Limits of Translation," in Nemiroff, ed., *Crossings*, 43–69.

Payne, Carole and Jeffrey Thomas. "Aboriginal Interventions into the Photographic Archives: A Dialogue between Carol Payne and Jeffrey Thomas." *Visual Resources* 18 (2002): 109–25.

Peers, Laura and Alison K. Brown. "Colonial Photographs and Post-Colonial Histories: The Kainai-Oxford Photographic Histories Project," *First Nations, First Thoughts*, University of Edinburgh, May 2005. http://www.cst.ed.ac.uk/Events/Conferences/index.html. Site visited 12 February 2007.

Perrin, Peter. "Robin Mackenzie: The Sense of Site." *artscanada* 214/215 (May/June 1977): 2–11.

Peterson, Donald. *Wittgenstein's Early Philosophy: Three Sides of the Mirror*. Toronto and Buffalo: University of Toronto Press, 1990.

Phillips, Christopher. "A Mnemonic Art? Calotype Aesthetics at Princeton." *October* 26 (1983): 34–62.

Phillips, David. "Photo-Logos: Photography and Deconstruction." In *The Subjects of Art History: Historical Objects in Contemporary Perspectives*. Cambridge: Cambridge University Press, 1998.

Phillips, Ruth B. "Settler Monuments, Indigenous Memory: Dis-membering and Re-membering Canadian Art History." In Nelson and Olin, *Monuments and Memory, Made and Unmade*, 281–304.

The Photographers Gallery, Saskatoon. *Search, Image and Identity: Voicing Our West*. Exhibition catalogue by Paula Gustafson and Carol Williams, 1994.

Pierce, Susan. *On Collecting: An Investigation into Collecting in the European Tradition*. London and New York: Routledge, 1995.

Pilkington, Mark. "Screen Memories: An Exploration of the Relationship between Science Fiction Film and the UFO Mythology." http://www.hedweb.com/markp/ufofilm.htm. Site visited 12 February 2007.

Pitseolak, Peter. *People from Our Side*. Ed. Dorothy Eber. Trans. Ann Hanson. Edmonton: Hurtig Publishers, 1975.

Pomian, Krzysztof. "Vision and Cognition." In Jones and Galison, eds, *Picturing Science, Producing Art*, 211–31.

Pontbriand, Chantal. "*Plus Tard*, plus tard … Michael Snow." *Parachute* 17 (Winter 1979): 49–55.

Poulin, Jacques. *Mr. Blue* [*Le vieux chagrin*]. Trans. Sheila Fischman. Montreal: Véhicule Press, 1993.

Power Plant – Contemporary Art at Harbourfront, Toronto. *Carl Beam: The Columbus Boat*. Exhibition catalogue by Richard Rhodes, 1992.

Prager, Jeffrey. *Presenting the Past: Psychoanalysis and the Sociology of Misremembering*. Cambridge, MA and London: Harvard University Press, 1998.

Presentation House Gallery, North Vancouver. *Death and the Family*. Exhibition catalogue by Karen Love, 1997.

– *Facing History: Portraits from Vancouver*, ed. Karen Love. Vancouver: Arsenal Pulp Press, 2002.

– *Marian Penner Bancroft: By Land and Sea (prospect and refuge)*. Exhibition catalogue by Karen Henry, 1999.

– *Sandra Semchuk: Coming to Death's Door — A Daughter/Father Collaboration*, 1991.

– *Jin-Me Yoon: Touring Home from Away*. Essay by Shauna McCabe, 2002.

Price, Mary. *The Photograph: A Strange Confined Space*. Stanford: Stanford University Press, 1994.

Proust, Marcel. *Swann's Way* (1913), *Remembrance of Things Past*, volume 1, trans. C.K. Scott Monarieff. New York: Random House, 1934.

Purdy, Anthony. "Memory Maps: Mnemotopic Motifs in Creates, Poulin, and Robin." In *Essays on Canadian Writing* 80 (Fall 2003): 261–81.

Quine, Dany. "Poussière d'étoiles, espace et temps." *Le Soleil* (6 March 1999): D20.

Rabb, Jane M. *The Short Story & Photography 1880's–1980's*. Albuquerque: University of New Mexico Press, 1998.

Radstone, Susannah, ed. *Memory and Methodology*. Oxford and New York: Berg, 2000.

Randolph, Jeanne. "Stan Denniston, Mercer Union Gallery." *Artforum* (April 1983): 82.

– *Psychoanalysis & Synchronized Swimming*. Toronto: YYZ Books, 1991.

– *Symbolization and its Discontents*. Toronto: YYZ Books, 1997.

Rawls, Anne Warfield. "Orders of Interaction and Intelligibility: Intersections between Goffman and Garfinkel by Way of Durkheim." In *Goffman's Legacy*, A. Javier Treviño, ed. Oxford and New York: Rowman & Littlefield Publishers, Inc., 2003.

Read, Herbert. *The Art of Sculpture*. Princeton: Princeton University Press, 1961, 1969.

– *Icon and Idea: The Function of Art in the Development of Human Consciousness*. New York: Schocken Books, 1965, 1972 .

Rees, A.L. and Frances Borzello. *The New Art History*. Atlantic Highlands, NJ: Humanities Press International, Inc., 1988.

Reeve, Charles. "Arnaud Maggs." *Canadian Art* (Fall 2001): 122–3.

– "If Computers Could Paint: Charles Reeve Speaks to Jeff Wall." *Books in Canada* 28, 8/9 (Winter 2000): 3–7.

Reid, Emma. "'Flashbulb memory' theory fades in light of new findings." *EXN.ca*, Discovery Canada, 2002.

Renan, Ernest. "Qu'est-ce qu'une nation?," Conférence faite en Sorbonne, le 11 mars 1882. http://ourworld.compuserve.com/homepages/bib_lisieux/nation01.htm. Site visited 12 February 2007.

Renaud, Nicolas. "After Brenda: Théâtre de la douleur et survie documentée." *Hors Champ*, 19 August, 1997, http://www.

horschamp.qc.ca/9708/emulsion/after_brenda.html. Site visited 12 February 2007.

La Réunion des Musées Nationaux, Musée d'Orsay, Paris, and The Art Institute of Chicago, Chicago. *Gustave Caillebotte: Urban Impressionist*. Exhibition catalogue by Anne Distel et al., 1995.

Ricardou, Jean. *Problèmes du nouveau roman*. Paris: Éditions du Seuil, 1967.

Rice, Ryan. "States of Beam: Remembering Carl Beam," *Canadian Art*, 23, 3 (Fall 2006): 120–22.

Richardson, Douglas S. "National Science Library: Art in Architecture." *artscanada* 190/191 (Autumn 1974): 49–67.

Richmond, Cindy. "Picturing Home." *ARTSatlantic* 60 (Spring 1998): 36–40.

Richter, Gerhard. *Atlas*. New York: D.A.P./Distributed Art Publishers, Inc., in association with Anthony d'Offay London and Marian Goodman New York, 1997.

Ricoeur, Paul. "Entre la mémoire et l'histoire." *Transit online*, no. 22 (2002), http://www.iwm.at/index.php?option=com_content&task=view&id=283&Itemid=461. Site visited 12 February 2007.

– "The Human Experience of Time and Narrative." *Research in Phenomenology* 9 (1979): 17–34.

– *Memory, History, Forgetting*. Trans. Kathleen Blamey and David Pellauer. Chicago and London: University of Chicago Press, 2004.

– "The Metaphorical Process as Cognition, Imagination, and Feeling." *Critical Inquiry* 5, 1 (Autumn 1978): 143–59.

Robbins, Brent Dean. "Lacan: The Limits of Love and Knowledge," *Janus Head* 5, 1 (Spring 2002), http://www.janushead.org/5-1/robbins.cfm.

The Robert McLaughlin Gallery, Oshawa. *Carl Beam: The Whale of Our Being*. Exhibition catalogue by Joan Murray, 2002.

Roberts, Catsou, ed. *Michael Snow, almost Cover to Cover*. London and Bristol: Black Dog Publishing and Arnolfini, 2001.

Roberts, John. *The Art of Interruption: Realism, Photography and the Everyday*. Manchester and New York: Manchester University Press, 1998.

Robideau, Henri. *Big Stories*. Saskatoon: The Photographers Gallery, 2001.

Roegiers, Patrick. "The Self-Resistant René Magritte." In Abadie, ed., 38–49.

Rogoff, Irit. *Terra Infirma: Geography's Visual Culture*. London and New York: Routledge, 2000.

Ronna and Eric Hoffman Gallery of Contemporary Art, Portland, Oregon. "Jeff Thomas," *Encounters: Contemporary Native American Art*. Exhibition catalogue 2004.

Rorty, Richard. *Philosophy and the Mirror of Nature*. Oxford: Basil Blackwell, Publisher, 1980.

Rose, Barbara. "The Politics of Art Part II." *Artforum* 7, 5 (January 1969): 44–9.

Rosenberg, Avis Lang. "Robert Minden: Photographing Others." *Vanguard* 9, 7 (September 1980): 14–19.

Rosenfeld, Gavriel. D. *Munich and Memory: Architecture, Monuments, and the Legacy of the Third Reich*. Berkeley: University of California Press, 2000.

Rosenfield, Israel. *The Strange, Familiar and Forgotten: An Anatomy of Consciousness*. New York: Picador, 1995.

Ross, Toni. "Art in the 'Post-Medium' Era: Aesthetics and Conceptualism in the Art of Jeff Wall," *South Atlantic Quarterly* 101, 3 (Summer 2002): 555–72.

Roth, Michael S. *The Ironist's Cage. Memory, Trauma, and the Construction of History*. New York: Columbia University Press, 1995.

Rouleau, Martine. "Petites morts argentiques." *Vie des arts* 45, 185 (Fall 2001): 22–5.

Rubin, David C., ed. *Autobiographical Memory*. Cambridge: Cambridge University Press, 1986.

Rushing III, W. Jackson, ed. *Native American Art in the Twentieth Century: Makers, Meanings, Histories*. London: Routledge, 1999 .

Russell, Catherine. *Experimental Ethnography: The Work of Film in the Age of Video*. Durham and London: Duke University Press, 1999.

Russo, Mary. *The Female Grotesque*. New York: Routledge, 1995.

Ryle, Gilbert. *The Concept of Mind*. Harmondsworth: Penguin Books, 1986.

Said, Edward W. "Invention, Memory, and Place." *Critical Inquiry* 26, 2 (Winter 2000): 175–92.

Samuel, Raphael. *Theatres of Memory*. Vol. 1, *Past and Present in Contemporary Culture*. London and New York: Verso, 1994.

Santner, Eric L. *Stranded Objects: Mourning, Memory, and Film in Postwar Germany*. Ithaca and London: Cornell University Press, 1990 .

Sarbin, Theodore R. *Narrative Psychology: The Storied Nature of Human Conduct*. New York: Praeger, 1986.

Sartre, Jean Paul. *Imagination*. Trans. Forrest Williams. Ann Arbor: University of Michigan Press, 1962.

– *The Psychology of Imagination*. London: Rider and Company, 1950.

Savedoff, Barbara E. "Transforming Images: Photographs of Representations." *The Journal of Aesthetics and Art Criticism* 50, 2 (Spring 1992): 93–106.

Schacter, Daniel L., ed. *Memory Distortion: How Minds, Brains and Societies Reconstruct the Past*. Cambridge and London: Harvard University Press, 1995.

– *Searching for Memory: The Brain, the Mind, and the Past*. New York: BasicBooks, 1996.

– *The Seven Sins of Memory {How the Mind Forgets and Remembers}*. Boston: Houghton Mifflin Company, 2001.

Schama, Simon. *Landscape and Memory*. Toronto: Random House of Canada, 1995.

Schapiro, Meyer. *Impressionism: Reflections and Perceptions*. New York: George Braziller, 1997.

Scharf, Aaron. *Art and Photography*. Harmondsworth: Penguin Books, 1984.

Schegloff, Emanuel A. "Goffman and the Analysis of Conversation." In *Erving Goffman: Exploring the Interaction Order*, Paul Drew and Anthony Wooten, eds. Boston: Northeastern University Press, 1988: 89–135.

Schier, Flint. *Deeper into Pictures: An Essay on Pictorial Representation*. Cambridge University Press, 1988.

Schleifer, Ronald, Robert Con Davis and Nancy Mergler. *Culture and Cognition: The Boundaries of Literary and Scientific Inquiry*. Ithaca and London: Cornell University Press, 1992.

Schneider, Steven. "Monsters as (Uncanny) Metaphors: Freud, Lakoff, and the Representation of Monstrosity in Cinematic Horror." *Other Voices: The (e)Journal of Cultural Criticism* 1, 3 (January 1999). http://www.othervoices.org/1.3/sschneider/monsters.html. Site visited 12 February 2007.

Scholes, Robert E. and Robert Kellogg. *The Nature of Narrative*. New York: Oxford University Press, 1966.

Schwartz, Hillel. *The Culture of the Copy. Striking Likenesses, Unreasonable Facsimiles*. New York: Zone Books, 1996.

Schwartz, Joan. "'We make our tools and our tools make us': Lessons from Photographs for the Practice, Politics, and Poetics of Diplomatics." *Archivaria: The Journal of the Association of Canadian Archivists*, no. 40 (Fall 1995): 40–73.

Schwenger, Peter. "Corpsing the Image." *Critical Inquiry* 26, 3 (Spring 2000): 395–413.

– *Fantasm and Fiction: On Textual Envisioning*. Stanford: Stanford University Press, 1999.

Scott, Grant F. *The Sculpted Word: Keats, Ekphrasis, and the Visual Arts*.

Hanover and London: University Press of New England, 1994.

Sebald, W.G. *The Emigrants*, trans. Michael Hulse. New York: New Directions, 1996.

Semchuk, Sandra. "Reimagining Ourselves Here." In *Land: Relationship and Community – A Symposium*. Presentation House Gallery. North Vancouver, 2001: 32–5.

Séquence. *Éclipses et Labyrinthes*. Exhibition catalogue by Michel Campeau, Jean Arrouye, Elizabeth Wood, and Gilles Sénéchal. Chicoutimi, 1993.

– *Richard Baillargeon. Champs/la mer*. Chicoutimi, 1996.

Shaw, Nancy. "Geneviève Cadieux's Baroque Logic." *Prefix Photo* 2 (2000): 33–45.

Shedden, Leslie. *Mining Photographs and Other Pictures, 1948–1968*. Ed. Benjamin Buchloh and Robert Wilkie. Nova Scotia: The Press of the Nova Scotia College of Art and Design and the University College of Cape Breton Press, 1983.

Sherrin, Bob. "The Resistance of Remembrance." *Vanguard* (March 1984): 17–21.

Shohat, Ella, ed. *Talking Visions: Multicultural Feminism in a Transnational Age*. New York and Cambridge: New Museum of Contemporary Art and MIT Press, 2002.

Shorter, Edward. *A History of Psychiatry: From the Era of the Asylum to the Age of Prozac*. New York: John Wiley and Sons, Inc., 1997.

Shubert, Adrian. Review of Raanan Rein, ed., *Spanish Memories: Images of a Contested Past*." *Mediterranean Historical Review* 19, 2 (December 2004): 96–8.

Silverman, Kaja. *The Threshold of the Visible World*. New York and London: Routledge, 1996.

Simmel, Georg. "The Stranger," in his *On Individuality and Social Forms: Selected Writings*. Ed. Donald N. Levine. Chicago and London: University of Chicago Press, 1971, 143–9.

Sinha, Amresh. "Forgetting to Remember: From Benjamin to Blanchot." *Colloquy: Text, Theory, Critique*, Issue 10. http://www.arts.monash.edu.au/others/colloquy/issue10/sinha. pdf. Site visited 12 February 2007.

– "The Intertwining of Remembering and Forgetting in Walter Benjamin." *Connecticut Review* 20, 2 (Fall 1998): 99–110.

Sir Wilfred Grenfell College Art Gallery, Corner Brook, NL. "Diana Thorneycroft's *Martyrs Murder*." Essay by Austin King, 2003.

Skidmore, Colleen. "Touring an Other's Reality: Aboriginals, immigrants, and autochromes," *First Nations, First Thoughts*, Edinburgh, May 2005.http://www.cst.ed.ac.uk/Events/ Conferences/index.html. Site visited 12 February 2007.

Slyomovics, Susan. *The Object of Memory*. Philadelphia: University of Pennsylvania Press, 1998.

Smith, Doug and Michael Olito. *The Best Possible Face: L.B. Foote's Winnipeg*. Winnipeg: Turnstone Press, 1985.

Snow, Michael. *Michael Snow / A Survey*. Toronto: Art Gallery of Ontario, 1970.

– *Cover to Cover*. Halifax and New York: The Press of the Nova Scotia College of Art and Design, 1975.

– *The Collected Writings of Michael Snow*. Waterloo: Wilfrid Laurier University Press, 1994.

– "Notes on the Whys and Hows of My Photographic Works." In Société des Expositions du Palais des Beaux-Arts et al., *Michael Snow*, 112–23.

Société des Expositions du Palais des Beaux-Arts and Cinémathèque royale de Belgique, Bruxelles; Centre national de la photographie, Paris; Centre pour l'image contemporain, Saint-Gervais, Genève. *Michael Snow: Panoramique*. Exhibition catalogue by Piet Coessens, Gabrielle Claes, Régis Durand, and André Iten, 1999.

Societé d'études anglo-américaines des XVII et XVIII siècles. "Mémoire et création dans le monde anglo-américain aux XVIIe et XVIIIe siècles." Université de Strasbourg II, Actes du Colloque tenu à Paris les 21 et 22 octobre 1983.

Solnit, Rebecca. "The Struggle of Dawning Intelligence: On Monuments and Native Americans." *Harvard Design Magazine* (Fall 1999): 52–7.

Solso, Robert L. *Cognition and the Visual Arts*. Cambridge, MA and London: MIT Press, 1994.

Sontag, Susan. "Looking at War: Photography and Violence." *The New Yorker* (9 December 2002): 82–98.

– *On Photography*. New York: Farrar, Straus and Giroux, 1978.

Spence, Jo and Patricia Holland, eds. *Family Snaps: The Meanings of Domestic Photography*. London: Virago, 1991.

Spires, Randi. "Curating Political Art." *Art Views* (Fall 1987): 27–9.

Staats, Greg. *Animose*. Catalogue essay by François Dion, 2002.

– Artist Statement: *Animose*, 2000.

Steele, Lisa and Kim Tomczak, "'Oshawa 1938–45,' an interview with Carole Condé and Karl Beveridge." *Incite* 1, 4 (March/April, 1984).

Stein, Nancy L., Peter A. Ornstein, Barbara Tversky, and Charles Brainerd. *Memory for Everyday and Emotional Events*. Mahwah, NJ: Lawrence Erlbaum Associates, Publishers, 1997.

Steiner, Wendy. *Pictures of Romance: Form against Context in Painting*

and Literature. Chicago and London: University of Chicago Press, 1988.

Stephen Bulger Gallery. *Bertrand Carrière. Les Images – Temps*. Toronto, 1999.

Stewart, Jacqueline. "Negroes Laughing at Themselves? Black Spectatorship and the Performance of Urban Modernity." *Critical Inquiry* 29, 4 (Summer 2003).

Stewart, Pamela J. and Andrew Strathern, eds. *Landscape, Memory and History*. London and Sterling: Pluto Press, 2003.

Stewart, Susan. *On Longing: Narrative of the Miniature, the Gigantic, the Souvenir, the Collection*. Durham and London: Duke University Press, 1993 .

Strange, Carolyn, and Alison Bashford, eds. *Isolation: Places and Practices of Exclusion*. London and New York: Routledge, 2003.

Strawson, Galen. "Against Narrativity." *Ratio (new series)* 18 (4 December 2004): 428–52.

Sturken, Marita. "The Image as Memorial: Personal Photographs as Cultural Memory." In Hirsch, ed., *The Familial Gaze*, 178–95.

– *Tangled Memories. The Vietnam War, the AIDS Epidemic, and the Politics of Remembering*. Berkeley; Los Angeles; London: University of California Press, 1997.

Styles, Elizabeth. *The Psychology of Attention*. East Sussex: Psychology Press, 1997.

Szarkowski, John. *Photography Until Now*. New York: The Museum of Modern Art, 1989.

Szarkowski, John, and Maria Morris Hambourg. *The Work of Atget*. Vol. 2, *The Art of Old Paris*. New York: The Museum of Modern Art, 1982.

Szilasi, Gabor. *Gabor Szilasi: Photographs 1954–1996*. Montreal: Vox Populi and McGill-Queen's University Press, 1997.

Tate Britain. *American Sublime: Landscape Painting in the United States 1820–1880*. Exhibition catalogue by Andrew Wilton and Tim Barringer. London, 2002 .

Taussig, Michael. "The Beach (A Fantasy)." *Critical Inquiry* 26, 2 (Winter 2000): 249–77.

– *Mimesis and Alterity: A Particular History of the Senses*. New York & London: Routledge, 1993.

Taylor, Charles. "Religion Today." *Transit online*, no. 19 (2000). http://www.iwm.at/index.php?option=com_content&task=view&id=237&Itemid=413. Site visited 12 February 2007.

Taylor, Gail Fisher. "Gail Fisher Taylor Interview." *CKLN-FM Mind Control Series – Part 24*. Series started 16 March 1997.

Taylor, Kate. "Tags and Letters." *Canadian Art* 13, 4 (Winter 1996): 34–7.

Temple, Kevin. "If these walls could talk: Apparently unrelated videos let you make the connections." *Now*. 3 March 2005.

Thomas, Jeffery. Artist's statement. Artspace, Peterborough, 2001.

Thorneycroft, Diana. Artist's talk, Concordia University, 3 October 2002.

Thunder Bay Art Gallery, Thunder Bay. *Greg Staats: Memories of a Collective Reality – Sour Springs, 1995*. Essay by Janet Clark, 1995.

– *Stardusters: New Works by Jane Ash Poitras, Pierre Sioui, Joane Cardinal-Schubert, Edward Poitras*. Exhibition catalogue by Garry Mainprize, 1986.

Thunder Bay National Exhibition Centre and Centre for Indian Art, Thunder Bay. *Altered Egos: The Multi-Media Work of Carl Beam*, 1984.

– *Pow Wow Images: An Exhibition of Photographs by Jeffrey Thomas*. Exhibition catalogue by Tom Hill, 1985.

Tierney, Emiko Ohnuki. *The Monkey as Mirror: Symbolic Transformations in Japanese History and Ritual*. Princeton: Princeton University Press, 1987.

Tisseron, Serge. "L'inconscient de la photographie." *La Recherche photographique* 17 (Autumn 1994): 80–5.

– *Le Mystère de la chambre claire: Photographie et inconscient*. Paris: Flammarion, 1996.

Tom Thomson Memorial Art Gallery, Owen Sound. *Political Landscapes #1: Canadian Artists Exploring Perceptions of the Land*. Exhibition catalogue by Stephen Hogbin, 1989.

Tombs, Robert. "Inside the Eye of The Newfoundland Project, Thaddeus Holownia's Coney Island of the Mind." *Arts Atlantic* 19, 3 (Summer 2002): 6–12.

Townsend, "Flashes of Light: Diana Thorneycroft's 'impossible' photographs and the possibility of history," in Keshavjee, ed., *slytod: Diana Thorneycroft*, 37.

Treviño, A. Javier, ed. *Goffman's Legacy*. Lanham, MD: Rowman & Littlefield, 2003.

Tuer, Dot. "Four Questions upon the Reception of the Work of Art in the Age of Mechanical Reproduction." *C Magazine* 3 (Fall 1984): 62–5.

– "Is it Still Privileged Art? The Politics of Class and Collaboration in the Art Practice of Carole Condé and Karl Beveridge." In *But is it Art? The Spirit of Art as Activism*, Nina Felshin, ed. Seattle: Bay Press, 1995: 195–220 .

Valensi, Lucette and Nathan Wachtel. *Jewish Memories*. Trans.

Barbara Harshav. Berkeley, Los Angeles, and Oxford: University of California Press, 1991.

Van Alphen, Ernst. *Caught by History: Holocaust Effects in Contemporary Art, Literature, and Theory*. Stanford: Stanford University Press, 1997.

Vance, Jonathan F. *Death So Noble: Memory, Meaning, and the First World War*. Vancouver: UBC Press, 2000.

Vancouver Art Gallery, Vancouver. *Jeff Wall 1990*. Exhibition catalogue by Gary Dufour, 1990.

– *Marian Penner Bancroft: Recent Work*. Essay by Denise Oleksijczuk, 1990–91.

Vansina, Jan. *Oral Tradition as History*. Madison: University of Wisconsin Press, 1985.

Varnedoe, Kirk. *Gustave Caillebotte*. New Haven and London: Yale University Press, 1987.

Verge, Pierre G. "Bertrand Carrière." In *Look Again: A Guide to the Canadian Museum of Contemporary Photography*. Ottawa, 1992.

– "Notebook of Absence: Photographs by Bertrand Carrière / Carnet d'absences de Bertrand Carrière." Trans. Dwayne Perreault. *Blackflash* (Winter 1989): 23–9.

Vervoort, Patricia. "A Visual Autobiography: The Self-Portraits of Carl Beam," 2005 *First Nations, First Thoughts* Conference. Centre of Canadian Studies, Scotland, 5 May 2005. http://www.cst.ed.ac.uk/Events/Conferences/index.html. Site visited 12 February 2007

Villedieu, Yanick. "You Must Remember This!" *enRoute* (May 1999): 34–45.

de Vries, Ad. *Dictionary of Symbols and Imagery*. Amsterdam and London: North-Holland Publishing Company, 1974.

VU. Centre de diffusion et de production de la photographie, Quebec. *Bertrand Carrière. Conversations avec l'invisible*. Essay by Pierre G. Verge, 1992.

– *Bertrand Carrière. Les Images ~ Temps*. Essay by Mona Hakim. Quebec, 1999.

– *Carole Condé & Karl Beveridge: Théâtre des opérations*. Essay by Carol Condé & Karl Beveridge, 2003.

Wade, W. Cecil. *The Symbolisms of Heraldry*. London: George Redway, 1898.

Wajcman, Judy. *Women in Control: Dilemmas of a Workers Co-operative*. New York: St. Martin's Press, 1983.

Walker, Ian. *City gorged with dreams: Surrealism and documentary photography in interwar Paris*. Manchester and New York: Manchester University Press, 2002.

Wallace, Ian. "Photoconceptual Art in Vancouver." In Canadian Museum of Contemporary Photography, *Thirteen Essays on Photography*. Ottawa: CMCP, 1988: 94–112.

Walsh, Andrea Naomi. "Complex Sightings: Aboriginal Art and Intercultural Spectatorship." In Lynda Jessup and Shannon Bagg, eds, *On Aboriginal Representation in the Gallery*. Hull, Quebec: Canadian Museum of Civilization, 2002.

– "Visualizing histories: experiences of space and place in photographs by Greg Staats and Jeffrey Thomas." *Visual Studies* 17, 1 (2002): 37–51.

Walsh, Meeka, ed. *Diana Thorneycroft: The Body, Its Lesson and Camouflage*. Winnipeg: Bain & Cox, Publishers, 2000.

Walter Phillips Gallery, Banff. *Between Views and Points of View*. Exhibition catalogue by Daina Augaitis and Sylvie Gilbert, 1991.

– *Frame of Mind: Viewpoints on Photography in Contemporary Canadian Art*. Exhibition catalogue by Daina Augaitis, 1993.

– *Ken Lum: Photo-Mirrors*. Exhibition catalogue by Lisa Gabrielle Mark, 1998.

– *Storyland: Narrative Vision and Social Space*. Essay by Catherine Crowston, 1995–96.

Walton, Kendall L. "Transparent Pictures: On the Nature of Photographic Realism." *Critical Inquiry* 11 (December 1984): 246–78.

– "Experiencing Still Photographs: What Do You See and How Long Do You See It?" http://sitemaker.umich.edu/klwalton/files/stillphotos_7dec04draft.doc.pdf. Site visited 12 February 2007.

– "Looking Again through Photographs: A Response to Edwin Martin." *Critical Inquiry* 12, 4 (Summer 1986): 801–8.

– *Mimesis as Make-Believe: On the Foundations of the Representational Arts*. Cambridge and London: Harvard University Press, 1990.

– "On Pictures and Photographs: Objections Answered." In *Film Theory and Philosophy*, Richard Allen and Murray Smith, eds. Oxford and New York: Oxford University Press, 1998.

Warnock, Mary. *Imagination*. London: Faber and Faber, 1976.

– *Imagination and Time*. Oxford & Cambridge: Blackwell Publishers, 1994.

– *Memory*. London and Boston: Faber and Faber, 1987.

Watney, Simon. "Ordinary Boys." In Spence and Holland, *Family Snaps*, 26–34.

Watson, Petra. "*The Giant*: An Allegory." Paper presented at a symposium, "The Image: A Transient and Changing Paradigm. Image and Technology in the Context of Contemporary Visual Art Practice." Banff Centre for the Arts, 4–5 November 1994.

Weiss, Allen S. *Perverse Desire and the Ambiguous Icon*. Albany: State University of New York Press, 1994.

Wells, Liz, ed. *Photography: A Critical Introduction*. 3rd ed. London and New York: Routledge, 1996, 2004 .

– *The Photography Reader*. London and New York: Routledge, 2003.

Western Front Exhibitions Program, Vancouver. *Jin-me Yoon: Between Departure and Arrival*. Exhibition catalogue by Judy Radul, 1998.

White Water Gallery, North Bay. *Contemporary Rituals*. Exhibition catalogue by Curtis J. Collins, 1990.

Wiesel, Elie. *From the Kingdom of Memory: Reminiscences*. New York: Schocken Books, 1990.

Wigoder, Meir. "History Begins at Home." *History & Memory* 13, 1 (Spring/Summer 2001): 19–59.

Wilde, Oscar. *The Picture of Dorian Gray*. Oxford: Oxford University Press, 1974.

Willett, John. *Art & Politics in the Weimar Period: The New Sobriety 1917–1933*. New York: Pantheon Books, 1978.

Williams, Carol J. *Framing the West: Race, Gender, and the Photographic Frontier in the Pacific Northwest*. New York: Oxford University Press, 2003.

Williams, D.A., ed. *The Monster in the Mirror: Studies in Nineteenth-Century Realism*. Oxford: Oxford University Press, 1978, 1980.

Williams, Raymond. *Culture and Society: 1780–1950*. 1958. Reprint, with a new introduction. New York: Columbia University Press, 1983.

– *The Country and the City*. New York: Oxford University Press, 1973.

– *Keywords: A Vocabulary of Culture and Society*. Rev. ed. New York: Oxford University Press, 1983.

– *What I Came to Say*. London: Hutchison Radius, 1989.

Wills, David. *Prosthesis*. Stanford: Stanford University Press, 1995.

Wilmerding, John. *American Light: The Luminist Movement, 1850–1875*. Princeton: Princeton University Press, 1989.

Wimsatt, James I. *Allegory and Mirror: Tradition and Structure in Middle English Literature*. New York: Pegasus, 1970.

Winnipeg Art Gallery, Winnipeg. *Eight from Toronto*. Exhibition catalogue by William Kirby, 1975.

– *Robert Houle: Indians from A to Z*. Exhibition catalogue by Shirley Madill, 1990.

– *Robert Houle: Sovereignty over Subjectivity*. Exhibition catalogue by Shirley Madill, 1999.

– *Treaty Numbers 23, 287, 1171: Three Painters of the Prairies*. Exhibition catalogue by Jacqueline Fry, 1972.

Wittkower, Rudolf. *Sculpture: Processes and Principles*. Harmondsworth: Penguin Books, 1977, 1986.

Wittlich, Petr. "Closed Eyes, Symbolism and the New Shapes of Suffering." In The Montreal Museum of Fine Arts, *Lost Paradise: Symbolist Europe*. Montreal, 1995: 235–41.

Worringer, Wilhelm. *Abstraction and Empathy*. Trans. Michael Bullock. Chicago: Ivan R. Dee, 1997.

Yakimoski, Nancy. "Tableaux and Text in the Work of Brenda Francis Pelkey." *Prefix Photo* 3, 5 (May 2002): 6–17.

Yates, Frances A. *The Art of Memory*. 1966. Reprint. London, Melbourne and Henley: ARK Paperbacks, 1984.

Young, James E. "Between History and Memory: The Uncanny Voices of Historian and Survivor." *History and Memory* 9, 1 (Spring/Summer 1997): 47–58.

– "Memory and Counter-Memory: The End of the Monument in Germany." *Harvard Design Magazine* (Fall 1999): 4–13.

– *At Memory's Edge: After-Images of the Holocaust in Contemporary Art and Architecture*. New Haven and London: Yale University Press, 2000.

Zaslove, Jerry. "Decamouflaging Memory, or, How We Are Undergoing Trial by Space. While Utopian Communities Are Restoring the Powers of Recall." *West Coast Line* 34/35, 1 (Spring 2001): 119–57.

– "Faking Nature and Reading History: The Mindfulness toward Reality in the Dialogical World of Jeff Wall's Pictures." In Vancouver Art Gallery, *Jeff Wall 1990*, 64–102.

– "Herbert Read and Essential Modernism, or, The Loss of an *Imago Mundi*." *Collapse: The View from Here* 1 (1995): 153–90.

– "W.G. Sebald and Exilic Memory – His Photographic Images of the Cosmogony of Exile and Restitution." *Journal of the Interdisciplinary Crossroads* 3, 1 (April 2006): 205–38.

Zelizer, Barbie. *Remembering to Forget: Holocaust Memory through the Camera's Eye*. Chicago and London: University of Chicago Press, 1998.

Zerubavel, Eviatar. *Time Maps: Collective Memory and the Social Shape of the Past*. Chicago and London: University of Chicago Press, 2003.

Zolla, Elémire. *The Androgyne: The Reconciliation of Male and Female*. New York: Crossroads, 1981.

INDEX